Love, Sex, Gender, and Superheroes

Love, Sex, Gender, and Superheroes

••••••••••••••••••••••••••••

JEFFREY A. BROWN

Rutgers University Press

New Brunswick, Camden, and Newark, New Jersey, and London

Library of Congress Cataloging-in-Publication Data

Names: Brown, Jeffrey A., 1966– author.
Title: Love, sex, gender, and superheroes / Jeffrey A. Brown.
Description: New Brunswick : Rutgers University Press, [2022] |
 Includes bibliographical references.
Identifiers: LCCN 2021006632 | ISBN 9781978825260 (paperback) |
 ISBN 9781978825277 (cloth) | ISBN 9781978825284 (epub) |
 ISBN 9781978825291 (pdf)
Subjects: LCSH: Superheroes in mass media. | Sex role in mass media. |
 Love in mass media. | Comic books, strips, etc.—Social aspects.
Classification: LCC P96.S93 B76 2022 | DDC 813.009/352—dc23
LC record available at https://lccn.loc.gov/2021006632

A British Cataloging-in-Publication record for this book is available from the British Library.

www.rutgersuniversitypress.org

Manufactured in the United States of America

For Larry and Judy Fitzwater.
Thank you for the incredible help.

Contents

Love, Sex, Gender,
and Superheroes

Introduction

■ ■

Signifying Love, Sex, and Gender

> Just . . . *Wow*. Her Name is Artemis Grace.
> I can still remember the first time she punched me.
> —Jason Todd

The quotation above opens the story "Date Night" from *Red Hood and the Outlaws* #19 (2018). Jason Todd, a former Robin and the current antihero Red Hood, is finally going out for dinner and drinks with his teammate, the Amazon warrior Artemis. Jason's narration when he first sees Artemis dressed for their night out is meant to be a humorous throwaway line. Yet, the line manages to neatly combine some of the disparate themes about romance, gender, sexuality, and violence that run through the superhero genre and that constitute the focus of this book. These themes include the following: the spectacle of Artemis's beauty in a gown that shows off her impossible figure, Jason's overpowering attraction to her, the romantic ritual of a first date, the need to balance their public and private identities, and the memory of her physical strength and combat skills that oddly imply her sexuality is equally dangerous. Jason and Artemis's date night involves a great deal of adventure, but it is still framed as an important break in the series' monthly life-and-death battles. This slower, more romantic moment in a genre otherwise centered on extreme action is not unusual. Romantic interludes in ongoing superhero stories are commonplace and indicate the importance

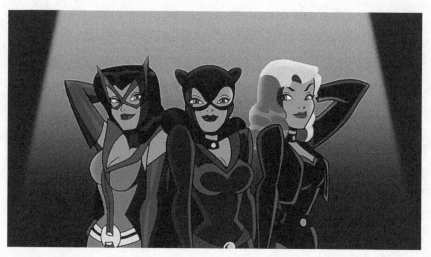

FIG. I.1 *Batman: Brave and the Bold*, 2009, season 2, episode 24

of lessons about gender, sex, and love. In fact, the story's title, "Date Night," is actually a very common designation for superhero tales. For example, the "Date Night" title has also been used in recent years in *Wolverine and the X-Men* #24 (2014) for Wolverine and Storm, *Batman Annual* #2 (2017) for Batman and Catwoman, *Amazing Spider-Man* #6 (2018) for Peter Parker and Mary Jane, and *Young Justice* #18 (2020) for Robin and Spoiler. And there are many issue titles with only minor variations on the theme, such as "Double Date" from *Batman* #37 (2017), where Batman and Catwoman share a date with Superman and Lois Lane. The preeminence of romance in superhero stories is an important theme to grapple with because it exposes how popular culture models and instructs consumers about the unspoken cultural rules and expectations of gender and sexuality, all under the guise of simple entertainment.

In a second season episode of the children's program *Batman: The Brave and the Bold* (2008–2011), the animated heroines Black Canary, Huntress, and Catwoman perform an impromptu nightclub routine while Batman is in the audience undercover. The women are illustrated in the series' signature style as innocent-looking, retro pinups. Their crime-fighting costumes double as a type of showgirl outfit: high heels, cinched waists, gloves, masks, and ample cleavage for all three (figure I.1). The cheery show tune the women sing, "Birds of Prey," is a masterpiece of innuendo about male superheroes and their sexual prowess, or lack of. "Green Lantern has his special ring, pretty strong that little thing! Blue Beetle's deeds are really swell, but who will bring him out of his shell?" Of the Flash, the women wink as they sing "Too bad sometimes he's just too fast!" Likewise, the women question whether Green Arrow is "shooting straight," complain that "Plastic Man can't expand," and declare "Aquaman's always courageous . . . his little fish, less outrageous," while Huntress wiggles her pinky

finger. Finally, all three women swoon and praise Batman, singing, "Batman throws his Batarang, what a weapon, that thang! Check out that utility belt, sure can make a girl's heart melt! He's always right there for the save, I'd like to see his secret cave!" Though the musical number is just a mischievous scene from a lighthearted cartoon, it is characteristic of how gender and sexuality are both addressed and disguised in the world of superheroes. The flirtatious double entendres of the song mask a preoccupation with sexuality, the clean retro look of the animation disguises the fetishistic aspects of the women's costumes, and the fawning over Batman's "weapon" and his ability to "make a girl's heart melt" valorizes a very specific version of masculinity as a cultural ideal. On the surface, superheroes may be all about fighting crime and saving the world, but just beneath that surface superheroes reveal an obsession with gender and sexuality.

This book considers the superhero genre, in comics and live-action film and television, as one of the many ways that the media reflects, reveals, and helps shape our perceptions of gendered identities and how we relate to others intimately. My goal is to explore a range of issues about gender and sex that are modeled by superheroes, issues that are interconnected, shifting, progressive, conservative, and complex. Superheroes are one of the most prominent and influential forms of entertainment in contemporary culture, especially since the feature films have come to dominate box offices worldwide. Superheroes are everywhere nowadays, in the media and in merchandising. Everyone knows who Batman, Superman, Spider-Man, Wonder Woman, and Black Widow are, at least in some sense. These characters may be regarded primarily as escapist fantasies, exciting and colorful figures who undertake thrilling adventures, but they also represent and naturalize ideas about sex and gender. In fact, superheroes can be influential precisely *because* they are dismissed as merely childish fantasies. Superheroes are assumed to be simple and innocent fun, not worthy of critical examination or reflection. Yet the genre's omnipresence makes the superhero effortlessly influential and instructive. By delving into the multifaceted ways that superheroes frame gender and sexuality, I hope to illuminate how the genre reinforces, and challenges, social norms.

The entire superhero genre functions much like the "Birds of Prey" musical number: obsessed with sex and gender but only addressing these themes indirectly through metaphors and symbols. The masks and disguises so pivotal to the genre emulate the way sexuality is prominent and hidden at the same time. No other narrative form relies on symbolism as excessively as superheroes do. In colorful costumes prominently adorned with iconic logos from a stylized *S* to the outline of a bat or a spider, or a red, white, and blue shield emblazoned with the Stars and Stripes, or a cowl meant to evoke the image of a cat, a wolverine, or a black panther, superheroes traffic in symbolism. Likewise, their clashes with supervillains represent moral parables as exciting adventures. The virtuousness of Superman triumphing over the avarice of Lex Luthor, Batman's ideology of law and order defeating the chaos created by the Joker, the democratic family

dynamic of the Fantastic Four overcoming the dictator Dr. Doom, and the diverse but unified American dream team of the Avengers repelling any number of alien/foreign invaders. Over and over again, superhero stories play out a basic cultural lesson of good triumphing over evil, justice over injustice.

The pervasiveness of the superhero and all that they stand for ("Truth, Justice, and the American Way") not only teach children social rules and moral behavior but also reinforce for adults the bedrock principles on which Western culture is based. That superheroes shroud any deeper meanings through symbolism only means that assumptions about issues like patriotism, morality, and justice (as well as gender, romance, and sex) go unquestioned and are accepted as natural or common sense. Furthermore, since superheroes are generally regarded as a simple and childish form of entertainment, they are camouflaged by what Henry Giroux (2001) describes as the "politics of innocence," which assumes the genre is harmless fun and incapable of influencing audiences. The presumed innocence of superhero entertainment is both cause and effect of the genre's historical avoidance of more adult themes, like sexuality. In other words, the genre is innocent because themes of sexuality are rarely dealt with directly, and they are rarely dealt with because superheroes are seen as too innocent. But the genre's persistent focus on gender (all those super *men* and wonder *women*) and bodies (packed with muscles, able to project powerful blasts, to shrink, to expand, to transform, etc.) belies a preoccupation with themes of gender and sexuality. The irony of superheroes being perceived as innocent, on the one hand, and as obsessed with themes of gender and sexuality, on the other hand, can result in some incongruous media forms. In fact, the cultural pervasiveness of the superhero genre has led to a number of areas where super sexuality is explicitly portrayed. Some of these more X-rated forms that exist on the fringes of superhero fiction are addressed in this book, including pornographic parodies, fan fiction/ art, erotic comics, and "Mature Viewers Only" television programs.

The global popularity of superheroes in contemporary culture makes them a convenient and effective device for talking about important issues. In his overview of the myriad ways that superheroes have been leveraged for social activism, Henry Jenkins declares, "Superheroes are now a vital element in our collective civic imagination" (2020, 25). Everyone understands the ideological implications of specific characters and the visual iconography that represents them. This ready familiarity with superheroes is part of our cultural lexicon and makes them useful tools for conveying complex political perspectives in a concise way. Jenkins's detailed description of *why* and *how* superheroes can be valuable rallying points for activism is worth quoting at length:

Superheroes are culturally pervasive, and thus handy for political deployment. They offer a shared vocabulary for talking about the relationship between personal and cultural identity. Different superheroes embody different conceptions of justice and the social good; these missions evolve over time in

response to changed social and economic realities. The superhero genre deals directly with issues of power and its responsible use. Superheroes change the world and never doubt their capacity to make a difference. Superhero comics provide alternate conceptions of the social good and different models for how to make change. The superhero comic articulates who the good guys are and what they are fighting for, as well as who the bad guys are and what they are fighting against. This political drama unfolds in bright primary colors, often lacking the nuances necessary to foster real-world change—but such fantasies provoke debates about possible alternatives to the status quo.

(2020, 34–35)

Jenkins is referring to superheroes' efficacy for activism related to broad, and often contentious, political issues like immigration, racism, sexism, LGBTQ rights, and the environment. But these same qualities mark the superhero as an important symbol for our cultural and personal understanding of gender, romance, sex, and sexualities. Moreover, the superhero can serve as an anchoring point from which we can view shifting and evolving beliefs about gender and sexuality. Superheroes are a "shared vocabulary" that can help us learn, question, and comprehend complicated notions about what it means to be masculine, feminine, heterosexual, homosexual, to be in a relationship, to be in lust, or even to be a shapeshifting alien in love with a sentient robot.

The incredible world of superheroes functions as an economical way to model and glorify beliefs about love, sex, and gender. The superheroes' amazing powers, impossible adventures, exaggerated bodies, and melodramatic relationships turn abstract cultural beliefs into observable and entertaining parables. Regardless of media format, be it comic book, live-action movies, animated film, or television, superheroes present audiences with visible proof of gender norms and intimate encounters. Or, at least, they purport to offer visible proof of these cultural ideals. Like other forms of popular culture, superheroes can really only *signify* evidence of abstract beliefs. Because superhero stories are such a stylistically and narratively exaggerated genre, they can, on one level, directly signify some abstract principles. Vague expectations of modern gender roles, for instance, may be difficult to convey directly, but the obvious conflation of muscular and powerful male bodies with moral superiority presents a concise image of ideal masculinity. As Michel Foucault famously argued in *Discipline and Punish: The Birth of the Prison* (1975), relations of power, social rules of conformity, and cultural expectations are played out on, and through, the human body. Similarly, we can see cultural ideals written (and illustrated) on the bodies of superheroes. The extreme bodies that constitute the standard uniform of superheroes and superheroines represent a fantasy of physical perfection and incredible power. The symbolism of the superhero is inscribed on and through their bodies. The colorful costumes they wear are themed to reflect their personalities and special abilities: lightning bolts for speedsters and those who wield electricity, fishnet

stockings and thigh-high stiletto boots for seductresses. The massive muscles of the Hulk or Thor reflect their unparalleled masculine strength. The hairy/furry bodies of characters like Wolverine, the Beast, and Sasquatch indicate their animalistic nature. Even geographic and national stereotypes are reflected in the names and powers of some heroes—for example, Fire is a hot-tempered Brazilian bombshell who can shoot green flames from her fingers, Ice is a Norwegian heroine equipped with wintery blasts, and the Dust is an Afghani mutant who can turn her body into a sandstorm.

Rather than mere innocent entertainment for children, superheroes thoroughly engage with ideas of masculinity and femininity, as well as marriage, love, family life, sexual assault, intimate partner violence, homosocial physical spaces, compulsory heterosexuality, queer representations, and transgender motifs. The genre's reliance on visual spectacles and its narrative emphasis on world-saving adventures mean that other, underlying themes must be signified through formulaic and visual conventions. Many of the repeated elements that signify gender, sex, and romance in superhero tales run through this book in various combinations as they stress and reflect different facets of these interrelated topics. Some of the most basic narrative and visual clichés found in superhero stories are explored from different angles in different chapters. As Mary Ann Doane notes, "It must be remembered that the cliché is a heavily loaded moment of signification, a social knot of meaning" (1991, 27). By looking at what these conventions communicate, and how they convey both obvious and implied meanings, my goal is to help untie (or at least loosen) the social knot of meaning around gender and sexuality. The foundational superhero convention of dual identities, for example, functions both narratively and visually as a metaphor for a number of binary concepts. In many ways the superhero genre revolves around reductionist binaries and dualities—right and wrong, good and evil, superhero and supervillain, male and female, costumed hero and secret identity. In fact, in addition to "tights and powers," argues Joseph J. Darwoski, "the secret identity is one of the most commonly known elements of a superhero tale" (2008, 461). The dual identity cliché established with the 1938 debut of Superman, and his mild-mannered alter ego Clark Kent, serves as a concise model for dominant ideas about masculinity. For there to be a Superman, there must also be a Clark Kent. The extraordinary is defined in contrast to the ordinary, and the less than ordinary.

More than just a genre cliché, the dual identity trope celebrates a specific version of masculinity as a cultural ideal. As I have argued elsewhere (Brown 2001), superheroes personify a version of what R. W. Connell (1987) describes as hegemonic masculinity. While hegemonic masculinity is rare, really more of an image or assumption about masculinity, it does function as a normative tool to promote conformity to an abstract gender ideal. As Connell and Messerschmidt later clarified, hegemonic masculinity "embodied the currently most honored way of being a man, it required all other men to position themselves in relation

to it, and it ideologically legitimated the global subordination of women to men" (2005, 832). In other words, the ideal of hegemonic masculinity is represented and given shape through the superhero fantasy; and hegemonic masculinity is assumed to exist in contrast to weaker men and women. At the most basic level, the superhero's duality, his transition from nerdy Bruce Banner to the incredible Hulk, from timid teenager Peter Parker to the spectacular Spider-Man, presents a clear fantasy of masculine empowerment. But this duality also presents an image of hegemonic masculinity (the Superman) and its opposite (the Clark Kent), combined in one unique package.

The superhero genre is presumptively associated with masculinity. The stories are mostly about super men doing super manly things, written and illustrated primarily by men for a mostly male audience. The masculine focus of the genre is just as pronounced in the Hollywood blockbuster movies that have dominated worldwide box offices ever since *X-Men* (2000) and *Spider-Man* (2002) inaugurated the current wave of live-action and CGI (computer-generated image) superhero films. Dozens of male heroes starred in their own film series before any costumed heroines were given the opportunity to headline their own franchises. To date, there are still only three superheroines from the big two companies (DC and Marvel) to star in solo movies: Wonder Woman, Captain Marvel, and Black Widow. In fact, the X-Men series (and the spin-off films of fan favorite character Wolverine) produced nine films and Spider-Man was rebooted three times before Wonder Woman became the first superheroine headliner of the modern era in 2017. Still, despite the genre's overwhelming focus on masculinity, romance is an important part of the basic formula. Caped crusaders, super soldiers, and mutants with incredible powers may seem like an unusual place for cultural lessons about love to ferment, but romance has continued to function as a cornerstone of the superhero fantasy. In comics, in movies, and on television, superheroes model romantic ideas and practices for audiences. Everyone is aware of famous romantic couples in the comics, like Superman and Lois Lane, Batman and Catwoman, or Spider-Man and Mary Jane Watson. Likewise, these romantic pairings have carried over into the dominant live-action versions where each superhero's ability to find love is as important to the story as defeating the bad guy. In the simplest terms: the superhero always gets the girl.

The importance of romance for superhero comic books is often displayed front and center on the sales rack. In addition to representing the dynamic inner contents of the book, comic covers also need to be visually striking to attract consumers, and they need to suggest story features that will appeal to readers. Surprisingly for an action genre, superheroes are almost as likely to be depicted on the cover of a comic book in a romantic clinch as they are punching someone. Even dark and macho heroes like Batman, Daredevil, and Wolverine are routinely shown dramatically kissing women on the covers of their books. The spectacle of romance is so commonplace that it seems to go far beyond merely confirming the hero's (and the genre's) heterosexuality. Like most cultural

expressions, superhero stories tend to focus on heterosexual romance, but in recent years they have also expanded the idea of love beyond the narrow confines of traditional heterosexuality. Indeed, the fact that queer romantic kisses have begun to receive the cover treatment as well suggests that issues of love are the central concern regardless of sexual orientation. Chapter 5will address how both heterosexual and (increasingly) homosexual romances are normalized and celebrated within the genre.

Romance is a central theme in superhero stories, but love and sexuality are not always easy dynamics for the genre to represent, even when the focus remains conservatively heteronormative. Part of this problem resides in the extreme depictions of masculinity and femininity that are the bedrock of most tales, both narratively and visually. In her historical analysis of female superheroes, Carolyn Cocca argues that the genre is well versed in "exaggerating traits associated with masculinity and femininity simultaneously," and that "female superhero bodies in action show strength and sexiness at some times, but in such poses their power is undercut as the reader is prodded to see them primarily as sex objects" (2016, 12). Furthermore, as Sabine Lebel observes in her analysis of the recent wave of blockbuster movies, "They are not only traditional in terms of the superhero narrative but they are positively regressive in terms of their portrayal of male and female bodies, and gender relations" (2009, 56). The square-jawed and muscle-bound hero is contrasted with the always voluptuous and beautiful heroine. In this regard, the genre's emphasis on duality is a useful metaphor for understanding more than just the structured nature of hegemonic masculinity. Duality in superhero stories also signifies a belief in binary distinctions between men and women (as well as between straight and queer, white and Other, good and evil, etc.). At an obvious level of visual representation, where super men are respected for their strength and abilities, wonder women are overdetermined as sexual objects.

The unique extravagances of the superhero genre enable a heavy use of symbolism at multiple levels: the colorful costumes that signify a character is "super," the dramatic names that indicate specific abilities, the powers themselves as metaphors for character traits (men as impenetrable and super strong, women as dangerous sexual lures), the physical transformations and dual identities suggestive of puberty and a wish-fulfilling power fantasy. The spectacular genre, its emphasis on the *spectacle* itself, and the importance of the visual aspects in both the comics and the movies present very specific symbols that contribute to the overall meaning of the genre. Many of these visual markers are addressed throughout the book, but I want to stress here the way that superhero stories have formalized certain visual conventions as not just clichés but as a concise symbolic shorthand with specific meanings. One of the most obvious of these visual techniques is the use of flashy onomatopoeic "sound effects" plastered over action scenes to emphasize their significance. The BAM! POW! and CRACK! that accompany a super punch delivered to the jaw of the villain are forever identified with

the campy live-action 1966 *Batman* television series starring Adam West and Burt Ward as the Caped Crusaders. Or, as Batman mocks the comic technique in *The Lego Batman Movie* (2017): "We're going to punch these guys so hard, words describing the impact are going to spontaneously materialize out of thin air." As silly as the visual convention of sound effects may seem, it is a device still used in comics because it signifies specific meanings. The moment is presented as a spectacle of violence. It is not just the sound effect that is of importance, but the overall mise-en-scene of the punch. The image of the "super punch" will be discussed in detail in chapter 8 in relation to intimate partner violence, but at the most basic level, the image conveys a moment and spectacle of the hero physically and morally vanquishing a villain.

Similar to the conventional image of the "super punch," visual tropes are commonly used in mainstream superhero stories to signify ideas about romance and sexuality without being overly explicit. Many of these visual clichés that reproduce dominant ideas about proper romantic behaviors are addressed throughout this book. One thing that struck me during my research was the highly formulaic visual depiction of significant events in comic books. In addition to the iconic punch scenes, romantic and sexual milestones (from first kisses to orgasms) are visually highlighted as momentous events. For example, chapter 2 addresses how women's symbolic powers of seduction that can reduce even the strongest of men to hormonal slaves are always visually conveyed with some version of stars or swirls or hearts floating around the hero's head; chapter 5 incorporates how romantic kisses, both heterosexual and homosexual, are framed to dominate a page with the background details just fading away; and chapter 9 unpacks how superheroes blasting various energies from their bodies implies an orgasmic release. Though superheroes have sporadically existed in nonvisually based media (e.g., 1940s radio programs, book novelizations), the extreme look of superheroes and their powers is an important symbolic element in both comic books and live-action films and television. More than in most genres, the appearance, the spectacle, and the visual conventions function as a crucial part of how the narrative is shaped. Furthermore, the visual tropes concisely (and almost subliminally) reinforce abstract cultural beliefs as natural or self-evident—such as the importance granted to the fantasy of true love's first kiss as a romantic milestone where time stands still, the outside world disappears, and both individuals are overwhelmingly in love. I have included an analysis of various generic conventions and provided illustrations to show how these abstract ideas are expressed in images, because the visual is an important part of how superheroes signify beliefs about gender, romance, and sexuality.

In his historical analysis of the social and political upheaval played out through American comic books in the 1960s, Ramzi Fawaz (2016) identifies shifting ideas about sexuality as a double-edged sword for superhero adventures. Progressive characters and politically charged stories facilitated a new perspective on social and personal politics. The influence of various movements, including civil rights,

feminist, and queer, was increasingly evident in comic books and found an easy expression via the unusual bodies of many superheroes (especially among Marvel's roster of a new wave of heroes). Popular figures like the Hulk, Spider-Man, and many of the mutant X-Men challenged the conventional depiction of heroic men and women as flawless gender ideals. Marvel's new wave of angsty and flawed characters served as the ultimate outsiders—easy analogies for anyone excluded from the traditionally white, male, heterosexual heroic norm. Fawaz points to the Fantastic Four as an example of how these superheroes simultaneously challenged and reinforced cultural assumptions about gender and sexuality. Fawaz argues that a character like the monstrous-looking Ben Grimm, a.k.a. the Thing, was understandable as a person who felt trapped in the wrong body or who could not conform to social expectations. Moreover, Fawaz continues, the unusual presentation of the Thing "suggested that a variety of discourse of bodily nonnormativity deployed to *consolidate* alternative sexual and gender identities in the face of homophobia and transphobia (such as the transsexual language of being 'trapped in the wrong body') could also be used to *destabilize* normalizing structures like heterosexual masculinity" (80). In other words, superheroes were capable of incorporating nonnormative gender and sexuality so effectively that they risked undermining the rigid ideals that have always been at the heart of the genre.

In addition to the Thing's inability to conform physically to a masculine ideal, Fawaz notes that sexual norms also became suspect through Marvel's premiere super family. "It is through the body's failure to present a specifically fixed gender identification, both at the level of physical appearance and the direction of its psychic desire," Fawaz argues, "that the question of sexuality is made manifest on the bodies of the Fantastic Four" (2016, 80). Moreover, Fawaz notes, characters like those in the Fantastic Four struggled to reaffirm and model conventional heteronormative roles, while also suggesting the complicated and fluid nature of sexual desires: "Though at times the direction of the character's desires seems obviously normative (all four characters romantically pursue members of the opposite sex), such desires are shot through with 'queer' feelings that attend the team's more obviously abnormal bodies. Ben's desire for his own monstrous second skin; Reed's split affections for Sue and his scientific research; Sue's equally split feelings for Reed and for Prince Namor, the team's on-again, off-again villain and king of Atlantis—all pointed to the fact of heterosexual desire gone awry" (80–81). Likewise, the superhero's excessive heterosexuality and extreme depiction of gender could also indicate the presence of same-sex desires thinly disguised. For example, Fawaz singles out the Fantastic Four's youngest member, the Human Torch, whose "blazing body functioned as both a visual expression of excessive heterosexuality—the hypersexualized teenage rebel—as well as its seeming opposite, the 'flaming' homosexual of popular political rhetoric" (81). Though Fawaz focused on the 1960s and 1970s Bronze Age of comics, the ambiguity of superheroes as conventional ideals of gender and sexuality

and as potentially progressive symbols of nonnormative bodies and desires has become even more entrenched over the intervening fifty-some years.

The portrayal of intimate desires within superhero stories has also shifted a great deal in recent years owing to a growing awareness and acceptance of different sexual identities, and the dismantling of the restrictive Comics Code of America that forbade any explicit depictions of sexuality and any hints of homosexuality or other "perversions." As each of the following chapters will explore, superheroes now regularly interact with a wide range of conventional and unconventional sexualities, both directly and indirectly. Gay, lesbian, bisexual, and trans characters have become far more prominent among superheroes. As have topics like casual sex, kinks, interracial romances, and even interspecies relationships. The standards of love, sex, and gender have expanded incredibly with superheroes over the past twenty years. When it comes to depictions of sexual acts among the cape and cowl set, there is likewise a broad range of ways, and types, of sex presented. There is a huge potential for subversive, or at least unconventional, sexual activities given the extreme physical abilities of the characters in this subgenre of science fiction.

Though the genre is based in large part on dualities (costumed vs. civilian identities, good vs. evil, etc.) and safeguarding borders (bodies, nations, morality, etc.), when it comes to sexual couplings among superheroes there is often a significant blurring of the boundaries. Indeed, superhero sexuality transgresses a number of boundaries beyond just heterosexual and homosexual relationships. Chapter 6 addresses the convention of sentient robotic superheroes entering into emotional and physical relationships with human characters. But the genre has also featured such unusual sexual pairings as human/alien (Superman and Lois Lane, Peter Quill and Gamora, Starfire and Dick Grayson), human/creature (Namor and his sea-monster-looking lover), human/demon (Hellcat and Damien Hellstrom, Deadpool and Satana), human/vampire (Batwoman and Nocturna), and human/god (She-Hulk and Hercules, Thor and Jane Foster, Captain America and the female Thor). There is a significant potential for these mixed and border-transgressing relationships to broaden the heteronormative cultural standard usually offered in the media.

Traditionally, these border-crossing relationships were disguised as conservative pairings. Superman may be an alien, but he looks like a (white) human male; thus his relationship with Lois Lane is rendered unproblematic. More recent depictions, however, revel in the unique possibilities of these unusual sexual encounters. For example, in DC Comics *Outsiders* #20 (2006) two of the team's alien members, the orange-skinned Starfire and the green-skinned Jade, accidentally walk in on Shift and Indigo having sex. Shift is a shape-shifter who can transform the chemical and atomic structures of raw materials, and Indigo is an advanced robot from the future who is learning about her ability to assume human feelings and impulses. The brief glimpse of Shift and Indigo having sex is bizarre (figure I.2): Indigo is naked, legs spread around Shift, while his body

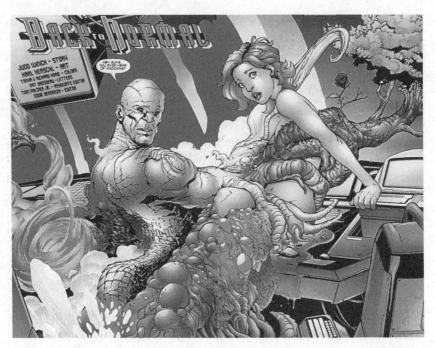

FIG. I.2 *Outsiders* #20, 2006, Judd Winick and Karl Kerschl

envelops hers in a mélange of vapors, branches, vines, crystals, metallic scales, and bubbling foam. The scene looks like anime tentacle sex more than anything that conventionally happens between people. The shocked and embarrassed Starfire and Jade stammer apologies and quickly walk away. "Oh my god, oh my god" Jade keeps repeating as she covers her eyes. "I'll be honest with you," Starfire says, "I've seen stranger couplings but not usually on Earth. And definitely not with bipeds." Yet, despite the strangeness of the romantic pairing and their sexual activities, the story does depict Shift and Indigo in a sweet postcoital snuggle where they confess their affection for each other. Their romance is portrayed as weird but natural and legitimate, progressive and unconventional but no less authentic than that of others.

Fawaz argues that the "discourses of bodily nonnormativity" in 1960s superhero comics that enabled analogies of alternate sexual and gendered identities ultimately needed to be countered for fear that they may "*destabilize* normalizing structures like heterosexual masculinity" (2016, 80). Similarly, as the spectrum of diverse sexualities has expanded within the genre, normalizing depictions of sexual relations are constantly reinforced. Though nonnormative sexualities are no longer derided in superhero stories, they are often overshadowed by the glamorized ideals routinely presented. Superhero intercourse cannot be shown (except in X-rated fringe versions), but the conventional signifiers of sexuality paint a blissful picture of romance and sex. Passionate kisses between the

handsome heroes and the beautiful heroines quickly transition to romantically moonlit bedrooms, or the couple basking in the golden glow of sunrise the morning after. Strategically crumpled white sheets, soft kisses, satisfied smiles, and whispered endearments frame these encounters as ideal romantic couplings, as models of assumed normative sexuality. The cumulative effective of these repeated scenes is to proffer a sexual script, a fantasy, evidence, and reinforce a hegemonic belief in romantic, monogamous loved as a destined meeting of two souls.

The concept of duality as an important organizing principle within superhero stories, particularly around the concept of hegemonic masculinity, is the focus of chapter 1. Specifically, this chapter investigates the way hegemonic masculinity is produced and reinforced at multiple levels through the symbolism of the superhero and his relation to the mythic phallus. The allegory of the phallus is an important reference point for establishing assumptions about masculine ideals. The mythical phallus parallels many of the ways that phallic masculinity both declares itself exceptional and averts scrutiny through what the stories show and *do not show*. The tension between what *is* and *is not* seen in relation to the phallus, and how it is presented, is an integral part of how hegemonic masculinity is vaulted as naturally superior. The superhero formula works to valorize a model of hegemonic masculinity—strong, powerful, hard bodied . . . in a word: "super." Indeed, many of the central conventions of the genre reinforce duality (seen/unseen) in layers that bolster the concept of hegemonic masculinity as unassailable. The superhero and his secret identity, the colorful costume and ordinary clothing, the powerful in contrast to the powerless, public and private personas: all contribute to the display and disguise of masculinity. Most mainstream depictions of superheroes, whether in comics, film, television, or video games, present almost ridiculously extreme images of phallic power while always keeping the penis safely out of view. One of the few instances where superheroes intersect explicitly with sexual display is in the area of pornographic parodies. The pornographic versions of popular superheroes expose, literalize, and fetishize the superhero penis as the ultimate "proof" of masculine privilege. While inviting the audience to look at and admire the superhero penis would seem to invite subversion of the norms of superhero representation, the heterosexual superhero porn parodies do not meaningfully undermine or recontextualize the superhero genre, but instead reinforce the superhero's presumption of hegemonic masculinity. The pornographic versions make literal many of the features that are symbolic only in mainstream superhero stories.

Chapter 2, "Women Dark and Dangerous," shifts the focus to superpowered women and how they pose a clear threat to the strength and independence of the male characters. Revealing masculinity's inherent mistrust or fear of femininity, women in superhero stories are often framed as the modern costumed equivalent of film noir's infamous femme fatale. The ability of classic femme fatales to seduce men and lead them to ruin is portrayed by characters like

Catwoman and Black Widow. Whether in slinky dresses or skintight, leather catsuits, these women use their sexuality as a weapon to disarm and manipulate men. The threat of emasculation that women present for even the most super of men complicates the presumption of hegemonic masculinity as an infallible quality. The femme fatale's legendary powers of seduction are often turned into literal superpowers among caped crusaders. Dozens of beautiful super femme fatales have the power to completely mesmerize and control men with just a flirtatious smile or a whispered command. Through magic, chemicals, pheromones, or mutant abilities, women like Poison Ivy, Spider Woman, Venus, Enchantress, Charma, Crimson Fox, and Encandora can rob men of their independence and free will, turning them into slaves eager to please their mistresses.

Chapter 3, "Secrets of the Batcave," considers the importance of male-only headquarters that serve to reinforce male homosocial bonding and to restrict any potentially negative feminine influences. The Batcave is one of the most famous fictional settings in the world. Batman's secret headquarters, hidden beneath stately Wayne Manor on the outskirts of Gotham City, has been featured in comic books, live-action movies, cartoons, and television series for over eighty years. The idea of a secret cave as a base of operations known only to the Dynamic Duo (and to young readers/viewers) is a crucial part of the overall fantasy of the Batman. But the Batcave is much more than just a base of operations for Batman's legendary war on crime; it is an eminently private male space where the Caped Crusader can hang his cowl. The cave also functions to reinforce a conception of masculinity for young readers that is premised on homosociality and an exclusion of femininity. The Batcave, and other male-only secret headquarters like Dr. Strange's Sanctum Sanctorum, Tony Stark's laboratory, and Green Arrow's Arrow-Cave, spatially represents a difference between the public and private masculine personas of the heroes. The manor/cave schism mirrors the public/private and superhero/secret identity duality at the heart of the formula (and explored in chapter 1).

The concept of the Batcave as a fantasy masculine space for boys is similar to *Playboy* magazine's imagined ideal of the swinging Bachelor Pad for sophisticated urban men. Both the cave and the bachelor pad are gadget-laden spaces where men can bask in consumerist pleasures and personal achievements. But where *Playboy*'s Bachelor Pad incorporates the goal of sexual conquest as a defense against accusations of a type of self-domesticated (read: feminized) masculinity, Batman's Batcave invokes heroic adventures as a safeguard of heterosexuality despite the male-only environment. The similarities between the cave and the pad were made explicitly clear in the 1970s when Batman / Bruce Wayne relocated from the manor to a rooftop penthouse as part of the editorial agenda to reheterosexualize the character after the campiness of the 1960s television series *Batman*. Like the bachelor in his pad, the superhero in his cave is a lesson in how to perform a specific version of masculinity. As innocuous as the Batcave may

seem as a fictional location, it lays the groundwork for normalizing and valorizing predominantly male-only spaces in the real world, like the boardroom, the locker room, or the clubhouse, thus excluding women from important places of power. The perceived threat that women pose to these spaces of male seclusion is also played out with the Batcave through the control of women's ability to see. Just as women in the comics have historically been objects of the male gaze, tales of the Batcave emphasize the male hero's preeminent view. The few women who do visit the Batcave are always blindfolded, literally left in the dark, when it comes to the hegemonic male's most intimate secrets.

The difficulties of superhero romance and the dilemma posed by marriage and domestic life is the central concern of chapter 4. Marriage and superheroes rarely go together with any lasting success. The superhero genre has traditionally trafficked in extreme gender ideals: *super* men with square jaws, bulging muscles, incredible powers, and able to defeat any threats; *wonder* women with perfect hair and beautiful faces, long legs, and ample bosoms. Superhero stories have traditionally valorized a very narrow definition of masculinity based on demonstrations of physical power. Or, as David Coughlan has insightfully argued, "comics suggest that strength in the masculine public sphere is the truest sign of manhood" (2009, 238). Marriage in American culture is seemingly anathema to the type of gender ideals represented in the world of superheroes. This chapter addresses the problematic function of marriage in superhero comics as the concept, or actuality, of marriage reframes the conventional masculinity and femininity of costumed characters. The long-standing and misogynistic belief that marriage emasculates or feminizes men through domestication has been vigorously reinforced in comics and is an unspoken reason why most heroes avoid settling down. But this fear of matrimony, of growing up, of committing to a woman, is a narrative device that also suggests a preference for homosocial (and possibly homosexual) bonds that publishers have unevenly tried to sidestep. Gender roles and expectations change in the few matrimonial situations that do occur as the heroes shift from public to domestic personas. The apparent mundanity of married bliss is at odds with the adventurous lifestyle of superheroes. The genre's difficulty in portraying marriage ultimately reinforces the belief that love and domesticity are incompatible with hegemonic masculinity and the unrealistic fantasy of female sexuality on offer in the genre. In recent years, however, thanks to changing industry standards and cultural shifts, superhero marriages have become an acceptable proposition and have redefined masculine and feminine ideals to include themes like equal partnerships and parental responsibilities. The increased strength and status of superheroines over the past twenty years has allowed for a true level of equality in many cases, where the wife's powers may exceed her husband's. The rise of strong women in the genre reduces marriage as a dangerous proposition for spouses.

The various methods used to normalize romantic milestones via superheroes are the central focus of chapter 5, "It Starts with a Kiss." For the most part,

mainstream superhero stories avoid explicit sexual activity. The genre's origin as adventure stories for children, and the continued economic need to attract young consumers, means that the most iconic superheroes (those from Marvel and DC) rarely explore sex directly. Even with all the images of muscular men and buxom women prowling the dark streets in tight leather outfits, comics have managed to maintain a general aura of virtuousness. Cultural beliefs and normative behaviors are naturalized through the stories and go unquestioned by audiences. First among these implicit norms is the presumption of heterosexuality as the baseline orientation of superheroes. Explicit sex may not be depicted in mainstream superhero stories, but the symbolic suggestions of romance and physical coupling are. The tales of costumed crusaders overwhelmingly signify heterosexuality as ideal, but in recent years there has been a concerted effort within the comics industry to incorporate nonheteronormative sexualities in a manner that does not stereotype, demonize, or diminish them. Chapter 5 traces how sexualities in contemporary superhero comics are constructed in a manner that normalizes heterosexuality through specific narratives, visual conventions, and social rituals through to the increasing normalization of LGBTQ sexualities by employing the same tropes. In particular, the chapter addresses common romantic elements often deemed a natural or socially proper progression in Western culture: momentous kisses, proposals, bachelor and bachelorette parties, and formal weddings. All of these rituals are routinely employed in superhero stories as a traditional means to celebrate heterosexuality. Progressively, these same rituals are also now used to help normalize same-sex relationships.

"Learning about Love and Robots," the sixth chapter, concentrates on the common character type of the sentient robotic superhero as a device used to work through the nature of humanity and love. Building on some of the ideas about "true love" addressed in chapter 5, and the conception of mind-body duality as a central component of the genre's foundation in binaries that runs throughout this book, the sentient robot is discussed as a useful mechanism to consolidate abstract cultural concepts about romance. Despite being artificial constructs, robotic heroes (and villains) are excessively gendered in their metallic forms in ways that replicate the extreme gender ideals presented with all superheroic figures. Female robots like Jocasta, Platinum, and Indigo are illustrated as virtually naked shiny forms with pronounced breasts and buttocks, shapely legs, pouty lips, and long, metallic hair, whereas male robots, such as Vision, Red Tornado, and Robot Man, are all presented as handsome and square-jawed images of virility with bulging biceps and six-pack abdominal muscles. The excessive gendering of robots raises some peculiar themes in relations to sexual objectification and fetishistic Pygmalion fantasies that are often incorporated into the stories. But, more importantly, each of these robots enters into a romantic relationship with a human and allows the story to directly pontificate on the nature of true humanity, the idea of a soul as the real essence of a person, and the magic of love as a divine force that can turn even a machine into a person, a partner, and a hero.

The robotic characters are typically depicted as Pinocchio-like in a quest to become human. Love becomes the gateway to greater humanity and proof of a soul within the machine. Yet, in relation to love as a humanizing ideal, gender remains an important factor as the female robots strive to become perfect mates for human males, and the male robots endeavor to be human via familial love as husbands and fathers.

Chapter 7, "Super Fluidity," considers the numerous ways that superheroes trouble gender boundaries and how these methods relate, and do not relate, to transgender identities. The chapter reviews many of the methods which superhero stories have employed regarding mind-body discordance and gender fluidity to suggest a type of transgenderism. The superhero genre routinely depicts body swaps, gender switched alternatives, and gender-crossing shape-shifters that metaphorically evoke trans conditions. Each of these narrative conventions imagines heroes as transformed from one gender to another. But while these narrative devices often touch on issues applicable to transgender experiences regarding bodies and identities, the superheroes always return to their original cisgender forms and confirm that the body and the gender they were born into is the natural and correct form. Problematically, the existence of these trans allegories has allowed the genre to avoid actual representations of trans characters until very recently. As superhero fictions have slowly become less conservative in relation to gender and sexualities, trans heroes are becoming possible as more than just metaphors. Within comic books, transgender characters have begun to populate minor roles in series at both Marvel and DC Comics. But to date, Aftershock Comics' character Chalice has been the only transgender hero to star in her own series, *Alters* (2016–2018). As a trans youth and superpowered hero, Chalice builds on the device of secret identities inherent in the genre to positively parallel the experience of personal transformation experienced by many people outside the confines of the comic book pages. Similarly, the popular television series *Supergirl* (2015–ongoing) added the trans hero Dreamer (played by real-life trans activist Nicole Maines) in 2018 and progressively showcased trans issues as human issues and created a space for nonnormative youth to be humanized (despite being an actual alien) and valorized. With *Supergirl*'s Dreamer and *Alter*'s Chalice, superhero fictions have begun to use the formula's reliance on issues of duality, gender, and transformation as an effective metaphor for more than just puberty. Likewise, the genre's premise that people who are different, who are "abnormal" in some way, can be morally upstanding heroes helps elevate the possibilities of how trans people can be perceived as both exceptional and familiar.

Sexualized abuse and intimate partner violence constitute the primary concern of chapter 8, "KRAKK! WHACK! SMACK!." The superhero fantasy is one of the few areas in modern culture where women can be routinely characterized as physically powerful, on par with or surpassing many male heroes. But this fantasy of equal strength does not mean male and female characters are treated equally when it comes to violence. The gender dynamics worked through

in superhero tales are progressive on a number of levels, but the continued hyper-sexualization of costumed women is intricately coupled with sadistic sexual assaults and instances of intimate partner violence that often undermine female agency at the same time that they suggest gendered abuse is a (super) villainous act of misogyny. This chapter addresses the linked, but incongruous, themes of sexuality and violence in the superhero genre, where women are positioned as erotic objects for male characters (and readers) in a manner that obscures the line between aggressive relationships, sexual assault, and intimate partner violence. The idea of "comic book violence" and the way it is depicted has evolved a great deal over the years. Both storylines and visuals have become more graphic in the portrayal of violence. Still, comics have maintained specific iconic conventions, such as having superheroes knock out the bad guys with a single punch, accompanied by an emphatic visual sound effect: BAM! POW! With superheroes the violence is typically stylized and illustrated as a symbolic moment captured for the reader's enjoyment. While blood may spray from the corner of a mouth, very little real damage is done. The genre's focus on brutal confrontations, hand-to-hand fight scenes, and the routine celebration of physical battles to resolve problems creates a fictional environment that blurs the line between *heroic* and *horrific* violence.

The unequal forms of violence faced by female characters have been well documented as part of the "Women in Refrigerators" trope first identified by comics writer Gail Simone in 1999, wherein female characters are killed, raped, depowered, brutalized, and crippled at a far greater rate than male characters. This chapter links incidents of rape and intimate partner violence with the genre's standard "Women in Refrigerators" mistreatment of female characters to explain the difficulty of incorporating real-world problems of sexual violence into a formula rooted in spectacular battles. For the most part, women have been the primary victims of sexualized superhero violence, but even such stalwart male characters as Batman, Green Lantern, Invincible, and Nightwing have been sexually assaulted. Moreover, whether the sexualized violence is male-on-female or female-on-male, the stories reinforce numerous misconceptions about the type of people who are sexual predators, and the portrayal of some victims as deserving and others as undeserving. Two specific cases that will be focused on in this chapter are Jessica Jones, who was raped and held captive by the mind-controlling villain Kilgrave in both her comic book series and the Netflix series based on it, and Harley Quinn, who has endured a long-running abusive relationship with the Joker across a number of media. Both Jessica Jones and Harley Quinn have been used to portray the more traumatic effects of sexual assault and intimate partner violence, and to explore ways that women may be able to escape abusive relationships.

The ninth chapter, "Pleasure, Pain, Climaxes, and Little Deaths," links the visual and ideological representations of super orgasms (both metaphorical and actual) with a conception of bodily truths and the cliché of temporary superhero

deaths. Drawing primarily from Linda Williams's landmark work on pornography (1985) and her related theories about horror and melodrama (1991), this chapter considers the symbolic importance of orgasmic release as both a narrative convention and a visual convention that unite the fantasy of bodies erupting with superpowers with bodies unable to contain extremes of pleasure (or fear or sadness). The often overlapping conceptions of orgasm as pleasure and pain—or as the French have dubbed it, *la petite mort* (the little death)—are brought together in the superhero where violent energies are often dispelled directly from the body in battle in an orgasmic blast. And conversely, actual orgasms in superhero stories are typically portrayed as uncontrollably super powerful, either accidentally activating the hero's powers at the moment of climax or using the same visual iconography as used in fights to provide a visible proof of orgasm, such as excessive visual sound effects (OOOOOH, rather than KAPOW) or the miraculous bright light of energy/pleasure that erupts from the couple's loins rather than fists, signifying incredible satisfaction. In likening the convention of powers to orgasmic release (and vice versa), chapter 9 also delineates between what is framed as the potentially emasculating and insatiable female orgasm, on the one hand, and the exhausting finite male orgasm, on the other. The gendered dynamics where orgasms and powers intersect also helps explain the infamous temporary deaths of male superheroes who give their all to save the world, and ultimately rise up again from the grave a few issues later, reinvigorated and ready to do it all again.

Finally, the conclusion provides a brief overview of the various ways we can observe how people use superhero imagery to express their understandings of gender and sexuality in the real world. By focusing on clothing as a public declaration of fandom and hero identification, we can understand how fans publically reveal beliefs and fantasies about gender and sexuality. Even something as common as superhero T-shirts can signify an acceptance of, or challenge to, conventional gender norms and can spark heated debates. Likewise, the gendering of superhero Halloween costumes for children establishes clear divides between stereotypes of boys as strong and active, and girls as pretty and frilly. Adult superhero Halloween costumes, meanwhile, solidify a more extreme divide between the genders with an emphasis on fetishizing women, even when they are dressed as male super characters. Conversely, the popular fan practice of cosplay (costume play) is often used to explore alternate gender dynamics and sexualities, especially in the subgenres of crossplay and cosqueer. The genre is also invoked directly in sexual terms through the mass marketing of superhero underwear and lingerie. In the comics, movies, and television programs, superheroes model specific gender ideals and work through an abundance of concerns about sexuality.

1

The Visible and
the Invisible

■ ■ ■ ■ ■ ■ ■ ■ ■ ■ ■ ■ ■ ■ ■ ■ ■ ■ ■

Superheroes and
Phallic Masculinity

There is a curious, and much talked about, scene in the middle of *Thor: Ragnarok* (2017). Thor (Chris Hemsworth) and the Hulk (a computer-generated image) are stranded on the alien planet Sakaar and forced to do gladiator-style battle for the amusement of the masses. After their epic bout, the two most powerful Avengers share lavish living quarters, complete with an oversize hot tub. At one point, Thor is explaining his escape plans to the Hulk, who is taking a bath. Suddenly the green behemoth casually emerges from the tub completely naked and makes no effort to conceal his loins. Thor is shocked and embarrassed; he stammers and tries to look away, as the Hulk confidently strides past. "That's in my brain now," Thor humorously laments. James Dyer's review in *Empire* describes the moment as "a priceless reaction to the sight of Hulk's giant green penis" (2017, para. 3). Likewise, Carl Greenwood's review in the *Sun* claims, "The look on the poor God of Thunder's face will tell audiences everything they need to know about the Hulk and will have them roaring with laughter" (2017, para. 2). Though the Hulk's presumably giant green penis is never actually shown, this scene is nonetheless very revealing for precisely the reasons Greenwood identifies. By playing superhero sexuality for laughs and simultaneously showing and not showing the Hulk's penis, this brief scene exposes the complicated web of relations between superheroes, masculinity, and sexuality, as well as a widespread

and assumed discomfort with examining those relations without the protective shield of sophomoric humor.

The issue I specifically want to investigate in this chapter is the way that hegemonic masculinity is produced and reinforced at multiple levels through the symbolism of the superhero. Even more specifically, I want to investigate how the masculine symbolism of the superhero is reinforced by the myth of the phallus. My case study for this investigation is the increasingly popular subgenre of superhero porn parodies. Most mainstream depictions of superheroes, whether in comics, film, television, or video games, present almost ridiculously extreme symbols of phallic power while always keeping the penis safely out of view. But the pornographic versions of popular superheroes expose, literalize, and fetishize the superhero penis as the ultimate "proof" of masculine privilege. While inviting the audience to look at and admire the superhero penis would seem to invite subversion of the norms of superhero representation, my analysis of popular heterosexual superhero porn parodies argues that these films do not meaningfully undermine or recontextualize the superhero genre, but instead reinforce the superhero's presumption of hegemonic masculinity.

As the naked Hulk scene suggests, the allegory of the phallus is an important reference point for fantasies about masculine ideals. Moreover, the fact that this scene both shows and *does not show* the mythical phallus parallels many of the ways that phallic masculinity both declares itself exceptional and averts scrutiny. The dynamic between what *is* and *is not* seen in relation to the phallus, and how it is presented, is an integral part of how hegemonic masculinity is vaulted as naturally superior. In reference to the presence and absence of the penis in popular media, Anja Hirdman (2007) argues that "questions of visibility, of what can be seen and not seen, are crucial for the symbolic authority of masculinity, or the myth of masculinity." Furthermore, Hirdman continues, "invisibility has always constituted a significant component of a privileged position allowing for certain aspects of the subject to remain hidden from common visibility—and yet to appear as if there is nothing hidden, nothing that has to be concealed from the public gaze" (159). Superheroes are one of the most visible contemporary models of hegemonic masculinity and help perpetuate an abstract notion of the phallus that is supreme but always hidden from view. But with the seemingly ever-growing popularity of superhero movies spawning a tidal wave of pornographic parodies seeking to capitalize on our society's current fascination with all things superhero, the mythical phallus of these caped crusaders is at risk of being exposed.

Parodies generally ridicule or critique the premise of the texts they are parodying. Superhero parodies in comic book form, like Garth Ennis's series *The Boys* (2009–2012) or Mark Millar's miniseries *Nemesis* (2010), question the hypermasculinity of generic superheroes, as do live-action parodies such as *Dr. Horrible's Sing-Along Blog* (2008) and *Super* (2010). Yet many of these mainstream superhero parodies ultimately still allow the protagonist to save the day, even if he is

a less than ideal model of masculinity (see Brown 2016a). Most contemporary heterosexual superhero porn parodies do not, however, intentionally ridicule the characters they focus on. Rather, they glorify them through a commitment to fidelity that includes the supposed fidelity of the superhero penis.

Phallic Models of Masculinity

The process of fostering identification with masculine ideals such as superheroes has been a central tenet of film studies. In her seminal work "Visual Pleasure and the Narrative Cinema," Laura Mulvey notes that male leads exemplify the "more perfect, more complete, more powerful ideal ego" (1975, 12) and that classical Hollywood cinema employs an array of narrative and stylistic techniques to align viewers with that perspective. Likewise, Steve Neale (1983) outlines how the visual conventions used to present heroic men offer viewers a form of "narcissistic identification" with the masculine fantasies of "power, omnipotence, mastery, and control" (11). Jon Stratton (2001), in his analysis of cultural fetishism and gender in relation to consumerism, explicitly links Neale's theory of narcissistic male identification to the metaphor of phallic authority: "The reason why male narcissism involves those fantasies Neale lists is because the man with whom the male viewer is narcissistically identifying exhibits, either in his body or in his actions, phallic power" (181).

To be clear, the phallus is a symbol or an idea of masculine power and privilege; it is not a body part. As Bordo notes, "It is a majestic imaginary member, against which no man's penis can ever measure up" (2000, 94–95). The phallus and the penis are not synonymous, but they are representationally intertwined. There is no direct relationship between the phallus and the penis, but there is a symbolic one, in that the phallus is suggestive of the penis in a way that elevates the physical marker of masculinity to justify inequities as natural gender differences. As Richard Dyer describes, "The penis is also the symbol of male potency, the magic and the mystery of the phallus, the endowment that appears to legitimate male power" (1993 113). Moreover, Dyer's general claim about the penis's inability to live up to the majesty of the phallus as depicted in popular culture is a near-perfect description of the majority of male superhero characters: "The penis can never live up to the mystique implied by the phallus. Hence the excessive, even hysterical quality of so much male imagery. The clenched fists, the bulging muscles, the hardened jaws, the proliferation of phallic symbols—they are all straining after what can hardly ever be achieved, the embodiment of the phallic physique" (1993, 116). Where much male imagery may strive to embody an impossible phallic physique, the illustrated superhero figure in comic books and the digitally enhanced live-action performers in modern superhero movies, combined with the incredible powers afforded these fictional champions of justice, are able to embody phallic masculinity in an exaggerated manner that is relatively unfeasible for real men to achieve.

Though the phallus as the preeminent symbol of hegemonic masculinity is forever linked to the penis as the definitive marker of sexual difference—what Richard Dyer refers to above as "the endowment that appears to legitimate male power"—the efficacy of the phallus is predicated on the absence of the actual penis. In order for the phallus to signify strength and power, the penis needs to remain invisible. As Jacques Lacan famously declared, "The phallus can only play its role when veiled" (1982, 82). This veiling that Lacan describes involves both obfuscating any association between the phallus and the penis that is too literal, and the near-constant censorship of the penis from public view. Penises must remain hidden in order to support the logic of the phallus, for fear of revealing the truth of Dyer's assertion that "penises are only little things (even big ones) without much staying power . . . not magical or mysterious or powerful in themselves, that is, not objectively full of real power" (1993 113). Indeed, most considerations of the phallus stress the importance of the invisibility of the penis in relation to the spectacle of the phallic symbol. Peter Lehman (1998) argues that "silence about and invisibility of the penis contribute to phallic mystique" (124). The literal and symbolic erasure of actual penises from public view facilitates the mythical position of the phallus as pure symbol. "Phallocentrism is an imaginary idea," Anja Hirdman (2007) notes, "relying on the invisibility of the penis in order to maintain its authoritative position in culture" (165). Likewise, Stephens (2007) maintains that "the penis is paradoxically both everywhere—disseminated through the proliferation of phallomorphic imagery and privilege—and nowhere, its specificity hidden from view" (87). The phallus needs to be ever visible to effectively signify masculinity as powerful, and the penis needs to remain ever invisible to avoid undermining the myth of the phallus.

Phallic symbols abound in the superhero genre—Thor's hammer, Wolverine's claws, the Punisher's guns, Cyclops's eye lasers, and so on. But nothing symbolizes and naturalizes superheroes' phallic masculinity as much as their heavily muscled bodies. Richard Dyer bluntly observes, "Muscularity is the sign of power—natural, achieved, phallic" (1992, 114). Impossibly massive shoulders, huge biceps, ripped quads, and sculpted abs are the standard bodily uniform for male superheroes. The comic book superhero body has only become more muscular over the years, to the point where many modern superheroes have bodies that professional athletes, underwear models, and bodybuilders might either envy or laugh at; the male superheroes drawn by the once record-breakingly popular artists at Image comics, for instance, have been roundly criticized for being so excessively muscular that real-life versions would be unable to stand. Despite this comical excess, and while certain monstrously large and hard characters such as the Hulk and the Thing can occasionally be read as critiquing as well as celebrating phallic masculinity, in general, the excessively muscular bodies of male superheroes imply that these characters' privilege, power, and superiority over others is natural and an innate part of masculinity. The visible muscularity of superheroes is so crucial that the actors who portray the caped

crusaders in the current wave of live-action movies are frequently required to undergo extreme body makeovers to approximate the brawny form of the hero. Hugh Jackman, Chris Evans, and Chris Hemsworth had to pack on a formidable amount of muscle mass to play Wolverine, Captain America, and Thor, respectively. Conversely, Chris Pratt had to exchange forty pounds of fat for lean muscle to portray Peter Quill, a.k.a. Starlord, in *Guardians of the Galaxy* (2014). Even the more traditionally lithe Spider-Man required Tobey Maguire to pack on muscle. In general, the actors who portray superheroes are expected to achieve a body that implies the character is naturally powerful and will triumph over any challengers. As Stratton describes, these types of hypermasculine film heroes represent "the active ideal of the male, the strong and powerful man who has the phallus and, metonymically, can represent the phallus" (1996, 119). The supermuscular body of the superhero veils any weaknesses that might disprove the intrinsic supremacy of the phallus.

Returning to the naked Hulk scene, we can see how the film reinforces the association between muscularity and phallic symbolism by appearing to mock it through the excessively pumped-up body of Chris Hemsworth's Thor and the massive CGI characterization of the Hulk. In his review of *Thor: Ragnarok* for the entertainment news website Vulture, Kyle Buchanan explicitly addresses the hot tub scene and how it raises many of the issues about masculinity, power, muscles, and phallic symbolism that lurk just below the surface of superhero stories:

> The gratuitous shirtless scene is a Marvel-movie staple, and few of its heroes have been paraded around half-nude more than Chris Hemsworth. As Thor, possibly the most swole superhero in the Marvel Cinematic universe, Hemsworth can be counted on to reliably remove his shirt for no reason whatsoever beyond marketing purposes. The latest Marvel movie, *Thor: Ragnarok*, readily continues that tradition—and yup, Hemsworth still has physical dimensions that would make any mortal man envious—but at the same time, Marvel realizes that the ante must be upped. . . . It falls to *Thor: Ragnarok*, then, to break that barrier in the most unexpected way, stripping the familiar purple skivvies off the Hulk in a nude scene. . . . So while Thor can manage an impressive shirtless scene, Hulk one-ups him by casually strolling past Thor in the nude, letting it all hang out. Thor reacts to the full-frontal glimpse reserved only for him but the rest of the audience has a moment to ponder Hulk's rear, and there's a whole lot there to ponder.
>
> (2017, para. 4)

This short passage from Buchanan's review contains several points worth noting in the context of superhero phallic symbolism. First, the recognition that every Marvel movie contains a "gratuitous shirtless scene" is an indication of how

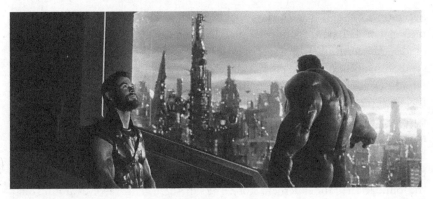

FIG. 1.1 *Thor: Ragnarok*, 2017 Marvel Studios

important it is, and how conventional it has become within the genre, to always display the muscularity of the actors. Second, the description of Chris Hemsworth's shirtless moment as evidence that he "still has physical dimensions that would make any mortal man envious" exposes the fact that the display of the hero's muscles is as important for male viewer identification and aspiration as it is for heterosexual women or gay men in the audience, as a sexual offering. It is also recognition that Thor's exceptional muscularity is crucial to his status as a *super* man—that is, as an embodiment of phallic masculinity. Third, that the physical excess of the Hulk's body, which is only possible as a CGI rendering, not only extends the logic that the bigger the muscles, the more ideal the masculinity, but also demonstrates this superiority—the Hulk's "one-up" over Thor—through his nudity, by "letting it all hang out." And fourth, that the Hulk's presumed giant green penis is never actually seen by anyone other than Thor, so we have to assume the Hulk's penis is exceptional based solely on Thor's reaction (figure 1.1). In other words, the Hulk's penis is framed as a phallus precisely because audiences never actually see it, just a reaction to it. Compounding things is the fact that *it* does not—and cannot—exist in reality anyway, as the Hulk's entire body is a computer-generated image.

The abundance of phallic symbols in the world of superheroes suggests the depth of insecurity about masculinity in our society. All of the formidable powers, muscles, and armor of male superheroes serve to dispel any possibility of weakness. In Neale's terminology, the superhero is a complicated ego ideal that may inspire anxiety as much as it does confidence. "The construction of the ideal ego . . . is a process involving profound contradictions," Neale argues, "while the ideal ego may be a 'model' with which the subject identifies and to which it aspires, it may also be a source of further images and feelings of castration, inasmuch as that ideal is something to which the subject is never adequate" (1983, 13). It is impossible for real men to live up to these fantastic fictional models of

hegemonic masculinity. The fact that Neale describes the possibility that real men may feel anxiety about their inability to meet the unreasonable demands of ideal masculinity as "feelings of castration" again highlights the interrelated symbolism of the mythical phallus and the flesh-and-blood penis. The next chapter addresses the fear of emasculation posed by women within the genre, further marking the hypermasculine bluster of the superhero as a phallic masquerade covering for worries about inadequacy. The unremarkable normality of the penis haunts the mystique of the phallus. Similarly, the shadow of male insecurity that haunts the superhero genre—which is guarded against so vehemently by a surplus of phallic symbols—can be read as analogous to the themes of duality at the foundation of the superhero story. The superhero genre revolves around dual identities: the mild-mannered reporter who can become Superman, the timid teenager who turns into the amazing Spider-Man, the 4F civilian who becomes a super soldier, the irresponsible playboy who is really a Dark Knight, and so on. The symbolic disjuncture between the phallus and the penis parallels the inherent duality of a genre that hinges on the differences between the superhero and the secret identity, wherein the secret identity is usually either average or ineffectual (and thus implicitly feminized).

The male superhero can be understood as the embodiment of phallic masculinity, and conversely, the symbolic logic of the phallus can be interpreted as similar to, or even constitutive of, major conventions of the superhero genre. To put it simply: the conventional traits that distinguish the male superhero from his civilian identity are comparable to the relationship between the phallus and the penis. In a binary frame, the phallus is to the penis as the superhero is to the secret identity (and vice versa). The phallus and the superhero are both strong and gifted with magical powers; they are both visible and public icons whose true secrets need to be disguised, masked, and veiled. On the other side of the divide, the penis and the secret identity are weak and lack any real power; thus, they have to avoid being exposed or unmasked for fear of revealing the mundane humanity behind the fantasy. As disparate as the two sides are—as different as the superhero is from the secret identity, and the phallus from the penis—there is not a great distance between them. Yet the border between these two sides is clearly delineated and marked by the colorful costume that serves as a literal veil for the secret identity and the penis. The contrast between the superhero and his secret identity encompasses a range of opposing characteristics that are magically combined within the superhero genre. These same qualities align in the disparity between the phallus and the penis, and the distinction between the phallus and the actual male organ is also magically resolved in the superhero narrative. The costume as veil disguises the inherent weaknesses in the equation and presents the superhero/phallus as spectacular. Table 1.1 demonstrates how the binary nature of phallic superheroism can be divided along a range of intertwined qualities associated with masculinity and its invisible other.

Table 1.1
Superhero and the Disguised Other

Superhero		Secret identity
Phallus		Penis
Superhuman	C	Human
Powers	O	Lack
Strong	S	Weak
	T	
Veiled	U	Exposed
Visible	M	Invisible
Masked	E	Unmasked
Public		Private

Hardcore Superheroes

The carefully maintained image of the superhero as an embodiment of the phallus is potentially put in danger when the hero's sexuality becomes the object of the story. The rise of superhero porn parodies risk exposing (both literally and figuratively) the costumed hero's penis. X-rated depictions of superheroes are nothing new. In the first half of the twentieth century, the infamous trend of "Tijuana Bibles" cheaply illustrated the explicit sex lives of popular characters (see Barry 2017), including the likes of Superman, Batman, and Captain Marvel. Likewise, fan-produced slash fiction and art continues to depict the sexuality of superheroes, often in hardcore or "deviant" ways (see Jenkins 2006). The emphasis on ideal bodies and skintight costumes in superhero comics easily suggests a fetishistic side to the adventures and marks the characters as ripe for (s) exploration. Even though there is a long tradition of underground or fan-based creations that venture into the realms of hardcore depictions of superhero sex, mainstream comic books, films, and television programs avoid any X-rated portrayal of sexual activities in order to maintain their massive underage audience. In the market-dominating comic books from Marvel and DC, superheroes do have sex and glimpses of flesh are seen, but genitals are never illustrated, except in the form of ultra-smooth "packages" based more on underwear mannequins than actual bodies. Instead, the stories tend to cut to postcoital scenes of Batman and Catwoman, or Daredevil and Elektra, that imply (or state) the sex was amazing.

With superhero movies currently raking in record-setting box-office profits for Hollywood, the porn industry has sought to cash in on the superheroes' popularity and erotic potential. Dozens of superhero porn parody movies are now released annually, and they are consistently the most profitable X-rated videos produced. As Dru Jeffries (2016) notes in his analysis of these pornographic parodies in relation to fan fiction, "The porn industry is following Hollywood's

lead by taking superheroes more seriously than either had in decades past, and both are being rewarded with financial success and devoted followings" (276–277). The demand for superhero porn parodies is significant enough that the two largest adult film production companies have each developed their own line devoted to comic adaptations—Vivid Superheroes and Wicked Comix. "Parodies, once a cheaply filmed niche segment of the adult movie market, are big business these days," declared an Associated Press article that was picked up by hundreds of mainstream media outlets, including *USA Today*. These parodies, according to the AP story, are "filled with expensive special effects, real story lines, actors who can (sometimes) actually act and costumes that even comic-book geeks find authentic" (Associated Press 2013, para. 4). The porn parodies are an excuse to explore the sexual exploits of all these attractive characters running around in skintight fetish costumes. Now, fans can see Batman, Robin, and Catwoman having a threesome, or watch Spider-Man get a rooftop blowjob from Black Cat, or see Wonder Woman have sex with all of the men in the Justice League at the same time.

Axel Braun is the adult film director most associated with the superhero porn parodies. Braun has been credited with nearly single-handedly raising the quality of pornographic movies and reinvigorating the industry. Even mainstream news outlets have reported on Braun's achievements. For example, Fox News reported, "Director Axel Braun has become the most in-demand X-rated director in the world by taking popular super heroes and creating super successful porn parodies. The adult film director has directed more than 400 movies since 1990, but it was his work on Vivid's *Batman XXX: A Porn Parody* in 2010 that cemented his name when it became the best-selling and most-rented title of 2010" (McKay 2013, para. 2). Since the success of *Batman XXX*, the prolific Braun has directed over seventy films, including a remarkable number of superhero characters in films such as *Avengers XXX, Wolverine XXX, Man of Steel XXX, Thor XXX, She-Hulk XXX, X-Men XXX, Captain America XXX, Wonder Woman XXX, Batman vs. Superman XXX, Supergirl XXX, Suicide Squad XXX, Avengers vs. X-Men XXX*, and *Justice League XXX*. In addition to the requisite XXX included in each of the titles, all of the films are subtitled either *A Porn Parody* or, more recently, *An Axel Braun Parody*. The designation of "parody" implies that the films mock, ridicule, or critique their subject matter, but Braun's style of superhero porn parodies is a parody only in a legal sense. The claim of parody allows the porn industry to use characters that are the corporate properties of Time-Warner (DC) and Disney (Marvel) without fear of lawsuits. But, as Axel Braun freely admits in interviews, his films are not making fun of comic book characters or storylines. In fact, Braun claims he is striving for a greater degree of fidelity to the original comics than many of the Hollywood film productions pursue.

As the leading creator of superhero porn parodies, Axel Braun produces parodies that may appear as particularly well-funded fan films (with hardcore sex

included), due to his attention to detail, his fidelity for the look and character-izations of the original comic book source material, and his professed geekdom. Both Iain Robert Smith (2015) and Dru Jeffries (2016) insightfully discuss Braun's superhero porn parodies as akin to fan videos. Smith reasons that "the current cycle of porn parodies resembles less the exploitation features . . . than a commer-cialized form of fan film" (115), and Jeffries argues that "Braun's superhero paro-dies present a unique point of intersection between Hollywood, fandom, and the porn industry, appropriating transformative textual practices usually asso-ciated with fan productivity in order to attract hardcore fans to their hardcore product" (279). But the popular heterosexual porn parodies do little to challenge cultural standards of gender and sexuality because they are commercial entities trying to capture as many viewers as possible. Heterosexual superhero porn par-odies adhere to very conventional and conservative interpretations of their sources, unlike slash and other creative works produced by fans within gift econ-omies. Fan-produced narratives often explore sexual relationships outside of official canon and subvert cultural norms through gender-bending or changing the sexual orientation of characters.

Whereas fan fiction and gay parodies often either implicitly or explicitly cri-tique their sources through their recontextualizations of canon, the Axel Braun style of superhero porn parodies stabilized conventional conceptions of male superheroes as exceptional models of masculinity. Because the superhero porn parodies are not really "parodies," and because they are produced within the con-text of top-tier heterosexual porn production, these films reinforce and natural-ize traditional conceptions of gender and power. In his discussion of the potentially carnivalesque qualities of fan-produced slash and current porn par-odies, including those directed by Axel Braun, Paul Booth (2014) maintains that slash is always subversive to a degree, but that porn parodies tend to only exag-gerate gender norms. "Slash," writes Booth, "allows the reader (and the writer) to re-examine traditional notions of patriarchy within traditional society through *subversion* of the sexuality of the main characters, porn parody does the oppo-site, it forces the audience to confront the patriarchal modes of contemporary media through overt *hyper-articulation*" (2014, 401; italics in original). Super-hero porn parodies may be an extreme fringe form of the dominant superhero narrative, but these pornographic versions function to solidify ideas of phallic masculinity in a manner that is even more conservative than what is found in the original comic books. Not only does the hero always defeat the villains, but he also sexually satisfies every woman he meets. Male anxieties about sexual per-formance and penis size have no place in pornographic fantasies, even if these issues have recently begun to creep into the mainstream comic books. For exam-ple, in *Guardians of the Galaxy* #4 (2013) notorious lothario Tony Stark (a.k.a. Iron Man) beds the green-skinned alien warrior Gamora but fails to impress her. Tony is left in bed ashamed and embarrassed as the disappointed Gamora shrugs and heads back to the bar. This type of upset to Tony's ego and reputation has

no place in *Iron-Man XXX* (2013), where Stark easily satisfies numerous women, good and bad, individually and in groups.

In the X-rated depictions, the hero's penis is necessarily revealed; but through the narrative and visual conventions of pornography, the penis becomes the phallus and reinforces the association between the phallic symbol and the male organ it is based on. Hirdman notes the importance of the penis's transition from invisible to eminently visible: "In hardcore pornography the penis is everything but invisible, and the connection to the phallus is not just on an imaginary level. Hence, this spotlight position brings with it a need for securing the penis as spectacular, as ever erected (and usually large)" (2007, 165). Because the overwhelming majority of superhero porn parodies are targeted at heterosexual viewers (male, female, and couples), the male porn star's penis is presented as remarkable, powerful, ever-hard, and always satisfying to women. The superhero penis that is shown in these films may not be as ridiculously oversized as the ones depicted in online erotic fan art and X-rated commix (where it is often larger than a character's entire torso), but the superhero penis is equated with the professional porn star penis. The explicit representation of the porn star penis—a version of the male organ that Linda Williams refers to as "not just ordinary but quite spectacular" (1989, 266)—means that when the penis is visible in this media form it is presented as embodying phallic properties. Thanks to casting choices based on male physical endowments, careful editing of sexual scenes, and the scripting of female responses during intercourse, this "super-penis" of the superhero / porn star is routinely larger than average, never limp, never impotent, and never disappointing. Like the conventional male superhero, the super penis is portrayed as powerful, hard, big, and conquering.

Like the mainstream movies they reference, the superhero porn parodies substantiate the hero's masculinity through fight sequences and special effects, albeit on a much smaller scale. But in the porn parodies, the hero's true superiority is confirmed by his sexual conquests. As is the norm in pornography, the hero has mindboggling sex with almost every woman he encounters. Whether she is a civilian, a superheroine, or a supervillain, no woman can resist the hero's super penis. For example, when Wonder Woman (Romi Rain) first meets Green Lantern (Xander Corvus) in *Justice League XXX* (2017), she initiates sex with him, claiming she needs to see if he is powerful enough to help fight alien invaders. After Green Lantern satisfies her with oral, vaginal, and anal sex, Wonder Woman declares him strong enough. Likewise, Black Widow (Peta Jensen) has sex with Captain America (Charles Dera) in *Captain America XXX* (2014) to determine whether he is a traitor or the real hero. After Captain America brings Black Widow to a screaming climax, she declares him to be the legendary super soldier. In *Superman Vs. Spider-Man XXX* (2012) Superman (Ryan Driller) proves he really is a "man of steel" in a threesome with Mary Jane Watson (Capri Anderson) and Liz Osbourn (Lily LaBeau). And, in *X-Men XXX* (2014)

Wolverine (Tommy Gunn) has sex with the villainess Polaris (Chanel Preston) that is so fulfilling she converts to the X-Men's side in their battle against her evil boss, Magneto.

The male superhero in these parodies manages to have triumphant sex with all manner of women. Superheroines and supervillainesses alike are kept in line by, and in thrall of, the super penis. In every case, the superhero's super penis extends the phallic status of the character's hypermasculinity. The women in the movies "oooh" and "aahhh" over the costumed hero's penis, they gasp at how big it is, and moan about how good it feels inside them. And, despite the porn starlets' own hypersexuality, the women are always left satiated by the superhero's performance. These pornographic conventions link the penis to the phallus. As Bordo argues, "The penis becomes a phallus when . . . it is viewed as an object of reverence or awe" (2000, 95). Chris Hemsworth's muscles combined with expensive special effects signify phallic masculinity in the Hollywood *Thor* films, but in *Thor XXX* (2013), the muscles and the special effects are not needed—the porn star penis alone conveys phallic power. Of course, even here the penis is not really the phallus, but it is narratively and visually presented as phallic. In other words, the super penis is to the real penis as the superhero is to the secret identity, and as the phallus is to the penis.

The phallic masculinity bolstered in the porn parodies is predominantly portrayed as white. Thus, the parodies reinforce and mirror the mainstream superhero films and comic books the porn versions reference. Despite the incredible number of superhero porn parodies that have been produced in the past decade, very few Black superheroes have been included. African American porn stars Lexington Steele and Nat Turner played Nick Fury and Luke Cage, respectively, in *Avengers vs X-Men XXX: An Axel Braun Parody* (2015), and Lexington Steele also played Deadshot in *Suicide Squad XXX: An Axel Braun Parody* (2016), but all three of these roles were minor supporting characters. Racial stereotypes about nonwhite bodies and sexual appetites are common in mainstream pornography (see, for example, Shimizu 2007; Nash 2014, Miller-Young 2014) and can present a qualifying problem for parodies that function to uphold a belief in white phallic masculinity. Age-old racial stereotypes about Black men as more bodily (read: larger, stronger, and better endowed) than white men are often embraced in pornography, especially in the common subcategorization of BBC (big Black cocks). In the simplest racial terms, if the parodies focused on Black superheroes in conjunction with the pornographic logic of BBCs, then white masculinity and the white super penis might be undermined, or presented as lesser than the almighty phallus it claims to be. Moreover, as Hirdman (2007) insightfully notes, part of the phallic mastery displayed by white male performers in porn involves the performer's almost mechanical control over passion and his own body. While porn is about giving in to corporeal pleasures, cultural scripts encourage white men to maintain control of their bodies at all times. As Hirdman observes,

"White men are so much more than their bodies. The white male is not confined to his corporeality. The white man's sexual drama, as evident in hardcore porn, concerns questions of how to have a sexual urge while controlling it, how to simultaneously be a body while denying this cultural position" (167). Just as the comic book superhero often struggles to maintain complete control over his powerful body, the porn superhero must demonstrate control over his corporeal pleasures. Black masculinity in pornographic terms adheres to an entirely different script of being excessively, even painfully, large, and of embracing carnal pleasures. Both of these racially informed differences threaten to undermine the idea of white-heroic-phallic-masculinity that is mutually reinforced between the mainstream and the pornographic depictions of superheroes.

The racist logic that characterizes Black men as threateningly hypermasculine (as overendowed) also assumes a weakened or feminized version of masculinity associated with Asian men (as underendowed). Where Black male porn actors have only rarely been used in the hardcore superhero parodies, Asian men have been completely ignored. This focus on white characters, and white phalluses, in porn parodies might change owing to the success of Marvel's *Black Panther* (2018) and the studio's forthcoming feature *Shang-Chi and the Legend of the Ten Rings* (2021); but it is more likely that Black- and Asian-focused parodies will be relegated to specific niche categories as race fetishism porn. The relative exclusion of nonwhite men from porn parodies serves to bolster the penis as a sign of the white hero's phallic masculinity. But while white female porn stars dominate the parodic depiction of superheroines, nonwhite women pose no threat to the mythical white male phallus, and so they are easily integrated into the porn films. The stereotype of a hypersexual female Other who can be dominated by white men only reinforces the status of the superhero as the ultimate hegemonic male. For example, the Black porn starlets Skin Diamond and Jasmine Webb have played Storm (from the X-Men), and Ana Foxxx has enacted Domino in *Deadpool XXX* and Photon in *Captain Marvel XXX*. Likewise, Asian porn actresses have appeared as a number of superheroines, including Polly Pons as Silk, Asa Akira as Katana in *Suicide Squad XXX*, and Lulu Chu as the X-Men's Jubilee.

The Importance of Costumes

The conventions used in pornographic texts like the superhero porn parodies uphold the myth that the white male organ legitimates male power—that the penis can be a phallus. Yet, even though these porn star penises are presented as phallic-like in their size, strength, power, and infallibility, the superhero costume remains an important part of the equation for bolstering the relationship between superheroes and phallic masculinity. The fidelity to the comic book versions of the superhero costumes in Axel Braun's movies is routinely singled out by critics, and by Braun himself, as a key part of the parodies' appeal. Hollie McKay's

FIG. 1.2 *Supergirl XXX*, Wicked Pictures 2015

report for Fox News observes, "Braun is known for casting actors who can actually act, and for paying meticulous attention to every wardrobe detail" (2013, para. 6). Similarly, a profile of Braun in the *Chicago Tribune* declared, "Known for his 'geek porn' parodies like *Spider-Man XXX*, *Batman XXX*, *Iron Man XXX*, etc., his films are noted for having costumes that are often startling faithful to the comic book visuals" (Serrano 2014, para. 5). Braun's desire to accurately reproduce the superhero costumes was evident from his first huge success, *Batman XXX*, where he went as far as tracking down the original fabric and colored dyes that were used to make the iconic costumes for Adam West and Burt Ward in the 1960s television series *Batman*.

Ironically, the superhero costumes are even more important when the characters are transferred to a genre whose central purpose is to reveal the body—to strip it naked and expose its secrets (figure 1.2). As Linda Williams (1989) has shown, modern video pornography is about far more than just nudity and a showing of genitals; it is about trying to capture and reveal the truth of bodies (particularly the mysterious female body) and sexual pleasures. Images of penetration in hardcore pornography provide evidence of actual intercourse, and the visual demonstration of penile ejaculation (or the "money shot") confirms male pleasure. But for women, who are assumed to lack any objective physical proof of orgasmic pleasure, pornography relies on what Williams refers to as a "frenzy of the visible." All of the woman's moaning, screaming, convulsing, and verbal declarations of pleasure in pornography are meant to signify the truth of her excitement. These same conventions that testify to the phallic power of the superheroic

penis offer, at a broader but interrelated level, "the visual evidence of the mechanical 'truth' of bodily pleasure caught in involuntary spasm; the ultimate and uncontrollable—ultimate *because* uncontrollable—confession of pleasure in the climax of orgasm" (Williams 1989, 101). Chapter 9 focuses on the symbolic link between explosive powers and orgasmic release in superhero stories and how that physical climax is coded differently for male and female characters. But here, in the pornographic parodies, the visible frenzy of the woman's body is meant to signify a truth of female sexual pleasure, and when this overwhelming pleasure is derived from the male organ, the penis becomes the phallus. The superhero costume is more important than the exposed body in the porn parodies as a means to transfer the phallic abilities of the pornographic super penis to the super man and, circularly, to offer evidence of phallic power as rooted in the male organ. Here the costume is not a veil for the penis (which is portrayed as a phallus in itself), but is still needed to mark the wearer as powerful, special, bordering on omnipotent—in a word: phallic.

The costume must remain on during the sex scenes not because it reveals the "truth" of sexual pleasure but because it visually confirms the "truth" of phallic masculinity personified by the superhero. The colorful costume in these porn parodies is the link between the phallus and the penis, and the penis *as* the phallus. Jeffries argues, "The graphic display of the naked body requires, first and foremost, a naked body, which would strip the superheroes of both their unique identities and their fetishistic charge." After all, "without the costumes they are not superheroes, they are just porn stars" (Jeffries 2016, 281). The more fantastical aspects of the superhero body that can be illustrated in the comic books or through advanced digital technologies in mega-budget Hollywood films are impossible to re-create in lower-budget films. In the porn parodies, bodies cannot fly, burst into flames, turn to steel, or stretch like rubber. In fact, given the potential for innovative carnal possibilities, the sexual acts depicted are very standard. Because of budget restrictions, there is no floating sex in the clouds, no super-speed vibrating fingers during foreplay, no power-ring-generated green sex toys. The costume needs to remain on at all times, especially during intercourse; the pornographic imperative to reveal the body is necessarily balanced with the need to maintain the pretense that these are superheroes engaging in various carnal acts. The male heroes' costumes come complete with holes in the crotch so that the porn star penis can be revealed, and put into action, without taking off the iconic costumes. As in most heterosexual pornography, the female superheroine and/or villainess body is the primary object of sexualization, meaning that the women's costumes often open more to reveal breasts, buttocks, and vaginas. But in virtually every case, the tights, boots, masks, and capes stay on for the duration of the sex scene. Vicki Karaminas (2006) argues that the superhero's costume is important because it "succeeds in signifying industrial strength associated with the ideal hyper-muscular superhero body: *the look* of power, virility

and prowess" (498; italics in original). The combination of the costume's "look of power" and the display of the porn star super penis mutually reinforces the association between superheroes, hegemonic masculinity, and the mythical phallus.

Returning to the Hulk and his presumed giant green penis, the porn parody version of the character shifts the burden of phallic symbolism from the impossibly large muscles to the porn star penis. The budgetary differences between a Disney blockbuster movie franchise and a quickly produced porn video required a less expensive way to portray the Hulk in all his glory. Thus, *The Incredible Hulk XXX: A Porn Parody* (2011) eschewed CGI technology and instead opted to mimic the nostalgic look of the television series *The Incredible Hulk* (1977–1982). In the pornographic version, Dr. David Banner's (Dale DaBone) experimentation with sexual frustration turns him into the Hulk (Lee Stone), a raging sexual beast. The alternation between the mild-mannered scientist played by DaBone and the more heavily muscled and green-skinned Hulk embodied by Stone mirrors the division between Bill Bixby as Banner and the green spray-painted bodybuilder Lou Ferrigno as the Hulk in the original television show. By choosing to present the Hulk through a relatively normal (but muscular) actor in green paint, the X-rated film saves money and also adheres to pornography's imperative to demonstrate the "truth" of real bodies. In the parody, both Banner and the Hulk satisfy numerous sexually insatiable female swingers and prostitutes. And in the finale, Banner's research partner Dr. Elaina Marks (Lily LaBeau) helps tame the Hulk's sexual rage through fornication that is extremely gratifying for both of them. Because the porn version can show the Hulk's penis, and because the Hulk's penis is performed by a professional porn star penis, the phallic symbolism of the exaggerated CGI muscles is not needed—it would be redundant. A thin layer of green paint is costume enough to solidify the relationship between superheroism and phallic masculinity.

Williams clarifies the relationship between "phallus" and "penis" in hardcore pornography as a presumption of sexual knowledge and mastery. Williams argues, "Hardcore pornography is not phallic because it shows penises; it is phallic because in its exhibition of penises it presumes to know, to possess an adequate expression of the truth of 'sex'—as if sex were as unitary as the phallus presumes itself to be" (1989, 267). Extending Williams's observation, the superhero porn parody is not phallic because it shows penises; instead, it is phallic because it presumes a unifying mastery of sexual knowledge and prowess as a form of masculine power. Furthermore, the comic book and Hollywood versions of superheroes are not phallic because of their muscles and their powers—those are just phallic signifiers. Instead, they are phallic because they present masculinity as naturally dominant, authoritative, and infallible.

The lengths that both the mainstream and the pornographic versions of superheroes will go to in order to reinforce a presumption of hegemonic masculinity

signified in phallic terms implies a fundamental insecurity. The fantasy of masculinity embodied by superheroes is an impossible extreme, an overexaggeration meant to mask inadequacies and realities. The lingering fear that even super masculinity can fail to meet expectations is addressed in the next chapter. Carrying on the metaphorical link between the phallus and masculinity, chapter 2 explores some of the ways that strong and sexualized women are framed as an emasculating threat to hegemony and male dominance.

2

Women Dark
and Dangerous

■■■■■■■■■■■■■■■■■■■■■■

Super Femme Fatales
and Female Sexuality

> Two figures merged as one. Each feels
> nothing but the softness of the other.
> Then, between dark man and pale woman
> *(who, if anything, is darker than he)* cold
> air finally rushes.
> —*Batman* #390 (1985) "Women Dark
> and Dangerous"

The comic book series *Superman's Girlfriend Lois Lane*, which ran from 1958 to
1974, focused on Lois's adventures as an investigative reporter, but, more often
than not, the stories centered on her attempts to make Superman jealous or to
trick him into a romantic commitment. In his analysis of the series, Michael
Goodrum argues, "Concerns about marriage and Lois's ability to enter into it
routinely provide the sole narrative dynamic for stories and Superman engages
in different methods of avoiding the matrimonial schemes devised by Lois" (2018,
442). The symbolic conflict between superheroes as public adventurers and the
implication that marriage domesticates and weakens men will be addressed in
detail in chapter 3. But *Superman's Girlfriend Lois Lane* also revealed the way

that female sexuality is characterized as a threat to masculinity as part of the long tradition of vilifying women. In issue #98 (1970), the story "I Betrayed Superman!" saw Lois enrolling in Metropolis's famed method acting school, where she is cast as Delilah opposite Superman, who agrees to play Sampson. During the play Lois is surprised when she is able to cut Superman's hair with an antique razor. Superman immediately loses all of his incredible powers. When the now weak Superman proposes to Lois she hesitates and he accuses her of loving him only for his fame and powers. The story then reveals that it was never really Superman, just another method actor in makeup. But replaying the Sampson and Delilah parable through Superman and Lois Lane is indicative of how female sexuality is portrayed as castrating. The introductory "splash page" for *Superman's Girlfriend Lois Lane* #98 (figure 2.1) may not reflect what actually happens in the story, but it does frame Lois as a threat in a familiar cultural context as she reclines seductively, Superman's hair in one hand, the magical razor in the other (the blade very close to his crotch). Lois laughs at his helplessness and declares she has "planned this for a long time." Just like the original biblical tale, "I Betrayed Superman!" is a fairly transparent metaphor for castration.

The vilification of women as sexually irresistible, deceitful, and castrating is, of course, not unique to superhero stories. This conception of women as emasculating runs throughout history, across nations, and is expressed in every media form. Indeed, the gendered insecurities of patriarchal culture are inherent in this dynamic and provide the basis for the influential form of feminist media study that originated with Laura Mulvey's landmark essay "Visual Pleasure and Narrative Cinema" (1975). Mulvey argues that classic Hollywood films demonstrate the complex ways that women are constructed as erotic spectacles for the controlling masculine gaze of the camera, and the audience, as a means to negate the threat women's phallic lack poses to male presumptions of power. "But in psychoanalytic terms, the female figure poses a deeper problem," Mulvey reasons. "She also connotes something that the look continually circles around but disavows, her lack of a penis, implying a threat of castration and hence unpleasure. Ultimately, the meaning of woman is sexual difference, the absence of the penis as visually ascertainable, the material evidence on which is based the castration complex essential for the organization of entrance to the Symbolic Order and the Law of the Father. Thus, the woman as icon, displayed for the gaze and enjoyment of men, the active controllers of the look, always threatens to evoke the anxiety it originally signified" (64). In other words, men fetishize women in an attempt to exert control over them because men fear the threat of emasculation that the female body represents.

This threat of female sexuality is readily apparent in superhero stories. Powerful, sexy, and dangerous women populate the genre and seem constantly poised to unman even the most incredible of male heroes. Quite often, seduction itself is turned into a superpower employed by both heroines and villainesses. Not all

FIG. 2.1 *Superman's Girlfriend Lois Lane* #98, January 1970

costumed female characters have seductive powers that enact castration anxieties, but even without these specific powers, superheroines and villainesses are so over-determined as sexual ideals that they reveal masculinity's overwhelming fear of female sexuality. Previously I have discussed the way heroines have been fetishized in comic books and movies as phallic women (Brown 2011), accessorized with the symbols of the dominatrix: leather catsuits, thigh-high boots, corsets, big hair, big breasts, long legs, swords, guns, and whips and lassos. While these overtly and spectacularly phallic superheroines are one dimension of castration compensation, I want to focus here on the other side of the equation, the women whose *seductive* nature is the greatest danger to masculinity. Despite (or also because of) the fetishistic construction of an eroticized and unknowable form of femininity in the superhero genre, the potential for women to steal male power via their sexuality remains a threat that needs to be contained, over and over again.

The complex relationship among superheroes, hegemonic masculinity, and phallic symbolism discussed in the previous chapter is often reinforced, challenged, and threatened by female characters like Delilah / Lois Lane. Lois's primary purpose within the overall Superman fantasy, a purpose usually at the heart of the stories in *Superman's Girlfriend Lois Lane*, is to confirm and bolster the masculinity of the Man of Steel. An integral part of the original adolescent male power dream offered by the superhero is the ability of the hero to win, indeed to be irresistible to, the most beautiful women. But as Delilah, Lois reveals the equally important fear of women that is part and parcel of male desire. For all of the genre's focus on masculinity as a hegemonic ideal, as strong, impenetrable, eminently visible, and naturally superior to women and lesser men, the superhero formula also exposes the self-doubt inherent in this phallic economy: the fear that even super masculinity is still susceptible to insecurities and physical inadequacies. The presumably unassailable masculinity can be betrayed by its own desires and by the very women who are supposed to validate the hero's super status. This chapter is concerned with how the superhero genre exposes fears of emasculation through the construction of femininity as sexually desirable and potentially lethal. While the dreams and wishes of the traditionally masculine audience are expressed through the powerful body of the male hero, the concomitant anxieties and fears are consolidated and projected onto the sexy female body. The portrayal of women as a sexual threat is not unique to the superhero formula. It is one of the most enduring ways that women have been demonized within patriarchal societies. The trope also serves as an effective means to naturalize a fear of women and to restrain or punish their sexuality. Tales of biblical women like Delilah and Eve, or from myths and folktales including Circe, Pandora, Helen of Troy, Medusa, and Salome, as well as the nameless sirens, mermaids, and succubus, all serve as precursors for many modern superheroines and villainesses.

Dangerous Women

The closest modern parallel often invoked in the superhero genre is the femme fatale made famous in film noir during the late 1930s and the 1940s (the same time period that saw the birth and rapid expansion of the comic book superhero). The film genre revolved around these strong women whom Yvonne Tasker has described as "striking female characters who are mysterious, ambiguous, often entrancing, and at times duplicitous" (2013, 353). As an archetypal figure of seduction, the femme fatale encapsulated a fear of women who embraced the only path to power typically afforded to them. As Deborah Walker-Morrison summarizes, "The femme fatale of classic American film noir lures her hapless male lover into committing murder or other violent crimes on her behalf and then promptly sets about disposing of him" (2015, 25). In particular, Walker-Morrison points out that the image of the spider-woman "who would destroy both earnest men and innocent women, has thus become the most ruthless of fatales, the most emblematic figure of noir paranoia. . . . The fatale as spider-woman combines physical seductiveness with lethal ambition" (25). Despite the relatively short-lived cycle of classic film noir, the femme fatale has continued to circulate in various media formats as a concise expression of a dangerously seductive woman. Chris Straayer has argued that the femme fatale is not limited by genre boundaries; instead, she has "the ability to contribute a *noir*ish quality to any genre" (1998, 161). The dangerously sexy femme fatale and the lethal spider-woman have been carried to extremes in the superhero genre. Among the colorfully garbed cape and cowl set, femme fatales tend to be dressed in revealing costumes or skintight catsuits rather than clingy cocktail dresses, and the power of seduction wielded by the femme fatales has morphed into superpowers for heroines and villainesses alike. There is a direct line from the femme fatales of noir to feline fatale criminals like Catwoman and Black Cat in the world of superheroes, from spider-women and black widows to the heroines Spider-Woman and Black Widow. The power of femme fatales embodied by actresses like Barbara Stanwyck in *Double Indemnity* (1944), Joan Bennet in *Scarlet Street* (1945), Rita Hayworth in *Gilda* (1946), Ava Gardner in *The Killers* (1946), and Veronica Lake in *The Blue Dahlia* (1946) rests in their irresistible sexuality. With a flash of leg, a come-hither look, and a long drag on her cigarette, the femme fatale manipulated men and put them on a path to ruin. The traditional femme fatale was cold, calculating, and ruthless. In a world ruled by powerful men, the femme fatale knew how to use her beauty and her sexuality (the only access to power afforded women) to control the men around her and achieve her devious goals.

The fiercely independent, smart, and determined femme fatale might have been a progressive depiction of women at a time when post–World War II gender roles were in flux. But film noir did not celebrate the femme fatale's strength; instead, the genre thoroughly vilified her as a criminal, a murderess, a homewrecker, and a moral deviant. The femme fatale was a transgressive

figure (and still *is* in modern incarnations) and was always thoroughly punished by the end of the film to ensure that patriarchal order was restored. "The femme fatale is situated as evil and is frequently punished or killed," argues Mary Ann Doane in her pivotal discussion of women in film. "Her textual eradication involves a desperate reassertion of control on the part of the threatened male subject" (1991, 2). Or, as Andrew Dickos notes in his history of film noir, she "must inevitably die—or, at the very least, be mortally injured or be arrested for her crimes" (2002, 162). The femme fatale is a criminal defined by her sexuality—moreover, she is a criminal in large part *because* of her sexuality. Thus, punishing her consolidates and reinforces the legal order and the patriarchal order. When it comes to femme fatales in superhero stories, the issue of punishing them for dangerous sexuality functions in much the same way for those who are criminal. But many of the female characters who rely on seductiveness as one of their "powers" are superheroines (or at least antiheroines) and so their containment under patriarchy occurs in different ways. The twin forms of super femme fatales, the castrating and the phallicized femme fatale, represent different ways patriarchy views and polices the threat of female sexuality.

The film-noir-inspired seductress has been a mainstay of superhero stories for over eighty years. The modern femme fatale of superhero adventures, whether in a slinky cocktail dress or leather catsuit, similarly distracts and manipulates men in order to complete her mission or to get away with her crime. Her beauty and flirtations easily unarm even the most powerful of men. A character like DC Comics' Catwoman, a villainess turned antiheroine, has been defined by her sexuality since she first debuted in *Batman* #1 (1940), where she escaped the Dynamic Duo while Batman was daydreaming about dating her. Over the years, Catwoman has consistently flirted with, seduced, and duped Batman and countless other male characters while in her costumed identity and as Selina Kyle, her civilian persona. In linking Catwoman's visual iconography to historical women of power, Genevieve Valentine describes her as "by turns an agent of chaos, a schemer, a love interest, a woman of appetites, a reluctant hero, and a seeker of power" (2018, 596). Like many femme fatales, Catwoman is a criminal as much for her transgression of gendered expectations as for her nocturnal theft of jewels and cat-themed artifacts. She is a woman who wants power on her own terms and is willing to use her sexuality as a means to that end. Catwoman signifies femininity as enticing but also dangerous, whether she is appearing in comic books targeted for children or those rated "For Mature Readers Only," in the campy 1960s television series or modern cartoons, in video games, or in blockbuster Hollywood movies. In her most recent solo series, *Catwoman* (2018–current), written and primarily illustrated by Joelle Jones, she looks and acts every bit the modern femme fatale both in and out of costume. In issue #3 (2018) Selina Kyle confidently struts through a mob-run casino in a daring black dress as the men fall over themselves gawking at her. The mobsters try to intimidate Selina into leaving town, but she coolly dismisses them with a few

sharp words and a seductive pose. As the leather-clad Catwoman she slinks across rooftops and uses her whip or her fists on any men who challenge her. Moreover, even in costume with a gun pointed at her head she is able to flirt and tease men to gain an advantage. For example, in *Catwoman* #7 (2019), when a corrupt cop who works for the local criminal kingpin gets the drop on her, Catwoman calmly flirts with him, leans in close as if to kiss him, and then kicks him in the stomach when his guard is down.

In the Marvel Cinematic Universe, Black Widow (a.k.a. super spy Natasha Romanoff) has likewise been defined as a femme fatale from her debut in *Tales of Suspense* #52 in 1964 through to her modern depiction in MCU films performed by reigning sex symbol Scarlett Johansson. As Chris Davies describes Black Widow in his overview of her development within the films, "Clad in a figure-hugging black cat-suit, her combination of deadliness, sexuality and Russian 'otherness' made Romanoff the quintessential, albeit reductive, archetype of the femme fatale. Even her pseudonym, Black Widow, evokes an embodiment of deadly femininity" (2019, 83). Moreover, Davies notes, "using an array of gadgets and acrobatic martial arts, her fighting style is simultaneously graceful, skilled and sexual" (84). As Davies points out, even the way Black Widow beats up men is framed as sexual. Like Catwoman, Black Widow does not have traditional superpowers, but her skill as a seductress is so effective it can be considered a type of superpower. In the films, Black Widow's extremely sexual persona, her beauty, and her flirtatiousness allow her to make fools of men, from American billionaires to European gangsters to Asgardian gods. "Do you think I'm pretty?" she asks the gunrunners with a flutter of her eyelashes as they prepare to torture Romanoff in her first scene in *The Avengers* (2012) movie. Costumed in just a little black dress and tied to a chair, Black Widow is able to flirt all the information she wants out of the bad guys before she frees herself and trounces all of them single-handedly. Black Widow is no less a femme fatale in the comics, where she manages to flirt her way around every manner of male character, leaving a trail of heartbroken men (and often broken bones) behind her. In her most recent solo series, *The Web of the Black Widow* (2019–2020), for instance, in the first issue she infiltrates a high-society party simply by wearing a sexy dress and then manages to drug Tony Stark with a kiss while dancing, then flirts her way past numerous guards to reach her target. As one of her famous comic book taglines declares, "No man can resist the Black Widow."

Catwoman and Black Widow, the leather-clad and evening-gown seductresses, are far from the only femme fatales in the superhero genre. In fact, most women in the genre represent some combination of sexuality, power, and erotic threat to men. Just like the names "Catwoman" and "Black Widow," even the names of many costumed women allude to the sexual danger they pose: Vixen, Fatality, Harpy, Dream Girl, Lorelei, Lillith, Seductress, Temptress, Enchantress, Satana, Katana, Dagger, Aphrodisiac, Persuasion, Barb Wire, Bombshell, Fatale, Knockout, Hellcat, Manhunter, Livewire, Siryn, Cupid, Obsession,

FIG. 2.2 *Dark Reign: New Nation* #1, 2009, Jeff Parker and Carlo Pagulayan

Encantadora, Plastique, Lilith, Sin, and Medusa. There are even numerous seductive female characters associated with snakes (suggestive of the biblical tale of Eve tempting Adam into his undoing), including Viper, Anaconda, Asp, Black Mamba, Diamondback, Princess Python, Serpentina, Snake Girl, Whisper A'Daire, and Copperhead. Moreover, where Catwoman's and Black Widow's seductive powers seem to border on the supernatural, many of the superheroines and villainesses have actual superpowers premised on sexual manipulation. In the *X-Factor* series, Siryn is a mutant who can modulate the sound of her voice to make people fall in love with her; the psychotic stalker Cupid injects Green Arrow with a chemical "love potion" to enslave him; Crimson Fox is a heroine with Justice League Europe who exudes a pheromone that lets her control any man; Enchantress is an evil Asgardian sorceress who uses magic to bend men to her will; Spider-Woman is a heroine whose powers include the ability to release pheromones that place men in her thrall; Venus is an ancient goddess who works with the Agents of Atlas and reduces crowds of men to drooling, orgasmic messes when she sings (figure 2.2); Charma is a

criminal who exudes an aura that makes all of the men of the thirty-first-century super team the Legion of Super Heroes into her helpless slaves; Nocturna is a vampiric thief who wears a narcotic perfume to ensnare Batman; and Star Sapphire is an intergalactic ex-terrorist (and Green Lantern's ex-girlfriend) whose magical ring gives her control of men's emotions, specifically love and lust. These women, and others like them, extend the concept of the sexually dangerous femme fatale into the heavily symbolic world of superheroes.

Poison Ivy, from Batman's rogues gallery, is perhaps the clearest example of feminine seduction as a superpower. Poison Ivy first emerged in *Batman* #181 (1966) and has proved a popular character in the animated television series, live-action film, and countless comic book appearances. Though Ivy's story and characterization have shifted over the years, her core backstory details how the genius botanist Dr. Pamela Isley was harassed and experimented on by a male superior who altered her genetics with plant attributes that gave her the power to control all forms of fauna. This power included plant-based toxins that now run through her veins and allow Ivy's touch to be poisonous to anyone she comes in contact with. As Poison Ivy she became a plant-themed criminal and, more recently, an ecoterrorist fighting against corporations and governments ravaging the earth's jungles and forests. At various times Poison Ivy has turned people into plant-human hybrids and has commanded massive vines to hold people, strangle them, or rip buildings apart. She has turned Gotham's Central Park into a lethal tree-lined fortress, and in a recent storyline Ivy managed to take over the whole world by manipulating the toxins found in common foods. But Poison Ivy's most iconic power is the complete control over men allowed by the chemicals in her body. Poison Ivy's preferred criminal method is to simply control male police officers, security guards, and even superheroes, which allows her to steal whatever she wants or to escape from any jail. Ivy has used this power to commit murder, rob banks, and force Bruce Wayne to take her and Harley Quinn on a wild shopping spree. Ivy has also seized control of Wayne Enterprises by controlling the men on Wayne's board of directors, and she has even turned Superman into her slave and commanded him to attack Batman. Though Poison Ivy's mind-control toxins can theoretically be passed to her victims through any form of skin-to-skin contact, she almost exclusively relies on a kiss as the method of delivery. One kiss from the sexy Poison Ivy and any man becomes her puppet.

The symbolic purpose of Poison Ivy and her like is a clear warning about the potential of castration posed by women. Victoria Tedeschi describes Poison Ivy as a menace because "she presents a literal threat to male agency as she is able to incapacitate powerful paramours through pheromonal mind control" (2019, 41). Desire and danger, sexuality and vulnerability combine for the predominantly male audience through the figure of this super femme fatale. Superman is the epitome of hegemonic masculinity: he is stronger than anyone, is bulletproof, defies gravity, is faster than the speed of light, is smart, handsome, and muscular,

can see through walls, and can blow over buildings. Superman embodies a phallic ideal of masculinity, but even the Man of Steel can lose control of his powers with a kiss from Poison Ivy. "Lover," Poison Ivy whispers to Superman as she strokes his chest in the landmark "Hush" storyline in *Batman* #612 (2003), "kill them." Heat vision immediately blasts from Superman's eyes as he follows Ivy's command and tries to kill Batman and Catwoman. Superman misses and later mumbles "I . . . can't . . . *kill* . . ." But Ivy snaps at him, "*No* man can resist me. Even Superman." She then purrs, "Now, come closer so I can remind you what will make me happy" as the panel zooms in on a close-up of her pouty lips. The fact that Poison Ivy always uses a kiss as her way to control men confirms the sexual nature of the power. Nor is Ivy alone in this method: Black Widow uses a narcotic lipstick to deliver her trademark "Widow's Kiss" that knocks men out; the mutant Rogue is able to steal anyone's powers through direct contact, but she usually kisses her victims to steal their strength. The initial *X-Men* (2000) film signified the castrating nature of this act when a teenage Rogue kissed her boyfriend for the first time and literally drained the life out of him.

This type of cautionary tale about women controlling men through sexuality is often aimed at the youngest of comic book readers and viewers of cartoons like *Batman: The Animated Series*, *Batman: The Brave and the Bold*, *Super Hero Squad*, and *Teen Titans, Go!*. In one clear example from *Batman & Robin Adventures* #8 (1996), Poison Ivy ensnares the adolescent Robin and, with one passionate kiss, turns him into an eager pawn (figure 2.3). With the Boy Wonder bound in vines, Ivy seductively wraps her leg and arms around him, strokes his hair, and leans in with her lips close to his, as she coos, "You love me, don't you, Robin? Would you like to kiss me again?" A delirious Robin repeatedly murmurs "Yes." "What would you do for me?"—"Anything."—"You'd become my willing slave," Ivy asks intimately, "just for the chance to kiss me again." But when Robin admits "Yes" again, Ivy dismissively pushes him away: "Teenagers. Everything is rush, rush, rush. Well you don't start at the top floor with me, buster. You have to work your way up." Ivy's partner in crime, Harley Quinn, squeals with laughter at Robin's humiliation. "You may kiss my foot," Poison Ivy says as she fetishistically offers her boot for Robin to kiss. "You have your pets, Harley," Ivy remarks as she leads Robin away on a leash. "Now I have mine." Despite the younger demographic for this series, the erotic overtones are fairly obvious.

Poison Ivy's sexuality controls Robin, robs him of his strength and his own free will, and turns him into a "willing slave" to her. A few pages later the story tried to stay appropriately safe for young readers while still suggesting the sexual nature of the enslavement. A shirtless Robin is shown massaging Poison Ivy's feet while she is covered only by a small towel and lounges on a divan. "Are you two finished yet?" Harley asks peeking in. "Ooooooh! In a minute Harley," Ivy responds, as she purrs to Robin, "*Oh*, That's good, baby." Similarly, this image of an entranced male superhero metaphorically "pleasing" a super femme fatale with

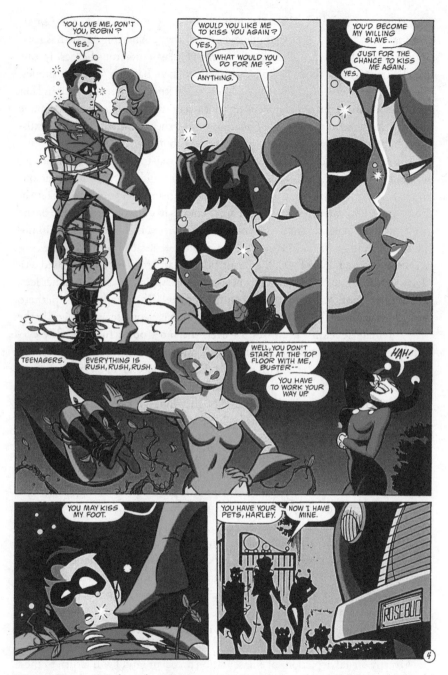

FIG. 2.3 *Batman & Robin Adventures* #8, 1996, Ty Templeton and Rick Burchett

foot rubs is repeated in other tales meant for young readers. In *Justice League Adventures* #17 (2004), for example, where the rogue Amazon Aresia has used an ultrasonic device that affects only men to enslave numerous heroes. In one panel, Aresia gloats about her control of the men as Batman feeds her grapes, Green Lantern serves her a drink, and Superman kneels at her side rubbing her feet. Despite the sanitized and seemingly innocent way the male heroes are made to serve the women, the warning remains for even the youngest readers to be distrustful of women or risk becoming weak and submissive.

The repeated use of foot rubs as an innocuous way to suggest an intimate act without being overtly sexual allows the stories to avoid anything too salacious in younger-skewing titles. Still, like Quentin Tarantino movies where the fetishistic focus on women's feet is a recurring theme (is it any wonder that one of the most notable conversations in Tarantino's *Pulp Fiction* is about the erotic implications of foot massage?), superhero stories often embrace images of male subservience to the female foot. The beautiful woman's foot is typically used as a sign of man's defeat or submission, whether it is massaging or kneeling at her feet, kissing her boot, or being ground under her heel. The image of a superhero brought low under the foot of a dominant woman is a concise way to signify the threat female sexuality promises for even the most powerful men. The eye-catching covers of comics often use this symbolism to great effect: *Wonder Woman: The Hiketeia* (2002) infamously depicts a close-up of a grimacing Batman on the ground with Wonder Woman's iconic red boot on his face pinning him down; Dick Grayson (ex-Robin and Nightwing) is trussed in bondage-style ropes, face down on the ground as high-heeled boots strut menacingly toward him on the cover of *Grayson* #13 (2015); *The Totally Awesome Hulk* #5 (2016) shows Enchantress resting her feet on the kneeling green behemoth and holding him with a chain wrapped around his neck; the cover of *Green Lantern* #18 (2007) portrays the scantily clad Star Sapphire standing over the gasping hero, the heel of her pink, thigh-high boot on his throat; *Ultimate Spider-Man* #84 (2005) features two very cleavagy bad girls, Black Cat and Elektra, standing over a fallen Spidey, each with one foot holding him down; and on the cover of *The Amazing Spider-Man* #677 (2012), Black Cat is posed triumphantly over the unconscious bodies of both Spidey and Daredevil, her foot on Spider-Man's chest and Daredevil's nunchucks in her hands. In all of these instances of superhero domination via a stiletto-heeled boot, the woman on top is explicitly illustrated as voluptuous and eroticized, thus implying not just defeat but sexual submission and humiliation.

Overtly sexual depictions of emasculation do occur (and I will return to these below), but primarily the super femme fatales use their enchanting powers as a sexual *tease* to achieve their goals. Only a few male characters, like Starfox and Kilgrave, have seductive powers, and they will be addressed in detail in chapter 8 in relation to sexual assault storylines. But for the most part, super femme fatales use the promise of sex to get power, while men use their powers to get

sex. The sexually aggressive nature of the super femme fatale usually remains at the level of flirtations and unfulfilled promises. Foot massages instead of actual sex. Moreover, on the few occasions where the enchantments do lead to sex, it is only with the villainesses who wield seduction as a superpower, never the heroines with the same powers. Whether overt or implied, the aggressive and spectacular sexuality of the super femme fatales is always the locus of her transgressive and threatening status. Like the femme fatale of film noir, the seductive woman in superhero stories is transgressive not just because she is sexually aggressive; rather, it is because she does not conform to traditional expectations of women in a patriarchal society. The real crime of the femme fatale, super and otherwise, is her self-interested pursuit of money, power, independence, and anything else she desires. Kate Stables, in her discussion of how femme fatales have been increasingly defined in Hollywood one-dimensionally, as nothing more than an icon of dangerous sexuality, argues that in early noir films the spider-women mere marked by "their hunger for independence, their unfeminine ambition or unsettling sexuality, the threat they posed to cultural norms was merely that of the woman outside the conventional social structures" (1998, 170). The self-fulfilling masculine fear and desire of female sexuality is intricately tied up with a constant need to shore up patriarchal expectations of, and control over, women. According to this misogynistic logic, female sexuality and independence are commiserate threats.

Fear of Superpowered Women

Female independence is presented as threatening to patriarchal norms through the disguise of emasculating sexuality. In other words, the woman's sexual allure is a threat only because it may lead to her independence from men. "Independence is her goal, but her nature is fundamentally and irredeemably sexual in film noir," argues Janey Place. "The insistence on combining the two (aggressiveness and sensuality) in a consequently dangerous woman is the central obsession of film noir. . . . Self-interest over devotion to a man is often the original sin of the film noir woman and metaphor for the real threat her sexuality represents to him" (1998, 47). For these women, as for the super femme fatale, sexuality is a means to an end, not an end in itself. The seductress's ability and willingness to use her sexuality to manipulate men for her own gain marks her as a threat to the social order, and as intrinsically dangerous in contrast to female characters that maintain a culturally acceptable level of propriety. "The dark woman of film noir had something her innocent sister lacked: access to her own sexuality (and thus to men's) and the power that this access unlocked" (36). The sexually charged presentation of ideal and fetishized female bodies in the superhero genre implies that any and all women can represent a threat of castration, but not all women explicitly leverage their sexuality for their own purposes—only the bad girls do. As the exotic enchantress Encantadora tells her cellmate after being captured by

Superman in *Action Comics* #761 (1999), "All women have equipment, love . . . some of us just use it better."

Whether she relies on pheromones, chemicals, magic, narcotics, mutation, or good old-fashioned flirting, the super femme fatale manipulates the male gaze and the standard fetishization of women to turn the tables on men. By using her power, her sexuality, she leverages the expectations of a misogynistic fantasy that is meant to control women and utilizes her own ability to control men. The male presumption of phallic power is exposed as an illusion (at least momentarily), undone by its own desires. In fact, in gendered terms, the super femme fatale figuratively "unmans" her victims. She robs them of their dominance, their strength, their free will, their super masculinity. Mary Ann Doane clarifies that the sexual threat posed by femme fatales in film noir links the symbolism of castration with the male's fear of losing his independence, his sense of self, that quality that theoretically frames men as autonomous subjects rather than mere (feminine) objects. "The femme fatale is an articulation of fears surrounding the loss of stability and centrality of the self, the 'I,' the ego," Doane argues. "These anxieties appear quite explicitly in the process of her representation as castration anxiety" (1991, 2). The heroes of film noir lose control over their bodies, minds, and autonomy through their overwhelming desire for the sexy and treacherous woman. Doane continues, "The power accorded to the femme fatale is a function of fears linked to the notions of uncontrollable drives, the fading of subjectivity, and the loss of conscious agency" (2). Doane's discussion of the symbolic evisceration of the masculine/phallic illusions of control and self-mastery caused by the femme fatale in film noir often becomes literal with super femmes who can completely remove a man's free will with just a kiss. Even if the likes of Poison Ivy, Charma, and Enchantress are not focused on physically hurting the superheroes, they still unman the men by controlling their hearts and minds (and loins). The fact that the superheroines who wield mesmerizing powers work and fight alongside many of the most iconic heroes, and that the seductive villainesses are considered as dangerous as monsters like the Joker, Red Skull, Doctor Doom, and Carnage is an indication of just how big a threat female sexuality is to men.

Occasionally, the threat of castration posed by beautiful and strong women in superhero stories is surprisingly literal. Even Wonder Woman, the original superheroine, has seductively, but forcibly, threatened to rip a man's testicles off. In *Wonder Woman* #19 (2013) the Amazonian Princess is fed up with the sexual comments that the "New God" Orion constantly mutters about her. To the surprise of all her adversaries, Wonder Woman passionately kisses Orion and then grabs his testicles (outside of the frame) as he screams (figure 2.4). In this instance, the kiss that is usually presented as a powerful image of authentic and spectacular romantic feelings (as discussed in chapter 5) is used as a feint to undermine Orion's attempts to exert a form of masculinity over Wonder Woman. Keeping her face intimately close to Orion while she squeezes him, Wonder Woman whispers in his ear: "I can live without your disrespect. Can you live without these?"

FIG. 2.4 *Wonder Woman* #19, 2013, Brian Azzarello and Tony Akins

The pained Orion responds "I don't want to . . . ," and she informs him, "Then respect me, or I'll *rip* them off. We clear?" When Orion tries to reassert his masculinity with one more sexist comment after Wonder Woman lets him go, she knocks him down with a powerful punch.

Wonder Woman's direct threat to tear off Orion's genitals is relatively atypical for mainstream superhero stories. Far more common is the image of women kicking men in the crotch. Almost every male hero—from Ant-Man to the Hulk, as well as numerous villains and background characters—has been kicked or kneed in the crotch. Sometimes the blow is depicted as the final, and deserved, coup d'etat that a female character can spectacularly deliver to defeat a male opponent. Black Canary, DC's fishnet-and-corset-wearing heroine, has kicked brutish sexual harassers in the balls (*All-Star Batman and Robin* #3, 2005); she has kneed supervillains between the legs (*Birds of Prey* #1, 1996), as well as her own fiancé Oliver Queen (*Green Arrow* #36, 2018); and in *Birds of Prey* #80 (2005) she slams a police officer's crotch into a metal railing as his fellows officers observe, "*Never* have kids. Not now!" Other costumed women also use this "castrating" attack, from Batgirl kicking muggers (*Batgirl: Year One* #7, 2003) and Mystique booting a couple of henchmen (*Mystique* #15, 2013), to the preadolescent Molly Hayes kicking an alien Skrull in the balls (*Runaways* #8, 2005) and Zatanna kneeing a demon (*Justice League Dark* #0, 2012). In other cases, the crotch kick is played primarily for laughs as it both disables and humiliates the men. For example, in the conclusion to *Heroes in Crisis* (2019), Harley Quinn knees the Flash as other heroes snicker, and in the last issue of *Fear Itself: Homefront* (2013), X-23, a female clone of Wolverine, kicks a pre-Hulk Amadeus Cho in the nuts for trying to trick her into forming a new super team. "*NNNGGG*! I'll take that as a strong *maybe* . . ." Amadeus groans as he sinks to the ground, eyes bulging. "Thank you for not using your claws . . ." As sophomoric as these "crotch assaults" may seem in a genre that frequents in superpowers and world-saving battles, their frequent inclusion is a clear reminder of where men feel (or are told) vulnerability resides.

The previous chapter began with a discussion of the naked Hulk scene from the film *Thor: Ragnarok* that implied a giant green penis and simultaneously hid it from view in order to preserve the symbolic status of the phallus. And the chapter concluded with mention of the pornographic version of *The Hulk XXX* as an example of alternative ways that the myth of the super phallus is secured. The figure of the Hulk works well as a phallic symbol since he is so clearly constructed as an excess of masculinity (all rage and muscles) as opposed to his alter ego, Dr. Bruce Banner (all brains and nerdiness). But even the Hulk, that mindless incarnation of phallic masculinity, is utilized as a warning about the emasculating threat of female sexuality. In the movie *Avengers: Age of Ultron*, Black Widow is able to soothe the Hulk by speaking softly to him until he reverts to the mild-mannered Bruce Banner. But this only works for the beautiful Widow; when

Thor humorously tries to calm the Hulk with the same technique in *Ragnarok*, it does not work.

The analogy of the Hulk as the mythic phallus and Bruce Banner its emasculated opposite, the powerful male who loses all his strength to a sexual woman, is made even more explicit in some comic book tales. In *The Defenders* (2005) miniseries, for example, the mystical seductress Umar is desperate for a lover who can satisfy her and help her seize the throne from her brother. Infatuated with the barbaric Hulk, Umar beds him; but after just a few off-screen grunts the Hulk is finished. "Just like the rest of them. Six minutes and they're out like a light," Umar laments while standing over Hulk's slumbering body. "Someday I will meet a man *capable* of keeping up with me." Having exhausted himself sexually, the Hulk shrinks back into his Bruce Banner form right in front of her shocked eyes. The illustration of the Hulk's swollen and veiny forearm shrinking into the limp, anemic arm of Bruce Banner makes it clear that this depowering of Hulk is akin to losing his erection after sex. Umar is furious that the Hulk has been replaced by "a puny, pale imitation of a man!" She demands he turn into the Hulk again, but for days he is unable to—the sex has so drained his strength he now has performance problems. Being incredibly blunt about the superhero/phallic versus secret identity / lack dynamic, Umar explains, "You see, Bruce, you're utterly useless to me. Its your large, stupid, and inordinately well-endowed other self I require." This hard/soft device is used again in *The Incredible Hulk* #7.1 (2011), where the green monster refuses to relinquish control of his shared body to the puny Banner. In fact, Hulk claims to have killed Banner, which may be true since he has not emerged in over a year. But in the midst of a battle with the Red She-Hulk (actually Betty Ross, Bruce Banner's ex-wife), she rips off her clothes and straddles him right in the middle of the street with the wreckage of burning cars all around them. Fade to "Two hours later . . ." and the red and green hulks are resting naked, postcoital, in each other's arms when suddenly the Hulk fades away and only the skinny Bruce Banner remains. The message is clear, even for a Hulk: sex will drain a man of his powers.

The siren's call of the classic femme fatale lures the man to his doom just as the original sirens led sailors to theirs. The male's inability to resist her charms is both a result and a cause of what Gaylyn Studlar (2013) identifies as a failure to live up to masculine ideals. Studlar argues that in film noir, "not only do men fail to adhere to socially normative ideals of altruism, honesty, and social responsibility but even the established expectations that movie heroes should mentally and physically dominate their antagonists is not met" (370). The broad failings of the men in film noir make them susceptible to the emasculating seduction of femme fatales, and their susceptibility doubly marks them as failures. Studlar is careful to point out that the enchanting women are not solely responsible for the male's inadequacy: "Film noir suggests that male loss of control and power are not defined solely by the protagonist's carnal relationship to a beautiful woman

who may be a femme fatale. The potentially disturbing failure of men in film noir to achieve conventional masculine 'success,' whether material or moral, private or communal, exceeds the explanatory locus of male/female relations" (370). In other words, the film noir male's inability to live up to dominant standards of ideal masculinity, including, but not limited to, being able to maintain a position of power and agency in relation to beautiful women, is a sign of gendered failure. The potentially emasculating seductive powers of the modern super femme fatale similarly provide not only a measure of masculine failure among costumed men but also a reconfirmation of hegemonic masculinity in some cases. Because sexual enchantment is a power often wielded by both superheroines and villainesses, and with male superheroes *and* villains falling victim to this feminine power, the lessons about ideal masculinity and femininity are different than the basic premise in film noir.

When criminals or ordinary men fall under the sexual spell of the super femme fatale they become helpless pawns, lovesick puppies willing to do whatever the beautiful woman commands, from rubbing her feet, to committing murder, to turning oneself over to authorities. Spider-Woman can stop the brutal Wrecker from pulverizing her teammates simply by flirting with him in *The New Avengers*. Venus can reduce an entire army of Mongol warriors to a quivering mass by merely singing a few lines of an orgasm-inducing song in *Agents of Atlas*. Siryn can turn an angry J. Jonah Jameson and his aide compliant with a simple lilt in her voice in *X-Factor*. Likewise, a single kiss has turned countless background male characters, beat cops, and prison and security guards into mindless lackeys for the likes of Poison Ivy, Enchantress, Charma, and Star Sapphire. The criminals and ordinary men, like the men of film noir described by Studlar, "fail to live up to masculine ideals" (2013, 369). The moral and ethical flaws of the villains, and the presumed shortcomings of the ordinary men, mark them both as examples of failed masculinity, weak enough to be overwhelmed by the seductive powers of erotic women. These cases represent the definitive castrating consequence of failing to embody cultural ideals of masculinity: the loss of power, independence, self, freedom, and possibly even one's life.

Conversely, the hegemonic masculinity of the superhero is ultimately reconfirmed after initially being compromised by the seductive powers of the super femme fatale. The superhero always finds a way to break free from the femme fatale's spell. The hero's ideal masculinity may be momentarily vulnerable, but these moments of weakness typically function to confirm the extreme fortitude of the super man in the end. No matter how powerful the super femme fatale's magic spell, pheromones, or toxins are, the superhero eventually reasserts his superiority. Unlike the failed masculine types in film noir that Studlar describes as lacking "normative ideals of altruism, honesty, and social responsibility" and the ability to "mentally and physically dominate their antagonists," (2013, 44) the superhero models these exact traits in excess, even in his struggles with enchanting seductresses. Batman demonstrates his intellectual superiority

whenever he resists Poison Ivy's controlling intoxicants by developing antidotes, preparing pesticides and other countermeasures, or using sheer willpower, mentally steeling himself against her manipulations. Superman exhibits his faithfulness and moral certainty in the "Hush" storyline when he shrugs off Poison Ivy's control in order to save Lois Lane when she is in danger. The Amadeus Cho version of the Hulk frees himself from Enchantress's spell in *The Totally Awesome Hulk* #6 (2016) by declaring a firm sense of self. Batman displays his moral absolutism in *Superman/Batman* #40 (2007) when he refuses to give in to his overwhelming carnal desire for the married goddess Bekka, whose power is "the creation of desire, both physical and emotional." When Bekka informs the Caped Crusader that the only solution to their shared passion is consummation, Batman grimly insists "*that* will never happen." Green Lantern outwits Star Sapphire and uses his indomitable willpower to escape her during numerous battles. Spider-Man escapes from Enchantress's love control after proving brave enough to face Thor in a fight in *Spider-Man: Secret Wars* #3 (2010). Time and again, superheroes manage to overcome the sexual enchantments they suffer from beautiful women.

Typically, the hero is able to overcome the super femme fatale's seductive powers, thus reasserting the superiority of his hegemonic masculinity. He may initially succumb to her sexuality, but he always finds a way to avoid being lost to it. As the generic demands of the superhero plot require, this reconfirmation of his masculinity is conveyed through the capture or defeat of the mesmerizing villainess, a return to the natural order, the status quo. The hero's victory is often cast in distinctly phallic terms, affirming not just his superior masculinity but the mythic status of the phallus as the invisible symbol of male domination (and female sexual satisfaction). For instance, in *Shadow of the Bat: Annual* #3 (1995), Poison Ivy describes Batman as "so dark and mysterious! So athletic and muscular and lithe and graceful! And, no doubt, handsome under the mask! The perfect man!" Similarly, in *Action Comics* #760 (1999), the voluptuous Encantadora flirts with Superman and leads him on a worldwide chase to stop her from selling kryptonite to various criminals looking for a way to defeat the Man of Steel. The kryptonite is fake, but Encantadora's magical powers of suggestion still manage to reduce Superman to a weakling in her presence. When Superman is finally able to outsmart her suggestions and apprehend her, Encantadora tells him, "I had heard, Superman, that you had a strength of will, a focus that set you apart from most men. I've never *believed* in men, as a rule. Secretly, I had hoped you would live up to the legend, and you *have*." Encantadora's sexually charged speech confirms that only a superman is able to "live up to the legend," to measure up and meet her expectations. The sexual implication of what sets Superman "apart from most men" is carried through as she offers herself to him: "Soy Tuya, I'm yours. Now that you've got me, what do you want to do with me?" But continuing to resist her charms, Superman replies, "Nothing as *exotic* as you're thinking. Although handcuffs will be involved." Encantadora kisses him

passionately and explains, "I may be a con, but only with the marks. . . . I'm always straight with *real* men." The message is clear: only real (super) men can resist erotic manipulation and prove themselves masculine enough to satisfy sexually aggressive women.

When the hero is strong enough to overcome the super femme fatale, the narrative imperative that the superhero must defeat all evils and save the day merges dominant concepts about legality, morality, and justice with notions of masculine superiority and the vilification of sexually aggressive women. In other words, the superhero genre can work to contain the threat of female sexuality in much the same way it addresses crimes like murder and theft. Moreover, the stories can benefit from the use of female characters as titillating sexual fantasies and then disavow that the fantasy might exert a power over men. Janey Place argues that in film noir, "the ideological operation of the myth (the absolute necessity of controlling the strong, sexual woman) is thus achieved by first demonstrating her dangerous power and its frightening results, then destroying it" (1998, 45). The same dynamic holds true for the villainous super femme fatale who is first shown to rob even the most incredible men of their powers, and then is defeated and punished. Poison Ivy, Encantadora, Enchantress, Cupid, Nocturna, Sister Pleasure, Dala, Morgana, Charma, and their ilk are routinely overwhelmed by the virtuous hero and carted off to prison or the insane asylum, or banished to an Asgardian cell, or relegated to a different dimension.

The punishment of the criminal super femme fatales is in line with that of their film noir predecessors. But the superheroines who rely on similar powers of seduction have no clear cinematic precedent. Costumed heroines like Spider-Woman, Siryn, Venus, Crimson Fox, and Persuasion, as well as the nonpowered (but no less enchanting) figures like Catwoman, Black Widow, and Black Cat, predominantly use their sexuality in modern stories to fight against evil. In this regard, the heroic femme fatales may be closer to the popular stereotype of the sexy female spy than the spider-woman of film noir. As with the superhero genre, seductive women have functioned in espionage fantasies as agents for the forces of righteousness (e.g., the West) and as erotic snares employed by the villains (the East). While the female agents of both sides utilize their sexuality as the primary tool for completing their missions, only the evil foreign women engage in actual sex for duplicitous purposes. In her analysis of the television series *Alias*, for example, Miranda J. Brady observes, "While foreign female spies will shamelessly enter into a sexual contract (including marriage) to gain information, Sydney Bristow will only emulate the use of sex for espionage, saving copulation for meaningful, conjugal relations" (2009, 114). Bristow, the All-American good-girl spy, is sexual but only flirts and teases men to manipulate them. Similarly, the seductive superheroic femme fatale never debases herself, nor is she morally compromised enough, to consummate her seductive promises. In superhero stories, there is a distinct line of morality implied between femme fatales who are good girls and those who are bad girls. The heroines, those who do not carry through

on sexual suggestions, can still be understood as "good" because they use their seductive powers for justice.

Nevertheless, though sexual manipulation can be divided as a good skill or a bad one, depending on who is using it and why, the symbolic threat of female sexuality is still portrayed as a danger. Sexual manipulation may be less transgressive if it is utilized by a heroine, but it is still a threat to patriarchal dominance in general. In her discussion of classic Hollywood femme fatales, Janey Place summarizes, "In film noir, it is clear that men need to control women's sexuality in order not to be destroyed by it" (1998, 36). This imperative of controlling female sexuality to avoid being unmanned by it is just as important in superhero stories. Even if the weaponized sexuality is a tool used by heroines rather than villainesses, it still needs to be punished or contained. The double bind of representing women is that they are systematically hypersexualized to appeal to the traditionally masculine focus of the genre (and general cultural standards of misogyny), and then they are deemed punishable as an arousing threat to masculine strength and independence. The trend of punishment linked to sexuality is extended to all women in the genre, good and evil alike. The unequal manner in which female characters are treated has been well documented through the infamous "Women in Refrigerators" list first put forth by comics writer Gail Simone in 1999. The now-familiar term of "fridging" refers to any form of violence targeted specifically at female characters that is excessively brutal, sexualized, and/or depowering. The ever-expanding "Women in Refrigerators" chronicles the various ways female characters have been disproportionately, and brutally, victimized. As Simone told *Bitch* magazine, the list "was shockingly long, and almost no one in the already small pool of valid superheroines escaped the wave of gynocentric violence" (Cochran 2007). Female characters suffer more degrading and more permanent physical violence in superhero stories primarily because they are female and because they are a sexual threat to masculinity. Chapter 8 will address how the sexualization of super female characters is intertwined with misogynistic violence against women.

Reflecting the gendered priorities of the genre, the concept of fridging stresses how violence against female characters functions to support and motivate the development of the male heroes. "Women characters are routinely killed to negotiate relationships between men," Trisha L. Crawshaw observes. "Fueling the tensions between men superheroes and their archenemies, violence against women characters serves as a cheap plot twist" (2019, 99). Or, as Salter and Blodgett describe fridging: "the condemnation of a woman character to an unpleasant fate or peril in order to motivate a male hero or advance a plot point. Such acts don't always end in the death of the character, but usually do" (2017, 115). Wives, girlfriends, daughters, and superheroines alike are routinely subject to sexual, physical, and psychological assault by villains to provide the male hero with a purpose, with something to avenge. The violence done to female characters inspires and justifies the males' violent responses. While the practice of

fridging is widespread, it plays out in explicitly misogynistic terms with the villainess super femme fatales. The seductive powers of these women are framed as a personal violation, robbing men of their independence, that may hurt even more than a punch from an oversize robot or massive alien invader.

The following chapter focuses on one of the consistent narrative strategies utilized within the superhero story to marginalize female characters and to bolster the independence of male ones. The inherently masculine bent of the genre (predominantly made by men for a presumed male audience) is often reflected in the "boys' club" mentality of the stories. In fact, the boys' club logic is made literal through the repeated exclusion of women from the fictional spaces deemed male-only domains. The homosocial space of the superhero headquarters creates an imaginary world where men can bond with each other, reveal their private selves, and still be models of masculinity unencumbered by the influence or threat of women.

3

Secrets of the Batcave

■■■■■■■■■■■■■■■■■■■■■■■

Masculinity and
Homosocial Space

Virginia Woolf's famous declaration that a woman needs "a room of one's own" to write her stories and to carve her own space within the literary canon still resonates nearly a century later. Woolf's succinct phrasing recognizes the importance of private places in relation to gender and achievement. Gender-segregated spaces continue to be a concern in Western culture (and other societies for a variety of reasons) as a form of bedrock on which patriarchy is built and maintained. From bathrooms and locker rooms, where the genders are separated on the premise of sex, to boardrooms and oval offices, where genders are often separated based on systemic misogyny, women have struggled to gain access to places of power. The convergence from the locker room to the boardroom entrenches patriarchal privilege through access to specific male-only spaces. And conversely, this continuum of segregated spaces excludes women from these casual and formal places where often crucial conversations are had and decisions are made. The recent outrage and political debates about the legality of access to public bathrooms for trans people only underscores how important the idea of gender-segregated space remains in American culture. Moreover, popular media still typically reinforces the stereotype that men and women are inherently different, with diametrically opposed personalities, interests, concerns, and needs that are reflected in the spaces they occupy. According to countless advertisements and reality television programs: men have "man caves" where they can watch sports,

drink beer, and bond with other men free from the judgmental eyes of women; women have "she sheds" where they can scrapbook, drink wine, and gossip with other women without the condescending shadow of men. Here I want to consider the historical and social influence of one of the most famous male spaces in popular culture, the Batcave, for how even something as seemingly frivolous as a caped crusader's hideout can influence beliefs about masculinity.

The Batcave is one of the most famous fictional settings in the world. Batman's secret headquarters, hidden beneath stately Wayne Manor on the outskirts of Gotham City, has been featured in comic books, live-action movies, cartoons, and television series for over eighty years. Batman debuted in *Detective Comics* #27 in 1939, and several stories hinted at Batman's hidden underground lair. But the Batcave made its first dramatic appearance in the *Batman* movie serial of 1943 and was immediately incorporated as a regular setting in the comic books as well. The idea of a secret cave as a base of operations known only to the Dynamic Duo (and to young readers/viewers) became a crucial part of the overall fantasy of the Batman. As the introduction to the 1948 story "The 1,000 Secrets of the Batcave!" in *Batman* #48 described the superhero headquarters, "Deep under the surface of Gotham City is a mammoth cave which is known but to two people—Batman and Robin! For this is the Batman's subterranean retreat—The Batcave! It is the Batcave that provides secret shelter for the Batplane, Batmobile, a criminological laboratory, and all the other crime-fighting tools of the Batman!" But the Batcave is much more than just a base of operations for Batman's legendary war on crime; it is an eminently private male space where the Caped Crusader can hang his cowl. The cave also functions to reinforce a conception of masculinity for young readers that is premised on homosociality and an exclusion of femininity.

The characterization of Batman has undergone numerous shifts in different eras, as should be expected for any figure that has been hugely popular for over eighty years and has appeared in thousands of different stories across multiple media platforms. But despite whatever superficial changes he has gone through, Batman has always represented a clear example of hypermasculinity. Batman is virtually infallible; he is a supreme detective, an Olympic-level athlete, a master of all the martial arts, a scientist, an inventor, and incredibly strong. As Bruce Wayne he is handsome, wealthy, a popular member of Gotham's ruling class, and a captain of industry. The larger-than-life version of masculinity embodied by Batman is a fictional example of what R. W. Connell (1987) describes as "hegemonic masculinity." According to Connell and Messerschmidt, "Hegemonic masculinity was distinguished from other masculinities, especially subordinated masculinities. Hegemonic masculinity was not assumed to be normal in the statistical sense; only a minority of men might enact it. But it was certainly normative. It embodied the currently most honored way of being a man, it required all other men to position themselves in relation to it, and it ideologically legitimated the global subordination of women to men" (Connell and Messerschmidt 2005, 832). Batman personifies an idealized version of "a minority of men [who] might

enact" this type of hypermasculinity. Extreme masculinity is the foundation of the superhero genre. Elsewhere I have argued that the firm gender binary observed in Western culture depicts masculinity as a cluster of desirable traits in opposition to undesirable, or feminine, ones: hard *not* soft, strong *not* weak, reserved *not* emotional, and active *not* passive (Brown 2001). Batman, like most superheroes, personifies this image of masculinity as a rejection of any and all qualities that could be deemed "feminine." Moreover, because Batman is not blessed with superpowers to augment his masculinity, he is a self-determined and self-made *super* man.

Still, for all of Batman's independence and self-reliance, he is also famously one half of the Dynamic Duo. The character of Dick Grayson / Robin was introduced in 1940 as Bruce Wayne's ward and Batman's teenage sidekick. The editors at DC Comics wanted to include Robin as a proxy for young readers to identify with, and as a narrative tool for Batman to explain things to. Robin proved an immediate success and inspired dozens of other sidekicks, including Aquaman's Aqualad, Green Arrow's Speedy, Captain America's Bucky Barnes, The Human Torch's Toro, and so on. Bruce Wayne's butler, Alfred Pennyworth, is the only other character who knows Batman's secrets and is involved in both his life as a millionaire playboy and as a costumed crime fighter. During the Golden Age of comics (1938–1956), Batman's public and private lives were based around his close male bonds with Robin and Alfred. Bruce Wayne may have played the role of wealthy bachelor and man-about-town with beautiful women on his arm, but in his private and superhero lives Batman's world was decidedly male-centric. In fact, from the moment young Bruce Wayne's parents were famously gunned down in an alley, his only important relationships are with men. Sasha Torres describes Batman's male-centric environment after the death of his parents in familial terms: "This moment inaugurates Bruce/Batman's participation in a series of all-male families—not only Alfred with Bruce but also Bruce with his ward, Dick Grayson, and Batman with Robin" (1996, 240). The secret Batcave beneath Wayne Manor represents a spatial embodiment of this all-male sphere.

The Batcave is such an important part of the Batman mythos that DC Comics published a special graphic novel collection in 2007 titled *Batman: Secrets of the Batcave* with the best stories from the Golden Age to the twenty-first century that focused on the cave. The majority of the adventures in the collection (twelve out of sixteen) are from the 1940s and 1950s and reveal the origins of many of the iconic trophies that have decorated the Batcave for decades, like the life-size robotic dinosaur from "Dinosaur Island" (*Batman* #35, 1946) and the giant penny from "The Penny Plunderers" (*World's Finest Comics* #30, 1947). Several of the tales revolve around Batman and Robin admiring their souvenirs and reminiscing about their daring exploits. In "The Thousand and One Trophies of Batman!" (*Detective Comics* #158, 1950), the Dynamic Duo add their latest prize and the narration notes, "As the two great crime-fighters begin inspection of their

numerous trophies, it recalls memories of their most thrilling exploits." "Robin," Batman asks in one frame, "remember when the Joker's big mechanical dice-cup rolled out these super dice in the case of 'The Gamble with Doom'?" Or in another, the Caped Crusader asks, "Remember the case of the 'Chess Crimes,' Robin?" In many of these early stories it is clear that the Batcave is a place where Batman and Robin can bond and relish their accomplishments as heroes.

Another major focus of these early tales from *Batman: Secrets of the Batcave* involves criminals infiltrating the secret lair and trying to kill the heroes. In the "Thousand and One Trophies" story, the smuggler Dr. Doom (not to be confused with Marvel's Doctor Doom) is accidentally brought into the cave hidden in a sarcophagus. Dr. Doom activates a number of the dormant trophies and other gadgets in an attempt to kill Batman and Robin. But, of course, the duo escape all the booby traps and Dr. Doom eventually dies in one of his own traps. In "The Batman Dime-Museum" (*Detective Comics* #223, 1955) the mobster "Big Jim" Jarrel and his goons dig their way into the cave hoping to make it their own hideout. But Batman and Robin learn of the plan and divert the underground river to flood the tunnel. "Big Jim" and his men are then apprehended when they crawl their way back above ground. And, in "The 1,000 Secrets of the Batcave" (*Batman* #48, 1948), the escaped convict Wolf Brando stumbles into the hideout while avoiding the police. Brando tries to run over the heroes with the Batmobile, scorch them with the Penguin's flame-throwing umbrella, and crush them by knocking over the giant dinosaur. Eventually, Brando is startled by a group of real bats and falls into a subterranean whirlpool that carries his lifeless body out to the East River. In an afterword, the Caped Crusaders reflect on the case, with Batman telling Robin, "It was the Batcave that defeated Wolf Brando. And then it cast out the enemy who would have done Batman harm! Yes, the real hero of this case was the Batcave!" As these early stories exemplify, the Batcave may be a safe place for Batman and Robin to bond and reflect on their many adventures, but it is also a place of action and death-defying heroism. Moreover, the cave is their secret (and sacred) place that must be defended from all trespassers. Even the cave itself is a hero and an active protector of Batman's secrets.

Chapter 4 will touch on the Batcave (and other superhero hideouts like Superman's Fortress of Solitude, Green Arrow's Arrow Cave, Daredevil's Brownstone, and Dr. Strange's Sanctum Sanctorum) as it functions as a masculine private space for a public figure in contrast to the feminine ascribed space of the home. Here I want to look specifically at the Batcave as a type of masculine-defined liminal space between Batman's public outings as a superhero and Bruce Wayne's private home life (I'll return to the importance of Bruce Wayne's home below). The exclusively masculine space of the cave models for young readers a version of a boys' club free from feminine influences. Or, as Pamela Hill Nettleton describes modern boys' clubs: "homosocially segregated areas where men keep company with other men and women rarely, if ever, dare (or are allowed

to) tread" (2016, 563). The Batcave is a private club, restricted to Batman, Robin, Alfred, and the target audience of young male readers. In the Batcave, Batman and Robin are free to discuss their cases, plot their adventures, train their bodies and minds, analyze clues, and if need be, console each other. The readers are invited to vicariously be a part of the boys' club, learning all of the cave's secrets and being privy to Batman's private moments. The inclusion of readers is made explicit on at least two covers: both *Batman* #48 (1948) and *Batman* #203 (1968) depict Batman and Robin showing readers a cross section of the Batcave and all its different areas. The stories may just be juvenile fantasies about fun exploits, but they also function to indoctrinate readers into a belief about the value of male-only relationships and valorize masculinity through an exclusion of the feminine.

The exclusion of women in favor of homosocial bonds, even in early Batman stories, runs the risk of slipping from homosociality to connotations of homosexuality. Indeed, Batman and Robin have long been regarded as gay icons in queer culture and have endured numerous cultural panics about their "secret" connection and what it may imply. In her historical review of the Batman and Robin partnership, Catherine M. Vale notes, "The resulting relationship between the Caped Crusader and his ward became more complex and controversial than creators had anticipated. . . . As a result, Batman and Robin's relationship in these early years shared paternal, collegial, and romantic bonds" (2015, 101). The implied questions about Batman and Robin's partnership came to a head during the 1950s McCarthy era moral panics about juvenile delinquency, which involved accusations about the sexual "perversions" being offered in comic books. In his book *Seduction of the Innocent* (1954), the infamous Dr. Fredric Wertham reasoned the Dynamic Duo was "like a wish dream of two homosexuals living together" (190). "Only someone ignorant of the fundamentals of psychiatry and of the psychopathology of sex," Wertham continued, "can fail to realize a subtle atmosphere of homoeroticism which pervades the adventures of the mature 'Batman' and his young friend 'Robin'" (190). To counter these accusations of homosexuality, DC Comics introduced the character of Batwoman (Kathy Kane) in 1956 to serve as a more appropriately heterosexual interest for Batman. But the narrative restrictions that require the Dark Knight to remain romantically unencumbered in order to be effective as a superhero did little to reduce the stigma about Batman and Robin's bond.

In a queer reading of Batman and Robin it is easy to interpret the cave as a type of closet. The use of the closet as a metaphor succinctly implies the way homosexuality has often been hidden away from public view, as a concealed space where an individual's true self is shut behind a door. The closet metaphor is also premised on the long tradition of homosexuals needing to feign heterosexuality in public for fear of reprisals and discrimination. Similarly, the Batcave can be (and has been) suggestive of a private place where Batman and Robin can be their "true" selves in sexual terms, as opposed to the facade of hypermasculine

heterosexuality they present in their public adventuring. Both the closet and the cave are places where secrets are kept, be it a secret sexuality or a secret identity. In fact, the emphasis on secrets in Batman stories, especially related to the Batcave and his identity, clarifies the life-or-death importance of keeping some things hidden. That these secrets are shared with readers only strengthens the bonds of vicarious inclusion to the homosocial boys' club atmosphere of the cave. I have discussed the debates about Batman and Robin's sexual orientations elsewhere (Brown 2019), as have numerous other critical studies (see Medhurst 1991; Williamson 1997; Wilde 2011; Shyminsky 2011; and Vale 2015). And while the complex sexual dynamics are an important factor in relation to the cave, in this chapter I want to focus more on the homosocial aspects of the Batcave as a focal point for negotiating superhero constructions of masculinity.

Long before man caves became a popular concept in Western culture, the Batcave established a prototype for the idea of an exemplary masculine domain. Most considerations of domestic masculinity chart the various ways men have used space within the feminine-identified home to carve out specific domains where they can embrace traditional concepts of masculinity (for example, see Gelber 1997). The undergirding principle regarding the desire for gender-segregated domestic spaces is, as Risto Moiso and Mariam Beruchashvili put it, "centered on the premise that men perceive the home as emasculating, capable of undermining their masculine identities" (2016, 658). Thus, American men have a long tradition of gravitating to areas they can call their own, where they are free to do "manly" things, "such as a basement, a workshop, a garage, or a barbecue pit, which benefit from historically accrued masculine associations" (658). The modern man cave extends this desire for a gender-segregated, homosocial location within the home where men can luxuriate in masculine behaviors while surrounded by masculine décor. In their analysis of the television series *Man Caves* (2007–current), Rodino-Colocino, DeCarvalho, and Heresco argue that the current popularity of these exclusively homosocial spaces is linked to shifting conceptions about gender normativity: "Man caves promise to 'remasculinize' men by referencing traditional notions about rigid gender differences in a time when gender categories seem to be dissolving" (2018, 630). Masculinity is a social construction and performance that homosocial spaces like the man cave can encourage, establish, and validate.

The Batcave has always presented a model of a private male space that reinforces hegemonic masculinity (and thus also functions to deflect any overt suggestions of homosexuality). In addition to being a central location for Batman's secrets, the Batcave was always ideally masculine in function and décor. The cave houses multiple versions of the ultimate muscle car, the Batmobile, as well as motorcycles, jets, rockets, helicopters, speedboats, a tank, and even a personal submarine. Trophies from Batman's countless victories over every manner of villain line the rocky walls of the cave. An extensive gym/training room is filled

FIG. 3.1 *Forever Evil* #4, 2013, Geoff Johns and David Finch

with weights, punching bags, gymnastics equipment, and target dummies. There are multiple caches of various nonlethal weapons and other devices, including batarangs, grappling guns, small explosives, gas masks, and armored Bat-suits. The cave also includes a state-of-the-art crime lab and one of the world's most advanced computers with access to every police and military information network. The Batcave is protected by multiple security systems, booby traps, and other defensive measures. The excessively masculine accoutrements of the Batcave appear regularly in the comics, movies, and television programs. The vastness of the cave and all the technological marvels it houses are often highlighted in comics panels designed to give an impressive view of the Dynamic Duo's lair, from Dick Sprang's iconic portrayals of the Batcave in the 1940s, overflowing with colorful paraphernalia, to modern versions that are darker but equally impressive (figure 3.1).

While the Batcave shares many obvious similarities with the modern concept of the man cave, it is perhaps more closely aligned with that other prototypical male domestic space: the bachelor pad. Most famously promoted within the pages of *Playboy* magazine between the 1950s and the 1980s, and in a series of late 1950s and early 1960s Hollywood films dubbed the "Bachelor-Pad Cycle" (Worland 2018), *Playboy*'s fantasy apartment is brought to life in all its technicolor glory in such films as *Pillow Talk* (1959), *The Apartment* (1960), *Under the Yum Yum Tree* (1963), *Come Blow Your Horn* (1963), and *Marriage on the Rocks* (1965). *Playboy* was famously launched by Hugh Hefner in December 1953, just as concerns about the nature of Batman and Robin's relationship were beginning to be widely expressed, and the magazine carved out a very new and distinctive model of masculinity that remains influential today. Unlike earlier men's magazines, which focused on outdoorsy activities like hunting and fishing, *Playboy* created an image of a sophisticated, urbane, upper-class masculinity that

pursued decidedly indoor pleasures. The two primary, and interrelated, pleasures that *Playboy* offered men in an affluent postwar America were stylish consumerism and eroticized women.

Though *Playboy* is most famous for its centerfolds, the magazine's emphasis on consumption is its central ethos. The magazine offers monthly suggestions for consumables: luxury cars, designer furniture, high-end liquors and cigars, modern fashions, and women. In fact, the inclusion of centerfolds was a crucial component for justifying the magazine's construction of masculinity based on consumption. "By the mid-twentieth century the feminine connotations surrounding consumerism were still pronounced. Self-conscious consumption, therefore, remained an uncertain field for masculine identities keen to maintain their credentials of heterosexual manhood," argues Bill Osgerby in his study of the magazine's history. "Hence *Playboy*'s nude pictorials were crucial. The pin-ups served to mark out the magazine as an unmistakably masculine and heterosexual text, allowing readers—secure in the knowledge that their 'manly' identities would not be compromised—to cruise freely through the magazine's bounty of fashion and furnishing" (Osgerby 2005, 100). The explicit depiction of women as sexual objects to counter any feminizing implications of consumerism was combined in *Playboy*'s articles about architecture and the ideal bachelor pad. As Osgerby notes, "The magazine's regular features on 'Modern Living' chronicled not only the latest in gadgets and trendy furnishings, but also spotlighted a series of luxurious 'Playboy Pads'—a combination of real and imaginary lairs—perfectly suited to the hip man of means" (105). The proposed bachelor pads in *Playboy*, which were realized in the movies a few years later, positioned consumption as a means to pursue heterosexual conquests.

Just as the Batcave housed and incorporated a plethora of gadgets for fighting crime (computers, batarangs, rocket launching cars, etc.), the *Playboy* apartment imagined a state-of-the-art male space designed for seduction. Elizabeth Fraterrigo describes *Playboy*'s fantasy of mastery over the private domain: "Gadgetry abounded in such forms as a hi-tech entertainment wall, an ultrasonic dishwasher, and the bedroom's console of switches and buttons that gave the playboy complete control over the apartment" (2008, 752). Likewise, Osgerby notes the importance of gadgetry for the magazine's heterosexual lairs: "Hi-tech gadgets were always a key feature of the archetypal bachelor pad. This was exemplified not only in *Playboy*'s regular profiles of the latest hi-fi hardware, but also in the magazine's concepts for fantasy devices" (2005, 108). All of the gadgets and designs imagined by the magazine were stylish, but more importantly they were functional. They allowed the imaginary bachelor to mix cocktails for his female guests, prepare exotic meals, dim the lights, play romantic music, and have the couch transform into a bed with just the flick of a few switches. All of the conspicuous consumption was justified by the end goal of successful heterosexual activity. The Batcave served a similar function for a younger male audience, but instead of a male space full of gadgets designed to glorify masculinity through

the seduction of women, the cave provided a fantasy location for boys where consumption and machinery validated masculinity through crime-fighting adventure.

Technology and gadgets have been thoroughly gendered masculine in Western culture (see Lohan and Faulkner 2004; Bodker 2017), as opposed to the more feminine-ascribed attributes associated with nature and emotions. Technology, especially tech geared toward seduction, allowed *Playboy* to encourage and masculinize consumption. Similarly, all of Batman's famous gadgets used to fight crime validated masculinity and normalized consumption for young male readers. Batman and Robin modeled a masculine mastery of technology as part of all their adventures. Batman's popularity with young fans also promotes consumption as a factual practice through the countless forms of merchandising that are available, and have been since the 1950s. Children who want to imagine themselves as Batman, or construct their own Batman tales, can purchase costumes, capes, batarangs, decoder rings, bat-signals, utility belts, toy Batmobiles, batcopters and bat-boats, and of course "action figures" (the term itself indicative of confirming masculine play as distanced from what girls do with "dolls"). And, as any parent who has endured a child's wishes for the holy grail of Bat-toys can attest, the Batcave is always the biggest and most expensive toy in the set. Whether the toy cave is based on the designs from the 1966 television series or the modern blockbuster movies, it is a focal point for imaginative play where the child, the Caped Crusaders, and the gadgets come together.

The similarities between the Batcave and the bachelor pad became obvious and unequivocal during the 1970s. The phenomenal success of the 1966 television series *Batman* (see Yockey 2014), featuring Adam West and Burt Ward as the colorful Dynamic Duo, brought Batman his widest audience to date. Interestingly, the television program demonstrates another level where the worlds of Batman and *Playboy* intertwined. The campy television series was inspired by late-night screenings of old *Batman* serials from the 1940s hosted by Hugh Hefner at the Playboy Mansion. Attendees laughed at the melodramatic tone of the outdated films and producers recognized the possible mass appeal of creating a pop art series. The silly and campy tone of the television show reignited questions about the potential "queerness" of Batman and Robin. Thus, when the rush of Batmania subsided with the program's cancellation in 1968, DC Comics set out to reestablish the Caped Crusader as a serious and grim adventurer rather than a melodramatic man in a cape tossing out childish puns and dancing the *bat*usi. DC Comics sought to return Batman to his roots as a stoic Dark Knight. In his analysis of queer themes in Batman, Andy Medhurst describes this agenda as a "painstaking reheterosexualization of Batman" (1991, 159). Medhurst insightfully points out that the close homosocial relationship between Batman and Robin, a partnership that lends itself to an easy queer interpretation, has always been a problem for convincingly constructing Batman as a model of heterosexuality. "If one wants to take Batman as a Real Man," Medhurst

argues, "the biggest stumbling block has always been Robin" (159). Conversely, Neil Shyminsky reasons that Robin's immaturity and asexuality actually function to bolster Batman's heterosexual status. For Shyminsky, Batman is "made to seem more potent, masculine, and unassailable—he is straightened—through his contrast with his sexually indeterminate or pathologized sidekick" (2011, 298). Still, in *Batman* #217 (1969), the comic's editors attempted to eliminate any lingering suspicions about the crime fighters by removing Robin from the series. Within a couple panels Dick Grayson is packed up and shuffled off to college, leaving Batman to his solo adventures for the first time since 1940.

The removal of Robin from Batman's stories (aside from a few guest appearances) was undoubtedly an important part of reheterosexualizing Batman. But where *Batman* #217 effectively writes Dick Grayson out on the issue's first page, the rest of the comic book works to further reheterosexualize Batman / Bruce Wayne by embracing a very *Playboy*-inspired change. Right after Dick leaves in a taxi, Bruce tells Alfred, "Dick's leaving brought home the stark fact that our *private* world has changed! We're in grave danger of becoming outmoded! Obsolete dodos of the mod world outside! Our best chance for survival is to close up shop here!" Bruce continues to explain his plan to Alfred (and to readers) as they toss a few bags in the back of a convertible and drive into the heart of Gotham City (figure 3.2). "This is our new home," Bruce declares as he shows Alfred the newly constructed penthouse atop the towering Wayne Foundation building. With just a few panels of exposition Bruce Wayne is moved into his new bachelor penthouse, which comes complete with all of the technology and décor highlighted in the pages of *Playboy*, and a few extra Bat-gadgets as well. The cover of *Batman* #217 clarifies that Batman's move to the city is even more important than Robin leaving. The cover depicts a stern-looking Batman striding out of the cave, which is now covered in dust and cobwebs—the only nod to Robin is his costume hanging deflated on a rack—while Alfred wipes away a tear. "Take a last look, Alfred," Batman barks, "then seal up the Batcave forever!" But the symbolic cover is somewhat misleading as the all-important Batcave is re-created underneath the Wayne Foundation building.

The parallels between Bruce Wayne's penthouse and *Playboy*'s concept of the ideally functional bachelor pad are apparent on a number of levels. The comics included cutaway illustrations and blueprints of the penthouse, Wayne Foundation building, and the new Batcave that were reminiscent of *Playboy*'s architectural designs. In addition to pointing out the penthouse's central fireplace, wet bar, lounge, and rooftop pool, the illustrations label the "secret" elevator, "secret" lab, "secret" communications center, and "secret" exit for the Batmobile (still so many secrets). The move also facilitated a merger of Bruce Wayne's business life and his heroic exploits as Batman. "Now, as Bruce Wayne, I'll be keeping a closer eye on Foundation affairs by day," he explains to Alfred as he opens his briefcase, "and 'sockin' it to 'em' by night!" Bruce adds as he unpacks his Bat-suit. Part of the *Playboy* bachelor pad philosophy was to create a physical space where hip

FIG. 3.2 *Batman* #217, 1969, Henry Boltinoff and Frank Robbins

young professional men could seamlessly integrate their work with their leisure. With the bachelor pad's open floor plans, array of convenient gadgets, and a bedroom that included a desk and a liquor cabinet, the *Playboy* man combined work and pleasure (moreover, pleasure could be treated as work, and work regarded as a pleasure). As Elizabeth A. Patton argues, "In addition to promoting consumption as a lifestyle, *Playboy* magazine's construction of the knowledge/cultural professional and the reconstitution of the bachelor pad as a public/private space merged leisure, work and consumerism through communication technology within the domestic sphere, what is now understood as a major aspect of the live-work lifestyle" (2015, 103). Immediately after unpacking, Bruce sits at his penthouse desk and tells Alfred, "This is where Batman and the Wayne Foundation start to join forces!" Business and pleasure converge with the relocation to the penthouse just as *Playboy* advised; though the "pleasure" for the playboy is sexual conquest, the comics substitute the equally masculine conquest over supervillains as Batman's pleasure.

It was crucial to the aspirational version of masculinity presented by *Playboy* that the ideal bachelor pad be in direct contrast to the trend of familial responsibilities and suburbanization that the magazine feared was feminizing American men in the 1950s. The penthouse was an ideal concept for the playboy because it implied not just a masculine space primed for seduction but also an achievement of wealth, class, sophistication, and power. "*Playboy*'s penthouse, then, was the antithesis of the suburban family home. Cosmopolitan and urbane, it was set in the heart of the throbbing city," Osgerby argues. "Moreover, located on the top floor of a modern skyscraper, the penthouse dominated the visual space of the metropolis, its commanding position drawing on a rich architectural heritage in which height was symbolic of superior status, masculinity and power" (2005, 105). The penthouse is not just an apartment; it is a signifier of individuality, strength, success, and dominion over the city. The comics regularly reinforced the assumption of Batman's masculine supremacy through narration when he would swing back to his penthouse after a night of fighting crime. For example, in *Batman* #322 (1980): "The gleaming Wayne Foundation seems almost out of place against the jagged Gotham skyline. Its ultra-modern architecture is flanked by buildings more baroque in design. While its roof is crowned with a plush penthouse apartment that is home to millionaire philanthropist Bruce Wayne, and thus, home as well to the Batman!" Or, in *Batman* #344 (1982): "The sounds of the city seem muted here in the shadow of the Wayne Foundation Building, as if the city speaks only in whispers around such wealth and power." The phallic symbolism of both the *Playboy* penthouse ideal and the towering Wayne Foundation is difficult to miss. Batman is the toughest man in Gotham City, and Bruce Wayne has the biggest and most revered skyscraper in the city to prove it. If being Gotham City's premiere superhero were not enough to demonstrate Batman / Bruce Wayne's hegemonic masculinity, the penthouse functioned to further validate both his masculinity and his heterosexuality.

Just as the design of the Wayne Foundation penthouse followed *Playboy*'s bachelor pad efforts to combine work and leisure, the building itself, like the original Batcave before it, was a marvel of form and function. The Wayne penthouse was depicted as a luxurious bachelor pad where Bruce could unwind, host cocktail parties, and woo beautiful debutantes on the sweeping balcony. But the home also featured a miniature crime lab and computer system for occasions when Bruce did not feel like taking the secret elevator all the way down to the new Batcave. Some issues highlighted the state-of-the-art security systems installed in the penthouse. In the story "Night of Siege" from *Batman* #306 (1978), the Masked Manhunter brings drug kingpin Hannibal Hardwicke to Wayne's penthouse to protect him from the costumed assassin Black Spider. When Hardwicke questions why he is supposed to hide out in "one of the best-known buildings in Gotham City," Batman explains, "It also belongs to a good friend of mine, Bruce Wayne! He happens to be out of town at the moment so I'm sure he won't mind if we use his penthouse for the next few hours." When Black Spider does attack, he manages to momentarily subdue the Caped Crusader but then has to navigate a gauntlet of laser traps and other obstacles as he approaches the interior of the penthouse. Still, once he gets inside, Black Spider succumbs to sleeping gas in one of the outer rooms (which Batman then safely disperses with high-tech air conditioners). Hardwicke is amazed and asks, "What sort of place *is* this? A playboy's penthouse filled with all these *gadgets*?" Batman and Alfred divert suspicion by claiming that Wayne had them installed in case he ever needed the place as a safehouse. But, as older readers would know, every playboy's penthouse is supposed to be equipped with fantastic gadgets. Batman's just happened to be designed for daring adventures rather than for daring seductions.

Batman occupied the Wayne Foundation penthouse for over a decade, then Bruce suddenly announced that he wanted to move back to Wayne Manor in *Detective Comics* #513 (1982). After visiting the original Batcave briefly in the previous issue, Bruce reflects, "This old cavern *still* feels like 'home.'" Bruce, Dick, and Alfred moved back to the manor and its Batcave—trophies, equipment, gadgets, and all—reestablishing the cave as the ultimate homosocial space. Shortly after their return a new Robin (Jason Todd) was brought on board and Dick Grayson graduated to a more mature superhero identity as Nightwing. Indeed, the Batcave has remained a homosocial "home" for Batman, Alfred, Dick, and Jason, as well as the other young Robins that would follow, including Tim Drake and Damien Wayne. In the modern era, the Batcave's "boys only" rule has been bent but not broken. The Barbara Gordon version of Batgirl visited the cave only once in the 1960s (and she was blindfolded when the Dynamic Duo took her there), but more recently she has been granted honorary membership to the cave as part of the Batman family. And for a brief period, starting in *Robin* #126 (2004), Stephanie Brown (a.k.a. Spoiler) became the first Girl Wonder under Batman's tutelage. But just a couple of issues later, in *Robin* #128, Batman fires

Stephanie for failing to meet his strict expectations. And in the 2000s, the Cassandra Cain version of Batgirl became a regular visitor to the cave until she was set up in her own apartment. Though strong female costumed heroines have become commonplace in current Batman comic books, the Batcave has remained a primarily homosocial space for the male heroes.

The fact that Batgirl was blindfolded when she first visited the Batcave in *Detective Comics* #363 (1967) is indicative of some of the more pernicious gender politics involved with access to this particular homosocial space. In that story, "The True-False Face of Batman," Batman and Robin bring their newest ally back to the Batcave with the promise of revealing the Caped Crusader's greatest secret, his real identity. To Robin's astonishment, Batman removes his cowl to show Batgirl he is Bruce Wayne. But Batman had smeared some wax on his face to trick Batgirl into thinking that Bruce's face was just another mask—thus ensuring that Bruce Wayne would be the last person she would suspect to be Batman. The ruse works, as Batgirl thinks to herself: "If Batman had really wanted to take me into his confidence, he'd never have blindfolded me to and from the Batcave!" Within the stories, Batman always explains that using a blindfold keeps the occasional guest to the cave unaware of its location. This precaution is logical, but the regular act of blindfolding female visitors suggests that the men want to protect their "secrets" from the prying eyes of women specifically. In addition to this 1967 case of Batgirl, the blindfolded woman device has been used numerous times over Batman's eighty years in print. For example, in the 1948 story "Scoop of the Century" from *Batman* #49, photojournalist (and sometime Bruce Wayne girlfriend) Vicki Vale is blindfolded and brought to the cave to take a photograph. In *Batman* #432 (1989), he brings a blindfolded female private investigator, Maxine "Max" Kelley, to the Batcave when they are working the same case about a missing child (figure 3.3). "A cave! You live in a cave? This is a joke, right?" Max yells, before adding, "By the way, the *blindfold* was real kinky." As will be discussed in detail in the next chapter, Batman blindfolded Catwoman in 2013 when he took her to the cave in *Forever Evil* #3. "I'll admit it," Catwoman purrs suggestively, "I've imagined a scenario involving you, me and a blindfold before Batman." But Batman ignores her flirtation and tells her, "I'm taking you someplace few people have been, Catwoman. The less you know about its exact location, the better. . . . There are secrets about me you're safer not knowing." Upon seeing the Batcave, Catwoman insightfully whispers, "Wow, nice bachelor pad." And, in the 2019 issue of *Harley Quinn* #58, Batman blindfolds villain-turned-heroine Harley when he brings her to the cave as part of a mission. The mischievous Harley tries to peek while in the Batmobile, but Batman sternly barks, "DO NOT TOUCH THE BLINDFOLD!"

Taken together, these scenes of women blindfolded when taken to the Batcave clarify how private the location is and how male-centric it is as a physical space. And while the Batcave / bachelor pad metaphor substitutes adventures for sexual conquests, the sexual implications of this convention are still apparent.

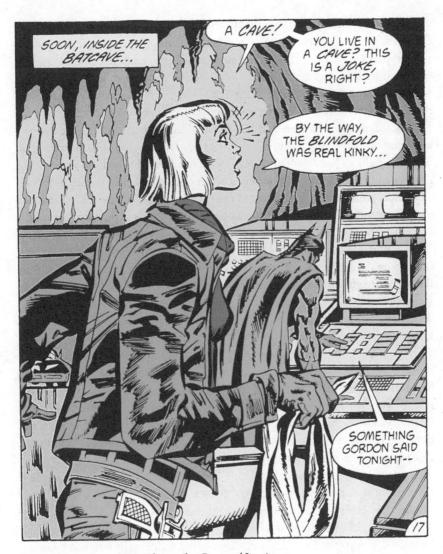

FIG. 3.3 *Batman* #432, 1989, Christopher Piest and Jim Aparo

Bruce Wayne had just finished a date with Vicki Vale when Batman blindfolds her. Batgirl is brought to the Batcave so Batman can "reveal" something to her. Max Kelley openly notes how "kinky" the use of a blindfold is. And Catwoman, Batman's most frequent romantic partner, teases that she has fantasized about a more sexual way to use a blindfold with Batman. The fetishistic undertones of these stock scenes have always been present, but they have become more explicit over the years. The image of the blindfolded woman has long been a staple of light-BDSM sex, a popular and common "kink" that plays with fantasies of power and powerlessness, of seeing and not seeing. In sexual terms the blindfold signifies what Valerie Steele refers to as fetishism's appeal to scenarios of

unequal power and control in intimate settings. And, as Steele notes, these fantasy scenarios exaggerate "the power differential implicit in traditional gender stereotypes" (1996, 172). Though female super characters have come a long way in the comics, traditional cultural assumptions about men as powerful and women as powerless are still reinforced through these scenes that confirm Batman's unassailable hegemonic masculinity.

That it is primarily women who are blindfolded when brought to the Batcave also reinforces the cultural privileging of the male gaze and the limitation of women's right to "see." As Laura Mulvey famously established in 1975, cinema grants male protagonists the power of a nearly omniscient vision, whereas female characters are primarily the object of the gaze. At its most basic: men look and women are looked at. The masculine ability to see implies a control of the narrative, an authority over other characters, a type of supremacy in every situation. The men can see the clues, the bad guys, and the beautiful women. Restrictions on women's access to an authoritative vision can leave them in the dark (both literally and figuratively), deny them crucial information, and confirm their value as a sexual object. As a hypermasculine superhero, Batman embodies a superior vision and the knowledge that comes with it. Batman seemingly sees all and knows all: he is a master of surveillance, he always sees clues the police have missed at crime scenes, he sees through every supercriminal ruse, and he sees every enemy's weakness. Within the narratives Batman controls vision so readily that he never becomes the object of the gaze; he sticks to the shadows, criminals do not see him until he wants them to, he always slips away from meetings with Commissioner Gordon unseen, and he very effectively hides away his secret identity from prying eyes. The blindfolding of women when they are brought to the cave literalizes his masculine control of the gaze. Batman dictates what they can and cannot see of him and his boys' club. Batman's disproportionate anger when Harley Quinn tries to peak—"DO NOT TOUCH THE BLINDFOLD!"—along with a pointed finger is both condescending and cruel.

In the blockbuster comedy *The Lego Batman Movie* (2017), the naive Dick Grayson discovers the Batcave shortly after being accidentally adopted by Bruce Wayne. "Does Batman live in Bruce Wayne's basement?" Dick naively asks. "No," Batman replies, "Bruce Wayne lives in Batman's attic." This humorous exchange underscores the theme of masculine duality within the genre and the difficulty of untangling the idea of who superheroes *really* are. Are they the civilian identity or the costumed hero? Which is the secret identity? The dual identities of Batman and Bruce Wayne are mirrored in the duality of the Batcave and Wayne Manor / Wayne penthouse. In her discussion of hidden sexual identities and superheroes, Catherine Williamson points out that "one identity is generally privileged as 'original'—Kal-El the alien baby, Bruce Wayne the orphan—but as either crimefighting superheroes or mild-mannered playboys/reporters, the caped crusaders always have something to hide" (1997, 6). Williamson focuses on costuming as a key signifier of identity and concealment. "Significantly," she

argues, "each identity is constructed (and conceals its particular secret) through costume as well as performance: hence we have Superman's blue tights versus Clark's wire-rimmed glasses; Batman's black cowl versus Bruce Wayne's dressing gown" (6). Williamson describes this use of costuming as "a form of same-sex drag." The Batcave and the manor/penthouse function similarly to present and confirm Batman / Bruce Wayne's hegemonic masculinity, as either (and both) an adventurer or a billionaire playboy. Both identities are a facade of ideal heteronormative masculinity. The cave and the manor/penthouse are part of the overall masculine masquerade and performance.

Indeed, one of the central secrets disguised by the Batcave and Bruce Wayne's residences is that hegemonic masculinity itself is nothing more than a facade, a masquerade bolstered by the appropriate settings. The central Batman stories have too much invested in maintaining the character's masculine sovereignty to risk exposing the facade. Batman is carefully crafted as naturally superior in every way, and his hypermasculinity is essential to the core heroic fantasy he represents. But a range of peripheral stories dealing with the Batman mystique suggest a tongue-in-cheek strain of ridiculousness about his overwrought masculine performances, and perhaps some underlying sexual tensions that can never be fully absolved. For example, in an episode of the popular children's cartoon *Teen Titans, Go!* (2013–current) titled "Sidekick," Robin is tasked with watching over the Batcave while Batman is out of town. The other Teen Titans follow him and proceed to playfully violate the sanctity of the cave. Robin frantically tries to get his friends to take the cave seriously, but they proceed to play, pretending to be Batman by using all of his gadgets and weapons. Starfire (Robin's crush) even puts on an extra Bat-suit and does her best imitation of the gravelly voiced Dark Knight. The goofiness of the Titans suggests that Batman's hypermasculine performance is just an illusion created by all these extreme symbols of toughness. Interestingly, when Robin sees Starfire in the skintight Bat costume, his eyes bulge and he falls over drooling in passion. Apparently, Robin's overwhelming object of lust is a hybrid of Batman and Starfire. The confused homoerotic tones come to light in a way that Dr. Wertham would have been thrilled by.

In a different vein, the lighthearted story "Doom Patrol vs. Teen Titans" featured in the comic book *SOLO* #7 (2005) by acclaimed writer/artist Michael Allred has the very retro-looking Titans throwing a party in Bruce Wayne's bachelor pad while Batman is supposed to be at a crime-fighters banquet. Gawking at the swanky apartment, Speedy declares, "We are going to party like it's 1969!" When Wonder Girl complains about Bruce's record collection of outdated crooners, Robin reveals, "He doesn't really bring girls here. Once or twice a month he drags Wonder Woman or Batwoman up here to keep up his bored playboy facade. They mostly just sit around and play cribbage all night. A swinger he's *not*!" The party quickly gets out of control when more and more teen superheroes show up. After some silly super hijinks, the young heroes all stumble out of the penthouse just as a tuxedo-clad Bruce Wayne returns with his date Kathy Kane

(a.k.a. Batwoman). "Thanks again for coming up here tonight after the banquet, Kathy," he says as he reaches to unlock the door. "Bruce Wayne was about due for another playboy night." "My Pleasure, Bruce," Kathy replies while thinking to herself, "and maybe tonight we'll do more than play cribbage, you big goof." Apparently, all of Bruce Wayne's playboy reputation is really just a cover for his lack of interest in sex. The ideally seductive penthouse is merely another part of the disguise. Noncanonical stories like these imply that both the superhero and the playboy are nothing more than performances, that the ideal of masculinity represented by both Batman and Bruce Wayne is all smoke and mirrors.

Despite the few exceptions that make light of Batman's persona, the male-only space of the Batcave (and other superhero lairs) has been reified in countless stories for over eighty years. The Batcave is perhaps the most quintessential example of a primarily homosocial space in popular culture. It is certainly the most famous. In addition to toy sets for children, adults can purchase home décor like "Welcome to the Batcave" doormats, framed lithograph prints and architectural drawings of the cave, and numerous wooden and metal signs emblazoned with "The Batcave"—often marketed as an ideal man cave accessory. Though the Batcave is a fictional environment, it does establish and normalize the concept of a desirable homosocial space for men. Moreover, in combination with the larger image of hegemonic masculinity modeled by Batman, the Batcave makes male-only spaces seem normal and heroic for young fans. The stilted inclusion of some female heroines to the cave is a progressive change in recent years, but the unequal treatment of female visitors only reinforces outdated misogynistic assumptions about women as weaker people still controlled and defined by how men see them. Or even worse, that women are merely sex objects and/or an emasculating threat to men. Pamela Hill Nettleton warns that "gendered territories in and outside the workplace become physical incarnations of troubling retrograde sexual politics and ideologies where men construct and foster friendships and partnerships exclusively with men and forbid the presence and influence of women" (2016, 563–564). With very few exceptions over the past eighty years, women have only been guests in the Batcave, a place the men call home.

Though the homosocial boys' club of superheroes remains an important part of the formula in modern stories, female characters have begun to infiltrate some of the heroes' private spaces. As the next chapter will review, the seemingly disparate worlds of masculinity and femininity typically safeguarded within the genre are compromised when heterosexual romantic pairings take center stage. Superhero marriages, in particular, have traditionally played out the masculine fear of being symbolically castrated or domesticated by women. But as the genre evolves, marriage has become an increasingly useful device to develop characters in novel ways and to explore the addition of mature familial responsibilities under a broader conception of masculinity.

4

Marriage, Domesticity, and Superheroes (for Better or Worse)

■■■■■■■■■■■■■■■■■■■■■■■■

A recent trend in wedding photography is pictures that playfully expose super-hero T-shirts under the formal attire of the groom and groomsmen. Either the men are ripping their shirts open themselves to reveal a superhero emblem under-neath (à la Clark Kent's famous pose) or, feigning surprise and admiration, the bride and bridesmaids are tearing the shirts open for the men. At first glance this wedding photo shoot cliché seems out of place. Hardcore comic book fans have been known to have superhero-themed weddings, complete with full costumes for everyone in attendance, Batman rings, Captain America invitations, Spider-Man decorations, and so on. But the subtle approach of a heroic symbol under a tuxedo does not seem to be limited to fans. The outfits and the poses clearly sug-gest the basic masculine superhero fantasy that underneath every mild-mannered male is a superman. But uniting the symbolism of weddings and superheroes is curious given that matrimony is very rarely a focus in the stories of caped crusaders. Superheroes regularly fight supervillains, monsters, and alien invad-ers. They do *not* regularly get married and live happily ever after.

Marriage and superheroes rarely go together with any lasting success. The superhero genre has traditionally trafficked in extreme gender ideals: *super* men with square jaws, bulging muscles, and incredible powers and able to defeat any threats; *wonder* women with perfect hair and beautiful faces, long legs and ample bosoms, dressed in revealing costumes and capturing villains without messing up their makeup. Yes, issues like justice, morality, violence, and politics are

important narrative themes in superhero comics, but the depiction of gender fantasies is the bedrock of the entire genre. Comic book super men signify a cultural paradigm of hegemonic masculinity, and the wonder women represent a feminine standard of objectified beauty and sexuality. Specifically, superhero stories have traditionally valorized a very narrow definition of masculinity based on demonstrations of physical power. Or, as David Coughlan has insightfully argued, "comics suggest that strength in the masculine public sphere is the truest sign of manhood" (2009, 238). Marriage in American culture is seemingly anathema to the type of gender ideals represented in the world of superheroes. This chapter addresses the problematic function of marriages in superhero comics as they recontextualize the traditional masculinity and femininity of costumed characters. Gender roles and expectations change in the few matrimonial situations that do occur as the heroes shift from public to domestic personas. The apparent mundanity of married bliss is at odds with the adventurous lifestyle of superheroes. The genre's difficulty in portraying marriage ultimately reinforces the belief that love and domesticity are incompatible with hegemonic masculinity and the unrealistic fantasy of female sexuality.

In his influential essay "The Myth of Superman" (1972), Umberto Eco argues that the commercial and serial nature of comic book adventures occurs in an "Oneric," or dream-like, climate where each story "takes up again from a sort of virtual beginning, ignoring where the preceding event left off" (19). According to Eco, the hero is a myth and must remain timeless or "inconsumable" while he simultaneously appears to exist within the parameters of our time. This flexible treatment of time is what allows characters like Superman, Batman, and Captain America to fight criminals for nearly a century while they remain in their late twenties or early thirties. Their never-ending war on crime cannot end, nor can these characters ever age or move toward narrative completion or death. One of the examples Eco gives for an irreparable event that would bring the hero closer to death is marriage. "If Superman married Lois Lane, it would of course be another step toward his death, as it would lay down another irreversible premise," reasons Eco, who concedes, "Nevertheless, it is necessary to find continually new narrative stimuli and to satisfy the 'romantic' demands of the public. And so it is told 'what would have happened *if* Superman had married Lois'" (22). Similar "imaginary" marriage stories were repeated for most of the major male superheroes. In addition to maintaining the status quo of the hero's world so that he can continue his monthly adventures with no real change, relegating the possibility of marriage to "imaginary" stories put it on par with other ridiculously fantastic tales like "What if Superman was a gorilla?" or "What if Batman was a vampire?" In the early decades of comic book superheroes, marriage seemed to be as ludicrous a concept as the hero turning to a life of crime.

Eco's analysis focuses on stories primarily from the Silver Age of comics, which comics historians roughly date from 1956 to 1970. The structure that Eco identifies in superhero comics as crucial to maintaining the mythical narrative

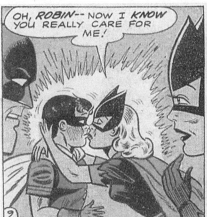
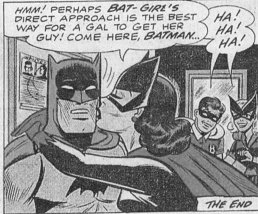

FIG. 4.1 *Batman* #153, 1963, Henry Boltinoff

logic that requires that nothing change also reflects the cultural concerns of the time period. In the conservative McCarthy era of early 1950s America, Dr. Fredric Wertham's sensationalistic book *Seduction of the Innocent* (1954) contributed to a moral panic about comic books. Wertham's infamous claims included Batman and Robin being a gay couple, Wonder Woman being a lesbian, and comics promoting deviance in general, including voyeurism, sadomasochism, and violent juvenile delinquency. Faced with a moral public outrage and a Senate hearing witch hunt, the comics industry chose to create the self-monitoring Comics Code Authority (CCA) in 1954 to ensure proper and morally safe stories. Among the many requirements for a comic to receive CCA approval were directives that any romantic storylines were to "emphasize the value of the home and the sanctity of marriage," and "illicit sex relations are neither to be hinted at nor portrayed." In his historical analysis Michael Goodrum notes that "DC's response to this formalizing and imposition of conservative outlooks was to retreat into producing narratives and images that championed contemporary values" (2018, 446). Thus, the character of Batwoman (Kathy Kane) was introduced in 1956 to serve as a love interest for the Batman, and her niece, Bat-Girl (Betty Kane), was brought in shortly after to function as an age- and gender-appropriate girlfriend for Robin. Though Batwoman and Bat-Girl became regular additions to the Dynamic Duo's adventures in an attempt to confirm their heterosexuality, the rigidity of the Comics Code meant that anything beyond a few blushing flirtations between the characters was forbidden (figure 4.1). Covers and storylines may have hinted that Batman and Batwoman would fall in love, but the restrictions of the code and the commercial necessity of keeping the Batman and Robin partnership as the focal point of the narratives often made the women seem more like a threat to the men's independence than a romantic temptation.

The CCA's explicit mandate to valorize heterosexuality and marriage, at the same time that it forbade any depictions of or allusion to actual sexuality, created an odd bind for superhero romances. Moreover, the sexual revolution of the 1960s and the rise of second-wave feminism contributed to the comic book industry's dilemmas about how to handle romance. One of the corporate strategies already established in the postwar publishing market was to clearly demarcate romance from adventure comics along gendered lines. Romance titles were targeted to girls, such as DC's *Girls Love Stories* (1949–1973), *Girl's Romances* (1950–1970), and *Young Romance* (1963–1975), and Marvel's *Love Romances* (1949–1963), *My Romance* (1948–1966), and *Teen-Age Romances* (1949–1955). In her overview of early romance comics, Jeanne Emerson Gardner (2013) argues that the titles appealed to young women because they "dealt with every one of the hectic transitions that took place in the lives of young women and addressed the uncertainty that accompanied their rapidly shifting roles from daughter to spouse, student and worker to homemaker, carefree girl to responsible woman . . . and balance new ideas of romantic partnership with traditional expectations of masculine authority and feminine submissiveness" (17). Love, marriage, and homemaking were presented in romance comics as aspirational ideals for women. On the other hand, adventure stories, especially superheroes, were geared specifically to boys and mostly avoided any romantic overtures.

One particularly interesting series that bridged the gap between superheroes and romance comics during the Silver Age was *Superman's Girlfriend Lois Lane* (1958–1974). Michael Goodrum focuses on this *Lois Lane* series for how it revealed the era's concerns about women as both romantic distractions and infringements on the male domain of work. Goodrum notes the prospects of marriage (both real and what-if scenarios) were the primary device used to address both romance and the place of women: "Concerns about marriage and Lois' ability to enter into it routinely provide the sole narrative dynamic for stories and Superman engages in different methods of avoiding the matrimonial schemes devised by Lois or her main romantic rival, Lana Lang" (2018, 442). Lois Lane's role as an investigative reporter has challenged traditional roles for women ever since she first appeared alongside Superman in 1938. But the stories in her own Silver Age title routinely "put Lois in her place," as Superman claimed more than once. In this time period, men assigned the home as the proper literal "place" for women, and their metaphorical "place" was subordinate to men. This assumption that some locations (like the home) were feminine and others (like the office) were masculine became an interesting structural device. "Despite Lois's career ambitions, she still yearns to attain domestic ends, to be married and to take up her position as a wife and homemaker" (446), Goodrum argues. "*Lois Lane* is driven by the desire for domesticity as both end goal and method of containment for a 'difficult' woman" (447). In numerous stories Lois attains superpowers, or pretends to have them, thus telling Superman he can marry her knowing she is safe from harm. Lois also transforms herself in various ways in

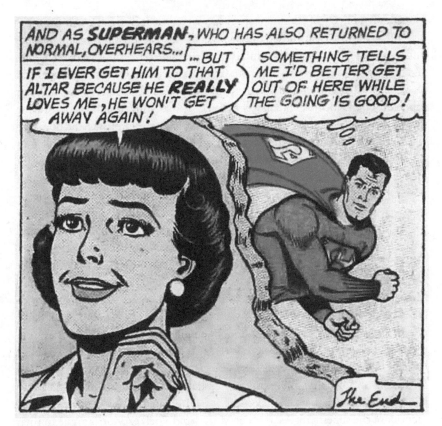

FIG. 4.2 *Superman's Girlfriend Lois Lane* #4, 1958, Otto Binder and Wayne Boring

an effort to be irresistible. She tries to make Superman jealous by dating or get-ting engaged to other men, including Lex Luthor, Bruce Wayne, the Devil, aliens, and even Clark Kent. And countless imaginary tales explore what family life for Superman and Lois would be if they wed, always with some unexpected down-side for Lois. In almost every case, Superman counts himself lucky to have escaped being trapped into marriage (figure 4.2). Through complicated schemes to trap or trick Superman into marriage, and a number of extreme what-if marriage sce-narios, *Superman's Girlfriend Lois Lane* repeatedly depicts the home and family as the ideal place for women and as an emasculating threat to men.

Superhero comics mirror our cultural conceptions of work as a masculine realm and the home as a feminine domain. In his work on gender and physical spaces, Andrew Gorman-Murray (2008) notes, "The construction of gendered identities and power relations is spatialized, most prominently through the binary of so-called public and private spaces, where women are normatively identified with domestic and suburban environments, and men with the world of paid work" (368). Moreover, since at least the Victorian era (see Tosh 2005), this

conventional binary of labor and space has served to bolster ideas of hegemonic masculinity and to naturalize unequal gender divisions. "Hegemonic masculinity became the norm, legitimizing patriarchal relations based on power and inequality," summarizes Rezeanu (2015), "associating women with domestic space of unpaid labor and men with paid work from the public space" (11). For superheroes, the ultimate fantasy of hegemonic masculinity, public adventuring (work) is engendered masculine and homosocial, whereas the private and domestic is aligned with femininity and heterosexual coupling. The prevailing logic during the Silver Age of comics was the rather adolescent fear that marriage meant men were weakened by women and emasculated by domestic responsibilities. In postwar 1950s and 1960s American culture, this tension between men's resistance to "being tied down" and a romanticized conception of the nuclear suburban family was evident in the popularity of Hollywood's bachelor-focused romantic comedies of the era (see Worland 2018), such as *Pillow Talk* (1959), *Sex and the Single Girl* (1963), or *How to Murder Your Wife* (1965). But where the confirmed bachelor of the movies usually fell in love and conceded to marriage, the more youthful-oriented comic book superhero always managed to avoid being "trapped" by a woman. The superhero's fear of the domestic, of being *domesticated* and thus less powerful, may be humorously obvious in stories from the 1950s and 1960s, but even now it remains a powerful organizing principle within the genre (and in Western culture generally).

The binary logic that masculinity is publicly demonstrated through strength while the private realm belies male weakness is mirrored by the conventional dual identity of the superhero. As Voelker-Morris and Voelker-Morris argue in their discussion of masculinity in comics, "The public and private sphere gender divisions found in traditional social structures of the United States can be used to parallel the roles of the male superhero and his alter ego" (2014, 106). Thus, the public figures of Superman, Batman, Spider-Man, the Hulk, and so on signify hypermasculinity, whereas the private (secret) identities are the weaker and embarrassing alternative: mild-mannered reporter Clark Kent, spoiled playboy Bruce Wayne, nerdy high schooler Peter Parker, and wimpy scientist Bruce Banner. The superhero identity is a rejection of the private, less masculine, more mundane self. The super man in these stories traditionally exists in opposition to the private and the domestic. Moreover, in most superhero narratives the destruction of the family has been the primary impetus for the violent revenge fantasy at the core of superheroes. Superman's parents die with Krypton, Batman's mother and father are gunned down in an alley, Daredevil's single father is killed by the mob, Spider-Man's beloved Uncle Ben dies in his arms, Robin's parents are murdered by extortionists, Iron Fist's mother and father die in a plane crash in the Himalayas, and so on. Being alienated from the idealized nuclear family is a cornerstone of the superhero formula. In his analysis of identification and superhero masculinity, David Coughlan (2009) argues that the cliché of the orphaned superhero requires alternative ideas about families within the genre:

"Superman, like Batman and Robin, Captain Marvel and Spider-Man, is an orphan, and therefore immediately distanced from a natural, in the sense of biological determined, experience of the domestic. Comic books, therefore, frequently show how those displaced from traditional familial structures, or denied lineal or territorial claims, can form other communities" (235). In lieu of traditional family structures, superheroes embrace partners, teams, and support organizations as makeshift families. But these alternatives tend to be male- and work-centric environments that reinforce the distinction between masculine spaces of work and female spaces of domesticity.

The very idea of colorful caped crusaders and masked vigilantes has always been rationalized in the stories as a way to preserve the hero's secret identity, thus protecting innocents in his life who may be put in harm's way. As Coughlan (2009) describes the trope, "Superheroes use anxiety over the possible dangers to those who get too close to them to defend the strategy of masking their identity" (244). As many of the imaginary tales in *Superman's Girlfriend Lois Lane* illustrate, if Superman married Lois she would be in constant danger from his enemies. As a wife, Lois is presumed to be an Achilles' heel for Superman, a glaring weakness to be exploited. This trope continues in modern comics despite all of the cultural changes since Superman refused to settle down with Lois in the 1950s. A concise example occurred in *Nightwing* #76 (2020) when Dick Grayson is confronted with the knowledge that his girlfriend Bea has learned he is a masked hero. In a flashback, Dick recalls Batman telling him: "Happiness—certainly if it's of the house with the white picket fence variety—is not an option for us." Reluctantly, Nightwing lies to Bea and says he does not love her, as his internal monologue rationalizes: "It's because I love her so much, that I can't. I have never hated myself more than I do right now. I'm sorry, Bea. So very, very sorry. But I'm doing this for you." This form of gendered logic that positions men as the primary heroes and women as a weakness, as victims in waiting, was fully exposed when Gail Simone began compiling the "Women in Refrigerators" list in 1999. The ever-evolving list catalogs female characters who have been killed, depowered, or excessively victimized (often in a sexual manner) in superhero stories. The refrigerator reference is from a 1994 Green Lantern story where the hero discovers his girlfriend has been dismembered and stuffed into his refrigerator. The unequal levels of violence that comic book women are subjected to gives substance to the idea that wives and girlfriends are a hero's weak spot. Women often suffer in superhero tales merely, as Gianola and Coleman (2018) note in their discussion of the 1973 death of Spider-Man's girlfriend Gwen Stacey, "as a means to propel a male character's story forward" (261). Of course, male heroes are subjected to a large degree of violence and are often killed as well. But the men typically triumph over their pains and even return phoenix-like from the dead. Female characters are much more likely to sustain permanent damages or to remain dead—the women's tragedies provide pathos and motivation for the male heroes to defeat the villains.

One of the most notable modern examples of "fridging" the innocent wife of a superhero takes place in DC Comics' 2004 miniseries *Identity Crisis*, written by Brad Meltzer and illustrated by Rags Morales. The central mystery that dominates the seven-issue story is the murder of Sue Dibney (who was also pregnant), the adoring wife of Ralph Dibney, a.k.a. the Elongated Man. The entire Justice League tries to figure out who murdered Sue, and how. She died from burns while inside her locked apartment, but there is no sign of a fire, or even of anyone having entered to commit the crime. The prevailing theory is that the second-tier villain Dr. Light somehow carried out the crime that leaves the Elongated Man shattered, and most of the other superheroes worried for the people they love. An attempt is made on the life of the Atom's ex-wife, Jean Loring, and Superman's wife Lois Lane receives a death threat. Robin's (Tim Drake) biological father is murdered by Captain Boomerang on behalf of the mysterious mastermind. The shocking revelations of *Identity Crisis* crystallize and compound how dangerous it is to mix a life of superheroism with the domestic. The heroes eventually learn that Atom's ex-wife, Jean, used his shrinking technology to kill Sue Dibney in a crazed attempt to get him back into her life. Even more controversially, the reader learns that Dr. Light raped Sue Dibney years ago, and when several members of the Justice League catch him, Dr. Light threatens to go after all their families. "It's your weakness, isn't it? I finally got it," Dr. Light taunts the heroes. "I'll find her again, you know. Then I'll find *all* of yours. . . . What about you, Flash? I see a wedding ring bulging under that costume. You got someone at home?" The heroes, including Hawkman, Green Lantern, and Green Arrow, vote to use Zatanna's magic on Dr. Light to erase his memory and to make him more simpleminded. When Batman discovers what they are doing and tries to stop them, the heroes use Zatanna to steal his memories as well. *Identity Crisis* illustrates that the private domestic world makes the superhero vulnerable and weak and can also morally compromise the hero's values.

The comic book logic that domestic bliss risks lessening the hero was reconfirmed in the failed marriage of Batman and Catwoman that dominated the Dark Knight's adventures from 2017 through 2019. DC Comics surprised the world when writer Tom King had the on-again, off-again couple get engaged in *Batman* #24. Subsequent stories featured Batman and Catwoman informing the Bat-family and other heroes, stealing a wedding dress, battling villains' intent on breaking up the couple, even attending bachelor and bachelorette parties. Despite the long buildup and an avalanche of publicity, Catwoman ended up leaving Batman at the altar in "Wedding Special," *Batman* #50. Catwoman realizes that if her love makes Batman happy, then he will not be as stern and dedicated a superhero as Gotham needs. "You are an engine that turns pain into hope. If we're happy . . . and we could be so happy," Catwoman explains in the note she leaves for him, "I kill that engine. I kill Batman. I kill the person who saves everyone." The implication is that a happy and content Batman is a softer Batman, less an icon of hegemonic masculinity. R. W. Connell (1987) originally

categorized "hegemonic masculinity" as a cultural ideal that normalized man-
liness as rooted in physical, economic, and social superiority to women and
lesser or subordinated men. Connell and Messerschmidt (2005) later clarified:
"Hegemonic masculinity was not assumed to be normal in the statistical sense;
only a minority of men might enact it. But it was certainly normative. It embod-
ied the currently most honored way of being a man" (832). As a fictional ideal,
the ever-victorious Batman (like all superheroes) presents a perfected model of
manliness. According to Connell and Messerschmidt, "Hegemonic masculini-
ties can be constructed that do not correspond closely to the lives of actual men.
Yet these models do, in various ways, express widespread ideals, fantasies, and
desires" (838). In order to maintain this fictional standard of masculinity as an
ideal for audiences, Batman must remain angry and ever vigilant; he cannot be
tainted by love and/or domesticity.

Love and family responsibilities reduce the superhero's ability to embody his
masculine superiority over others. The vulnerability of loved ones as a weak spot
is something the superhero cannot afford. Coughlan describes the recurring
dynamic where the hero must ultimately remove "himself from the home because
he cannot trust himself not to harm his family, given the violence that defines
him as a man" (2009, 235). This factor reinforces the notion that "for any super-
hero, the idea of home also signifies the location of weakness" (246). For decades,
the hegemonic masculinity personified by superheroes has been required to shun
real intimacy for fear that it will lead to distraction, domesticity, and emascula-
tion. Interestingly, the narrative logic that women weaken men also applies to
the supervillains. "I've felt some changes coming over me since you entered my
life. I've been reminded of what it's like to be part of a couple, to care for some-
one who cares for me. It's the first time in recent memory I've had those feelings,"
the Joker tells his girlfriend in Paul Dini's *Batman: Harley Quinn* (1999), "and I
hate having those feelings! They're upsetting, confusing, and worse, distracting
me from getting my share of Gotham now that the getting's good!" In her dis-
cussion of the Joker and Harley relationship, Tosha Taylor argues that "just as
Batman sometimes finds it hard to balance his relationships with Catwoman . . .
with his role as the self-appointed savior of the city, the Joker finds that he can-
not function as Gotham's most fearsome villain if he gives in to his unexpected
desire for a romantic partnership with Harley" (2016, 85–86). The genre's persis-
tent fear that romantic relationships are an emasculating trap to both hypermas-
culine heroes and psychotic villains exposes the adolescent boys' club mentality
that first formed the superhero over eighty years ago.

The superhero genre marks a clear difference between domestic space and pri-
vate space. The domestic is a place where the public hero intersects with loved
ones and family responsibilities. The domestic also suggests a sense of privacy—a
chance for the hero to take off his mask and embrace his secret identity. But the
most privileged private space in comics is characterized as an almost exclusively
masculine enclave. Long before the concept of the man cave was popularized in

American culture in the 1990s via the short-lived men's movement, Batman had the Batcave, Green Arrow fashioned an Arrow-Cave, Superman built his Fortress of Solitude, Tony Stark (Iron Man) had his lab, Dr. Fate had his Tower of Fate, Dr. Strange had his Sanctum Sanctorum, and so on. These caves and labs and secret hideouts serve as private spaces for the masculine public personas to find respite from adventures without resorting to conventionally domestic locations. The superhero lair literalizes the genre's overriding concerns about hegemonic masculinity being defined in contrast to femininity and lesser men. These lairs are essentially high-tech and secretive boys' clubs.

In her analysis of work-related boys' clubs on television, Pamela Hill Nettleton (2016) describes these clubs in terms that would also fit the superhero hideout: "homosocially segregated areas where men keep company with other men and women rarely, if ever, dare (or are allowed to) tread" (563). And the assumed young male reader can belong to the heroes' private realms, just as Nettleton's viewers "can virtually 'inhabit' these masculine spaces, along with male characters, and in a way, participate in boys' club membership" (568). Numerous Golden and Silver Age comics promised to privilege readers by revealing to them the "secrets" of the Batcave or the Fortress of Solitude. The symbolic importance of these private, but still masculine, spaces continues in modern comics. For example, when Batman "first" (at least in this continuity) brings Catwoman to the Batcave during the "Hush" storyline in 2002, he thinks, "I have made a decision to bring Catwoman back to the cave. I do not do this cavalierly. The cave, in so many ways, is my most private place" (*Batman* #617). Likewise, a decade later in the "Forever Evil" event, Batman again brings a blindfolded Catwoman to the cave for the first time, telling her, "I'm taking you someplace few people have been, Catwoman. The less you know about its exact location, the better.... There are secrets about me you're safer not knowing." When he removes her blindfold, Catwoman simply and insightfully remarks, "Wow, nice bachelor pad" (*Forever Evil* #3, 2013). As important as these lairs are for the superhero, as extravagant "bachelor pads," they are not a convention that extends to superheroines. The closest parallel might be Oracle's Clock Tower as a base of operations for the all-female Birds of Prey. But the Clock Tower is also Oracle / Barbara Gordon's home, so it doubles as a domestic female space. Where men have caves, women—even costumed women—have homes.

In the Modern Age of comics (roughly 1985–present), publishers have been much more willing to explore the possibility of major characters getting married as the logical development of years, or even decades, of romantic relationships. But the generic logic that marriage and domesticity are anathema to heroic masculinity remains a factor to be addressed in the stories. The rarity of superhero weddings means that when they do occur, they become a big event—and huge sellers. Publishing houses like Marvel and DC Comics typically tease weddings for months in advance, mainstream news outlets report on the nuptials, and expensive "Collector's Editions" are released to boost sales figures. Numerous side

stories build the suspense (envious supervillains) or add a more lighthearted element (bachelor and bachelorette parties). In addition to reaching a narrative milestone and the culmination of long-running storylines, the wedding comics also appeal to fans by bringing together all of the costumed heroes in the publisher's universe (and often having them battle all of the villains who invariably try to crash the party). Most notably, Spider-Man wed longtime love Mary Jane Watson in 1987, Jean Grey (Phoenix) and Scott Summers (Cyclops) of the X-Men married in 1994, Superman and Lois Lane married in 1996, both Marvel couples Luke Cage and Jessica Jones and Storm and Black Panther exchanged vows in 2006, Black Canary and Green Arrow married in 2007, and the X-Men Gambit and Rogue became husband and wife in 2018. Marvel also gained a lot of media attention for the same-sex marriage between mutant hero Northstar and his partner Kyle Jinadu in 2012. Though many of these, and other, superhero marriages have been narratively undone (and some redone), erased, or relegated to alternate universes through the increasingly common practice of rebooting characters or entire fictional universes, these modern marriages are forced to address gender roles in a different way than most costumed adventures.

It is important to note that most of these superhero weddings in the modern age involve characters who are equally powerful. Superhero and superheroine marriages help negate the conventional excuse that the average spouse (typically the wife) is vulnerable to the hero's enemies. The trope of wife as potential damsel in distress has, obviously, not been completely eradicated. The inclusion of Superman / Lois Lane and Spider-Man / Mary Jane Watson as high-profile modern super marriages demonstrates that wives can still reveal a hero's soft spots. But even these average wives have often been recast as equally super-powerful women. The popular ongoing series *The Amazing Spider-Man: Renew Your Vows* (2016–current) is set in one of Marvel's parallel universes and features the exploits of the entire Parker family (Peter, Mary Jane, and daughter Anna May), all of whom have identical Spider powers. And in the series *Superwoman* (2016–2018), Lois Lane temporarily assumed Superman's powers and carried on his heroic mission. All of the other superheroine wives (e.g., Storm, Phoenix, Black Canary, Jessica Jones) are equal to, or more powerful than, their superhero husbands. These super couples are partners in adventuring; they are equals in their public roles as costumed heroes.

The superpowered wives allow the stories to avoid the image of women as merely damsels in distress. In fact, several of the stories about these super couples intentionally reverse the gender roles of who can be held captive and who can be a rescuer. For example, at the conclusion of the first issue of the *Green Arrow and Black Canary* series (2007–2010) that immediately follows their wedding special (*Everyone Who's Anyone in the DCU Will Be There!*), it is revealed that Green Arrow has been kidnapped by Amazons and is being held on the mythical island of Themyscira. Naked, except for a loincloth, and covered in bloody scrapes and bruises, Green Arrow is trapped in a suspended cage while dozens of Amazons

thrust their spears at him through the bars to try to silence him. "Yeah," this husband in distress taunts them, "I'm just telling you, when my *wife* finds out about this . . . You big bitches are gonna be in some very deep @#$%!" And, of course, in the second issue Black Canary does come to rescue Green Arrow and trounces countless Amazons in the process. For super couples, either of them can be the knight in shining armor or the person in distress. Modern equals in marriage and superpowers means being equal in the public realm of heroism and the mundanity of the domestic sphere.

When both partners are super, the distance between the public and private realms shifts. Domestic spaces are depicted as unnatural to both male and female heroes, and the domestic also becomes less removed from the world of exciting adventures. As befits the fantastical science fiction of superheroes, even mundane tasks often become a rousing activity. In *Mr. and Mrs. X #6* (2018), when Rogue and Gambit throw a cocktail party in their penthouse shortly after getting married, many of their mutant colleagues from the X-Men attend. But just before their guests arrive, the Thieves Guild crash into the apartment and threaten to kill Gambit (Remy LeBeau). Rogue is more concerned about the living room getting messed up than about the death threats: "Not in this house, Remy. I spent too long gettin' it ready. You take this nonsense outside." In fact, Rogue is eager to stop her party prepping and switch to beating up bad guys. When Gambit asks if she wants to join him on the roof for the fight, Rogue quickly claims, "Wild horses couldn't stop me." Similarly, in *Jessica Jones #3* (2018), the super-villain Lone Shark punches his way into Jess and Luke Cage's apartment while they are preparing for a birthday party for their five-year-old daughter. Jessica and Luke trade wall-shattering punches with the mutated shark-man while her inner narration thinks, "I don't want to kill this guy on my kid's birthday. Plus, that will make an even bigger mess." Humorously, the villain notices the decorations and stammers, "Are you trying to throw a birthday party for your kid?—Oh Man, I'm sorry. . . . It's a real jerk that ruins a kid's birthday party." The heroes decide to let him go and clean up for the party instead of fighting any longer.

The general equality of the super couples in the public/work/masculine realm of costumed adventuring also allows the stories to explore a relative equality between the characters in the private/domestic/feminine environment of the home. Both the super husbands and the wonder wives are shown begrudgingly tackling mundane tasks like making meals, grocery shopping, and folding laundry. The implication of these modern comic book marriages is clear: the world of superheroing is no longer a male-only domain, and the home is no longer a feminine environment. This sharing of heroic and domestic responsibilities is clearest when the super couple have super children. When children are included in the stories, they typically fall into two categories: either they are normal kids and thus an extreme source of vulnerability, or they are superpowered and merely need guidance to learn how to protect themselves. Jessica Jones and Luke Cage's

unpowered daughter, Danielle, has been kidnapped by Skrulls and rescued by her dad, and she has been used as a lure by Kilgrave (a.k.a. the Purple Man), only to be saved by her mom. Conversely, superpowered children like Superboy (Jonathan Kent) may still be a cause for parental concern, but they are often shown to be perfectly capable of protecting themselves, and even rescuing their parents on occasion.

The marriage of Scott Free (a.k.a. Mister Miracle) and Big Barda (two escapees from the supremely evil world of Darkseid) has been humorously atypical since the couple wed in *Mister Miracle* #18 in 1974. Scott, an incredible escape artist, is the central character of their stories, but Barda is clearly marked as the tougher and more bloodthirsty of the pair. Barda towers over her adoring husband by at least a foot, she is extremely muscular, and she has superhuman strength. Mister Miracle escapes things, Barda smashes them. In other words, Barda is coded as the more masculine of the couple. She is more at home on a battlefield than in a kitchen. Tom King and Mitch Gerads's award-winning miniseries *Mister Miracle* (2017–2018) juxtaposes Scott and Barda's private life to their roles as military leaders for the armies of New Genesis in a war against Apocalypse. The couple commute between their California condo and the alien star system via a "Boom Tube," though on occasion some of the other New Gods come to visit them in their home. The series mocks the incompatibility of superheroism with mundane domestic spaces as colorful demigods are forced to squeeze onto a small sofa with Big Barda in front of a veggie platter. The couple casually talk about remodeling the condo while they kill their way through guarded corridors on their way to Orion. After Barda gives birth to the couple's first child midway through the series, Scott and Barda take turns leading their army against Darkseid while the other stays home to care for baby Jacob—superhero job sharing. They often discuss over the phone mundane, but important, parenting things like pediatric appointments, feeding schedules, poop color, and first steps while one of them is in the midst of battle. When Darkseid offers to end the conflict that has taken millions of lives in exchange for custody of the one-year-old Jacob, Scott and Barda are devastated. The fear of losing their child motivates Mister Miracle and Big Barda to do the impossible and kill Darkseid. Pretending to go along with Darkseid's wishes so that he gives up his deadly "omega beams" (laser eyes), Scott then breaks the deal and fatally stabs the evil god with a special knife that he snuck into the room inside a veggie tray.

Marvel's *The Amazing Spider-Man: Renew Your Vows* (written by Gerry Conway and illustrated by Ryan Stegman) indulges in the premise of a superhero family that fights together against all manner of villains. Peter and Mary Jane's daughter, Anna May, inherited her father's spider powers. And Peter was able to adapt a power-siphoning piece of technology so that he and Mary Jane could share powers. When Anna May is eight years old, the precocious youngster begins to fight crime alongside her parents, Spider-Man and Spiderette, as Spiderling. From the very beginning, the series clarifies that the entire Spider family is the

FIG. 4.3 *The Amazing Spider-Man: Renew Your Vows* #4, 2017, Gerry Conway and Ryan Stegman

focus and that Spider-Man is learning to think about his role as hero, husband, and father in a different way. In other words, Spider-Man, and by extension his readers, has to revise the genre's established conception of hegemonic masculinity. At home, Peter and Mary Jane are shown taking turns making meals, cleaning, and taking Anna May to school. But even more importantly, when he is in costume as Spider-Man (the public realm traditionally associated with hegemonic masculinity), the dialogue and monologues reveal a change in perspective necessitated by a super family. In the first issue, the Spiders go up against the Mole Man and his underground minions, and as Spiderette leaps into the fight alongside her husband, she thinks, "Peter has a hyperactive responsibility gene. Sometimes he forgets he isn't alone. We share this life together. All of us." When Spider-Man worries about Mary Jane possibly getting hurt in the fight, she reminds him, "It's about *us*. You're not a solo act anymore. You haven't been since we got married. Look, I get it. You're a *guy*. You think it is your role to keep me safe. Maybe that was true once. Not anymore . . . certainly not since Annie." Then, as the first issue closes with Annie in the clutches of the villain, Peter thinks to himself, "Mary Jane was right. What we have together. It isn't about MJ *or* Peter, not anymore. But it isn't about Mr. and Mrs. Parker as a couple, either. It's about our family. It's about our daughter. It's about Annie." Of course, Peter still tries to protect his family, but they also protect him (figure 4.3). Fighting bad guys becomes the same as "family fun night," and the Parkers share a love, closeness, and appreciation for each other because they support one another. *Renew Your Vows* shows that including the domestic realm, including a family, does not mean a hero is less heroic or less masculine.

Though the superhero genre has served as an effective analogy for male adolescence for most of its history, the inclusion of marriages and families in modern stories allows the basic formula to serve as a metaphor for other developmental milestones. The adolescent male power fantasy of ripping open one's shirt to reveal the superman underneath, or to be bitten by a radioactive spider, doused in just the right mix of chemicals and lightning, or granted powers by an ancient wizard, is still a potent idea of masculine transformation. But as a wish-fulfilling fantasy, this traditional definition of masculinity remains very narrow. After over eighty years, superhero comics are branching out to grapple with life changes beyond just gender and puberty. Parenting, domestic responsibilities, midlife crises, retirement, disabilities, and other life milestones can be explored through the symbolic world of superheroes. Superheroes in different situations, like in families, require a rethinking of or at least a reflection on basic social assumptions about gender and responsibilities.

5

It Starts with a Kiss

■■■■■■■■■■■■■■■■■■■■■■■

Straightening and Queering
the Superhero

Even in a genre that frequently traffics in extreme gender images, Batman stands out as one of the clearest and most popular embodiments of hegemonic masculinity. Batman is the best fighter, the greatest detective, the most tenacious, and the most resourceful superhero. Batman is all the more powerful because he does not have superpowers to rely on—even the Caped Crusader's secret identity is a masculine fantasy. Billionaire playboy Bruce Wayne is no mild-mannered reporter or timid teenager. Despite, or perhaps because of, Batman's extremely masculine persona, the character's sexuality has long been a point of contention. In the 1950s, Fredric Wertham infamously proclaimed Batman and Robin a gay couple: "It is like a wish dream of two homosexuals living together. Sometimes they are shown on a couch, Bruce reclining and Dick sitting next to him, jacket off, collar open, and his hand on his friend's arm" (1954, 190). Debates have raged ever since Wertham made his very public accusations. Over the decades, the fans, editors, and writers alike have all claimed Batman as a red-blooded heterosexual man. Legendary Batman writer Frank Miller, author of *Batman: The Dark Knight Returns* (1985) and *Batman: Year One* (1986), argues, "Batman isn't gay. His sexual urges are so drastically sublimated into crime-fighting that there's no *room* for any other emotional activity" (quoted in Sharret 1991, 38). Likewise, comics historian Mark Cotta Vaz notes, "For a virile, passionate man such as Batman it must be frustrating to steel himself against love's siren call, giving

himself totally to his crime-fighting obsession" (1989, 16). And Michael Brody claims, "The issue of Batman is not one of sexual orientation, but more a question of balance. There is a lack of sexual interest, all sublimated into his rage and crime-fighting" (1995, 176). Still, the arguments continue even as Batman celebrates his eightieth anniversary and has enjoyed unprecedented worldwide success in comics, movies, television, toys, and countless other licensed forms. Regarding how seriously people take Batman's personal life, Jenée Wilde argues, "The very pervasiveness and tenacity of the debate suggests that the question of Batman's sexual identity goes much deeper. In other words, why do so many people care? Why do we, the consumers of pop culture—as well as pop culture at large—insist on nailing down a sexual identity for Batman, be it heterosexual, homosexual, or asexually repressed?" (2011, 110). That a fictional character can inspire so much speculation regarding his imagined sexuality is a reminder of how important it is for people to see their desires reflected in the media.

When it comes right down to it, the sexuality of superheroes is entirely subjective. As Andy Medhurst has argued, "If I want Batman to be gay, then, for me, he is. After all, outside of the minds of his writers and readers, he doesn't really exist" (1991, 162). For the most part, mainstream superhero stories avoid explicit sexual activity. The exploration of actual superhero sex (of all kinds) is explored only on the fringes of the genre, such as slash fiction, pornographic video parodies, and independent press comics (see chapter 1). The genre's origin as adventure fiction for children, and the continued economic need to attract young consumers, means that the most iconic superheroes (those from Marvel and DC) rarely explore sex directly. Ironically, violence has always been less of a concern with superheroes, unless it begins to overlap with sexuality. Even with all the images of muscular men and buxom women prowling the dark streets in tight leather outfits, comics have managed to maintain a general aura of virtuousness. The entire genre is safely shrouded in what Giroux refers to as a "politics of innocence," wherein audiences are encouraged to assume the fantasy is harmless fun. Cultural beliefs and normative behaviors are naturalized through the stories and go unquestioned by audiences. First among these implicit norms is the presumption of heterosexuality as the baseline orientation of superheroes. Sex is not depicted in mainstream superhero stories, only the suggestions of romance and physical coupling. But the tales do overwhelmingly signify heterosexuality as ideal. In recent years, though, there has been a concerted effort within the comics industry to incorporate nonheteronormative sexualities in a manner that does not stereotype, demonize, or diminish them. This chapter traces how sexualities in contemporary superhero comics are constructed in a manner that normalizes heterosexuality through specific narratives, visual conventions, and social rituals through to the increasing normalization of LGBTQ sexualities by employing the same tropes. Specifically, the discussion will address the common romantic elements of momentous kisses, proposals, and weddings, all of which have been employed in superhero stories as a traditional means to celebrate

heterosexuality, and which are now also used to help normalize same-sex relationships.

Normalizing Heterosexual Romance

In his introduction to *Hetero: Queering Representations of Straightness*, Sean Griffin notes that in "sexuality studies, little investigation has been done with regard to how heterosexuality functions as a social construct—how it must continually reify its primacy through repeated rehearsals, performances, and announcements" (2009, 1–2). Griffin points to the development of feminist studies in the 1990s that began deconstructing masculinity, and ethnic studies in the 2000s that questioned whiteness as a baseline social category, as crucial to critiquing heterosexuality as a cultural norm. "Both of these developments," Griffin argues, "have turned attention to the dominant ideological positions, attempting to unseat their power as an almost unspoken 'default' core from which everything else is defined. Similarly, queer theory needs to draw out the bland, white bread, vanilla, missionary position, monogamous, married, patriarchal form of heterosexuality and point out it is just as much a social construct as any minoritized sexuality" (4). Mass media plays a major role in constructing and reinforcing contemporary ideas about sexuality and heteronormativity by obsessively modeling and celebrating a very narrow definition of romance. The narrative of boy meets girl, they fall in love, and they live happily ever after has been glorified in countless pop songs, Hollywood movies, television series, and novels. The repetitive and formulaic nature of this core narrative of romance presents a specific pattern and landmark moments as the cultural ideal that both reflects and instructs our society. The superhero genre similarly depicts and reinforces heteronormative beliefs through the centrality of its widely celebrated couples: Superman and Lois Lane, Batman and Catwoman, Spider-Man and Mary Jane Watson, Green Arrow and Black Canary, Mr. Miracle and Big Barda, Cyclops and Jean Grey, Reed Richards (Mister Fantastic) and Sue Storm (Invisible Girl), Daredevil and Electra, Vision and the Scarlet Witch, Gambit and Rogue, and so on.

Studies that address the socially constructed dynamics of heterosexuality have often focused on the formalized ways that heterosexual development has been ritualized, celebrated, enacted, modeled, and observed (in real life and in the media) through concepts such as dating, proms, first crushes, first kisses, weddings, bachelor parties, girls' nights, childbirth, and parenting. "Through such rituals, heterosexuality is conspicuously displayed with the community supporting or enforcing its standards of sexual identity" (Griffin 2009, 5). Many of these same milestones are incorporated into superhero narratives as part of the overall character development or ongoing storylines. The heteronormative rituals may seem smaller in scale, but they tend to outlast whatever conflict the hero deals with in each issue. Though romance can have an impact on the adventures,

it is more often depicted as part of the subplot, part of the character's real life, a background element to all the excitement. The superhero's more personal events are cordoned off as romantic interludes. But the pivotal heteronormative moments in superhero tales are just as important as any victory over Thanos, Galactus, or Darkseid. Defeating the bad guy is only one part of the superhero's defense of the status quo; "getting the girl" is also crucial for maintaining the status quo of heteronormativity. Through some of superherodom's most famous couplings (and many of the less famous ones as well), heterosexuality is depicted as natural, inevitable, and celebrated. World-shattering struggles between good and evil may constitute the raison d'être for superheroes, but the visual and narrative emphasis placed on spectacles such as kissing, proposals, and weddings reveal how heterosexuality is reified for audiences.

The seemingly simple act of kissing functions in Western culture as a complex symbolic gesture. Who gets to kiss whom? Public or private? Sexual or platonic? On the forehead or open mouths? As innocuous as a kiss between two characters may seem in popular fictions, it is a powerful instructive act for audiences. For many people, reading the sensational description of a kiss in a novel or observing close-ups of actors kissing passionately on-screen in the movie theater or on television is the first introduction to "how" and "why" kissing happens. These media representations also glorify the kiss as an emotional culmination and a narrative conclusion. The subject of kisses may appear better suited for a discussion of the romance genre, but kisses are treated in superhero stories as extremely important events. Historically, caped crusaders followed the classical heroic pattern of being rewarded with a kiss by whichever damsel in distress he saved. In modern superhero adventures, the kiss has taken on an even greater significance and is less often framed as a reward for the hero. Suggesting equality of a sort, superhero kisses are now typically between a superhero and a superheroine, or a noncostumed character who is treated as an ally rather than a damsel in distress. The performance of kisses in various media forms has, through the sheer repetition of specific conventions, elevated kissing to a sign of passion, true love, a fated union. The fact that almost all of the dramatic kisses depicted in the media have been, and still are, between a man and a woman serves to naturalize heterosexuality as the norm and heterosexual coupling as the pinnacle of happiness. Though the superhero genre may seem overwhelmingly preoccupied with playing out an adolescent male power fantasy based on violent adventures, the genre's use of kissing reinforces ideas about heteronormativity as an assumed fact, made all the more normal within the context of bombastic action.

Superhero comic books have built on the visual and narrative conventions established by the movies for kissing scenes, and have developed several elements that are specific to comics. Since the dawn of cinema, the Hollywood kiss has been an elaborately staged event that utilizes a number of (often clichéd) techniques to convey its importance. The music builds to a crescendo as the camera zooms in for a close-up of the leading man and woman, their faces perfectly lit

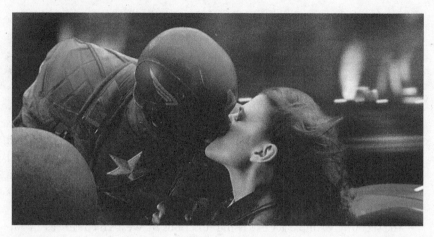

FIG. 5.1 *Captain America: The First Avenger*, 2011, Marvel Studios

as they come together with a rush. Everything else in the scene falls away or is blurred by the camera's myopic vision of the couple. Nothing matters but their passion. We see them tilt their heads just right, their lips touch, their hands hold each other's faces, before the camera cuts away or the scene fades to black. The continued importance of these overwrought moments can be seen clearly in almost every contemporary superhero film. The iconic upside-down kiss between Spider-Man and Mary Jane in *Spider-Man* (2002) is one of the most memorable scenes in the film. Likewise, as *Captain America: First Avenger* (2011) builds to a climax, just as Cap is about to leap from a speeding car onto a jet to catch the escaping Nazi villain the Red Skull, he pauses for a first kiss with Peggy Carter. With her hair blowing in the wind and the music swelling, the action slows down and the camera looms in to capture their kiss (figure 5.1). During the climactic battle in *Man of Steel* (2013), Superman catches Lois Lane in midair and flies her to safety as Metropolis is destroyed behind them. The smoke momentarily clears as they pause to look into each other's eyes, embrace, and finally kiss long and hard. When the Wasp saves Ant-Man from drowning near the conclusion of *Ant-Man and the Wasp* (2018), she is overjoyed when he regains consciousness; she grabs his face with both hands and kisses him in a passionate close-up while people run around screaming behind them. All of these scenes, variations of which appear in nearly every superhero film, employ cinematic conventions of a momentous kiss to signify the importance of the event for the characters and, in turn, to confirm that their love was meant to be. The fact that these examples all occur in combination with the final epic battle against the supervillain further emphasizes the excitement of the kiss and confirms heterosexual romance as equally important to the narrative.

Miriam Kent (2019) notes that the modern wave of Marvel feature films is structured around the idea that the romantic pair are meant to be together. Whether or not viewers are aware of the long-standing history of the various

couples from the comics, the films narratively, visually, and structurally imply that they will inevitably fall in love. In addition to Spider-Man and Mary Jane, Captain America and Peggy Carter, Ant-Man and Hope van Dyne, Marvel has presented numerous other heterosexual couples whose relationships anchor the films—for example, Tony Stark and Pepper Potts in each of the *Iron Man* films (2008, 2010, 2013), Peter Quill and Gamora in the *Guardians of the Galaxy* movies (2014, 2017), Thor and Jane Foster in most of the *Thor* adventures (2011, 2013, 2021), Stephen Strange and Christine Palmer in *Doctor Strange* (2016), and T'Challa and Nakia in *Black Panther* (2018). Interestingly, Kent argues that these Marvel films reinforce the idea of certain heterosexual couples fated to be together, but also as perpetually kept apart. The problems created by the superhero's powers and selfless responsibilities tend to trap the cinematic couplings in a relationship that can never be fully realized. As Kent observes, these films showcase both "the utopic ('they were meant for each other') yet dysfunctional ('they can never be together') nature of heterosexuality, making it appear natural and invisible" (2019, 119). Kent sees this double-bind as caused, in part, by "contemporary postfeminist rhetoric" (120) that regards heterosexual desires as relatively incompatible. In a practical sense, the dystopic "they can never be together" side of the heterosexual trope allows the films to extend the romantic tensions across a number of sequels. Comic books, on the other hand, are a more flexible medium and can reboot or rewrite romantic relationships at any given time.

The stylized cinematic techniques used to signal the kiss as a grand moment in movies (close-up, swelling music, slow motion, etc.) have parallel conventions in the static comic books. The superhero kiss is framed as a spectacular event within the story, and often on the book's cover as well. In fact, it is interesting how often superhero comic books feature a couple kissing on the cover as an enticing marketing strategy, especially for a genre considered excessively masculine in focus and readership. The primary cover of *Justice League* #12 (2012), for example, featured Superman and Wonder Woman in a midair embrace, lips just about to meet, their bodies encircled by her shining magic lasso and bathed in the glow of a brilliant sunset. This kiss between two of the most prominent super characters, who had never been a couple before, attracted widespread media attention and the issue garnered numerous collectable "variant" covers with slightly different portraits of the airborne clinch. In 2017, sales of *Spider-Man* #12 got a huge boost when the cover featured an upside-down kiss between Spider-Man (the Miles Morales version) and Spider-Gwen (Gwen Stacey from an alternate universe). The coupling of Miles and Gwen solidified an important relationship that readers had been clamoring for. Even a couple as famously "on again off again" as Dick Grayson (Robin/Nightwing) and Barbara Gordon (Batgirl/Oracle) is repeatedly depicted romantically on covers. The pair first kissed in 1975 in *Batman Family* #1 and soon after began dating. Though they have broken up at different times, and Dick has been involved in other serious romances (most significantly with Starfire), the pair has been regularly featured

on covers kissing or happily swinging over the city together—for example, *Birds of Prey* #8 in 1999, *Nightwing* #104 in 2005, *Nightwing Annual* #2 in 2007, and *Batgirl* #15 in 2017. The frequent covers depicting Barbara Gordon and Dick Grayson in some form of romantic tableaux have proved an effective way to attract fans who continue to be invested in their relationship. Teasing the kiss on the cover of the comics in an effort to attract buyers suggests how important the romance is for readers. Moreover, by putting the kiss on the cover, it is framed as the most important element of the story and normalizes the (heterosexual) kiss as both natural and spectacular.

One of the reasons for the inflated significance of the superhero kiss is that it represents the symbolic climax of heterosexuality. Actual climaxes, both metaphorical and implied, will be discussed in chapter 9. For the most part, mainstream comics, like mainstream movies, glorify the heterosexual kiss because it has to stand in for the act of sex. In her discussion of classical Hollywood techniques for romantic scenes, Linda Williams notes, "Kisses, when stylized and elaborated by the Hollywood narrative cinema, would eventually become synecdoches for the whole sex act" (2006, 294). Thus, heterosexuality is invoked and sentimentalized while also remaining a mystery. The satisfied aftermath of sexual encounters may be shown, but not the act itself. If taken directly, comics and movies would suggest that a grand kiss is immediately followed by waking up in bed next to each other. Williams describes this as a cinematic ellipse (. . .): that moment in between that cannot be shown, that has to be imagined or assumed by viewers. The fade to black of cinema, the *dot-dot-dot* of literature, and the gutter between panels in comic books are where the imagined sex can occur. This ellipse obviously satisfies censors, but it also ensures a belief that the heterosexual encounter was idyllic.

In the medium of comics, the big kiss is depicted through specific conventions that emphasize its value as a synecdoche for sex itself. Where the movies use music and close-ups to glorify the kiss, comic books typically increase the symbolic magnitude of the moment by increasing the illustration of the kiss. The kiss is always granted a greater visual presence than other moments in the story. The kiss bursts through the limitations of multipaneled pages, either with a significantly larger frame that dominates the other panels or with a full page just for the kiss. The visual implication is that the kiss, and everything it signifies, is too big and too important to be contained by borders. *Batgirl: Year One* #3 (2003) effectively uses the technique of magnifying the kiss in contrast to the other panels on the page to stress its importance (figure 5.2). The alternate, the full-page strategy, is adopted in a story retelling Batman and Catwoman's earliest romantic encounter in *Batman Annual* #2 (2017). When Batman and Catwoman remove their masks to share their first kiss, it is given an entire page (figure 5.3). Moreover, the spectacle of the kiss is ensured as all background details are removed from the page and no thought bubbles or captions distract from the passion of the embrace.

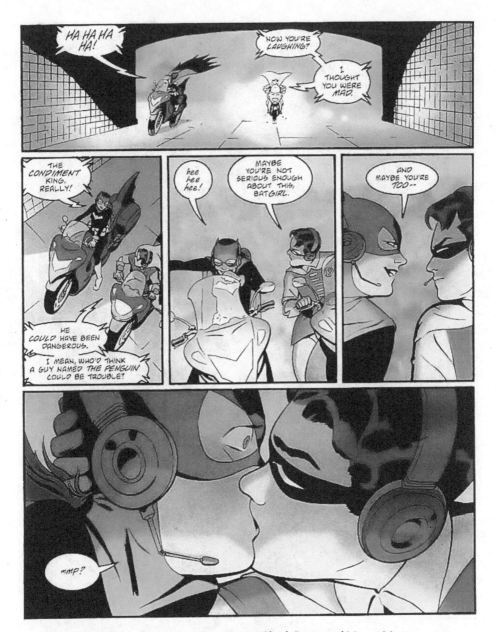

FIG. 5.2 *Batgirl: Year One* #3, 2003, Scott Beatty, Chuck Dixon, and Marcos Martin

Both of these comic book super kisses also typify the contextual lead-up to the kiss, or the symbolic foreplay to the symbolic climax, in a manner made familiar by movies. "Getting ready for the kiss, we are learning, is often more dramatic and more teasingly erotic than the kiss itself," writes Williams. "If we care to think of the kiss as the synecdoche of the whole sex act, then this part

FIG. 5.3 *Batman Annual* #2, 2017, Tom King, Michael Lark, and Lee Weeks

standing in for the whole has its own foreplay" (2006, 303). Williams describes the cinematic foreplay as those moments before the kiss where bodies slowly get closer, intimately closer, and where even flirtatious dialogue slowly gives way to speechless passion: "It often consists of two faces held close together, talking or just looking, on the verge of a kiss. When two people are seen in profile looking at one another at close range, their eyes cannot take in the whole of the other's face without a certain surveying movement up and down or from side to side. . . . The music surges once again as, silhouetted in profile, face to face, their mouths and noses almost touching" (304). Batgirl and Robin laugh and tease each other, leaning in closer and closer until their lips meet in the kiss. Likewise, before Batman and Catwoman's full-page kiss, the couple slowly approach one another in her apartment. They cautiously remove their cowls, allowing themselves to be vulnerable, and then are consumed by the passion of the kiss, as Catwoman's wine spills, unheeded, onto the floor.

The serial nature of comic book stories contributes to a sense that the glamorous heterosexual romance is not just natural but inevitable. The famous super couples mentioned earlier have become iconic because their romance has been told over and over again by different creators, in different mediums, and in different eras. This ultimately leads to a sort of preordained expectation that certain superheroes will become romantically involved with specific characters— that they *have* to become involved. No matter what parallel universe or new rebooted continuity the story takes place in, audiences know that Superman and Lois Lane (or Reed Richards and Sue Storm, or Aquaman and Mera) are meant to be together. Batgirl and Robin's kiss in *Batgirl: Year One* #3 may surprise her, but readers know the couple are destined to have a romantic relationship. Likewise, fans were well aware that Vision and the Scarlet Witch would become involved in *The Avengers* movies because they have a long and storied history together in the comics. This inevitability of certain heterosexual couples (born from repetition) conveys a sense of being "fated to be together." Of course, as fictional characters, they are not really fated to be together. They are merely paired up out of tradition and to satisfy audience expectations. But the lingering implication that these heterosexual couples are fated to be together further reifies the idea of heterosexuality itself as expected, natural, and normative. Moreover, the fantastical what-if type of speculative stories often told in comic books suggests that the love of these ideal heterosexual couples transcends even time and space. For example, in the seemingly infinite variations of Spider-Man explored across Marvel's multiverse in the epic *Spider-Verse* event (2014–2016), Peter Parker and Mary Jane end up together whether they are in Victorian England or a postapocalyptic wasteland. Another strategy is used in *Batman Annual* #2 mentioned above. Where the first short story looks back on the start of the Batman and Catwoman romance when they were young, the second story in the issue looks forward to their relationship when they are an elderly married couple surrounded by their children and grandchildren. In fact, the past kiss depicted in the first

tale (figure 5.3) is echoed in the full-page, future kiss of the second tale. The implication of these bookended kisses is that heterosexual romance is also enduring because it is so natural, pure, and everlasting.

In addition to the repeated performance of the epic kiss as a spectacular and momentous heterosexual event, superhero stories also confirm heteronormativity by showcasing the events leading up to, and including, weddings. Patricia Arend argues that the entire marriage process is designed to valorize heterosexuality: "Weddings ritualize and dramatize patriarchal and heteronormative gender relations through such actions as bridal showers that equip women for taking care of a home, the 'giving away' of the bride, usually by her father or other male relative, a hyper-emphasis on her appearance relative to the groom's, and the announcement of her name change as part of the couple at the ceremony and/ or reception" (2014, 145). The classic marriage proposal is likewise rooted in the presumption that the man must kneel and present an exquisite ring and, most importantly, that it is up to *him* to ask her. Superhero proposals tend to be very conventional, even in twenty-first-century comics. In *Black Panther* #15 (2006), King T'Challa takes a knee and asks Storm (of the X-Men) for her hand in marriage. In *Green Arrow* #75 (2007), the Emerald Archer kneels to propose to Black Canary. Though in *Injustice II* #4 (2017), the tables are turned when she kneels to propose to him (he does get down on his knees to accept). In *DC Universe Rebirth* #1 (2016), Aquaman kneels and holds out a ring. Mera asks, "Arthur, what are you doing?" and he tells her, "It's a surface custom." The Caped Crusader kneels on a darkened rooftop to propose to Catwoman in *Batman* #24 (2017). In the rebooted *Fantastic Four* #1 (2018), Ben Grimm (a.k.a. The Thing), armed with flowers and a ring, bends his rocky knee to ask his girlfriend, Alicia Masters, to marry him. And *X-Men Gold* #30 (2019) has Gambit kneeling to surprise Rogue with a traditional proposal. There are a few exceptions to these very conventional proposals (e.g., Kitty Pryde proposes to Colossus in *X-Men Gold* #20 [2018]), but for the most part, superheroes seem to relish the symbolic formality and the theatricality of traditional romantic rituals. As with the spectacular heterosexual kiss, the importance of every proposal is highlighted by page-dominating, or full-page, illustrations.

The epic kisses and the formal proposals are depicted in superhero comics as incredibly important, even solemn, moments that reinforce heteronormativity. Bachelor and bachelorette parties, on the other hand, are treated far less solemnly even though they are significant rituals in relation to heterosexuality. The gender-divided festivities are explicitly meant to mark the passage of the bride's and the groom's carefree days of sexual availability. As a part of the wedding process that openly revolves around desires and indulgences, bachelor and bachelorette parties publicly celebrate the more carnal aspects of heterosexuality as normal behavior. The frivolities of bachelor and bachelorette parties are typically played for laughs in the comics, as the rare light moment in a genre that is frequently melodramatic. Just the idea of costumed superheroes getting drunk at a strip club

seems absurd. The gender politics of the bachelor/bachelorette parties as depicted in comics is interestingly skewed. It would seem logical to treat the ritual bachelor party as an excuse to present sexualized images of women that go beyond even the exaggerated norm of super women in costumes, especially given the assumed masculine focus of the genre's core readership. But while the super men may take the groom out for a few drinks, they typically opt out of strip clubs. The heroines, on the other hand, seem to relish the opportunity for a bit of reverse sexism. For example, in *Green Arrow and Black Canary: Wedding Special* #1 (2007), when the men of the Justice League arrange a party for Green Arrow on the eve of his wedding, they cancel the strippers at his request. But Black Canary and the superheroines of the DC universe have a rowdy private party with plenty of male strippers getting bills shoved in their G-strings. Likewise, while Nightwing and Superman take Batman out for burgers in *Batman: Prelude to the Wedding, Part Two* (2018), Catwoman and her friends drunkenly flirt with male strippers in *Part Four* (2018). And in *X-Men: The Wedding Special* (2018), Colossus refuses to go to a strip club during his bachelor party in Vegas, so the guys settle for a casino and a brawl with a demon. But for the bachelorette party, Kitty Pryde is escorted to a wild night of strippers and karaoke by the female X-Men.

Superhero nuptials are depicted in comics and marketed by publishers as huge events. In fact, the only other event that comes close to the spectacle of the wedding is the death of a major superhero. That weddings are usually a bigger deal in comic books than saving the universe is an indication of how important the event is within a heteronormative culture. Within the comic book universe, the fuss made over a superhero wedding is rationalized as a unique opportunity to bring together hundreds of costumed characters for a celebration (and possibly a fight if supervillains try to crash the event, which they often do). Furthermore, because the marriage is seen as the culmination of readers' desires to see long-running couples taking on a formal commitment, it is treated with a great deal of fanfare. At the cultural level, superhero weddings are treated as a significant event because weddings are the ultimate celebration of heterosexuality. Wedding ceremonies, especially the traditional "white weddings" that most superheroes undertake, are very formal and public events where every detail is designed to celebrate the love between the bride and the groom. Sean Griffin notes, "Weddings in particular underscore the theatricality of heterosexuality" (2009, 5). And the superhero genre clearly loves to be theatrical. In her discussion of the symbolism of modern weddings, Katrina Kimport argues the event is "an overriding heterosexual romance narrative with one (virginal) bride and one groom as its protagonists, [that] perpetuates the construction of heterosexuality as both normal and immutable" (2012, 875). This unspoken normality and immutability of heterosexuality is played out in the routine grandeur of comic book weddings, both in the story and in the marketing of the event.

The formula for superhero weddings was established in 1965 with the marriage of Reed Richards and Sue Storm in *Fantastic Four Annual* #3. Dozens of

Marvel superheroes and other recognizable characters mingle before the ceremony and then watch as the happy couple exchange vows. The Richards/Storm event also inaugurated the tradition of supervillains interrupting the wedding and causing an all-out super brawl. The weddings are formal affairs with the brides in traditional white dresses and the grooms in suits or tuxedos. Whether officiated by a priest, rabbi, or shaman, the wedding is always endorsed as both a sacred and a civil ceremony. The ceremonial performance of heteronormativity allows the couple to profess their undying and inevitable love for each other. In *New Avengers Annual* #1 (2006), Jessica Jones interrupts her own vows to tell Luke Cage, in her own direct way, "I want you to know, I truly believe that together we are so much better than we are apart. . . . No goon attacked us at our wedding, so I'm going to take that as a good sign. And even *if* the worst happens, it's a weird feeling, but I know for a fact we can deal with it." Or, as Ben Grimm (the Thing) tells his bride as they exchange rings in *Fantastic Four* #5 (2018), "Alicia, I've been across the whole universe, and I ain't ever met anybody as beautiful as you. Inside and out. Everything you touch, every moment you're a part of, is all the more beautiful for you being there. More than anyone, *you* are what makes my whole life beautiful." When Dr. Doom and Galactus interrupt this Fantastic Four wedding, super-genius Reed Richards is prepared. As his gift to Ben and Alicia, Reed created a temporal device that allowed the ceremony to continue while the world outside was frozen in place. The magnitude and inevitability of this coupling is so special that the moment transcends time itself. No matter which superhero is getting married, the message is always clear: love is greater than any supervillain.

Publishers seek to capitalize on the elevated stature of weddings by treating them as special narrative events, as significant turning points for the heroes, worthy of expensive collectors' issues and spin-off stories. It is now standard practice at both Marvel and DC to release "Wedding Special" issues as milestones, as well as spin-off comics that lead up to the wedding. The weddings are also commemorated with merchandising ephemera like statues, T-shirts, wedding albums, posters, and coffee table art books. *Batman* #50 (2018), the issue in which Batman and Catwoman were scheduled to be married, was released with over thirty collectable variant covers. Illustrated by some of the biggest names in comics, the variant covers all depicted some version of Batman and Catwoman, or Bruce Wayne and Selina Kyle, at the altar or in a loving embrace. Major news outlets reported on the planned nuptials, many comic book stores offered customers a slice of wedding cake, and some stores even hired actors in Batman and Catwoman costumes to act out the wedding on the day the comic was released.

Normalizing Nonheterosexual Romance

For much of the genre's history, LGBTQ characters have been nonexistent. On the surface, superheroes have long been a bastion of heterosexual masculinity.

The hypermasculine adventures, personas, and bodies of the characters yoke together the idea of caped heroism and a palpable aura of heterosexuality. But just beneath the surface, alternative sexualities continue to be associated with the world of superheroes. "At every moment in their cultural history," Darieck Scott and Rami Fawaz contend, "comic books have been linked to queerness or to broader questions of sexuality and sexual identity in US society" (2018, 198). Accusations of explicit or implied "sexual deviancy," from fetishism and sadism to homosexuality, have been lobbied at superheroes since their very conception. Given the obsessive focus on men as heroes and comrades, Lee Easton and Richard Harrison even claim that it is impossible for "comics to keep the line between the homosocial and the homosexual straight when it is so precariously thin." In fact, Easton and Harrison argue, superheroes "create *a queer space*, where various forms of masculine identifications and desires are *simultaneously* available" (2010, 138; italics in original). The overt form of masculine identification offered by most stories is the reader's imaginative alignment with the superhero as an ideal of hypermasculinity—a dream version of the self that is powerful, confident, resourceful, and admired. However, the genre conventions of mild-mannered secret identities, intimate same-sex sidekicks or teammates, and muscular male bodies dressed in colorful and tight costumes facilitate a range of other "identifications and desires." In other words, the very structure of the genre that creates an indelible concept of hegemonic and heteronormative masculinity also implies other *queerer* possibilities.

The queer connotations of superheroes have been touched on in several of the previous chapters, including the homophobic 1950s-era moral panic over comic books spurred by Fredric Wertham's sensationalistic book *Seduction of the Innocent* (1954), the concurrent Senate hearings on juvenile delinquency, and the subsequent attempts to "reheterosexualize" (Medhurst 1991) the genre. But the comics industry was never able to completely erase the possibility of queer interpretations of the central heroes. As numerous queer studies scholars have explored, audiences that fall outside the assumed heterosexual norm often employ alternative strategies to find expressions of themselves in popular media forms. Marginalized sexualities have been forced to strategically read "against the grain" or "between the lines" of heteronormativity as both a defensive and an affirming tactic. The visual and narrative conventions utilized in superhero stories facilitate easy queer interpretations. Catherine Williamson (1997) details how the central device of the hero's dual identity mirrors the oftentimes closeted nature of homosexuality and allows an identification with the alternation between different performed and costumed versions of masculinity. "It is the disguise itself," Williamson argues, "or rather the convention of the 'secret identity' which allows for queer readings of superhero texts" (4). As Williamson explains, "The 'secret identity' trope reminds me of two oftentimes related but not interchangeable phenomena, drag and the closet: drag because of the way superheroes use clothing and performance to signify an ironic relationship between gender and sex;

the closet because of the way secrecy and silence permeate all corners of super-hero characterization, including—and especially—sexuality" (3). In other words, nonheteronormative readers are able to understand the disguise as analogous to the queer history of concealing one's true (sexual) self and of putting on alterna-tive identities. Exploring another genre convention, Neil Shyminsky (2011) focuses on the ambiguous relationship between the hero and the sidekick, a com-mon partnership originated with Robin in 1940, as a means of negotiating homosexuality. Shyminsky argues that the sidekick shoulders the most obvious signifiers of homosexuality, thus serving at one level to help "straighten" the main hero by contrast. Ultimately, Shyminksy details in relation to the original side-kick, "Robin does not simply cast doubt upon the sexuality of sidekicks or even upon sidekicks and the superheroes who train them. Rather, Robin's costumed 'gay' sidekick status—predicated as it is upon uniforms, secret identities, unusual abilities, isolation, and superhero homosociality—implicates the *entire* tradition of masked superheroes" (304). No other mainstream genre is as doubly defined as both heteronormative and nonheteronormative by the same core conventions.

The superhero genre, like all forms of popular culture, has made significant efforts to improve both the quantity and the quality of nonheteronormative representations. "Contemporary comic books open up possibilities in terms of the gender and sexual orientation of their characters," Nickie D. Phillips and Staci Strobl reason. "In recent years depictions of superheroes and crimefighters have gone beyond the white, male historical standard, with minority, lesbian, gay, bisexual, and female characters becoming more prevalent in best-selling comic books" (2013, 141). Marvel's Northstar became the first superhero at either of the two major comic book publishing companies to be identified as gay when he came out during an AIDS-related storyline in *Alpha Flight* #106 (1992). The outing of a second-tier hero from Marvel's Canadian-based super team did not exactly open the floodgates for more sexually diverse characters. But with the new mil-lennium and an increased recognition of queer characters in most media forms, comic books introduced a significant number of nonheteronormative superhe-roes. Modern gay heroes include Wiccan and Hulkling from *Young Avengers* #1 (2005) and Bunker from *Teen Titans* Vol. 4 #1 (2011). Likewise, numerous new lesbian heroes have debuted since the turn of the century, such as Negasonic Teenage Warhead in *New X-Men* #115 (2001), Karolina Dean and Nico Monoru from *Runaways* #1 (2003), Grace Choi and Thunder starting with *The Outsiders* Vol. 3 #1 (2003), and America Chavez (Miss America), first seen in *Vengeance* #1 (2011). And bisexuality has gained some renown through recent characters, including Daken, Rictor, Shatterstar, Bling, Knockout, and Madam Xanadu.

In addition to creating original nonheterosexual characters over the past two decades, both Marvel and DC Comics have retroactively revised the sexuality of some of their pre-existing superheroes. DC has recharacterized Catwoman, Catman, and John Constantine as bisexual and repositioned the original Green Lantern (Alan Scott) as gay. Likewise, at Marvel, Hercules, Quasar, and

Giant-Man have all been rebooted as queer. Two of the biggest examples of revisionist queering of superheroes occurred with the reintroduction of DC's Batwoman as a lesbian heroine in 2006, and the revelation in 2015 that Iceman of Marvel's perennially favorite team *The X-Men* is gay. As discussed in chapter 3, Batwoman was first introduced in 1956 as Kathy Kane, an heiress who moonlights at crime fighting but whose real purpose was to romantically pursue Batman and thus help defuse the accusations of homosexuality that were directed at the Dynamic Duo. Reintroduced fifty years later, the modern Batwoman is Bruce Wayne's maternal cousin, Kate Kane, an ex-soldier driven out of West Point because she refused to renounce her lesbian sexuality. Where once Batwoman served to ensure heteronormativity, she now challenges it as a confident, out-and-proud lesbian hero who has proved immensely popular with a wide range of audiences. Marvel's Iceman first appeared in 1963 in *The X-Men* #1 and has been one of the most popular mutant characters for over half a century. Always depicted as impetuous and a bit immature, Iceman / Bobby Drake had a reputation for being an aggressive flirt and a womanizer. But in a complicated storyline that sees a young Bobby transported to the present where he encounters an older version of himself, Bobby is forced to realize that he has always been gay but repressed his sexuality by overcompensating with pretenses of heterosexuality. Outing Iceman allowed the writers to explore his tentative steps in romantic encounters with men, first in the various X-Men titles and then in his own solo series.

The introduction of numerous new LGBTQ heroes and the sexual revisioning of several existing characters have altered the heteronormative presumptions of superheroes. Additionally, the genre has seen the sexuality of one of its most popular characters, Harley Quinn, evolve in response to plot points, fan desires, and changing cultural standards. Harley Quinn's first appearance in the DC universe was in 1992 in the award-winning television program *Batman: The Animated Series* (1992–1995). Harley's presence as "the Joker's girlfriend" served to negate the queer connotations of the flamboyant clown. Unfortunately, as will be discussed in chapter 8, the Joker/Harley relationship has consistently been both physically and emotionally abusive as the Joker mistreats Harley at every turn, yet she remains blindly devoted to him. But Harley's relationship with Poison Ivy has provided a safe alternative, with Ivy supporting Harley and repeatedly encouraging her to leave the Joker. The innuendo of being more than just friends has been recognized (and encouraged) by fans ever since the pair first teamed up in the episode "Harley and Ivy" in 1993 and has carried over into dozens of comic book iterations. Though Harley has carried on romantic relationships with a number of men other than the Joker, Ivy has been the constant in her life. The two women are often shown flirting, hugging, and kissing, and in 2015 the authors of Harley Quinn's solo series confirmed through DC Comics' official Twitter account that Harley and Ivy are "girlfriends without the jealousy of monogamy." In other words, Harley is bisexual and is free within the stories

to romance whomever she wishes regardless of gender or heteronormative expectations. In discussing the various ways Harley has been coded as bisexual, Alex Liddell argues that Quinn "shatters the notion that super powered protagonists need to be heterosexual and male with idealized morals, as she is none of these things and currently is one of DC Comics' best-selling characters" (2017, 103). In the comics, Harley is frequently depicted kissing both men and women without any stylistic differences between the kisses, though Harley's same-sex kisses are occasionally accused of pandering to an adolescent male audience with the kisses framed as titillating girl-on-girl action. For example, *Harley Quinn* #25 (2017) portrays a heartfelt reunion between Harley and Ivy, but it includes two supporting male characters (as proxies for the readers) who look on in awe and delight. Interestingly, the romantic relationship between Harley Quinn and Poison Ivy is openly foregrounded in comic book series like *DC's Bombshells* (2015–2017) and *Injustice 2* (2017–2019), and in the HBO GO cartoon series *Harley Quinn* (2019–ongoing).

The marked increase in gay, lesbian, and bisexual characters in superhero fictions has been an important development born from the success of LGBTQ Rights and Awareness political movements. The fact that so many queer people have been introduced in both the Marvel and DC universes as not just background or supporting figures but outright superheroes is a huge step in overcoming the way nonheteronormative characters have been mistreated or marginalized in the past. Moreover, nonheterosexual superheroes are being treated the same as heterosexual heroes in romantic matters, particularly in the comics. Nearly identical narrative and visual strategies used to reinforce heteronormativity through superhero romance are now utilized to portray same-sex romances as similarly normal. While queer relationships, and the formal recognition of them, are not *exactly* on par with heterosexuality yet, they are increasingly subjected to the same formulas and conventions that are taken for granted in heteronormative depictions.

Romantic and physical affection between same-sex characters was once explicitly forbidden by the Comics Code of America, established in 1954 following Fredric Wertham's accusations of rampant homosexuality in comic books. As Easton and Harrison argue in their historical account of superheroes, "Wertham's homo-panicked diatribe is part of a larger pattern in postwar culture to secure specific formations of white, middle class, heterosexual masculinity as the sanctioned norm of male behavior" (2010, 137). But cultural perceptions have changed a great deal since the 1950s, and while heterosexuality may still be regarded as a "norm of male behavior," it is not as exclusively or as diligently enforced in current stories. In fact, the once-forbidden same-sex kiss has become standard in modern superhero comics. Same-sex kisses have become such a regular feature that they are no longer newsworthy. Instead, most of the kisses are treated as spectacular only in the same sense that the clinches between Batman and Catwoman, or Daredevil and Elektra are spectacular. For example, the kiss

between Teddy and Billy (a.k.a. Hulkling and Wiccan) (figure 5.4) in *Avengers: The Children's Crusade* #9 (2012) is preceded by a full page of flirty banter between the couple as they get closer and closer to each other in the frames. Just as this narrative and visual convention serves as symbolic foreplay for the heterosexual couples, it likewise provides a natural buildup to the big kiss. Their dialogue also presents them as a normal couple with the same fears, doubts, hopes, and dreams as any other young couple in love. Teddy tells the depressed Billy, "I know that life is way too short for you to be sitting here wasting yours. And mine." Glumly, Billy asks, "Are you breaking up with me?" "And give you another reason to sit in the dark doing nothing?" Teddy replies. "Sorry, Kaplan. You're stuck with me. Till death do us part." Shocked by the phrasing, Billy hopefully asks if that was a proposal, and Teddy teases that it depends on whether he is going to get over his depression. When Teddy and Billy do kiss on the following page, it is treated as romantic, significant, and entirely normal. The borderless image of their kiss takes up the majority of the page and is devoid of any distracting background images. The kiss is what matters, not the sexuality. Likewise, the lesbian kiss between Nico and Karrie (figure 5.5) featured in *Runaways* #12 (2018) is preceded by a two-page spread of them slowly getting closer to each other until they just can't resist. Their kiss is spectacular and romantic, an enlarged image without border lines and nothing but stars in the background. Importantly, these two examples are not anomalies or exceptions; dozens of same-sex kisses are treated this way. All of the symbolic weight accorded to the heterosexual kiss as a momentous, natural, and inevitable event is now also ascribed to the homosexual kiss. By using the equivalent narrative conventions and artistic techniques that reify heteronormativity via superhero romance, these same-sex kisses help establish a conception of homonormativity as well.

Billy and Teddy discussing the possibility of getting engaged in *Avengers: The Children's Crusade* #9 in early 2012 preceded the first same-sex superhero marriage in a Marvel comic by only a few months. In June 2012, Marvel's Jean-Paul Beaubier, better known as the mutant hero Northstar, a veteran member of both Alpha Flight and the X-Men, wed his longtime boyfriend Kyle Jinadu in *Astonishing X-Men* #51. Amid the real-world debates about the legalization of same-sex marriage in America that dominated headlines in the early 2010s, Marvel's willingness to showcase a gay wedding was regarded as a bold and progressive move. Without ignoring the controversial political aspects of the wedding, Marvel still depicted the event in the same way it has presented heterosexual weddings. In the issues leading up to the wedding, Jean-Paul proposes to Kyle on bended knee, followed by a full-page kiss. A supervillain almost destroys them, but the attack serves only to confirm how much they love each other and want to make a permanent commitment. Northstar's outdoor wedding is a formal event held in New York City's Central Park with hundreds of guests. Dozens of superhero friends and teammates are in attendance, both in and out of costume. Jean-Paul and Kyle's union is publicly celebrated in front of the gathered

FIG. 5.4 *Avengers: The Children's Crusade* #9, 2012, Allan Heinberg and Jim Cheung

FIG. 5.5 *Runaways* #12, 2018, Rainbow Rowell and Kris Anka

witnesses and their vows are similar to the declarations of love voiced in all the heterosexual superhero weddings. "Kyle, I know how precious life is. And how fleeting. I will never take that for granted. I promise you that," says Jean-Paul. "And I know what a gift it is to have someone to share that life with," Kyle replies. "I promise to love you in good times and bad. I promise to inspire you." Jean-Paul says, "I promise to cherish you. I promise to be your home." Then the happy couple kiss, and in their reverie they end up floating in the air above all the cheering guests.

Northstar's wedding in *Astonishing X-Men* #51 (2012) received a significant amount of attention from the mainstream media. Predictably, commentary from Right-leaning news outlets was alarmist while Left-leaning coverage was full of praise. But Jean-Paul and Kyle's nuptials are not the only same-sex wedding to happen in the comics. In Wildstorm Publishing's *The Authority* #29 (2002), Apollo and Midnighter (queer analogues of Superman and Batman) exchanged vows formally in front of their colleagues on the deck of an interdimensional spaceship. And though the wedding was undone when Wildstorm was purchased by DC Comics and rebooted in "The New 52" initiative (2011), Apollo and Midnighter are still a romantic couple. *Batgirl* #45 (2015) featured the wedding of Barbara Gordon's best friend and roommate Alysia Yo (who also happens to be transgender) and her girlfriend Jo. Wonder Woman officiates a wedding between two women in *Sensation Comics Featuring Wonder Woman* #48 (2015). When Clark Kent comments that he did not know she was a proponent of gay marriages, Wonder Woman replies, "Clark, my country is all women. To us it is *not* 'gay' marriage. It's just marriage." And, though the wedding itself is not depicted, the comic book *Injustice 2* #70 (2018) reveals that in the universe based on the *Injustice* video game, Harley Quinn and Poison Ivy were married by an Elvis impersonator in Las Vegas. Same-sex weddings may not have caught up to heterosexual ones yet in superhero comics, but their increased visibility is helping to normalize a much wider range of sexualities than ever before. Moreover, as some same-sex couples become more iconic and enduring across reboots and parallel universes, the impression that pairs like Harley and Ivy, Hulkling and Wiccan, and Apollo and Midnighter are destined to be together will increase.

Left at the Altar

The serial format of comic books and the melodramatic tendencies of the narratives often work together to create an element of soap opera with superheroes. And, like televised soap operas, weddings serve as special moments of celebration and drama. Also like soap operas, some comic book weddings fall through at the last moment. Catwoman does not meet Batman for their scheduled rooftop wedding in *Batman* #50 (2018), leaving the Caped Crusader even more grim and gritty than before. And in *X-Men Gold* #30 (2018), Kitty Pryde literally "ghosts" her groom Colossus at the altar as she uses her mutant powers to phase through

the ground when she gets cold feet during the vows. But even these two recent examples of failed weddings do not undermine the concept of an inevitable romantic union between two characters fated to be together. Batman and Catwoman work through their respective heartbreak, depression, insecurities, and feelings of guilt to repair their relationship (and to defeat the villain Bane together). After a year of turmoil, the couple quietly and privately wed in *Batman* #85 (2019). Love also ultimately wins out in the X-Men as the longtime couple Gambit and Rogue decide to make use of the officiant and all of their gathered friends by getting married in Kitty and Colossus's place. Moreover, shortly after leaving Colossus at the altar, Kitty tells him that she does love him with all of her heart; she just worried that they were getting married on shaky ground. But the very next issue features an adventure set in the future where Kitty and Colossus are older but clearly still in a relationship, and she is pregnant with their child. Always destined to be together despite a failed wedding ceremony.

Unfortunately, the superhero marriage that was scuttled by publishers rather than for narrative reasons was the intended wedding between Kate Kane (Batwoman) and Gotham City police detective Maggie Sawyer. *Batwoman* #17 (2013) pleasantly surprised fans and critics when Kate proposed on the last page of the issue. The Gay and Lesbian Alliance Against Defamation (GLAAD) award-winning series had already made enormous strides in representing nonheteronormative characters by providing Kate Kane with a complex personal life and exploring her sexual history with women. The same-sex proposal represented a first at DC Comics and suggested a willingness to be more progressive regarding sexuality with a character linked symbolically and narratively to the company's most profitable character, Batman. After the excitement of the engagement died down, the editors at DC informed *Batwoman* coauthors J. H. Williams and W. Haden Blackman that Kate and Maggie would not be permitted to get married. DC claimed that its heroes needed to remain unmarried in order to focus on their adventures unencumbered by family responsibilities, rather than the decision having anything to do with Batwoman's lesbian identity. Disappointed with the editorial restrictions, Williams and Blackman quit the series. With queer characters and relationships only beginning to flourish in superhero comics, the inability to see Batwoman's engagement through to a wedding was particularly disappointing and easy to understand as a political decision. Eventually, as queer characters become more common and normalized within the genre, engagements (successful or not) will become more commonplace.

The unfortunate decision to scuttle the same-sex marriage of Kate Kane and Maggie Sawyer in *Batwoman*, and to subsequently break the couple up altogether, is especially narrow-minded given the genre's willingness to explore unconventional romantic relationships through analogy. Even before the interracial marriage of Luke Cage and Jessica Jones occurred in Marvel's *The Avengers* in 2006, comics had featured long-term romances between humans and aliens (for

example, Professor Xavier and Shi'ar empress Lilandra Nerami, Alicia Masters and the Silver Surfer, Nightwing and Starfire), and between humans and monsters (for example, Abby Arcane and Swamp Thing, Liz Sherman and Hellboy, Madame Xanadu and Etrigan). Certainly, if superheroes are open to marrying orange-skinned alien princesses or literal demons from Hell, a human lesbian marriage should not be too shocking. The following chapter builds on the significance of romance and marriage among superheroes as a normalizing event taken to an extreme with robotic characters. The signs and rituals of love are used to demonstrate humanity on a level that is supposedly beyond the mere desires of the flesh.

6

Even an Android
Has Feelings

■■■■■■■■■■■■■■■■■■■■■■

Learning about Love
and Robots

> Scarlet Witch: That *something* inside
> you—was your soul.
> Vision: My soul? But—I am an android!
> I do not possess a soul!
> Narration: She presses her lips to his, and
> that is answer enough!
> —*Marvel Team-Up* #42 (1975)

> You put off Cap to snog a robot?! My god,
> man! At least call in the rest of the
> mighty Avengers!—One-Eyed Jacquie
> —*The Mighty Avengers* #35 (2010)

Thanks to thousands of pop songs, romantic movies, books, and television series, love remains one of the most powerful, but still the vaguest, of cultural beliefs. The ideology of love is a defining principle for society despite being difficult to define, even by the poets and musicians. "All you need is love," claimed two of the twentieth century's greatest philosophers, Lennon and McCartney. Without any clear definition of what love *is*, they still concluded, "Love is all you need."

Our shared (and sometimes conflicting) beliefs about love influence our interpersonal relationships, our families, our legal unions, our religious systems, and our self-conceptions. What exactly love means can vary drastically from person to person, but in general, Western culture presents an understanding of love as the most powerful of emotions, almost magical or divine in nature, a form of destiny, a meeting of two complementary souls, eternal, monogamous, unconditional, and able to overcome all challenges. Though everyone has a sense of these romantic qualities of love, rarely are individuals taught the rules of love directly. We learn through enculturation and socialization, we see it modeled by people in our lives, and we observe it in our entertainments. Superhero stories demonstrate a very specific conception of romantic love, made all the more influential by the fact that the characters are cultural ideals, supposedly perfected men and women who are powerful, altruistic, and always the good guys. Iconic romantic couples like Superman and Lois Lane, Spider-Man and Mary Jane Watson, or Batman and Catwoman implicitly present a very dramatic approach to love. As the previous chapter addressed, audiences learn the rituals of romance by witnessing scenes of infatuation, courtship, first kisses, weddings, and happily-ever-afters as part of the historical process for normalizing heterosexual relationships, and more recently for naturalizing homosexual relationships. This chapter is concerned with how the genre has articulated the abstract concept of love through the use of robotic superheroes, and how love is portrayed as inextricably bound to perceptions of gender, sex, consciousness, and free will.

Though love is a relatively ambiguous concept and an emotional state perceived in a variety of ways, it is granted a cultural preeminence as the most important and the most human of emotions. In superhero stories, as in science fiction and other entertainments more broadly, love is characterized as an almost magical force. More than just an emotion, love can reach the level of being a superpower itself. Love can inspire superheroes to incredible heights, it can turn villains into heroes, it can bring people back from the dead, it can overcome time and space, and it can even birth entire worlds. At first glance, the idea of love as a compassionate, affectionate, intimate, and tender emotional extreme seems oxymoronic in a genre that revolves around spectacular physical battles. In the blockbuster movie *Wonder Woman* (2017), the Amazon princess may declare "Only love can truly save the world," but she is also a fierce warrior who never hesitates to draw her sword. Likewise, the Star Sapphire Corps, an offshoot of the Green Lanterns, derive their cosmic powers from the energy of love and seek to spread compassion across the cosmos—and they are more than willing to fight to the death to champion love as a way of life. In other words, wrapped up with all the thrilling adventures and fights is a message about the importance of love (romantic, platonic, and familial) as an ideal emotional truth. Superhero tales repeatedly present love as so powerful that even an android can be overwhelmed by it.

Sentient, anthropomorphized robots with incredible powers are a common character type in the fantasy worlds populated by caped crusaders. These robotic

superheroes allow the genre to flirt with philosophical themes about free will, creation, and the existence of a soul. As their superhero names suggest, these robotic wonders traverse the gap between being man and machine: the Metal Men, Robot Man, Machine Man, and M-11 "the human robot." In addition to these robots, figures like Red Tornado, Indigo, Amazo, Jocasta, the Vision, and his daughter Viv Vision function as blank slates curious about the peculiarities of humanity and the intangible experience of emotions, particularly the concept of love. The seamless integration of sentient robots who fight for justice along-side both Marvel's and DC's greatest heroes provides an easy narrative device for the genre to blatantly talk about the importance and the meaning of love. In vary-ing degrees, each of these sentient super robots becomes involved in a romantic relationship with a human partner. Perhaps the most famous of these human/ robot romantic relationships is the one between the Vision and Scarlet Witch of Marvel's Avengers. The two have been depicted as a couple in the comics since the 1970s, from dating, to marriage, to having children and living in the sub-urbs. The Vision and Scarlet Witch romance has reached a much wider audience in recent years through *The Avengers* movies and the *WandaVision* series on Dis-ney+. Similarly, DC Comics' Red Tornado is married to a human woman and is father to their adopted daughter. Scientist Hank Pym, the original Ant-Man, has been in a romantic relationship with the robotic Jocasta. The shapeshifting Platinum of the Metal Men openly pines for Dr. Magnus, the man who inven-ted her. Robot Man is in a relationship with his Doom Patrol teammate Crazy Jane. And, the Vision recently built his own teenage daughter, Viv Vision, who is confused about her sexuality and experiments romantically with both her male and female teammates in the Champions.

Though robot heroes are completely android (as opposed to the numerous part-human/part-machine cyborgs that also populate the ranks of superheroes, such as DC's Cyborg or Marvel's Deathlok), they are just as thoroughly gendered as their human teammates. Explicitly gendered mechanical bodies are not unique to the superhero genre; it is a trope that occurs in film, television, advertising, and real-life robotics. The image of Arnold Schwarzenegger as the titular robot in *The Terminator* (1984) is characterized by Michael A. Messner in his analysis of Schwarzenegger's media-constructed masculinity as "an unambiguously vio-lent male-body-as-weapon" (2007, 467). In contrast, the feminine figure of Ali-cia Vikander as the robot Ava in the film *Ex Machina* (2014) manipulates the men around her thanks to what Sophie Wennerscheid describes as "her very sexy body, her expressive eyes and hands, her smartness, and last but not least thanks to her frailty" (2018, 42). Even when the figures remain obviously mechanical, as with the Transformers, there is still a stark contrast between the masculine eighteen-wheel truck that turns into Optimus Prime and the curvy pink-and-white sports car that changes into Arcee. In her analysis of robotic bodies in sci-ence fiction film, Despina Kakoudaki argues, "While ostensibly beyond or outside gender categories because of their inorganic status, mechanical bodies

nevertheless refer to a visual and narrative vocabulary that is exaggerated in its depiction of gendered humanity" (2014, 81). In fact, Kakoudaki also points out that rather than being treated as asexual machines, "the presence of technological or mechanical imagery indeed accentuates the stereotypical gendering of artificial bodies, with artificial men presented as strong silent types and artificial women as oversexualized, idealized depictions of a perfect woman, perfect wife, or perfect sexual slave or, alternatively, as phallic and dangerous, mechanical pin-ups that fuel new types of fetishism" (82). The superhero genre, a genre already obsessed with extreme depictions of masculinity and femininity, repeats and extends the gendering of robotic characters that has been established in other media forms.

Modern superhero robots are typically streamlined and metallic, usually polished to an incredible shine, their forms imitating the standard ideal muscularity favored for super men and the curvy sexual extreme required of wonder women. The robots are nearly identical to their human counterparts: the males all have strong, square jaws and bulging muscles, and the women all have pretty faces and flowing metallic hair. The shiny surface of their bodies doubles for the typical skintight costumes that show off the heroes' ideal forms. Where Superman's, Batman's, and Captain America's costumes look spray-painted on, with every rippled ab and defined pectoral muscle clearly visible, the robots are essentially naked and metallic versions derived from the same mold. Given the generic tradition of displaying female bodies in revealing costumes and erotic poses, it is not surprising that the robots gendered feminine are more explicitly depicted as essentially naked. The nude-looking female robot in popular culture is a trope that goes back at least as far as the iconic figure of the mechanized "Maria" from Fritz Lang's film *Metropolis* (1927), through to Soyarama's famous paintings of shiny metal pinups and centerfolds in the 1970s and 1980s, and continues in current video games like *Mass Effect 3* with the sexy character EDI. The relative absurdity of naked-looking female super robots in comic books has even become the subject of some ridicule within the stories themselves. In *Marvel Zombies 3* (2008), for example, the newly "woke" Robot Rights activist Machine Man tells Jocasta, "A more modest outfit wouldn't hurt you, you know! I mean, everyone can see *everything!*" She replies, "Who cares what they see? I'm a robot!" "Exactly," Machine Man snaps back, "not a '*ho*-bot!'" When Jocasta later becomes a regular supporting character in *Tony Stark: Iron Man* (2018–2019), she has begun to wear women's business suits for her new office job. There is no logical reason for super robots to replicate the ideal bodies of super humans. They are not exact simulacrums, their shiny metal-looking bodies deny the appearance of human flesh. The uniformly metallic look of the robots sets them apart, but the gendered bodies foregrounds the importance of sexual signifiers. The robots are not trying to pass as human, nor do their curvy or muscular forms help with their incredible powers (nor do they need to be embodied by human actors, as in the

movies). The humanoid form merely facilitates another opportunity for the genre to emphasize the spectacle of gender.

The use of gendered robots to visually reinforce the extreme forms of masculinity and femininity in superhero stories, both physically and behaviorally, is commonplace. For example, the cover for the first issue of the playful alternate universe tale in *Marvel Zombies 3* is an homage to the movie poster for the cult film *Army of Darkness* (1992), itself inspired by countless pulp paperback covers featuring heroic barbarians and most associated with the artists Frank Franzetta and Boris Vallejo. The stock image of a muscular, heroic male holding a weapon and standing atop a pile of his fallen enemies, while a buxom woman in need of protection clings sexily to his leg, has been recycled endlessly from *Conan the Barbarian* and *Star Wars* to *National Lampoon's Vacation* and *The Simpsons*. While this image of the muscular Machine Man standing over fallen zombies, his hands morphed into giant weapons, with the buxom Jocasta grasping his leg is a moment of tongue-in-cheek self-awareness, it does demonstrate the adherence to retrograde gender norms that even robots conform to. In a more straight-face manner, DC Comics' the Metal Men (figure 6.1) have always typified the mechanical superhero form. The team of shape-shifting robots first appeared in the 1962 comic *Showcase* #37 and have headlined several series and miniseries and made numerous guest appearances over the years. The team was created by, and works for, the pipe-smoking Dr. Will Magnus. The Metal Men consist of five male characters and one female character, each named for the specific metal they were crafted from. In addition to gender extremes, the Metal Men also reflect a range of implied racial and class stereotypes. Gold is the handsome, smart, Aryan-looking team leader; Lead is the broad-set and dim-witted robot with a working-class accent; Iron is heavily muscled, with a black-and-blue surface suggesting an African American image; Tin is smaller, cheaper, and insecure, a sometimes painful representation of a mensch; the red-hued Mercury is sleeker, mean-tempered, and (along with Tin) usually employed for comic relief; and the almost blindingly white/silver Platinum (a.k.a. Tina) is the lone female, forever trying to win Magnus's attention and his affection.

In terms of gender, robotic superheroes consistently reconfirm the genre's central preoccupation with traditional ideals of muscular men and beautiful women. The importance of exaggeratedly gendered bodies as the only acceptable form, even for robotics, is perhaps most apparent when the genre gender swaps mechanical characters. The ability to move the essence of a person into another body is a common narrative device used in superhero adventures. The following chapter will consider the ways sexuality is affected by body swapping in relation to trans metaphors. Here, however, I want to clarify that any gender fluidity suggested by changing the identity of the robots is negated through the mechanical form they are depicted as. Marvel's Vision is routinely depicted with a defined muscular form, reflective of his masculine identity. Similarly,

FIG. 6.1 *Justice League* #28, 2014, Geoff Johns and Ivan Reis

DC's Red Tornado is illustrated with a sleek but muscular form. Both characters may have synthetic bodies with an array of wires and mechanical pieces as internal organs, but their artificial forms still have defined pectoral muscles, six-pack abs, and bulging biceps. Vision and Red Tornado have each been reimagined as female characters in alternative stories set in parallel universes where the alternate female identity necessitates a corresponding physical change. In the 2006–2007 miniseries *Ultimate Vision*, Marvel's most iconic synthezoid is reintroduced as a curvy female artificial life form, looking a lot like the famous robot Maria from the classic Fritz Lang film *Metropolis* (1927) crossed with a modern *Playboy* centerfold. Likewise, the Red Tornado of DC's Earth-2 universe is animated with the spirit of Lois Lane starting in 2012. But as a female-identified robot, Lois Tornado's form is sculpted with an hourglass figure, long legs, and prominent breasts. Interestingly, the male versions of Vision and Red Tornado have always been bald, and that particular look is carried over into both of the female versions. Any relative gender neutrality implied by the baldness of these female characters is negated by the prominence of their overall sexualized appearance. Hair and skin may be optional, but large breasts and plump lips are a necessity to evidence the gender in a manner deemed appropriate by superhero stories.

Robotic Wonder Women

The sexualized physical depiction of Platinum in every version of the Metal Men and her insistent attempts to win Dr. Magnus's love are typical of the fetishistic implication of most female robots in popular culture. Moreover, like other female super robots, Platinum has incredible powers that mark her as a combination of the robotic types Kakoudaki describes above as a "perfect sexual slave or, alternatively, as phallic and dangerous" (2014, 82). Platinum, as well as Jocasta, Indigo, and Viv Vision, combines these possibilities that science fiction insists on for feminine robots. They are both sexual objects *and* dangerous, phallic women. Elsewhere, I have discussed the importance of artificial or gynoid women in relation to action movies as symptomatic of the masculine desire to control women and their sexuality (Brown 2011). There I argued that robotic women were an extreme, but not wholly different, device that allowed men to enact a fantasy of desirable women completely under the man's control: ideal women incapable of rejecting them, who are willing to do whatever the men want, who are, in other words, pure sexual objects. As Jon Stratton reasons about the long-standing appeal of fictional robotic women in contrast to real women:

> Manufactured by men, the production of the gynoid literalizes the fetishistic reconstruction of the female body. However, the female body has an existence prior to its taking-up within the fetishistic structure, and where the female body is inhabited by a "woman" capable of resistance to her fetishistic

interpellation, the gynoid is able to occupy more fully the role of libidinized phallic fetish. As an oftentimes indistinguishable or even "improved upon" substitute for a woman, the gynoid retains the sexual quality as a "woman" of being an object of heterosexual male desire whilst, in addition, being the site of an overdetermining fetishistic desire. From around the middle of the nineteenth century gynoids are preferred, and are both more desired and more feared, than the women for whom they substitute.

(2001, 210)

A similar, Pygmalion-like scenario of men creating their own idea of the perfect woman is also in play with robotic superheroines. Unlike movies, however, the long-running and serial format of comic book adventures allows the fetishism of robotic women to address emotional concerns about love as well as the obvious sexual implications.

At DC Comics, Platinum's romantic infatuation with her creator, Dr. Will Magnus, has been her defining character trait since the team's very inception. From the Metal Men's earliest adventures in the 1960s to their current incarnations, Platinum constantly tries to persuade Magnus to reciprocate her feelings. But her efforts have always been met with a cruel indifference by the doctor. For instance, in *Metal Men* #8 (1964) Magnus tells Platinum to behave more like a robot and less "like a chattering female" and that her feelings are just an illusion. "I dare you to tell me *this*—tastes like an illusion!" Platinum purrs as she kisses Magnus. But he just wipes his lips and says, "No, it tastes like being smacked by a cold, wet platinum bracelet!" And in *Action Comics* #590 (1987) Platinum seductively wraps herself around Magnus and whispers in his ear, "I suppose you're going to start up again insisting the way I *feel* about you is 'programming' too!" "Yes. Yes, it is, Tina," the doctor replies sternly, "and faulty programming at that!" The heartbroken Platinum storms off. "Will Magnus, sometimes you can be such a *beast!!!*" As the Comics Code restrictions established in 1954 eventually gave way in the early 2000s, Platinum's flirtations became more explicit. By *DC Comics Presents: The Metal Men* #1 (2011), Platinum sneaks into Magnus's room and is waiting in his bed, her shiny surface shifted into an extremely short negligee (figure 6.2). Magnus yells at her to get out, but Tina seductively protests, "But there are things *I* can do that no flesh-and-blood woman ever could!" The doctor has to carry her from his room to deter her.

As the only female member of the Metal Men, Platinum is yet another example of the "Smurfette Principle" (see Brown 2015) in popular entertainments where a token woman on a team of men is representative of feminine qualities in total. The five male robots that make up the Metal Men, as well as Dr. Magnus, allow masculinity to reflect a range of characteristics including intelligence, strength, loyalty, and determination. But without other women on the team, Platinum represents femininity as a singular type, and that type is decidedly sexual in nature (along with a bit of flightiness, superficiality, and vanity). Tellingly,

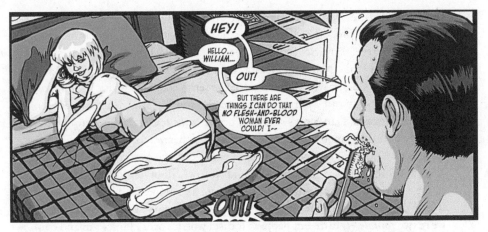

FIG. 6.2 *DC Comics Presents: The Metal Men* #1, 2011, J. M. DeMatties and Kevin Maguire

Platinum's lovelorn personality is only ever directed at Magnus, the person responsible for her programming—a programming that Magnus repeatedly chastises her about but never actually alters. In *Legends of Tomorrow* #3 (2016), for example, Tina catches Magnus after he is knocked out of a flying saucer: "Easy, Doc darling. I've got you!" "Thank you, Tina," Magnus replies, "but would you please stop calling me darling? You're a machine. You can't feel love." Unperturbed, Platinum responds, "Tell that to my poor pining responsometer, you gorgeous hunk of man-meat." The frustrated doctor complains, "Remind me to *reprogram* you later." Over the years it is revealed that Magnus's invention of the magical *whazzits* called the "responsometers" is the device that brings the Metal Men to life and determines their powers and personalities—their souls. At various times Magnus stresses the internal responsometers are the heart and soul of the Metal Men. In the most recent iteration of *Metal Men* (2019–2020), written by Dan Didio and illustrated by Shane Davis, the story confirms the obvious: that Dr. Will Magnus created Platinum to look like his ideal woman and programmed her with an overwhelming sense of love for him. In an unnerving twist, Platinum discovers she is physically modeled after a real woman whom Magnus was obsessed with in college but who rejected him as a creep. Decades of previous stories that implied Platinum's love for Magnus was genuine are recontextualized. Her perception of love has been based on his sadistic programming and his twisted desire to reject a woman who dismissed him.

Similar themes have been addressed in the Marvel universe with the robotic Jocasta, who was introduced in *The Avengers* #162 (1977). Jocasta was created by the evil robot Ultron (who, in turn, had been created by the Avenger Hank Pym, a.k.a. Ant-Man) to be his mechanical bride and aid in his subjugation of mankind. Ultron brainwashed Hank Pym to transfer the "life essence" of Pym's wife, Janet van Dyne (a.k.a. the Wasp), into the robotic body of Jocasta. Over numerous adventures Jocasta repeatedly betrays Ultron, thanks primarily to the

influence of Janet van Dyne's presence inside her robotic systems. Jocasta becomes an on-again, off-again member of the Avengers and a regular presence across the Marvel universe. In 2009 a new version of Marvel's signature super team, led by Hank Pym and Jocasta, debuted in *The Mighty Avengers* #21, written by Dan Slott, which lasted until the series concluded with issue #36 in 2010. During this run a serious romantic relationship was depicted between Hank and Jocasta. Dan Slott's storyline begins with Jocasta going through the recently deceased Janet van Dyne's mementos as her voiceover narrates, "I am *not* Janet van Dyne. I am Jocasta. A robot who, years ago, was programmed with Janet's brain patterns. I share her joys and sorrows, all of her feelings, but none of the experiences that forged them. Those were hers alone. And her story is now over. I'd like to think that Janet lives on in me, in some fashion, even though we're two *completely* different people." Jocasta worries over Hank Pym and considers rubbing his neck in the way she knows he likes, but decides that would be inappropriate. She asks Hank about his love for Janet, and if hitting her had been a sign of affection? (see chapter 8 regarding Hank's domestic assault of his wife). Hank is shocked and explains that he loved Janet "very much, more than anything" and that striking her "was wrong. It was the worst thing I've ever done." As the story progresses over the next few issues it becomes clear that Jocasta is devoted to Hank, even though he treats her as a servant (or a tool) and threatens her with things like erasing her sentimentality programming.

Interestingly, Dan Slott employs the Avengers' only nonsuperhero character, Jarvis the butler, as a concerned observer of Hank Pym and Jocasta's burgeoning romantic relationship. In the second issue of Slott's run *Mighty Avengers* #22 (2009), Jarvis interrupts Hank performing some maintenance on Jocasta, which he seems to mistake for intercourse. "My word. Excuse me. I . . . ," Jarvis stammers when he sees Jocasta with her legs spread and pulled up on a table while Hank uses a soldering gun on her. "Oh! Jarvis!" Jocasta exclaims as she tries to cover up. The illustration of the scene only confirms the sexual nature of the act Jarvis interrupted. The bright light from Hank's soldering tool appears to be coming from between Jocasta's legs, which is a visual convention used in comic books to signify orgasm (see chapter 9). At the start of issue #26, Jarvis again walks in on Hank and Jocasta, this time they are locked in a passionate kiss. "Oh, my!" Jarvis whispers in surprise. Later in the same book, Jarvis tells Jocasta, "It's inappropriate. You possess the brain patterns of his late ex-wife. And worse, Dr. Pym created Ultron, the robot who, in turn, created you. If you kiss Dr. Pym, it's akin to kissing your grandfather." Then, to Jarvis's shock, Jocasta flatly replies, "Actually, Edwin, in the circles I travel within the robotic community, Hank is seen as the creator of modern Artificial Intelligence. So, when I *do* kiss him, it's more like I'm kissing God." Their unconventional relationship continues until the end of the series when Jocasta learns that Hank's attention to her is part of his larger plan to bring Janet back to life. The furious and heartbroken

robot even strikes Hank in a tribute to the infamous moment when he had struck his wife years ago in *The Avengers* #213 (1981).

DC Comics' Platinum and Marvel's Jocasta are each unique and long-running robotic characters that have been written and illustrated by a number of different creators. Moreover, they have both been revised, rebooted, and re-created several times. Yet, despite their different personalities and powers, the modern depictions of both Platinum and Jocasta share narrative themes about robotic wonder women that reflect the genre's characterizations of love and sexuality. Both are presented as hypersexualized and hyperfeminized mechanical bodies. Both Platinum's and Jocasta's personalities and minds are patterned after the essence of a specific real woman, a woman whom the male scientist/creator loved and was rejected by. Both love the scientist responsible for their creation with a devotion that borders on worship, even if he is repeatedly cruel to her. Both look to their creator for an understanding of love as an authentic emotion. And both ultimately reject their male creator when they realize they have been manipulated.

Female robots are portrayed as longing for the truth of romantic love. Characters like Jocasta and Platinum feel love as an emotion but worry that it may not be real or authentic. Their concern is predicated on insecurities about their free will. Of course, being insecure about the status of love in a romantic relationship is not restricted to robots. Everyone worries about the truth or realness of their emotions and those of their loved ones. These general and very human insecurities are displaced via super robots into questions about the origin of their loving feelings. Is there a truth to love or were they merely programed that way? In *Metal Men* #6 (2020), when the Nth metal alien offers to liberate Platinum from Dr. Magnus's control, she initially protests: "I feel nothing but *love* for Magnus and there is no truer emotion. Everything I feel is *real*. What Will and I have together is *real*, too." But after Tina discovers that her feelings are a lie created by Magnus, and that she is based on a woman who scorned him long ago, she asks Nth metal to change her. At Marvel, Jocasta believes in her ability to love Hank Pym as an act of her own volition and free will. Before Jocasta first kisses Hank in *Mighty Avengers* #26, she tells him, "Because of *you*, I believe in the impossible." But in issue #36, Jocasta learns that Hank has been manipulating her, using her as an unwitting beacon to gather Janet van Dyne's scattered atoms from an alternate realm. "This was all—this was for Janet?" Jocasta cries, before her despair turns to anger. "You *USED* me!" Jocasta screams as she knocks him across the room. "Like I was a spare sprocket or wingnut! Like I was just some *thing*! That's all I've ever been to you, isn't it? You arrogant, little fleshbag!" When one observer worries Jocasta has gone "evil-robot on us," another replies, "Quite the opposite, luv. That response was all too human." The situations with Platinum and Jocasta reveal a continued Pygmalion-like cliché of curvy female robots designed for the gratification of men. As simply some *thing*. They also

perpetuate a gendered stereotype of women as lovelorn romantics, innocently manipulated by men, who then become furious scorned women. Moreover, it is the recognition that any sense of free will was just an illusion—particularly in regard to the love they felt so passionately—that is treated as the greatest offense.

The most recent robotic woman to become a fan favorite superhero is Viv Vision, the teenage daughter of the Avengers' mainstay Vision (whom we will return to below). Making her debut in 2015, Viv became a founding team member for the young superhero series *Champions* (2016–ongoing). The pink metal and green-haired Viv is less physically fetishized than most robotic women because she is an adolescent. Viv's breasts, hips, and legs are less exaggerated, and she is always illustrated wearing normal clothes rather than walking around essentially naked and shiny like her predecessors. Though Viv Vision is not treated as an erotic spectacle for readers, her sexuality is still a primary concern in many of the storylines. Unlike Platinum and Jocasta, Viv has not had her romantic interests precoded into her operating system by a male creator. In fact, Viv is portrayed as questioning her sexuality and experimenting with who she is attracted to. In *Champions* #2 (2016), after their first adventure, the team takes a break around a campfire to get to know each other, when Sam Alexander (a.k.a. Nova) asks Viv who her first kiss was. As she informs the group, "I have not yet experienced a romantic kiss. But I am curious as to how it might affect me biochemically." Viv leans closer to Nova, but the two are interrupted before their lips meet. By the end of the issue, the team discovers Viv making out with the teenage Hulk (Amadeus Cho) in the woods. But she informs the team that the kiss did not affect her neural receptors significantly. "Perhaps," Viv says as she glances at Ms. Marvel (Kamala Khan), "I should try a different *gender*." Viv's freedom to experiment with her sexuality implies a level of free will not often granted to robotic women. As she explains to Hulk in issue #8 when he asks if they can try kissing again, "Amadeus, I have been analyzing my feelings surrounding that moment for some time now. Similarly, I have been processing the emotional effects of various other stimuli. And while I have yet to thoroughly acquaint myself with a full enough sampling of sexual and gender identities to as yet determine my own—an attraction to boys is nowhere within me. I do not wish to injure your feelings." Viv is refreshingly uncertain about love and sexuality. Her character development avoids any absolutes or suggestions of a fated, all-consuming, and overwhelming love.

Viv's questioning not only allows her to explore her potential desires but also is used by the writers to illustrate some of the unspoken rules about physical attraction that need to be unpacked for many young readers (and plenty of older ones too). Just having free will does not mean that a person knows what they want or how to get it. Viv's recognition that "an attraction to boys is nowhere within me" leads to an interest in her female teammates. In *Champions* #27 (2018), Viv impulsively kisses Riri Williams (Ironheart) in the hallway of their headquarters (figure 6.3). Stylistically, the kiss is framed according to the visual

FIG. 6.3 *Champions* #27, 2018, Jim Zub and Max Dunbar

conventions used for most momentous kisses in comics, as discussed in the previous chapter. But where most superhero kisses are treated as spectacles of true love and the climax of romantic tensions, Viv's kiss is depicted as an unwelcome advance. "Viv! What the hell?!" Riri says as she pushes the android away. "Look, you're a really good *friend*, and you saved my life, but I—." Viv immediately apologizes and leaves Riri alone. In the next issue, the first in the *Champions* second volume, Riri is concerned that Viv is acting as though nothing happened. "Oh, do you mean when I pressed my lips against yours," Viv asks, "indicating an attraction that desired reciprocation?" Riri tries to explain: "You can't just go around kissing people! . . . I mean, kiss whoever you want, I'm all for that. But you, you have to make sure the other person wants it too! . . . You never even asked!" The confused Viv asks if she can kiss Riri now, but a frustrated Riri walks away. However, by issue #10 (2019) Viv manages a heartfelt and honest apology that breaks through to Riri, who has been mind-controlled by a supervillain.

"Riri, I was selfish and impulsive," Viv admits, "so wrapped up in my own feelings that I did not consider yours. I care about you so much. I . . . I'm sorry." A few pages later, Viv adds, "I don't want to push you away with my affection." Writer Jim Zubb is able to use Viv's robotic naïveté to illustrate some basic sexual rules that apply regardless of a person's sexual orientation.

Robotic Super Men

Romantic relationships are treated in a different manner with masculine robotic superheroes. Platinum and Jocasta have been framed primarily as feminine objects who become problematic only as they approach subjectivity, and thus reject precoded ideas about love. Sentient male robots, on the other hand, have been depicted as modern Pinocchios, animatronic boys striving to become fully human. Rather than focusing on the erotic possibilities inherently suggested by a sexy robot woman, the robotic men are employed to explore human emotions through love, marriage, and parenthood. The most popular robotic characters for DC and Marvel were created, coincidentally, within two months of each other in 1968. Red Tornado premiered in DC's *Justice League of America* #64, and the Vision debuted in Marvel's *Avengers* #57. Both characters conform to the heroic mold of handsome and muscular male figures with an unwavering desire to fight evil and protect the public. They have each proved themselves to be important parts of their teams and have earned the respect, camaraderie, and friendship of their teammates. Moreover, both Red Tornado and the Vision have married human women and become fathers.

Despite Vision being a sentient robot (or a synthezoid as Marvel dubbed him), he managed to find love with Wanda Maximoff, a fellow Avenger known as the Scarlet Witch. The pair started an unconventional robot/human relationship in *Avengers* #91 in 1971, they were openly declaring their love for one another by issue #99 in 1972, and the two were wed in *Giant-Size Avengers* #4 in 1975. Indeed,

Vision and Wanda are one of the most famous couples in comics, a quality that has been transferred to the MCU's current live-action version of the characters. The unusual coupling of a robotic man and a flesh-and-blood woman may have seemed natural in a genre populated by aliens, gods, mutants, demons, and other fantastic beings, but it was also a useful metaphor for broaching the subject of discrimination and interracial romances that challenged traditional beliefs. In fact, Vision and Wanda's interspecies marriage predated the first interracial kiss in superhero comic books, which did not occur until 1977 between the white Iron Fist and the Black Misty Knight in *Marvel Team-Up* #65. The first interracial marriage was not until 1998 when the white hero Wally West (a.k.a. the Flash) married Korean American Linda Park in DC's *The Flash* #142. And the first same-sex superhero wedding was in 2002 when Apollo and Midnighter exchanged vows in Wildstorm Publishing's *The Authority* #29.

Ever since Marvel introduced the concept of mutant superheroes in 1963 with *The X-Men* #1, the fictional genetic category has served as an analogy for various groups subjected to discrimination and social inequalities. As P. Andrew Miller (2003) observes in his discussion of ambiguity in the X-men, an "important aspect of the X-Men is its series-encompassing theme of prejudice and bigotry. The X-Men and all mutants are often hated because they were born different from anyone else" (283). Ultimately, Miller summarizes, "mutants can be seen as metaphors for any number of minority or marginal groups" (283). Over the decades, mutants have been employed to represent a range of persecuted groups including ethnic minorities, Jewish and Islamic Americans, immigrants, and LGBTQ people. Echoing this, Ramzi Fawaz (2016) argues in his analysis of 1960s social progress in comic books, "By popularizing the genetic mutant as a social and species minority, the series [*The X-Men*] laid the foundation for reimagining the superhero as a figure that, far from drawing readers to a vision of ideal citizenship through patriotic duty or righteous suffering, dramatized the politics of inequality, exclusion, and difference" (144). Furthermore, Fawaz concluded, "the elasticity of mutation as a metaphor for a variety of embodied and cultural differences made it a potent popular fantasy for vitalizing Marvel Comics' cosmopolitan ethos at the level of both comic book content and public reception" (144–145). Similar to the efficacy of the "Mutant Metaphor" as a means to incorporate stories of social injustice and discrimination without stirring a backlash from groups concerned about liberal political politics infiltrating children's comics, the Vision and Scarlet Witch's interspecies relationship has been used to suggest the challenges faced by interracial couples. In their own miniseries *Vision and Scarlet Witch* (1982) and its follow-up (1985–1986), the couple move to the suburbs to pursue a normal domestic life, even conceiving twin boys with some help from Wanda's magical mutant powers. But the interspecies couple has troubles blending in and experience discrimination firsthand. During their time in suburbia they face stares and scorn, even bigots who try to chase them out of the neighborhood. And, in *Avengers* #252 (1986), while Vision and Wanda are

living at the team mansion in Manhattan, their home in New Jersey is burned to the ground by bigots.

Vision's status as an ethnic Other is addressed most specifically by Esther De Dauw (2020) in her analysis of the ways Vision has historically been framed according to expectations of whiteness, and more recently repositioned as a failed pretender to middle-class, white normality. De Dauw argues that Vision's humanity is linked to his alignment with a normative white heterosexuality: "From the very beginning, storylines focusing on Vision are concerned with his status as a man, both in terms of humanity and masculinity. This human masculinity is defined through performances of domesticity, reflecting hegemonic masculinity's inevitable enmeshment with heterosexuality in dominant American narratives" (128–129). In marrying Wanda, moving to the suburbs, and having children, Vision confirms both his humanity and his masculinity. Vision loves, supports, and defends his family, enacting an ideal of masculinity founded on paternal protectionism. It is through loving his wife and children according to a middle-class script of heteronormativity that Vision fully transcends his robotic form. He is recognized and praised as a masculine ideal for his marriage to the desirable Scarlet Witch and his ability to father children. "Her pregnancy serves as proof of Vision's masculinity" (133), reasons De Dauw, who concludes, "Vision's search for humanity is intimately connected to his masculinity, which is defined through his heterosexual relationship" (134). In the Marvel universe, Vision is most complete as a man, and as a human, when he prioritizes his romantic love for Wanda and his paternal love for his twin boys.

As a superhero couple since the 1970s, Vision and Scarlet Witch have been one of the most enduring and popular of comic book pairings. The romance between these characters has been reinvigorated in the MCU with the live-action portrayals of Wanda Maximoff as the mutant sorceress by Elizabeth Olsen, and the soft-spoken robot Vision embodied by Paul Bettany, in several of Marvel's feature films and their own spin-off streaming series, *WandaVision* (2020–ongoing). In the comics, however, Vision and the Scarlet Witch have been vigorously uncoupled. The birth of their twins was reframed as black magic with stolen demon souls and then erased from existence altogether. After a dangerous adventure, Vision was reconfigured without the ability to experience a full range of emotions, and so the relationship fell apart and the marriage was annulled. And, when Wanda had a psychic breakdown, she magically forced Vision to attack the rest of the Avengers, which also led to his being brutally torn apart by the She-Hulk in *Avengers* #500 (2004). After some hostilities, the couple's relationship has grown closer as a deep friendship in recent years, and the popularity of the live-action Vision and Scarlet Witch may eventually result in some type of romantic rekindling.

Though the Vision and Scarlett Witch romance is over (for now) in the comics, Vision's desire to understand humanity is still a central topic. Vision's interests in domesticity and ideas about familial love become the central themes in

Tom King's award-winning miniseries *The Vision* (2015–2016). In this pivotal story, Vision builds himself a new synthezoid wife, Virginia, based on the brain patterns of the Scarlet Witch. He also creates twin teenage children, Vin and Viv, who are an amalgamation of Vision's and Virginia's brain patterns, and thus their programming still needs to mature. The Visions move into a middle-class suburb of Washington, DC, where the kids attend high school and Virginia manages the house whenever Vision is away on a mission with the Avengers. As Vision and his family struggle to fit in with their neighborhood, they question and learn what it means to love and care for each other. Unfortunately, Virginia inadvertently kills a costumed villain who breaks into her home and attacks her children, and later becomes embroiled in the accidental shooting of one of the children's classmates. The Visions cover up these events out of fear that they will be misjudged as threatening and be disassembled. In the end, Vin is accidentally killed and Virginia commits suicide after murdering the robot responsible for Vin's death. Still, Vision and Viv try to carry on with the pretense of being a normal family. De Dauw (2020) argues that Vision's failure in this series to create a sense of mundane suburban family life (despite having carefully manufactured all of the necessary simulacrum—wife, two kids, white picket fence, even a robotic dog) indicates a shift from hero to potentially misguided villain.

DC Comics' robotic Red Tornado has never been centrally defined by his romantic entanglements in the way Marvel's Vision has, but he has similarly been used to contemplate love and family as defining humanistic traits. In *Justice League of America* #106 (1973), the Red Tornado starts dating Kathy Sutton, whom he meets while trying to establish a secret identity as a normal human thanks to an incredibly lifelike mask. Posing as John Smith, Tornado visits an employment office looking for work; his case worker, Kathy, takes an immediate liking to him and invites him to lunch. The couple end up dating for decades and even share parenting duties for an orphaned girl, Traya, whom Tornado saved from a war-torn country in 1978. Red Tornado often worries about his ability to connect with humanity because of his robotic nature, but he repeatedly proves himself capable of very human emotions, especially love. Brad Meltzer's first story arc of DC's 2006 relaunch of *Justice League of America* addressed Red Tornado's desire to be fully human. When Red Tornado's body is destroyed (for the seventh time), he is able to transfer his soul into a cloned human body rather than his rebuilt mechanical form. Though he is forced to return to his robotic body by the end of the arc, for a time Tornado basks in his flesh-and-blood body. In the second issue, as John Smith, he stays awake watching Kathy sleep, thinking to himself, "I'm still savoring her smell. Her taste. Her touch. And I'm sore. I've never been sore before. It's worth it. Worth everything." Then, looking in on Traya: "My daughter, when I came home she said my breath smelled like licorice, that I have to start brushing now. This is the life I wanted. Prayed for. I'm human now. Truly human." Unfortunately, Red Tornado's human form does not last long. The flesh-and-blood body is too fragile for the dangers of superhero

FIG. 6.4 *Justice League of America* #24, 2008, Dwayne McDuffie and Allan Goldman

adventures. Tornado sacrifices himself to protect Kathy and Traya, thus proving that familial love is what marks him as truly heroic, and truly human. Although Tornado is returned to a robotic form at the end of the story, his family confirms that it is *him* they love; flesh or steel makes no difference.

A few issues later, after Red Tornado's android body has been destroyed once again by supervillains, his consciousness is transferred to the Justice League computer's mainframe while another vessel is built to house him. Tornado's new robotic body is efficiently assembled by the dream team of geniuses Batman, Dr. John Henry Irons (a.k.a. Steel), Dr. Niles Caulder (who created Robotman of the Doom Patrol), and Dr. Will Magnus (inventor of the Metal Men). But it is the league's resident magician, Zatanna, who is responsible for the mystical incantations for the dangerous, and potentially fatal, transfer of Tornado's soul to the new body. When Kathy and Traya suggest that John could stay in the computer rather than risk his life in *Justice League of America* #18 (2008), his holographic image tells them, "This isn't life, Kathy. Life is picking up my daughter and giving her a ride on my shoulders. Life is using my powers to help someone who wouldn't have a chance if I weren't there. Life is making love with my wife and smelling her scent on my skin afterwards." After the soul of John Smith has been successfully transferred into the new Red Tornado body, in issue #24 (2008), he decides that he no longer wants to be just "a family of sorts, an arrangement," but rather a legally binding family. Tornado gets down on one knee (a symbolic gesture still observed faithfully in comics; see chapter 5) and asks Kathy to marry him (figure 6.4). Domesticity and a nuclear family are presented as a heteronormative ideal that humanizes a robot (who just moments before had been housed in a computer system).

Red Tornado's pursuit of humanity and a traditional masculine identity through love is further developed in later storylines. The most obvious example

occurs in the miniseries *Red Tornado: Family Reunion* (2009–2010), where John Smith, Kathy, and Traya have moved to the suburbs and struggle to balance superhero adventures with PTA meetings and children's music recitals. The first scenes show Tornado awkwardly trying to understand the mundane experiences of domestic life and feeling as though he does not belong among the humans. Red Tornado discovers that the evil genius who created him, T. O. Morrow, had made three other elemental robots who have been reactivated: the water-controlling female robot Red Torpedo, the brutish earth-elemental Red Volcano, and the adolescent male, fire-wielding Red Inferno. Tornado's initial elation in discovering others like himself quickly gives way to fear and anger as Red Volcano is revealed to be a villain bent on revenge and destruction. When Volcano targets Kathy and Traya with a localized earthquake, Red Tornado must rescue them and then fight against his more powerful "brother." In protecting his human family, Red Tornado proves his love and his ability as a patriarch. As Tornado tells his "sister" Torpedo, "That's what family is for. Being there for each other." The final scene shows a fully integrated Red Tornado (not disguised as the human John Smith) sitting in the front row at his daughter's recital with his arm around his wife and a proud look on his face, as he reflects, "I have a human family that loves me very much." The message is clear: familial love is self-sacrifice and must always come first; it is a sign of humanity to be cherished.

Human Souls and Mechanical Bodies

The narrative lynchpin for all of these robot and human relationships is the assumption that the androids are more than just the sum of their mechanical parts. Time and again, readers are conditioned to accept that a very human soul, of sorts, exists within the robots. Moreover, it is a recognition of this ambiguously defined *soul* that justifies and substantiates the experience of love. Whether it is romantic, sexual, platonic, or familial love at stake, the assumption of a genuine inner self rationalizes the robot's ability to genuinely feel the emotion as authentically as human characters do. Ascribing some quintessential inner humanness to robot superheroes is a strategy grounded in the religious and philosophical belief that the human experience can be divided into two distinct realms: the physical or bodily, on the one hand, and the mental or spiritual, on the other (see Bordo 1989). Indeed, the foundational belief in a Cartesian duality of the mind and the body, or a religious presumption of a transcendent soul that animates the mere flesh of bodies, is often modeled in modern media forms where a person's essence can be transferred to any number of other host bodies (or machines). The following chapter will return to this dualistic premise of identity in relation to the trope of "body swapping" in superhero stories and how the concept is sometimes mistaken as an analogy for the experiences of trans people. Here I want to stress the importance of mind-body duality in relation to robotic characters as a device to present love as an overwhelming emotional, as well as bodily, condition.

The ability to duplicate a person's essence or freely transfer it from one host body to another is a staple of superhero stories. Thanks to an abundance of magical powers, alien technologies, shape-shifters, and mutant psychics, it is not unusual for storylines to feature, for example, Dr. Octopus inhabiting Peter Parker's body, Bruce Wayne's essence handed down from one clone body to another so that Gotham always has a Batman, or Captain Marvel and Dr. Strange switching bodies and powers. Robotic superhero characters carry this belief in mind-body duality to an extreme by relocating a human essence into a machine. Rather than merely projecting an anthropomorphized humanity onto the robot superheroes, they are typically equipped with some version of an authentic human mind. Vision's personality is based on the brain patterns of Simon Williams (a.k.a. Wonder Man), just as Jocasta is based on Janet van Dyne's brain waves. Virginia Vision is brought to consciousness with the brain patterns of Wanda Maximoff. Racecar driver Cliff Steele's mind is placed within the body of Robotman. One version of Red Tornado's origin claims he was a hero from a parallel Earth whose mind accidentally found its way into a robotic experiment on this Earth. Meanwhile, in DC's Earth-2, it is the mind of a mortally wounded Lois Lane that is transferred into the body of a Red Tornado android. Platinum discovers in the most recent version of the *Metal Men* that her personality is a duplicate of a real woman's. In fact, in the comics, minds are transferrable to machines to the extent that both Vision and Red Tornado have spent time as disembodied characters housed in the computers of their respective team's headquarters. Red Tornado explicitly addresses the philosophical underpinnings of his condition when his essence resides within the computer system during Alan Burnett and Dwayne McDuffie's run on *Justice League of America*. In issue #18 Tornado narrates, "The British philosopher Gilbert Rile did not believe in mind/body dualism. He ridiculed the entire concept, dismissively referring to it as 'The Ghost in the Machine.' And yet, here is my mind, existing in a computer. And there is my body. Broken, spare parts spread out on a table, irreparable. I am that ghost." What these superhero stories reinforce is a belief that it is the inner self, the soul, the ghost, that constitutes who someone really is. Furthermore, it is assumed that humanity resides in the soul, not in one's flesh and blood. There is a dominant belief in the soul as constant and pure, while the physical form is malleable and impermanent.

In her landmark discussion of anorexia nervosa as an ideological rejection of the body and its physical needs, Susan Bordo (1993) argues that the foundations of Western philosophy are rooted in a form of mind-body duality that privileges the ethereal qualities of the mind above the base desires of the body. Focusing on Plato, Augustine, and Descartes, Bordo summarizes the four central tenets that describe the body as an encumbrance. "First," Bordo observes, "the body is experienced as *alien*, as the not-self, the not-me. It is 'fastened and glued' to me, 'nailed' and 'riveted' to me, as Plato describes it." Bordo continues: "Second, the body is experienced as *confinement and limitation*: a 'prison,' a 'swamp,' a 'cage,'

a 'fog' . . . from which the soul, will, or mind struggles to escape." "Third, the body is *the enemy*, as Augustine explicitly describes it time and again, and as Plato and Descartes strongly suggest . . . a source of countless distractions . . . loves and lusts, and fears, and fancies of all kinds." And, finally, "whether as an impediment to reason or as the home of the 'slimy desires of the flesh' (as Augustine calls them), the body is the locus of *all that threatens our attempts at control*. It overtakes, it overwhelms, it erupts and disrupts" (144–145). Taking all four of these precepts together, Bordo insightfully concludes, "All three—Plato, Augustine, and, most explicitly, Descartes—provide instructions, rules, or models of how to gain control over the body, with the ultimate aim—for this is what their regimen finally boils down to—of learning to live without it. By that is meant: to achieve intellectual independence from the lure of the body's illusions, to become impervious to its distractions, and, most important, to kill of its desires and hungers" (1989, 145). But where transcending the baser appetites of the body may be the ideological goal for philosophers (and individuals with anorexia nervosa, as Bordo argues), the message of robotic superheroes is the opposite. In seeking fulfillment, characters like Platinum, Jocasta, Vision, and Red Tornado desire to experience love as an honest, overwhelming need. In other words, as part of the slimy desires of the flesh; as something that overtakes, overwhelms, erupts, and disrupts.

The mind-body duality at the center of robotic super characters is repeated, but inverted, with the tragic monster, another common character in superhero stories. Just as the essence or soul of the hero is encased in a metallic body in robotic superheroes, characters like the Hulk, the Thing, Frankenstein, and Swamp Thing often dwell on the disjuncture between the internal humanity of the person and the horrific physical form they are trapped in. Where the mechanical robotic bodies are classical shapes, streamlined, and self-contained, the monstrous bodies are out-of-control grotesqueries. The contrast between the robots' gleaming hard bodies and the monsters' bulky misshapen anatomies emphasizes the genre's focus on valorizing ideally gendered bodies, while also insisting that the soul is the real mark of the hero. The next chapter will return to the premise that characters like the Hulk and the Thing are heroes trapped in the wrong body as a possible analogy for trans sensibilities. For now I want to simply point out that the issue of mind-body duality in relation to gender and romance permeates superhero stories in a range of ways in addition to robotic superheroes.

The literalized "ghost in the machine" ploy that allows superhero robots to move from one host form to another implies the very transcendence the philosophers strived for. But time and again these stories reinforce an even deeper cultural belief in love as a rapturous physical as well as emotional state. Rather than wanting to cast off the physical form, the super robots desire to be fully loved and in love through the body as well as the soul. Of course, the robotic bodies circumvent many of the "countless distractions" faced by real bodies. The

androids do not need to eat, sleep, or defecate. Nor will they gain weight, get old, or become sickly. The more carnal bodily distractions are often embraced by the robots ("There are things *I* can do that no flesh-and-blood woman ever could!"). Sexuality becomes a way to substantiate the humanity of super robots because love and sex are so intimately linked in our modern ideas about romance. Moreover, the state of being physically overwhelmed by emotions like love or lust, happiness or sadness, that we assume signifies an unquestionable truth and someone's humanity is extended to robots in many of these stories. Thus, mechanical or not, it is the uncontrollable and bodily response to emotions that is presented as evidence of a soul.

The most common device used to illustrate an uncontrollable bodily response to strong emotions is the tear that cannot be held back, even by a stoic superhero. Chapter 9 addresses how superhero stories depict bodies losing control in orgasmic release, both literal and metaphorical, and how that relates to the oft-temporary deaths of characters. Though this chapter is focused more on love than sex, tears serve a similar function of marking the body as overwhelmed—as speaking its corporeal "truths." One of the most beloved moments in comic book history occurred in *Avengers* #58 (1968) when the Vision, who had been introduced only a few issues earlier, was invited to join Marvel's premiere team. After the Vision demonstrates his incredible abilities by battling Thor, the Avengers vote to accept him as their newest member. "Welcome aboard, friend!" Black Panther says. "You accept me," Vision asks, "though I'm not truly a human being?" The costumed heroes insist they would like to have Vision on the team. Before accepting the offer, Vision excuses himself and leaves the room for a moment, as Iron Man remarks, "Funny . . . for a second there, I thought I detected a trace of sentiment! But, his voice is so unspeakably cold!" "He can't help that, Avenger," Hank Pym explains, "and yet, if you saw his eyes right now, I'm sure you'd learn that . . . *even an android can cry*!" The end of Hank's sentence serves as narration for a close-up of the Vision as a single tear of happiness rolls down his synthetic face. As Tim Nelson summarizes in his discussion of this image of a tearful Vision, "That an android can cry was taken as proof of his humanity" (2004, 252). In the strange calculus of robots and human qualities, the soul is separable from the body and is the essence of humanity, but the physical proof of this humanity can be evidenced through the body. In other words, it is when the person/robot is so overwhelmed by emotions that they lose control of their bodies that their humanity is confirmed.

In fact, not only "can" an android cry, they can cry a lot. At various times Vision has shed tears of love, heartbreak, pride, joy, and despair. Likewise, Platinum has been an emotional robot from the early days of the *Metal Men* to current stories, crying when she is rejected by Dr. Magnus, when she sees a prettier robot, when she realizes a young fan is blind, and when she learns her personality is based on a real woman. Red Tornado (John Smith) sheds a tear when he worries about Kathy or Traya, when he is afraid he has failed his family, and when

he witnesses the power of forgiveness from ordinary citizens. The Lois Lane version of Red Tornado from Earth-2 cries when she saves a child and when she learns about the deaths of her own loved ones. Robotic tears signify humanity and the undeniable bodily truth of a character's love. A touchingly romantic example of tears as proof of true love occurred between Shift and Indigo in *Outsiders* #25 (2005). Shift is a clone of DC's chemical-controlling shape-shifter Metamorpho (a.k.a. Rex Mason), and Indigo is a young and innocent-looking female super robot from the future. At the start of the story Shift and Indigo are in bed having postcoital pillow talk. Indigo gives Shift an artificial rose and says, "Do not say that it's 'not real.' It is real. It is as real as you are. Or as I am. True, I was constructed, and you grew from a remnant of Rex Mason's body. Neither one of us was created through common convention, but it does not make us any less real. Less alive." Shift thanks her and tells her he loves her. Indigo leans into him for a kiss and says, "I know. I love you. And it's *real*." Tragically, Indigo is taken over by an evil program hell-bent on destroying Earth. When she is able to momentarily reassert her personality, she begs Shift to kill her and he reluctantly agrees. Shift's hands glow over Indigo's heart as he uses his powers to extinguish her. Both clone and robot shed a tear and tell each other their love is real.

The superhero genre is a fantastic fictional environment where robots, aliens, deities, monsters, and beasts can all mingle together on adventures and in romantic relationships. Stock characters, like the robot who wants to be more than just a machine, allow the stories to explicitly discuss what humanity is and how it is tied up with a conception of a true and selfless love for a partner and/or a family. While female gendered robots usually conform to a fetishistic depiction of women as sexual objects, there is an increasing awareness that treating women as just a "thing" for male pleasure is a villainous act. The inner persona of the female robot, that intangible quality that makes her sentient, means that even the mechanical woman (and by extension, all women) should be treated as a thinking, feeling, independent, and complete individual. In other words, to value a robotic woman merely for her shiny and curvy body is merely to repeat the general misogynistic mistakes of the real world. That is not real love, that is just objectification. Likewise, masculine robots may be the quintessential outsiders looking to understand what it means to be human and to be a man, but they repeatedly learn that fulfilling the role of a loving partner and family patriarch is the clearest path to humanity. Love conquers all, even being an inanimate object. Using robots to explore humanity literalizes the philosophical idea of a "ghost in the machine." The mind-body duality is substantiated in stories that continually stress that even robots have minds of their own, as well as hearts, emotions, and personalities—in short: souls. The following chapter furthers the discussion of mind-body duality in relation to trans identities where, like robots with souls, the tensions between an inner self and an outer form can be magically traversed, blended, and overcome.

7

Super Fluidity

■■■■■■■■■■■■■■■■■■■■■■

Transing and Transcending
Gendered Bodies

The June 2014 issue of *Time* magazine argued that American culture had reached a "tipping point" in regards to recognizing transgender individuals and the various issues they face. The magazine's cover featured transgender actress Laverne Cox, whose breakthrough role on the popular television series *Orange Is the New Black* (2013–2019) made her a de facto representative for transgender people. Transgender characters have become far more visible in recent years with prominent roles in award-winning television series and movies like *Orphan Black* (2013–2017), *Transparent* (2014–2019), and *The Danish Girl* (2015). A significant addition to transgender representation in popular culture occurred in 2018 when the TV show *Supergirl* added the trans character Nia Nal. Portrayed by the teenage trans activist Nicole Maines, Nia became the first live-action transgender superhero in her costumed identity as Dreamer. The introduction of Dreamer on *Supergirl* was the subject of only modest moral outrage from the usual far-right watchdog groups that routinely protest any progressive characters in the media. In fact, Dreamer proved to be a very popular repeat character, and thousands of fans defended her presence on the show as a powerful and diverse heroine. Within comic books, transgender characters have begun to populate minor roles in series at both Marvel and DC Comics. But to date, Aftershock Comics' character Chalice has been the only transgender hero to star in her own series, *Alters* (2016–2018).

The inclusion of prominent transgender superhero characters would seem both logical and provisional for a genre obsessed with idealized depictions of masculinity and femininity, ideological and bodily borders, and dual identities. *Logical* because the genre is defined by multiple narrative themes that echo transgender issues, and *provisional* because transgender characters may expose many of those same conventions as merely melodramatic clichés. Ellen Kirkpatrick describes the figure of the superhero speaking "to trans theory and subjectivity in several ways. It does so through direct representation, and indirectly through symbolic representation" (2015, 127). This chapter outlines some of the ways that superhero comic books have incorporated themes of mind-body discordance and gender fluidity that can be read as a type of transgenderism. The superhero genre routinely depicts body swaps, gender-switched alternatives, and gender-crossing shape-shifters that metaphorically evoke trans conditions. Problematically, the existence of these trans allegories has allowed the genre to sidestep actual representations of trans characters until very recently. As superhero fictions have slowly become less conservative in relation to gender and sexualities, trans heroes are becoming possible as more than just metaphors.

Elsewhere, I have discussed the curious bind faced by superhero bodies that are presented as both rigid/impervious and fluid/uncontainable (Brown 2011). As an extension of the hero's moral certitude and constant defense of the dominant social order, bodies can be impervious (like the bulletproof skin of Superman, Luke Cage, Wonder Woman, or Miss America) or fully protected by state-of-the-art armor (like Iron Man, Steel, Prometheus, or Booster Gold). Additionally, as an indication of their superhuman physical abilities, the heroes' bodies may also stretch (Mr. Fantastic, Plastic Man, Ms. Marvel), change size (Ant-Man, the Atom, Stature), transform to a different physical state (the Hulk, Ice-Man, the Human Torch), or shoot various energies (Cyclops, Captain Marvel, Photon, Dr. Light). Superhero bodies can become invisible, turn to sand or mist or dust, turn to steel, diamond, or rock, or become part machine or part animal. Superhero bodies can be solid and impermeable; they can also be unstable and flexible. Superheroes have also been aged, de-aged, turned into animals, or otherwise transformed. Scott Bukatman argues that modern comics strive to reinforce bodily borders, but characters like Marvel's popular mutants, whose "traumatized, eruptive bodies . . . continually threaten to overspill their fragile vessels," are situated as "categorical mistakes" that threaten the inviolability of bodily containment (1994, 115). The explosive and unpredictable bodies of these mutant superheroes have often been interpreted as metaphors for adolescence. Likewise, the discrimination mutants face for being different has been understood as an analogy for any number of real-world prejudices, including racism, antisemitism, and homophobia. These nonnormative but still gendered bodies framed as "categorical mistakes" also suggest a parallel to transgender struggles.

In fact, it is the very idea of inviolable "categories" that transgender people disrupt. The etymology of the *trans* prefix denotes crossing borders between

genders. This notion of crossing from one category to another, from one state of being to another, is common to many of the ways that superheroes parallel transgender ideas. The bodies of these characters transform, transcend, transmute, transition, and transmogrify in fantastic ways. Strict categorical boundaries should be powerless against caped crusaders who can turn their bodies to diamond, steel, or dust or who can travel through time and space with a wave of their hand. But for all the *trans*ing that superheroes do, the genre is also fundamentally preoccupied with shoring up boundaries. Superheroes guard the borders between good and evil, right and wrong, legal and illegal, but they also secure the boundaries between concepts that are arguably more subjective, such as us and them, natural and unnatural, and moral and immoral. All of these borders can be defended within the stories by defeating supervillains, monsters, and aliens who challenge the status quo. This binary logic of clear-cut good and evil is extended in the genre to suggest that the other binaries are just as clear. Dominant, but problematic and subjective, beliefs about moral and immoral are clearly demarcated when a figure like Superman or Captain America endorses a certain perspective. No less important within the genre is the border between masculinity and femininity. Superheroes signify an impossible ideal of hegemonic masculinity through their powers, their muscles, and their constant victories. Likewise, superheroines present an unattainable image of hypersexualized female bodies, clad in revealing costumes and perpetually offered to readers as an exotic spectacle. The categories of male and female may be regularly transgressed in superhero stories, but the assumed naturalness and the rigidity of gender boundaries are typically reconfirmed by story's end.

Super Wrong Bodies?

In his analysis of the various ways superhero comics reflected the tumultuous political and cultural climate of the 1960s, Ramzi Fawaz argues that narrative themes suggestive of transgender conditions have long been evident in comics, particularly with Marvel's new and more troubled heroes. For example, the debut of *The Fantastic Four* in 1961 introduced a semidysfunctional team of adventurers whose bodies are transformed by a freak encounter during a space mission. Reed Richards becomes a stretchable man of rubber; his girlfriend, Sue Storm, can become invisible on a whim; her younger brother, Johnny, can turn into a human flame; and Reed's best friend, Ben Grimm, becomes a super-strong creature made of orange rocks. Though Reed's, Sue's, and Johnny's transformations allow them to appear as their normal selves when not in action, Ben is always a hulking rock man. The monstrousness of Ben's new appearance is reinforced by his superhero moniker: the Thing. Ben feels like a hideous freak burdened with this grotesque body. Reed Richards tries to find a cure for his friend and manages to temporarily revert him to his human form, but Ben always mutates back into the Thing. Fawaz notes that "Ben's literal transitions from human to rock

form were also coded as transitions in gender identity, while his feelings of being 'trapped' in his mutated body echoed emergent discourses of transsexual (and later transgender) identity, which increasingly used the leitmotif of being trapped in the wrong body as a powerful description of the lived experience of transsexuality" (2016, 80). The Thing's corporeal situation, the dissonance between his mind and his body, is a trope that has been repeated and developed extensively in superhero stories and continues to suggest connections with transgender conditions.

The language of "trapped in the wrong body" has become the most common allusion for expressing the dilemma of transgender individuals. The phrase suggests the despair, trauma, and hopelessness that pre-transition people often feel. Using this metaphor via a superhero character like the Thing as early as the 1960s provided a simplified and safely displaced allusion to transgender issues. In the sixty years since Ben Grimm angrily emoted about being "trapped in the wrong body," our cultural understanding of what exactly that means and our cultural awareness and growing acceptance of trans people have changed a great deal. As Michael Lovelock argues in his analysis of normalizing depictions of trans women on television, "Gender transition is now represented as a means of realizing one's authenticity; a conduit to affective harmony and mental stability" (2017, 678). In fact, Lovelock identifies this shift from a public scorning of transgenderism to a laudable quest for self-fulfillment as grounded in the notion of a natural disparity between the mind as a fixed sense of self and the body as an improvable physical form. "The wrong body discourse of transgender selfhood has been central to this, seemingly far more positive, rhetorical spectrum." Lovelock continues, "In this model, the essential 'truth' of gender is located not in or on the body, but within the more intangible regions of the psyche or the soul" (678). In contemporary usage, the term "transgender" also indicates a broader range of sexual and gendered possibilities. "Transgender," notes Talia Mae Bettcher in her review of trans oppression, "was originally deployed as an umbrella term for those 'beyond the binary'" (2014, 385). Though there are political divides over the conceptualization of transgender as an ideological category, the fluidity of superhero bodies allows the genre to present a number of situations where characters are conceivable as both/either "trapped in the wrong body" or "beyond the binary."

Mirroring the ideological binaries safeguarded by the heroes, dual identities have always been a defining convention of superhero stories. Nearly every hero has their ordinary secret identity side and their costumed crusader side. Moreover, these two sides are depicted as extreme opposites: mild-mannered Clark Kent and Superman, timid teenager Peter Parker and Spider-Man, nerdy scientist Bruce Banner and the Hulk. These dual identities generally serve to substantiate the hero's hypermasculinity in contrast to his more feminized alter ego, and the duality signifies the fantasy of pubescent empowerment through bodily changes. But as the situation of Ben Grimm as the Thing described by Fawaz suggests, themes of duality and identity in the superhero genre transcend mere

costuming. "Superheroes," Neal Curtis and Valentina Cardo argue, "automatically lend themselves to intersectional theories of identity given that they are split between a heroic and a secret identity" (2018, 385). The fantastic situations found in superhero stories often literalize a deeply held cultural belief in Cartesian mind and body duality. As mentioned in the previous chapter in relation to sentient robots, Susan Bordo's discussion of individuals with anorexia nervosa stresses the ideological influence of our "dualistic heritage," which she summarizes as "the view that human existence is bifurcated into two realms or substances: the bodily or material, on the one hand; the mental or spiritual, on the other" (1993, 144). Tracing this dualistic heritage from Plato and Augustine through Descartes and into modern expressions, Bordo insightfully argues that the intangible mind (or soul, ego, persona, spirit) is regarded as one's true self. In contrast, we conceive and experience the body as alien, as a form of confinement, as the enemy in many cases, and as the locus of all that undermines our attempts at control. This belief in a Cartesian form of mind and body duality is rather obviously linked to the transgender language of feeling trapped in the wrong body, of a true self that does not align with the physical confinement of the body one was born with. I will return to this concept in relation to transgender depictions later.

Superhero comics, perhaps more than any other form of modern fiction, rely on our shared belief in mind-body duality and the possibility of separating the two (though body-swapping movies like *Freaky Friday*, *Big*, *Heaven Can Wait*, *17 Again*, and *The Hot Chick* come close). Interestingly, superhero stories also demonstrate a preoccupation with the gendered implications of the mind-body duality in ways that can suggest (but not replicate) transgender experiences. In the world of superheroes, a range of fantastic narrative devices evoke transgenderism without dealing with the issue directly. Female spin-offs of male characters, gender-flipping, transmogrification, cross-gender replacements, shape-shifting, reincarnation, and body swapping are common scenarios in comic books. Yet, while these devices play with ideas of an immutable underlying or internal identity (mind) and the alteration of a physical and gendered form (body), the implication of transgenderism tends to remain at the level of allegory. The various changes that the superhero body is often subjected to suggest what Aaron Taylor describes as "a culturally produced body that could potentially defy all traditional and normalizing readings. These are bodies beyond limits—perhaps without limits." Despite this possibility, Taylor notes that "superhero identities are constructed along very gendered lines" (2007, 345). Likewise, Ellen Kirkpatrick points out that "the superhero genre features all manner of material transformations and yet remains obsessed with rigidly and obviously gendered bodies" (2015, 126). Just because superhero bodies are frequently shown transitioning and transforming, swapping bodies, and reversing genders does not mean the genre challenges gender binaries.

For years superhero comics deflected criticism about the lack of ethnic diversity by claiming that dozens of heroes of color already existed in their fictional

universes. Those colors just happened to be red, green, blue, purple, and silver, rather than a reflection of underrepresented real-world skin colors. The same type of rhetorical feint is now used to argue that comics already incorporate trans representation. But for all the gender-flipping and body swapping in comics, the idea of transgenderism remains simply at the surface. These scenarios are not about aligning the external gendered body with an internal mind, but rather juxtaposing the conflict between the two. This does not mean that the genre is without pleasure or self-recognition for readers whose identities fall outside conventional gender binaries. The narratives of the fluid bodies of superheroes lend themselves to a variety of personal interpretations by readers. Just as queer audiences have always been able to "read against the grain" to accentuate the homoerotic aspects of officially heterosexual characters like Batman, Robin, and Wonder Woman, transgender aligned readers can adapt a trans perspective to the bodily alternations in comics. Queer interpretations of popular culture dismantle the protective facade of heteronormativity by accentuating the anomalies and the artificiality of dominant sexual assumptions. Alexander Doty (1993) famously argued that audiences could "queer" texts by exposing a range of inherently gay, lesbian, or bisexual themes, thus undermining dominant interpretations. Though Doty and many other queer studies scholars do not explicitly address transgender interpretative strategies, a parallel trans reading strategy can focus less on the sexual variations and more on the accentuated themes of gender performativity and cross-gender alternations. Like all underrepresented groups, transgender audiences can derive points of identification in ways that reflect personal experiences and desires even (or especially) when mainstream media does not provide sufficient representations.

In "Rereading Superman as a Trans F/Man" (2017), Dan Vena details his own "origin story" as a trans man and the important engendering parallels from superhero stories that intersected with his own childhood and adolescent experiences. Building on the rhetoric of fan studies, Vena argues "a figure does not need to be intentionally written as trans or as having transitioned bodily forms in some capacity (for instance, Mystique from the X-Men) to potentially resonate with trans fans" (2). Vena points to the all-important childhood fantasy of identification invoked by superheroes, that as children we can imagine ourselves becoming the superhero one day, as a crucial dream of "becoming," as a form of gender transcendence for some nonbinary children. "For trans readers," Vena notes, "the fantasy of becoming may be equally tantalizing because of the caged boundaries of the sexed/gendered body; but the prospect of becoming may also be regarded as an impossibility because the superhero also remains cisgender" (5). Despite the analogy of transformation being limited by the continued cisgender characterization of the superhero, the general duality, malleability, and play with gender attributes inherent to the genre create a space for trans identification. Drawing on the language about trans readings put forth by Stryker, Currah, and Moore (2008) as akin to queer readings (or queerings), Vena identifies his own

interpretations of Superman as a form of "transing." As a reading strategy practiced by a specific subaltern group, transing is a useful way to think about how trans fans can see themselves in stories as normative, accepted, and even heroic. But transing also implies a larger nexus of ideas about gender change and fluidity as a way to undermine assumed gender absolutes. "Transing," Stryker, Currah, and Moore argue, "is a practice that takes place within, as well as across or between, gendered spaces. It is a practice that assembles gender into contingent structures of association with other attributes of bodily being, and that allows for their reassembly" (2008, 13). The gender work of superheroes is one such space where, intentionally or not, transing is practiced.

Changing Genders?

While the number and quality of female superheroes have greatly improved in recent years, the genre has always revolved around idealized images of masculinity. With the exception of Wonder Woman, most of the iconic superheroes are men. And not just any men, but super men. Hypermasculine, all-powerful, muscle-bound, courageous, morally upright, square-jawed, predominantly heterosexual, hegemonic examples of ideal masculinity. But as early as the 1950s, when DC Comics introduced Supergirl as a female derivative of Superman, comics have provided feminine versions of popular male characters. The likes of Batwoman, Batgirl, Spider-Girl, She-Hulk, Mary Marvel, X-23, Lady Deadpool, and countless other derivatives have imagined what the super men would be like as women. As Suzanne Scott notes in reference to these female spin-offs, "Their code names (e.g. Batgirl, Supergirl) inevitably render their own inner character and biography as secondary to the originating male superhero's identity. Their costumes function similarly, subsuming the superheroine's identity by using variants on the male's immediately recognizable emblem" (2015, 155). Furthermore, the spin-off heroines reinforce objectifying genre standards because they are not just any women, but curvy and beautiful women in even more revealing versions of the males' costumes. As Scott declares about eroticized spin-offs, "It is difficult not to read the choices around the superheroine costuming as emblematizing the comic book industry's ongoing commitment to a male, cisgender, heteronormative readership, and the presumption that this demographic desires (or demands) sexual objectification" (155). Moreover, while the female spin-offs are always less powerful than the male characters they are derived from, and subservient to, they do embody an ideal of feminine beauty that complements the male's hypermasculinity. Thus, figures like Batman and Batgirl may share nearly identical costumes, powers, and motivations, but for all their similarities they also reinforce the binary norms of masculinity and femininity. For instance, the muscular male bodies and the voluptuous female bodies represent gender in extremes despite any symbolic links between the hero and the heroine. In other words, the existence of Batgirl does not bring into question Batman's

hypermasculinity, nor does the thematic and sartorial similarities to Batman make Batgirl anything less than ideally feminine.

Similarly, comic book publishers have used the concept of multiverses—different realities that the primary heroes can visit and where stories can explore what-if scenarios outside the scope of central continuity—to gender swap versions of the most iconic male heroes. For example, DC Comics has designated Earth-11 as a parallel reality where all of the characters' genders have been reversed. Wonder Woman becomes Wonder Man, but a greater emphasis is put of the female-to-male inversions like Superwoman, Batwoman, and Aquawoman. The characterizations of the heroes remain relatively fixed: Batwoman is gritty, Superwoman is optimistic, and so on, but the bodies are changed. These imaginative inversions, like the more canonical female derivatives, allow stories to explore the significance of gender in the world of superheroes. But, more commercially important, it allows the publishers to appeal to the possibly libidinous interests of the target male audience by offering eroticized female depictions of the characters, thus providing a "proper" heterosexual avenue for any reader desires.

In a sense, the female derivatives and the gender-swapped versions of notable male heroes in the comics function as an official and sanitized version of what fan activities like slash fiction, fan art, and cosplay explore more unabashedly. As fandom scholars such as Henry Jenkins (1992), Camille Bacon-Smith (1992), and Matt Hills (2002) have thoroughly established, fans express their own desires and beliefs about corporately owned media figures through a variety of creative means. Gender-reversed, gender-bent, or gender-reimagined versions of established superheroes have been written and sung about, drawn, sculpted, photoshopped, and turned into cartoons. As "Rule 63" of the internet humorously declares, for every fictional character that exists, there is a gender-reversed version of him or her somewhere on the web. The various forms of superhero gender reconfiguring undertaken by fans demonstrate what is often described as fandom's "transformative" function—transformative not just in the surface representation of the character but in how audiences understand the character or the entire genre. For example, Suzanne Scott examined an online collection of fan art where hundreds of illustrations depict Marvel's Hawkeye in poses and skimpy costuming that are normally reserved for eroticized female characters. Scott describes *The Hawkeye Initiative* as "illustrative of a broader trend in comics fan art toward gender swapped renderings of characters as a mode of transformative intervention" (2015, 151). The juxtaposition of the original comic art of provocatively posed heroines with the gender-swapped images of Hawkeye in the same pose lays bare the explicit and implicit sexism of the genre, Scott concludes, by decontextualizing and then recontextualizing images from the official media texts. Similarly, Christopher McGunnigle demonstrates how the trend of cross-gender cosplay, or "crossplay" as the subgenre is dubbed, facilitates a novel perspective on male superheroes and a liberating expression for female fans. "Gender swapping for women," argues McGunnigle, "allows for an uninhibiting of

social/gender restrictions that subverts the gendered hegemonies of the super-
hero narrative by appropriating masculine codes under feminine authority. By
identifying with a fictional character of another gender, behavioral perfor-
mances that lie outside of one's socially approved gender scripts can be brought
forth" (2018, 145–146). In addition to the personal/subcultural pleasure fandom
can find through "crossing" superheroes, these practices reveal an underlying
instability about gender that exists in the comics despite the genre's insistence
on strictly defined gender distinctions.

The gender variations of iconic (usually) male characters is relatively unique
to the superhero genre. *Star Trek* fans may crossplay as a female Mr. Spock or a
male Lt. Uhura, but there are no canonical Captain Kirk-Girl or Ms. Sulu
characters. The serial and commercial nature of the comic book medium explains
one reason for all the female derivatives of male superheroes. Simply put, the
industry reasoned that if Superman is selling comics, then a Supergirl should also
turn a profit. Moreover, the need to quickly produce multiple monthly stories
in a fantasy world where anything can happen led to a great deal of narrative
experimentation with possible characters. Unofficially, part of the commercial
logic of these female derivatives also resides in the assumption that a traditional
audience of adolescent males who love Batman and the Hulk will love them even
more with breasts as Batgirl and She-Hulk. This perspective suggests the twists
taken to appeal to sexual fantasies while maintaining a presumption of compul-
sory heterosexuality. The homoerotic allusions of young boys reading stories
about muscular men in skintight costumes punching each other is displaced or
deflected by the presence of fetishized female versions of those male characters.
Still, the implication of a homosexual desire is difficult to overlook with the
heavily sexualized versions of women in the men's costumes.

At times, the stories themselves hint at the underlying homoeroticism of this
form of cross-dressing, such as the scene from *Teen Titans Go!* described in chap-
ter 3 where Starfire puts on Batman's costume and Robin is reduced to a drool-
ing puddle of lust. Even more self-referentially, Peter Parker worries about his
arousal when his girlfriend texts a picture of herself wearing his Spider-Man out-
fit (figure 7.1) in *The Amazing Mary Jane* #5 (2020). To finish the movie she's in,
Mary Jane has to play the role of Spider-Man for the final scene because the orig-
inal actor quit. The flustered Peter tells Mary Jane, "You look amazing," but
then worries, "Wait—is that conceited for me to say? Never mind, I don't care."
Then, in recognition of the unusual situation of being aroused by his girlfriend
dressing up like him, Peter meekly continues, "Sorry, *um*, I'm a little at war with
myself right now. This is a very confusing time for me. And maybe you, depend-
ing on the context of that photo you just sent. I mean. You know. You're my gor-
geous girlfriend and you're dressed up like . . . I have so many big feelings."
While Peter humorously struggles with the layers of his arousal (heterosexual,
homosexual, autoerotic?), the art displays Mary Jane to full erotic effect. The
page-dominating frame shows Mary Jane in the tight Spider-Man suit, twisted

FIG. 7.1 *The Amazing Mary Jane* #5, 2020, Leah Williams and Carlos Gomez

to emphasize both her breasts and her buttocks. The costume now seems to have high heels built into the feet to elongate her legs, and the mask is in her hand so viewers can still see her pretty face and famous red hair. There is no narrative reason for this image other than pure cheesecake. But the cross-dressing aspects of the image mark it as a particularly complicated piece of cheesecake. While scenes like this avoid directly suggesting homoerotic attractions or transvestite impulses (or even autoeroticism), they do indicate how complex the maintenance and transgression of gender binaries can be in superhero stories.

Another, more recent trend involving superheroes and gender alternations has been cross-gender "replacements" for popular male heroes. Male heroes who have died or are otherwise unable to continue their roles have been, at least momentarily, supplanted by women. In the DC Comics' universe, the Question and Dr. Fate are personas now occupied by women, just as Bulletman has become the female Bulleteer. At Marvel, under its "All New, All Different" editorial initiative designed to explicitly diversify its roster of characters (see Brown 2019), Riri Williams, an African American teenager, assumed the role of Iron Man (later opting for the moniker Ironheart); Jane Foster became the female Thor when the traditional male Thor was deemed unworthy to wield the hammer; Wolverine's cloned daughter Laura Linney (a.k.a. X-23) became the Wolverine after his death; and Kate Bishop became Hawkeye after the original died (and they share the name now that he is alive again). Having female characters take up superhero identities that were previously male was used effectively in many of the stories to suggest that the women are just as good as, if not better than, the men. Laura's female version of Wolverine, for example, was just as effective in battle, but was more in control of her emotions. Likewise, Riri is just as brilliant as Tony Stark, and her homemade Iron Man armor is just as amazing, but she is less arrogant and more sensitive to social injustices.

Body Swapping

As a subgenre of science fiction, superhero tales often involve stories of body swapping that overtly rely on a Cartesian conception of mind and body duality. The plethora of magic, super science, powerful psychics, alien technology, and other fantastical narrative devices have been used to transplant the minds of heroes into numerous other bodies. Body swapping, possession, and transforming stories have, of course, been used as a pivotal plot device in all kinds of fictional stories. "Transformations are certainly nothing new in Hollywood cinema," notes Susan Jeffords in her discussion of masculinity in 1990s movies. "From vampire movies to alien takeovers, movies have been populated by people whose bodies have ceased to become their own and whose minds are being controlled by an external force" (1993, 204). But, Jeffords argues, the new "body shifter" movies she identifies, like *Big*, *Switch*, and *Beauty and the Beast*, function differently. "Here, it is the external body that is drastically changed, while

the internal self remains the same. That self changes only as it learns, by living in its transformed body" (204). The body-swap movies conclude that the participants are always changed for the better by the experience. Men are forced to confront systemic racism, women realize the pressures men face, the old appreciate the naïveté of youth, and the young understand the challenges of the elderly. Unfortunately, superhero body swaps rarely imply any similar long-term changes for the characters.

Superheroes switch bodies with other heroes, and with villains, on a fairly regular basis. They have also had their consciousness displaced into androids, clones, machines, or animals or placed in suspended animation. In the 1999 graphic novel *JLA: Foreign Bodies*, the members of the Justice League find all of their minds swapped into each other's bodies by the bad guy. *Ultimate Spider-Man* #66 and #67 (2004) saw Peter Parker and Wolverine exchange bodies thanks to Jean Grey's mutant psychic powers. In recent years, Batman's essence has been moved to a series of cloned Bruce Wayne bodies to ensure Gotham City will never be without its Dark Knight. The entire Justice League found their consciousness revived in new bodies a thousand years in the future in the series *Justice League 3000* (2013–2015). In a long-running storyline, the villain Otto Octavious (a.k.a. Doctor Octopus) assumed the role of Spider-Man in *The Superior Spider-Man* (2013–2014) after transferring his mind into Peter Parker's body. And in *All-New Wolverine Annual* #1 (2016), Laura Kinney's Wolverine and Gwen Stacey's Spider-Gwen temporarily switch bodies when Gwen is magically transported across the multiverse. In these and countless other superhero tales, body swapping is employed as a way to explore the differences between characters and to confirm the core personality traits as grounded in the hero's mind rather than in their body and their physical powers. Peter Parker is agreeable, funny, and smart no matter whose body he is in. Likewise, Wolverine is a tough, beer-swilling curmudgeon even in a fifteen-year-old's body. The superhero body swap also functions to establish a mutual respect between the characters. The transference is initially a problem as characters are ill equipped to handle each other's bodies/powers, but they typically learn to value the other's abilities and to appreciate the challenges the other person deals with on a regular basis. Superman learns how much physical pain Batman endures slugging it out with supervillains, and Batman learns how careful Superman has to be with immense powers to prevent hurting normal people. This standard "moral of the story" is the superhero equivalent of what Jeffords describes in body-swap movies as the self changing "only as it learns, by living in its transformed body" (1993, 204). Sadly, the lessons learned from being in someone else's body rarely extend to cross-gender swaps.

Even in children's cartoons superhero body swapping is a common occurrence. In the episode "The Criss-Cross Conspiracy," from the second season of *Batman: The Brave and the Bold* (2010), for example, an earlier version of Batwoman, who has been outlawed from superheroing, uses black magic to change bodies with

Batman, the ultimate icon of super-serious masculinity. Though played for laughs, the episode clearly suggests gender discrimination ("They never would have outlawed a *male* hero!" Batwoman declares), as well as homophobia and sexist stereotypes of women, and that crossing genders is thoroughly unnatural, even villainous. Once she occupies Batman's body, Batwoman sets out to kill the Riddler for his part in ending her days as a costumed crime fighter, while the real Batman is left tied up in her body. While freeing himself, Batman falls over and notes that in his new body his center of gravity is higher, glancing down at his ample bosom. Batman dons Batwoman's old costume so he can track her down, but falls on his face when he tries to walk in her high heels. And, when Batman confronts Felix Faust, the evil magician that gave Batwoman the transmogrification spell, he has to awkwardly deflect Felix's sexual advances, but eventually flirts back to get the information he needs. Faust is thrilled to help, lustfully telling this Batwoman, "Why anyone with your body would want another one is beyond me." Meanwhile, back at the Batcave, Batwoman swishes around in Batman's body, calls Nightwing "darling," and asks Batgirl what type of shampoo she uses. This new Batman even asks Nightwing, "Do I look fat in this outfit?" as he poses for inspection. The queer overtones of Batman prancing around in this campy way are clear even for young viewers. Of course, Batman and his allies thwart Batwoman and he returns to his original body. Batwoman is handed over to the police to serve her debt to society. Batwoman's official crime may have been attempted murder, but the implication is that she needs to be punished for tampering with gender identity and bodily integrity.

As this episode of *Batman: The Brave and the Bold* suggests, cross-gender body swaps in superhero stories are commonly played as much for humor as for character revelations. In *Captain Marvel* #6 and #7 (2019), Carol Danvers and Dr. Strange find themselves occupying each other's bodies and powers thanks to an enemy sorceress (figure 7.2). Immediately after the swap, they both comment on how weird it is to be in each other's bodies. "Speaking of friends and bodies, *yours* is very powerful," Dr. Strange says. "It's quite amazing, truly." But as his hands start to stray to his/her chest, Captain Marvel screams at him, "Hey! Watch the hands, magic man!" The two bicker about trivial things like he hates having her long hair, and she hates his temperamental cape. Eventually, they learn to appreciate each other's powers and work together to defeat the sorceress and get back into their original bodies. At the same time, over in *Marvel Team-Up* #2 and #3 (2019), Spider-Man and Ms. Marvel find themselves body swapped when a science experiment explodes near them. From behind Spidey's mask, Ms. Marvel freaks out at the change and asks, "How can you be so *calm*?!" In a recognition of what a common scenario this is in comic books, Spider-Man tells her, "It's not my first time at the body-swap rodeo, Ms. Marvel. Occupational hazard of superheroing." The two are forced to live as each other for a couple of days; during that time Ms. Marvel learns how much responsibility comes with adult life, and Spider-Man learns how difficult it is to be Kamala Khan, a Pakistani

FIG. 7.2 *Captain Marvel* #6, 2019, Kelly Thompson and Annapaola Martello

American teenage girl in Jersey City. Spider-Man becomes sympathetic to the pressures she faces at home as a dutiful daughter, as well as the casual racism and sexism experienced at school, and he even panics at the pain of an unexpected menstrual cramp in the middle of class. Of course, by the end of the two issues, they are each gratefully returned to their original and "natural" bodies.

Despite the experience of "walking a mile in someone else's gender," so to speak, superhero body-swap stories avoid any serious sexual politics and quickly return the various minds to what are deemed their properly gendered bodies. The implications of being in a differently sexed body are kept very PG-13. The characters may look under the masks and discover the identity of the hero whose body they now occupy, but there is no suggestion of them really exploring the other person's body. The stories gloss over the fact that, for example, the adult Peter Parker is in the body of an adolescent girl, and that Kamala Khan, a girl from a strict Muslim family who is not allowed to even kiss a boy, is now in a male body. Gender swapped for a few days means that, at the very least, Peter and Kamala had to change clothes, go to the bathroom, and shower in their new bodies. The potential violation of privacy or suggestion of perversion is deflected by minor gender anomalies like Peter enjoying strawberry lip gloss. The emphasis on humor helps reinforce the idea that, though minds and bodies are separable things, women's minds are better in women's bodies and men's minds in men's bodies. The characters are always relieved when they are returned to their own bodies. "Oh, thank god," Captain Marvel gasps when her body swap with Dr. Strange is over, overjoyed to be back in her familiar female body. Confirming the idea that minds have proper bodies they are meant to be in, Ms. Marvel summarizes the genre's conventional perspective when she argues that the untested procedure to reverse her body swap with Spider-Man is worth the risk: "Whatever else happens, we need—we need to be who we are. And that's not just about our powers or our memories. . . . People are more than a collection of bits and pieces and bodies and stored ideas. There's something else. Something bigger than that." Put more simply, Ms. Marvel then declares "I wanna be who

I am," and Spider-Man quickly agrees "Me too." Gendered bodily borders may be transgressed, but they are ultimately shown as natural and worth reinforcing.

In the superhero genre, shape-shifters like the Martian Manhunter, Miss Martian, Morph, Clayface, Chameleon Boy, Metamorpho, Shift, Loki, Hulkling, Xavin (indeed, the entire Kree race of aliens), and Mystique are the character types that overlap most clearly with the concept of a trans identity. These figures can change their physical appearance at will and perfectly mimic anyone else, including different genders. "When exploring trans representation and identities by way of the superhero genre, the mimetic shapeshifter is, problematically, de rigeur," Ellen Kirkpatrick argues. "Such characters are commonly posited as symbolizing trans experiences and realities, often suggesting and overstressing utopian correlations between shapeshifter characterizations and trans representation and identity expressions" (2015, 127). Shape-shifters can transition between male and female bodies in the blink of an eye, and it is easy to understand the allure of these characters for nonbinary audiences and as idealized analogues for transgender subjectivity. They have complete control over how they are seen, the transition process is not burdened with personal physical and emotional difficulties, and it does not risk social recriminations. Still, as Edward Avery-Natale argues, "all too often even they fail to wholly transcend embodiment, as even the shape-shifter ultimately shifts back to a perfected and sexed human form" (2013, 99). The ease of transitioning between masculine and feminine forms and the lack of negative consequences may represent an ideal fantasy of fluidity for trans audiences (and others who do not identify in strict binary ways), but the implication that the shape-shifter has a clear cisgender, one they were born to, undermines the critique of a natural baseline gender rooted in a biological body.

Mystique, from the *X-Men* comics and movies, is one of Marvel's most famous characters and its foremost shape-shifter. Alternating between villain and antihero, Mystique is a perfect mimic. Her mutant powers allow her to imitate anyone, right down to their voice, mannerisms, and even clothing. As Dorian L. Alexander notes in his thorough analysis of the character, "Mystique can, and often does, move through life as a man, despite her usual female identity" (2018, 181). Her ability to effortlessly shift between feminine and masculine forms is certainly suggestive of a transgender identity, but, like all superhero shape-shifters, Mystique is presented as "really" or "genuinely" the female she was born as. Alexander outlines a range of ways that Mystique is not only depicted as sympathetic to trans identities but also used to reinforce the idea of a true gendered identity as natural. Not only is Mystique illustrated most often in her natural female state with blue skin and bright red hair, but her default body is fetishized in superheroine fashion as hypersexual. With long legs, prominent breasts, flowing hair, and perpetually pouty lips, Mystique fits the mold of what the superhero genre imagines an ideal woman should naturally look like. It is an image of hypersexual feminine beauty reinforced in the movies through the casting of sex symbol actresses Rebecca Romijn and Jennifer Lawrence, both of whom spend

a good deal of screen time nearly naked, covered only by blue body paint and a few strategically placed scales. The visual emphasis on Mystique's gendered and sexualized body as her default natural form infers that her shape-shifting into masculine bodies is just part of her skill, a costume she wears to complete a task. In other words, the stories always identify her as feminine. "Mystique's gender identity is independent of her morphological form," Alexander continues, "despite consistently existing in a state that is male, female, or something in between" (2018, 184). Mystique is always presented in stories as a femme fatale, who may momentarily shape-shift into a masculine form, but reassuringly returns to her hypersexual female form as soon as the mission is complete.

Mystique's powers are formidable and could offer a utopian model for imagining trans possibilities in the media. But, as Alexander argues, Mystique's characterization as a villain, or at best a reluctant hero, situates her as uncanny or monstrous. Her abilities suggest an inherent deviousness, and her transformations from female to male, and back again, disrupt the assumed norm of gender binarism. As with negative perceptions of trans identities in the real world, shape-shifting can place any "individual into the realm of the uncanny, the rejection of strict sexual binaries destabilizing present conceptions of male and female and bringing to light elements of a distant human past. Mystique, with the potential to manifest the physiology of the stereotypical male and female, combines both categories" (Alexander 2018, 188). This troubling disruption of borders is often a point of concern for other shape-shifters as well, particularly the ones conceived as villains, like Loki, Clayface, and most of the Kree. Indisputably heroic shape-shifters like DC Comics' Martian Manhunter are never as singularly defined by their ability to change their appearance. Martian Manhunter can also fly, turn invisible, phase through solid objects, and communicate telepathically and is as strong as Superman. Shape-shifting is only one skill in his arsenal, and he uses it sparingly.

Aside from the allegorical depiction of trans characters in superhero stories (cross-gender analogues, body swaps, and shape-shifters), trans identities have begun to appear in stories. Though typically relegated to supporting roles, trans characters are beginning to be portrayed in a more positive light. For example, the first issue of the relaunched series *Batgirl* (2013) introduced Alysia Yo as Barbara Gordon's roommate and best friend who also just happens to be openly transgender. DC Comics did receive criticism later when a criminal Batgirl has been battling is revealed as trans in issue #37 (2014), but by *Batgirl* #45 (2015) the series included the first transgender wedding when Alysia married her girlfriend Jo. Even Batman was portrayed as a transgender ally in *Detective Comics* #948 (2017) when he introduces Batwoman to his longtime friend "post-human bioweaponry" expert Dr. Victoria October. Batwoman remarks on the striking name, and Victoria responds, "My deadname didn't have half the panache, I'm afraid." Victoria also tells Batman, "I did appreciate the card," which he presumably sent after Victoria completed her transition. Such positive trans moments

in superhero stories may seem relatively inconsequential, but they validate for readers that heroes, even one as universally admired as Batman, respect and welcome transgender people. Still, in a genre centered on amazing characters performing incredible acts of heroism, it is unfortunate that trans characters typically play supporting roles. "Few of these characters can truly be considered 'superheroes' in their own right," note Billard and MacAuley in their discussion of transgender comic book figures. "Rather, the heroics are left to cisgender characters, while transgender characters sit on the sidelines" (2017, 249).

Transheroism

The publication of *Alters* #1 (2016), written by Paul Jenkins for Aftershock Comics, introduced the first transgender superhero in comics: Chalice. The short-lived series followed Chalice's emergence as a superpowered "Alter," a type of genetic alternation much like Marvel's mutants. The story parallels Chalice's transition to being one of the most powerful Alters in the world with the male to female gender transition she has begun in her secret identity. Chalice's "secret identity" is Charlie, a teenage boy from Cleveland who has begun taking estrogen, but the real "secret" is that he has not yet told his family and friends he is transitioning. As part of her superhero costume, Chalice dons a long blond wig, makeup, and a stylized crop top with a schoolgirl skirt, high-heeled boots, and a short cape (figure 7.3). As a new Alter, Chalice presents in public as a typically hyperfeminine superheroine. She is dressed in a mildly fetishistic outfit and illustrated with glimpses of her shapely legs, hips, and breasts. When video of Chalice in action fighting criminals makes the news, several male viewers (including Charlie's macho brother Brian) comment on how hot she is. At home, as Charlie, she has to dress in traditionally boys' jeans and sweatshirts, and she enjoys going to baseball games with her family. Charlie struggles with guilt and anxiety as she puts off telling her family she is transitioning. She is afraid that her chauvinistic working-class father, in particular, will be unaccepting of her gendered truth. The age-old narrative premise that a superhero must keep his identity a secret to protect those around him from harm becomes less of a concern for Chalice than the very real-life potential for violence and rejection when trans individuals expose their secrets. Chalice does tell her other, more supportive brother, Teddy, who is a paraplegic (and secretly also an Alter). Charlie also eventually confides in a male childhood friend who is surprised, but understanding, and proud of her courage.

The double-double life of *he/she* and *secret identity / superhero identity* heightens the layers of risk and secrecy. Where the "closet" metaphor exposes the thematic similarities between secret identities and hidden queer identities (see chapter 3), Charlie/Chalice's situation reveals the two-way struggle faced by a trans character who feels less like her genuine self when the cape comes off. As Charlie ponders the layers of identity politics in the first issue, the inner dialogue

FIG. 7.3 *Alters* #1, 2016, Paul Jenkins and Leila Leiz

clarifies, "I want to be *myself*. But the only way I can ever be myself is as *her*." Fans and critics occasionally debate whether the likes of Clark Kent or Superman is the Man of Steel's real identity (Which is the costume? Which is the truth?). *Alters* manages to employ the classic secret identity trope but also stresses that as a trans character Chalice's true self exists only when superheroing, when she publicly presents as female. The cape, skirt, and boots may be part of the costume, part of the superhero masquerade, but the female persona is the truth. In *Alters*, author Paul Jenkins employs the concept of a newly emergent group of superpowered individuals who are misunderstood or feared by society in the same manner that Marvel has used mutants to signify any number of marginalized groups. Rather than utilizing the idea of Alters as a broad metaphor, Jenkins incorporates it as a way to parallel superheroism and transgender identities. When Chalice gives a televised press conference in issue #4 as the new spokesperson for Alters, her speech clearly serves a double purpose. She is ostensibly speaking about Alters, but readers are aware she is really talking about trans individuals:

> My name is Chalice. Some of you out there are pretty confused about people like me. Some of you are *worried*. Things are getting complicated. The world's changing too quickly We're showing up everywhere, and we're difficult to understand. Some of you might be *changing*, just like me. People are scared of you. They don't know how to react. Maybe even you don't know how to react. Well, realize something: that's okay. You're not *alone*. Pretty soon the world is going to wake up and realize this is how it is. And it's not going to change back. People like us are different. But it doesn't mean to say we are *bad*. It doesn't mean anyone should be afraid of us. . . . I didn't ask for this. It's just who I am. It's just who *we* are. And for those of you struggling to adjust—for those of you who need a hero—well, I'm your girl.

Addressing the camera, Chalice is framed as talking straight to the reader, making an impassioned plea about our changing world and the increased visibility of trans individuals, and giving voice in a popular genre to a more enlightening perspective about transgender as not evil, villainous, or dangerous. Rather, trans people (like the fictional Alters or mutants) are people just like everyone else.

Though *Alters* never found a mass audience and was discontinued after only ten issues, positioning a trans character as the lead superhero was a remarkably progressive step. But superhero comic books are a relatively niche medium in contemporary culture, especially for titles published by anyone other than Marvel or DC Comics. When the CW Network announced in 2018 that its popular program *Supergirl* would include a trans superhero, a much larger audience was introduced to a new and powerful image of trans people. The character of Nia Nal, who also goes by the superhero moniker of Dreamer (figure 7.4), is played by Nicole Maines. Maines had already received some fame as a transgender

FIG. 7.4 Dreamer (Nia Nal) *Supergirl*, 2018

woman who made headlines as an activist when she successfully sued her high school for the right to use the bathroom of her gender. Nia is the product of a human father and an alien mother, and she has inherited her mother's ability to dream the future and to use light as a solid projection. The inclusion of Dreamer as a regular on *Supergirl* received a great deal of positive press attention for breaking new ground for trans representation, and for employing a trans actress rather than another cisgender actor. Glowing articles profiling Maines and stressing the importance of depicting a trans character as a hero appeared in magazines as diverse as the *Hollywood Reporter*, *Glamour*, *Vanity Fair*, *Entertainment Weekly*, and the *Advocate*.

During Dreamer's second season on the show, the central storyline metaphorically addressed America's modern turn to xenophobia, racism, and immigration restrictions under the Trump administration. With a white-supremacist-like government/military force known as the Children of Liberty rounding up otherworldly aliens for prison and deportation, and fanning the flames of discrimination, fear, and hatred, even the alien Supergirl has limited her public appearances. Dreamer, however, picks up the slack, fighting crime and defending the aliens from persecution and violence while Kara Danvers (Supergirl) works to uncover the criminality of the Children of Liberty in her role as a reporter. Looking to humanize the aliens for the broader public, *Supergirl* employs a strategy akin to the one used in *Alters*, by having Kara interview Dreamer on live television in the episode aptly titled "American Dreamer" (season 4, episode 19). Like Chalice, Dreamer talks directly to the camera (and hence the real-world viewer as well), but Dreamer's speech explicitly includes mention of her being a trans woman, thus moving beyond mere metaphor for trans issues at the same time that the alien/immigrant parallel stays intact. "My parents believed that humans and aliens could coexist. And I am living

proof of that. But growing up wasn't easy. I am also a trans woman. I'm different, Ms. Danvers, but so is everybody. And I don't know when that became such a bad thing. The greatest gift we can give each other is our authentic selves and sharing that—sharing our truth—is what will make us strong. So here I am. I am both human and alien, and I'm a trans woman." With the inclusion of Dreamer, *Supergirl* is able to raise awareness of trans individuals both within the fiction and for audiences. Nia is depicted as sweet, funny, nerdy, and heroic. The program is able to simultaneously present a trans woman as both *super* human and *genuinely* human. The character may be doubled in the same manner as most caped crusaders are, as Nia/Dreamer, human/superhuman, even as alien/American. But Dreamer is not erroneously doubled in her gender representation; she is admittedly a trans woman in both her secret and heroic identities. She is not a male passing as female, she is not a shape-shifter, she has not been body swapped, nor is her body transformed by magic or alien technology. Perhaps even more importantly, Dreamer is not a trans character performed by a cisgender actor.

In a sense, trans characters and trans superheroes should be right at home in a fictional world where people are not bound to the corporeality of their bodies. But the genre's history of obsessively demarcating traditional ideals of masculinity and femininity, of shoring up the borders between the genders, has been slow to challenge the rigidity of gender binaries. Still, the incredible gender hyperbole in superhero stories, with all the super *men* and the wonder *women*, the bulging muscles and the extreme curves, has always risked exposing the socially constructed and performative nature of gender. Similarly, the genre's repeated use of transing bodily borders through shape-shifters, body swaps, alternate universes, character analogues, and so on, suggests the permeable nature of the physical and cultural borders the stories attempt to reconfirm by the end of each adventure. Though these various forms of transing may only be allegorically linked to transgender realities, they have helped create a perception for audiences that gender, identities, and bodies are not immutably set. The gradual inclusion of trans figures in superhero stories, in more than just an allegorical way, presents a potential to move beyond the conventional formula and conventional thinking.

8

KRAKK! WHACK! SMACK!

................................

Comic Book Violence
and Sexual Assault

The very first bad guy to be trounced by a superhero was an abusive husband. In the comic book that established the entire superhero genre, *Action Comics* #1 (1938), reporter Clark Kent gets word of a violent domestic situation, but it is the costumed Superman that busts into an apartment to find a man thrashing his own wife with a belt. The mysterious new Superman picks up the lout and hurls him against the wall, declaring, "You're not fighting a woman, now!" Superman, and all of the other amazing caped heroes he would inspire, quickly evolved to battling supervillains, evil geniuses, and alien invaders, establishing many of the genre's recurring narrative elements that are still key plot devices nearly a century later. Though domestic battery did not become a standard convention in superhero stories, this early scene portrays a gendered assumption of violence and the reality of what is now referred to as intimate partner violence (IPV). Superman's valorous defense of the unnamed woman being beaten by her husband clearly marks the thug's actions as heinous, but elsewhere in superhero stories the relationship among gender, sex, and violence has been problematic. For example, in *Batman* #1 (1940), when the Caped Crusader first encounters Catwoman, who will become a central romantic partner over the years, Batman initially manhandles her and roughly dismisses her protests with the condescending and misogynistic "Quiet, or Papa spank!" From the very formative era of the comics to the

current worldwide saturation of the superhero genre, chivalry and gendered violence have gone hand in hand.

As a reflection of Western culture, superhero adventures want to have it both ways: They want to vilify gendered violence, but also depict it as normal. They want female characters to be strong and independent, but also deferential and sexually objectified. Indeed, the superhero fantasy is one of the few areas in modern culture where women can be routinely characterized as physically powerful, on par with or surpassing many male heroes. But this fantasy of equal strength does not mean male and female characters are treated equally when it comes to violence. The gender dynamics worked through in superhero tales are progressive on a number of levels, but the continued hypersexualization of costumed women is intricately coupled with sadistic sexual assaults and instances of IPV that often undermine female agency at the same time that it suggests gendered abuse is a (super) villainous act of misogyny.

This chapter addresses the linked, but incongruous, themes of sexuality and violence in the superhero genre, where women are positioned as erotic objects for male characters (and readers) in a manner that obscures the line between aggressive relationships, sexual assault, and IPV. The idea of "comic book violence" and the way it is depicted has evolved a great deal over the years. Both storylines and visuals have become more graphic in the portrayal of violence. Still, comics have maintained specific iconic conventions, such as having superheroes knock out the bad guys with a single punch, accompanied by an emphatic visual sound effect: BAM! POW! With superheroes the violence is typically stylized and illustrated as a symbolic moment captured for the reader's enjoyment. While blood may spray from the corner of a mouth, very little real damage is done. Characters are super-punched thirty feet into the air or stomped into the ground by a giant robotic foot, and they usually get up and walk away. Moreover, even if a superhero is killed, readers know he will eventually come back to life (chapter 9 will return to this convention of temporary superhero deaths). The superhero formula revolves around violence. Using incredible powers to beat up any and all villains mano a mano is every caped crusaders' reason for being. As Kevin J. Wanner points out, "It remains rare for a superhero comic published by Marvel or DC not to feature at least one fight, or for the resolution of their stories not to involve violence. Depictions of superhuman acts of violence, their preparation, or their aftermath also remain central to comics' visuals, serving as a focus of many a full- or multipage tableau" (2016, 177–178). The genre's focus on brutal confrontations, hand-to-hand fight scenes, and the routine celebration of physical battles to resolve problems creates a fictional environment that blurs the line between heroic and horrific violence.

The super punch is routinely celebrated as a climactic moment in the comics. It usually signifies the hero's decisive victory over an adversary through an overwhelming show of force and righteousness. Visually, the super punch is presented

as a spectacle of violence, frozen at the moment when the hero's fist has connected with the enemy's face. Often accompanied by motion lines and visual sound effects, the comic frame stresses the expression of resolve on the hero's face, and the villain's head snapped back, face grimacing in pain and teeth or blood spraying from their mouth. This violent image is normalized in comics through sheer repetition, depicted multiple times in almost every superhero story. The standard super-punch panel is similar to the conventional "punch photograph" established by sports journalists covering boxing matches. "The essence of the punch photograph," Lynda Nead observes, "is the physical juxtaposition of two kinds of body: the puncher and the punched: the ideal and its disfigurement. The intact hard contours of one boxer is imposed on the crumpled, misshapen and often bleeding body of the other" (2011, 320). Nead succinctly argues that the punch photograph valorizes the classical hard male body of the puncher over the softened and feminized body of the punched. A similar logic is celebrated in the super-punch panel of comic books, often with even more absolute contrasts between moral righteousness and villainy implied. The frequent use of super-punch images as a shorthand for the hero's victory (both physical and moral) complicates issues when the hero is the victim of a punch or when the punch is itself a villainous act and/or a prelude to sex or sexual assault.

The superhero formula's persistent emphasis on physical combat and its normalization of interpersonal brawling can complicate depictions of sexual assault and/or IPV. For example, the four comics frames (figures 8.1–8.4) below each depict a typical superhero fight scene, complete with backgrounds abstracted in order to highlight the impact of the blow, and conventional visual sound effects— KRAKK, WHACK, SMACK, and WROKK! But each of these frames depicts a moment of unprovoked violence between a man and a woman; they have nothing to do with stopping a crime or protecting defenseless citizens from rampaging monsters. The first two frames portray violence between characters who have a long history of romantic involvement. The third is part of an argument that immediately turns into sex between an engaged couple. And the fourth is the precursor to a brutal rape. The similarities between these images and most superhero battle scenes reveal a significant problem in distinguishing *intimate* violence and *sexual* assault from the more conventional portrayals of *comic book* violence. In other words, the genre risks rendering all depictions of contentious relationships, sexuality, and violent conflicts as equally fictional and routine. Moreover, this style of comic book illustration that eschews any background details as a means to signify the magnitude of the moment is identical to the way a momentous kiss between superheroes is framed (discussed in detail in chapter 5). The representational similarity between a punch and a kiss is a concise indication of the genre's difficulty in delineating between sex and violence, romance and assault.

FIG. 8.1 *Superior Spider-Man* #20, 2013, Dan Slott and Giuseppe Camuncoli

FIG. 8.2 *Suicide Squad* #14, 2012, Adam Glass and Fernando Dagnino

FIG. 8.3 *Green Arrow and Black Canary Wedding Special*, 2007, Judd Winick and Amanda Conner

FIG. 8.4 *Invincible* #110, 2014, Robert Kirkman and Ryan Ottley

Sexual Figures

As addressed in chapter 2, superheroines are typically overdetermined as hypersexual figures. Of course, both male and female bodies are exaggerated ideals in the comics, but where the men are idealized as virile subjects, women are idealized as sexualized objects. The men are handsome and muscular, which means they are sexualized to a certain degree, but their physical perfection is presented as emblematic of their power and heroism. Superheroines, on the other hand, may have incredible powers, but their bodies (and costumes) are designed to imply sexuality, not strength. The standard superheroine form is identical from character to character: long and shapely legs, tiny waist, large breasts, long flowing hair, and pouty lips. As Anna Peppard has summarized, "Whereas male superheroes tend to display exaggerated power characteristics, such as muscles, female superheroes tend to display exaggerated sexual characteristics, such as breasts and buttocks, which their bodies are frequently contorted to display at the same time (in what is colloquially known as the 'broke back pose'). The sexual objectification of female superheroes has long been a convention of the superhero genre" (2017, 107). The conventionally one-dimensional portrayal of superheroines as hypersexual reinforces a misogynistic belief in women's only value being their beauty, and reinforces the fantasy that fetishized women are always fully available and desiring of men's lustful attention.

The revealing and fetishistic costumes worn by superheroines only further emphasize the sexual objectification of the female characters—for example, the cleavage-exposing tops worn by Power Girl and Wonder Woman, the short skirts of Supergirl and Mary Marvel, the tight leather bodysuits of Catwoman, Black Widow, and Black Cat, the fishnet stockings worn by Black Canary and Zatanna, the high-cut, one-piece bathing suit look favored by Psylocke, Elektra, She-Hulk, and the original Ms. Marvel, and the corset and thigh-high boots combination often modeled by Scarlet Witch and Emma Frost. In linking the fetishization of female characters and issues of gender-specific violence, I do not mean to reinforce any of the "rape myth" logic that regards women who *look* or *dress* in a sexually evocative way as asking to be objectified or victimized. But as Tammy Garland et al. argue, the "oversexualization of comic characters coupled with the sexual violence perpetrated against them reifies rape myths" (2016, 53). The reality is that these fictional women have historically been overwhelmingly designed by men for male readers and thus cater to certain fetishistic fantasies about female bodies and sexuality. Superheroines do not choose to "look" or "dress" in a sexual manner, but they are created by publishers to entice and attract an assumed male audience. It is no coincidence that most of the costumed female characters who come up repeatedly in this chapter as examples of sexual victimization (Black Cat, Black Canary, Harley Quinn) are first and foremost branded as sex kittens.

The marketability of sexy depictions of superheroines is evident with some of the most popular artists in comics today, who are best known for their pinup

or "Bad Girl" type drawings. Artists such as Amanda Conner, Adam Hughes, Terry Dodson, Ed Benes, Greg Land, and J. Scott Campbell have become synonymous with sexualized depictions of heroines and villainesses. Developing out of the Bad Girl trend of the 1990s, these modern illustrators still tend to be suggestive of pornographic images of women, but they also incorporate a sense of the more innocent sexuality of pinup models from earlier eras. Though all of these artists are incredibly accomplished at their craft as visual storytellers, the fact that their illustrations are enjoyed by fans (and promoted by publishers) primarily for the fetishized depictions of women reveals a persistent and pervasive sexism in the genre. The recent increase in female artists employed by both Marvel and DC Comics (e.g., Babs Tarr, Nicola Scott, Stephanie Buscema, Sara Pichelli, Emma Vieceli, Joelle Jones, and Veronica Fish) has reduced the explicit and exaggerated depiction of heroines.

Some female artists, like Amanda Conner, who has become a favorite of comic book fans primarily owing to her cute, but decidedly sexy, illustrations of heroines like Power Girl, Black Cat, Black Canary, and Harley Quinn, manage to combine a traditionally objectifying style with a playful sense of feminist critique. In their discussion of superheroes and third-wave feminism, for example, Neal Curtis and Valentina Cardo (2018) stress "the transformation that Harley Quinn went through at the hands of Amanda Conner" (4). Under Conner's tenure as writer and artist for Harley Quinn, the character went from being "covered head to foot in a harlequin outfit" to "revealing short pants and crop top" (4). But as Curtis and Cardo further note, "This transformation also involved her independence from The Joker. So, while her sexuality has been accentuated by her new look she is totally in control of it, making an important contrast with the earlier, less sexualized depictions when she was nevertheless in a deeply abusive relationship and very much controlled by The Joker" (5). They conclude that while Conner's style looks like traditional cheesecake, "the message from Conner seems to be that autonomy and agency with regard to one's sexuality is far more important than a 'modest' costume in an abusive relationship" (5). It is this type of awkward differentiation between the hypersexual depictions of women and the image of superheroines as empowered that is repeated and extended with the genre's routine portrayal of violence and attempts to address the issue of sexual assault.

Capes and Rapes

The unequal forms of violence faced by female characters have been well documented as part of the "Women in Refrigerators" trope first identified by comics writer Gail Simone in 1999. Noticing a trend in comic books where female characters are killed, raped, depowered, brutalized, and crippled at a far greater rate than male characters, Simone began chronicling the extreme violence women are subjected to as a form of motivation for the male heroes. The phrase "Women

in Refrigerators" refers to the infamous murder of Alexandra DeWitt, girlfriend of the hero Kyle Rayner, in *Green Lantern* #54 (1994). Kyle finds Alexandra dismembered and crammed into his apartment refrigerator as a gruesome message from his enemy Major Force. As Simone's list demonstrates, the way Alexandra was used to develop Kyle's character and to justify his heroic vengeance is a common trait. Hundreds of female characters have been treated to similar forms of gender-related violence. The disproportionate victimization of women goes beyond mere sexism in a traditionally male-focused genre. As Gabriel Gianola and Janine Coleman observe, "Woman as object is insulting; woman as cannon fodder is disgusting" (2018, 261). Obviously, male superheroes are also subjected to a great deal of physical violence, but men are portrayed as overcoming their pain and besting the villain themselves, whereas women tend to remain traumatized and to be reliant on men for revenge. The inordinate amount of violence suffered by superheroines is linked to their gender, but it is also linked to their sexuality. Much of the violence female characters are subjected to is framed as either an implicit or an explicit sexual assault. The fact that superheroines are thoroughly fetishized as sex objects and then (sexually) assaulted indicates an intimate association of female sexuality and victimization. "The sheer frequency with which female superheroes are sexually abused," Anna Peppard notes, "suggests the harmful dehumanization at the heart of their sexualization" (2018, 162). The overdetermined fetishization of costumed characters like Black Cat, Black Canary, Black Widow, Catwoman, Harley Quinn, Power Girl, the Wasp, and Huntress risks objectifying them to a point that suggests even the strongest and most independent of women merely exist for male sexual pleasures and motivation.

Perhaps the most infamous example of the "Women in Refrigerators" narrative device is the crippling of Barbara Gordon, a.k.a. Batgirl. In Alan Moore and Brian Bolland's seminal story *Batman: The Killing Joke* (1988), which is still routinely ranked as one of the top five graphic novels of all time, the Joker shoots Barbara Gordon in the abdomen and shatters her spine. The Joker then forces Commissioner James Gordon (her father) to look at a collage of pictures of Barbara wounded and naked. Whether the Joker physically raped Barbara has been a point of contention for years. Contextualizing the importance of Barbara's assault, Jose Alaniz argues it was not "just the act itself," but "the exploitative, ultra-violent storytelling employed in the scene made it ground zero in turn-of-the-century fandom gender wars, for many female readers it exposed the misogynist underpinnings of the industry" (2016, 59). The degree of sexualized violence applied to Barbara Gordon, merely as a narrative device to test and motivate Commissioner Gordon and Batman, illustrates the routine (almost flippant) depiction of gendered assault in superhero stories. It would take over twenty years for Barbara Gordon to be granted one of comic's miracle cures that would allow her to walk again, and to return to crime fighting as Batgirl.

Though the physical rape of Barbara Gordon by the Joker is only implied by the narrative of *The Killing Joke*, the symbolic rape of the character is no less

significant. Other women in superhero comics, even superpowered heroines, have been raped in more than just a metaphorical or symbolic manner. In a complicated storyline featured in *The Avengers* #200 (1980), Ms. Marvel (the Carol Danvers version) is revealed to have been raped by her own grown son from an alternate plane of existence. In Mike Grell's miniseries *Green Arrow: The Longbow Hunters* (1987), Black Canary is brutally and graphically tortured by sadistic drug dealers, and it is clearly implied that she is raped as well. Sometimes rape is revealed to have happened in a heroine's past and serves as part of her motivation to become a costumed vigilante. The 1989 *Catwoman* miniseries reimagined Selina Kyle's origin story as a teenage prostitute who is raped and beaten as the impetus for her pursuit of fighting skills. Another 1989 miniseries, *Huntress*, explains that at only six years old, Helena Bertinelli, the daughter of a mafia boss, was kidnapped and raped by a rival crime family. Likewise, Kate Bishop, who takes on the role of the archer Hawkeye, recalls in a flashback in *Young Avengers Special* #1 (2006) that she was raped as a girl, which is why she trained to become a hero. And much of the storyline for the acclaimed Justice League story *Identity Crisis* (2004), written by Brad Meltzer, hinges on the revelation that the supervillain Dr. Light once raped the Elongated Man's wife, Sue Dibney, and threatened to do the same to the spouses of all the heroes.

The difficulty of addressing an issue like rape in a genre built on themes of violence and sexual objectification is apparent in the series *Spider-Man / Black Cat: The Evil Men Do* (2002–2006). Written by Kevin Smith and lavishly illustrated by Terry Dodson, who is well known for his voluptuous depictions of female characters, the six-issue series tackled sexual assault head-on by revealing the college rape that Felicia Hardy endured that would turn her into the costumed Black Cat. As a popular femme fatale in the Marvel universe, Black Cat has a forty-year history as the quintessential sexual temptation of Spider-Man. Clad in her skintight black leather bodysuit with white fur trim that matches her flowing white hair, her ample cleavage always on display, Black Cat has long been overdetermined as a sexual fantasy figure, as a "sex kitten" for both Spider-Man and the target audience of young male readers to lust after. Unfortunately, this strategy of exploiting Black Cat's hypersexual depiction as her primary character trait (and primary value to consumers), which is on full display in *The Evil Men Do* through Dodson's artistic style and the flirty banter Smith writes for Spider-Man and Black Cat, seems at odds with a storyline seeking to address the routine sexual victimization of women.

Both Smith's script and Dodson's art for *The Evil Men Do* revel in Black Cat's overt sexuality and curvy figure. The story begins with a full three pages dedicated to glimpses of Felicia taking a shower while she mulls over putting her Black Cat suit back on and returning to New York to see Spider-Man. Once the adventure really gets going, Black Cat is posed in every image to emphasize her exaggerated figure to full effect. Likewise, Spider-Man and Black Cat constantly tease one another with sexual innuendoes and double entendres. When Black Cat

wraps herself around Spider-Man in midair, he says his "spider sense is tingling," and Cat asks, "Is that what you are calling *it* now?" When interrogating a thief, Spider-Man points at Black Cat and claims, "No woman with a chest like yours should be able to move as fast as you do!" She simply replies, "They act as ballast." And when they are breaking in on the bad guys, Spidey asks, "You coming?" and Cat responds, "Should I make some sort of sexy double-entendre, or just say yes?" But as Michael R. Kramer argues in his analysis of the series, "Rather than celebrating the elevation of Black Cat to potential lead character status," the narrative arc of *The Evil Men Do* "consistently undermines its heroine in ways that reinforce patriarchy and traditional gender roles" (2014, 235). When Black Cat pursues the lead criminal on her own, he manages to immobilize her and begins to rape her. As Kramer notes, "The rape is designed to punish Felicia's commitment to bringing criminals to justice, and, in doing so, crush her identity as a heroine" (239). Though Black Cat is saved at the last minute when the villain's brother kills him, she is the one who goes to jail for the murder. It is only near the conclusion of the story that Felicia reveals (with the help of a lengthy flashback) that she was a victim of date rape in college and has suffered through fear and anxiety ever since the assault. Moreover, despite all of her earlier strength and independence, the finale of the story sees Spider-Man and Daredevil teaming up to rescue Black Cat, thus positioning her as just another damsel in distress.

The Evil Men Do is a well-intentioned attempt to incorporate the reality of sexual violence into the superhero formula. The difficulty is that the story/art wants to have it both ways. "Too often, rape is used to titillate, and too rarely are the effects of trauma shown," argues Valerie Estelle Frankel about comic book rape. "This perspective means reducing the women to sexualized objects instead of sympathizing with their struggles" (2019, 77). Because Black Cat has been so thoroughly eroticized throughout her history with Spider-Man, she is repeatedly presented, first and foremost, as a sexual fantasy object for both Spider-Man and the presumed male reader. The shift in tone in the final act, when Felicia recounts her past sexual victimization, exposes the limitations of the superhero genre's one-dimensional depiction of characters like Black Cat when it comes to addressing issues of sexual assault. In essence, the comic book that has been treating Black Cat as an idealized sex object now posits that treating women as merely sexual objects is a villainous act. I do not mean to imply that an eroticized female figure like Black Cat is to blame for her assault—just as no woman in real life should be held responsible for being assaulted, no matter how she looks, dresses, talks, or presents herself. But *The Evil Men Do* wallows in Black Cat's visual objectification throughout most of the story, thus blurring the lines between the reader's and the villains' attitudes toward her.

The aggregate depiction of rape in the superhero genre, of both heroines and ordinary women, renders it in a manner aligned with how rape is portrayed in the media in general, as a violent sexual attack that leaves the woman emotionally scarred. "For the most part," Garland et al. argue in their overview of rape

incidents, "comic books reinforce a narrow view of what constitutes rape: a violent, brutal event that was probably brought on by the victim" (2016, 64). Problematically, the inherent violence and sexual objectification of women in the genre contribute to twin misperceptions: (1) that "real rape" occurs only if the woman fights back but is overpowered, and (2) that rape is a sexual act (rather than an assertion of power or dominance over another person) that may have been provoked by the overtly sexual nature of the woman. Most superhero stories do not do well with nuanced depictions of serious or sensitive issues. Likewise, the cumulative effect of constantly depicting women as hypersexual fantasies runs contrary to any more explicit message that women should not be treated as sex objects. As Garland et al. note, "The way sex is portrayed in these comic books may allow readers to think that the burden should be placed on the female to make sure that she does not act in a way that provokes someone to rape her, and that if she is raped, she did not fight hard enough to make the perpetrator stop" (64–65). The genre's preoccupation with spectacular fights suggests that physical battles and overpowering an enemy are the only ways to resolve conflicts. In most stories, battle scenes also imply a moral victory for the hero because the *good guys always win*. Thus, to be victimized in a comic book is to fail as a hero. The basic rhetoric, visual, and narrative conventions efface more complicated issues like systemic misogynistic violence, toxic masculinity, psychological and emotional manipulation, and a larger culture conducive to the institutionalization of rape.

As the superhero genre has evolved into a more mature form of storytelling, it has been able to incorporate serious real-world issues, like rape and IPV, without reducing the topics to something that can be neatly overcome with a powerful punch to a colorful villain. One of the most complicated and pivotal incidents of rape occurred with the ex-superhero turned private investigator Jessica Jones. Jessica's victimization at the hands of Kilgrave (a.k.a. the Purple Man) was explored first in the acclaimed comic book series *Alias* (2001–2003), written by Brian Michael Bendis and illustrated by Michael Gaydos. Later, the relationship between Jessica and Kilgrave became the cornerstone for the first season of the Netflix show *Jessica Jones* (2015–2019). The foul-mouthed and hard-drinking Jessica Jones is established in the comic book as a reluctant antihero; she has super strength but refuses to don a costume ever again. In the series' final story arc, Jessica reveals that her bad behavior and bad attitude are in large part due to her traumatic experience as a yearlong captive of Kilgrave. In both the comic book *Alias* and the Netflix program *Jessica Jones*, the Jessica/Kilgrave relationship is used to critique and expose the complexities and lingering effects of sexual assault. This serious look at rape is unprecedented for a popular genre that usually focuses on men in tights and alien invaders.

The superpower wielded by Kilgrave allows him to completely control anyone who is near him. In Jessica's recounting of the events in *Alias* #22–23 (2003), the flashback sequences are illustrated by Mark Bagley, whose more traditional superhero style of art suggests both Jessica's and the genre's willful naïveté when

it comes to sexual violence. When the young Jessica, who still went by the costumed identity of Jewel, first confronts the Purple Man, he simply says, "You're very attractive, Jessica. Take off your clothes." Jessica immediately strips and then is forced to endure his sadistic torture for months, including committing crimes for him, dressing in fetish clothing for his pleasure, and watching him have sex with various women against their will. In the comic, Jessica makes it clear that Kilgrave did not physically rape her—that would have been too mundane for him. But he did metaphorically rape her in every sense: robbing her of free will, controlling her, making her do things that she had no desire to. Jessica finally manages to escape Kilgrave's clutches, and years later she defeats him as a symbolic step toward reclaiming her own life. Jessica's trauma and her realistic addictions, anger, and depression as she struggles with PTSD are relatively unique for a genre rooted in the fantastic. It is significant that this complex treatment of abuse and trauma found expression on the fringes of the superhero genre. The more conventionally superhero*ish* a story is, the more difficult it becomes to deal with a topic like rape in a sophisticated manner. As Anna Peppard rightly notes in her analysis of Jessica's evolution in comic books, "Jessica Jones demonstrates both the tremendous potential of female superheroes as vehicles for critiquing misogyny and patriarchy as well as the difficulty in maintaining progressive gender politics within a genre where the visual and narrative conventions are so steeped in stereotypes and inequities" (2018, 158). The abuse survivor storyline in *Alias* works because the series had already gone to great lengths to avoid writing or illustrating the character for titillation.

The *Jessica Jones* streaming series on Netflix was widely lauded for its serious depiction of a survivor of sexual assault, and her eventual triumph over Kilgrave. *Jessica Jones* demonstrated that the basic building blocks of the superhero can be used to tell mature and complicated stories and still reach a massive audience. Premiering in 2015, amid widespread revelations about the sexual harassment and assault suffered by women in the entertainment industry at the hands of powerful men like Harvey Weinstein, Les Moonves, Matt Lauer, and Bill O'Reilly, *Jessica Jones* brought a superhero into the era of #metoo. Of the series, Shana MacDonald argues, "Jessica's trauma and anger are not vilified but justified. Her validation as an angry, powerful woman gives audiences a representational outlet for their increasingly recognized frustrations" (2019, 72). Jessica, as played by Krysten Ritter, is anything but glamorous. She is a bitter, foul-mouthed alcoholic who refuses to wear anything other than her old jeans, an oversized men's leather jacket, and her black Doc Marten boots. But Jessica is no less a hero. She may not save the world, but she saves everyone she can. And ultimately, she snaps Kilgrave's neck to stop his continued exploitation of women. "The character of Jessica Jones mirrors for women a superhero-themed fantasy of how they might counter the oppressive sexism in their everyday lives," MacDonald concludes, "twisting these questions into a launch point for feminist vengeance narrative" (2019, 80). The blockbuster movie versions of Wonder Woman, Captain

Marvel, and Black Widow may be widely hailed as feminist icons, but Jessica Jones was the first superheroine to really fight against the type of abuse women routinely suffer in the real world.

Kilgrave's ability to control people is a useful metaphor for the hegemonic privilege some individuals enjoy. "Kilgrave's superpower is the literal embodiment of male entitlement taken to the extreme," argues Verity Trott. "He asserts his will without hesitation yet feels sorry for himself, positioning himself as a victim on numerous occasions" (2019, 53). To a certain extent, Kilgrave as an embodiment of male entitlement is akin to the superhero convention of using one symbolic character as a representation for abstract social problems (see Pearson and Uricchio 1991), like the Joker symbolizing chaos or the Kree signifying foreign terrorists. But where the Joker is repeatedly jailed by Batman and the Kree are easily repelled by the Avengers, Kilgrave's enactment of misogyny is depicted as thoroughly embedded as part of our society. Dealing with Kilgrave / sexual assault takes more than just a superpowered punch. As Shana MacDonald notes, "Kilgrave's use of mind control to capture and constrain women as unwilling intimate partners speaks directly to the normalization of rape culture, violence, and control of women's bodies. The women Kilgrave takes as companions are turned servile, complacently performing an obedience that masks their lack of consent behind forced smiles" (2019, 74). Kilgrave's use of his powers for personal and sexual gratification marks him as a relatively atypical character. The only similar story arc occurred in *She-Hulk* #6 and #7 (2013), where it is revealed that the smarmy ex-Avenger Starfox uses his ability to inspire a feeling of euphoria to rack up sexual conquests with unsuspecting women (including She-Hulk years earlier). Starfox is put on trial but escapes before he can be found guilty. The villainy of Kilgrave (and to a lesser extent, Starfox) remains rare precisely because it exposes the gender-based injustices that are normalized in our society. In fact, Kilgrave's status as a bad guy can be seen as an affront to the basic masculine fantasy offered by the superhero story—a fantasy that incorporates an image of heterosexual success, of beautiful women throwing themselves at the feet of the all-powerful man.

Other superheroes and supervillains have powers similar to Kilgrave's (and Starfox's) but rarely use them to sexually abuse people. More typically, the ability to control others, be it through telepathy, pheromones, or magic, is coded as a feminine power linked to their seductiveness. As discussed in chapter 2, heroines and villainesses like Emma Frost, Jean Grey, Karma, Lady Mastermind, Martinique Jason, Persuasion, Satana, Circe, Natalia Knight, Charma, Crimson Fox, Dream Girl, Aresia, Venus, and Seductress are all able to turn men into slaves. The sexy super women signify an obvious level of castration anxiety for men. The X-Men's mutant heroine Rogue, for example, can steal anyone's powers through a single touch. The Gotham City villainess Poison Ivy is able to control anyone through chemical manipulation. Importantly, both Rogue and Poison Ivy (and many of these other women) use their powers primarily against men and

usually make contact with a kiss. Though these women represent a masculine fear of seductive femme fatales, they rarely use these powers for their own sexual pleasures. In superhero stories, men are reduced to fools when they are controlled by women; but women are made victims when they are controlled by men.

Though rape has been predominantly framed in the media, and in our culture at large, as a violent sexual act perpetrated by men against women, the reality is that as an assertion of power, anyone can be a rapist or be raped, regardless of gender or sexuality. Surprisingly, this is an area where superhero comics have progressively suggested that even the most stalwart and hypermasculine of characters can be victimized. In the current comic book era, male characters, including Batman, Green Arrow, Invincible, and Nightwing, have all been sexually assaulted by women. "Interestingly, these assaults are not portrayed as rape," argue Garland et al. in relation to the rape of men in comic books. "Instead, these instances are generally minimized and are used as a subplot to explain the birth of a child" (2016, 59). Indeed, both Batman and Green Arrow were "taken advantage of" while injured and drugged because the villainesses Talia Al Ghul and Shado, respectively, wanted to conceive their children. But where the cases of Batman and Green Arrow are somewhat unclear (neither hero was capable of consent to the intercourse or the pregnancy but their recollections of the events are foggy, and both heroes had previously been in consensual sexual relationships with their attackers), the cases of Nightwing and Invincible are unquestionably depicted as rape. When Nightwing (the former Robin, Dick Grayson) is physically exhausted and concussed after a fight in *Nightwing* #93 (2004), the mysterious femme fatale Tarantula pins him down on a rain-swept rooftop. "Don't touch me, I'm . . . ," the groggy Nightwing protests. But Tarantula tells him to relax, everything will be OK, as she removes his clothes and mounts him. After the encounter, Nightwing is left confused and angry, with feelings of guilt and betrayal. Even more graphically, in Robert Kirkman's Image series *Invincible* #110 (2014), the young Superman-like hero Invincible is brutally attacked by the alien Anissa after he refuses to have sex with her. Anissa insists, and the two trade punches flying through the sky until she gets the upper hand and slams Invincible to the ground hard enough to make a crater. As Anissa forces herself on the hero, Invincible repeatedly tells her "no . . . leave me alone . . . I don't want this" and struggles to free himself as she rips off his costume. "I don't care what you want!" Anissa declares. "And besides . . . it doesn't feel like you are so sure yourself" (figure 8.5). The implication here is that his involuntary erection is evidence that he really wants to be assaulted. But the violent depiction of the sexual act, and the image of a naked, battered, and crying Invincible left huddled in the crater afterward, leaves no room for doubt.

The rape of male superheroes is a complicated narrative device. The notion that even a Batman can be taken against his will, assaulted, and sexually exploited risks exposing the fantasy of hypermasculinity at the core of the genre as nothing more than the carefully crafted facade it is. The fact that modern comic books

FIG. 8.5 *Invincible* #110, 2014, Robert Kirkman and Ryan Ottley

are willing to suggest the vulnerability of icons of hegemonic masculinity is an indication of how far the industry has come in terms of evolving gender politics. In general, the rape of male heroes effectively contributes to the emotional trauma that rationalizes the characters' need for vengeance. Still, the examples of these four superhero rapes (Batman, Green Arrow, Nightwing, Invincible) are all tempered in overlapping ways. The most obvious commonality is that all of these rapes are female on male, rather than the more statistically common male-on-female assault. Moreover, all four of these assailants are illustrated as desirable women, ones that the heroes have had previous consensual relationships with (the exception being Invincible, but even he admitted an attraction for Anissa in an earlier issue). While this fact does not negate the nonconsensual nature of all the rapes, it may allow male readers to indulge in the imaginary identification of being so desirable that beautiful women will be driven wild with lust. The stakes are different for male readers than for female ones, and the sexual dynamics of the rape may be very different as well. In other words, in a twisted sense, the assaults may just confirm the preeminence of the hero's idealized sexuality. For example, when Talia Al Ghul informs Batman that he fathered her child in *Batman* #656 (2006), she asks, "Have you forgotten that night you and I shared under the desert moon above the Tropic of Cancer?" Batman claims only to remember "being drugged senseless and refusing to cooperate." Talia explains: "We chose you, the *perfect* man, to breed the perfect heir to the empire of Ra's Al Ghul." Then, in a clear nod to his sexual skills, Talia adds, "And believe me, you cooperated . . . *magnificently*." Yes, Batman is so manly that even when he is drugged and assaulted, his sexual performance is *magnificent*. Curiously, all these female rapists are also depicted as exotic Others (Talia Al Ghul is Middle Eastern, Shado is Japanese, Tarantula is Latina, and Anissa is an alien Viltrumite), while all the male victims are traditional superheroes—in other words, white heterosexual Americans. However subtle, there is a racial dynamic at work here that regards nonwhite women as dangerous to white men. As exotic Others, these women present both a sexual temptation and a sexual threat to the stalwart male heroes. Characters like this reinforce a stereotype of nonwhite women as vamps,

dragon ladies, and succubus. They figuratively, and in some instances literally, suck the life essence from the men.

Rough Sex and Dangerous Partners

Though rape is becoming an increasingly common form of sexual assault explored in comic books, it is not the only one. IPV has also become a topic addressed in superhero relationships, and like rape, it is undermined by the way the genre typically portrays sexuality and violence. Introducing a special issue of *American Literature* focused on gay and lesbian themes in comics, Darieck Scott and Ramzi Fawaz declare, "There's something queer about comics" (2018, 197). I will return to nonheteronormative sexualities later, but for the purposes of this chapter, I think it is fair to add that there's also something inherently *kinky* about superheroes. All those muscular men and shapely women running around after dark in masks and tight leather outfits, the BDSM overtones of the genre are difficult to ignore. In an earlier book exploring the cultural significance of Batman, I described the Dark Knight's consensual sexual encounters as falling into two distinct categories typical of modern comic book sexuality: lascivious or amorous. "Heterosexual encounters are portrayed as either lustful, aggressive and dangerous (*lascivious*), or romantic, affectionate and vulnerable (*amorous*)" (Brown 2019, 60). Though amorous sexual trysts do occur in superhero stories, they are far outnumbered by lascivious encounters.

One particularly notorious example of kinky and potentially dangerous sex occurred in *Catwoman* #1 (2011) when Batman confronts the feline fatale on a rooftop. "He tastes like metal," Catwoman thinks as she jumps him. "He uses an ointment or something to keep his exposed flesh safe. I've grown to like it. A lot." Catwoman's narration as they entangle makes the confluence between violence and sex clear: "I don't think he knows who I am. Although he is the master detective. So, maybe. But I sure as hell don't know who Batman is. And I don't need to know. This isn't the first time. Usually it's because I want him. Tonight, I think it is because I need him. Every time he protests. Then, gives in. And he seems angry. But that doesn't slow either of us down. Still, it doesn't take long—and most of the costumes stay on." The second issue starts with a collage of clenched teeth beneath cowls and leather gloves on bare flesh. Catwoman describes the sex as consensual but rough: "I'm trying not to be crude, but it plays out a lot like a bar fight. Bodies get hurled around. Things get broken. Some pretty filthy language is uttered. Some very misplaced anger is present. And tomorrow, there's definitely going to be some bruising." Conversely, in the two-part storyline in *Batman* #14 and #15 (2017), Batman and Catwoman have an emotional and heartfelt amorous encounter after a night of fighting crime together. In this case, they tenderly remove their masks and embrace a real connection rather than a violent clash of bodies. The softer, more amorous rooftop sexual encounter in *Batman* #14 and #15 was in direct contrast to the lascivious

scene featured six years earlier in *Catwoman* #1 and #2. The uncharacteristic tenderness of the moment marked a significant shift in Batman and Catwoman's relationship—a change so dramatic that it led to their engagement just a few issues later and an embrace of a more mature relationship, both sexual and professional.

The superhero genre revolves around episodes of spectacular violence and extreme physical confrontations. This predilection for brutality extends to lascivious sexuality and blurs the line between an acceptable norm of comic book violence and an uneasy depiction of sexual violence as normal. Lascivious physical relationships between costumed characters are almost as commonplace as hero versus villain fistfights. They can begin as simple antagonistic (but flirtatious) banter, or as outright punching each other as a type of foreplay. Moreover, these aggressive sexual encounters can happen between couples who have known each other for years, or between characters who have just met. In *Green Arrow and Black Canary: The Wedding Special* (2007), when Green Arrow and his fiancée Black Canary argue about battle strategy, the insults become personal and he accuses her of having slept with the entire U.S. Navy. Canary slaps him across the face and then in a wordless full-page sequence, illustrated by Amanda Conner, the rage of the two heroes quickly turns to passion as they fall to the floor and start ripping clothes off. Apparently, for some costumed avengers, a fight can function as a type of superhero foreplay. Green Arrow and Black Canary have been an on-again, off-again couple for decades, but similarly passionate scenes can occur between heroes who barely know each other. In *The Amazing Spider-Man* #4 (2014), for example, the mysterious Cindy Moon (a.k.a. Silk) is discovered by Spider-Man and the two web-themed figures almost immediately start fighting across the rooftops of Manhattan. Suddenly, just as Silk is about to punch Spider-Man in the face again, they are both overcome by spider hormones and, pressed against a brick wall, begin making out (figure 8.6). The following issue begins with both of them nearly naked rolling around on top of each other before they are forced to pause. Still, over the course of their adventure together, and whenever they come into contact with each other down the road, Spider-Man and Silk immediately go into "heat." They cannot keep their hands off each other . . . even when they argue.

The cliché of impassioned fighting that quickly shifts into passionate sex is not unique to superhero comics. Similar scenes are played for laughs on sitcoms, to heighten the tension in spy movies, or to prove emotional intensity on soap operas. The difference with superheroes is that this type of lascivious moment links the genre's core themes of violence and gender through sexuality. Regardless of the genre or the medium, the frequency of these moments where fighting becomes sex perpetuates a cultural belief that this same type of weirdly "magical romantic passion" underlies real-life arguments. Like romantic comedy films where stalking and obsession can be rewritten as a form of charming or endearing persistence that deserves to be rewarded (as long as the character looks like

FIG. 8.6 *The Amazing Spider-Man* #4, 2014, Dan Slott and Humberto Ramos

Matthew McConaughey or Ryan Reynolds), the trope of libidinous sex in super-hero stories helps affirm a very dangerous counternarrative regarding sexual violence. The cumulative message from these superheroic lascivious sexual encounters models a regressive gendered ideology. The inference for readers or viewers is the following: yelling, slapping, and punching may just turn the other person on, "no" may mean just force her or him to give in, and physical, mental, or emotional abuse may just be an indication that the other person really does care deeply for you.

Given that the superhero genre revolves around the frequent violent clashes between incredible figures, any depiction of romance and sexuality seems des-tined to become intertwined with brutality. While rape and other forms of sex-ual assault do occur periodically within superhero stories, these incidents are clearly marked as vile acts that need to be avenged with the perpetrator being savagely punished. Rape is unequivocally categorized as an abhorrent crime for crime fighters to battle with their fists. For the most part, the ideology of super-hero stories is comfortable with clearly demarcated boundaries of right and wrong, good and evil, moral and immoral. In this binary logic, rape is easy to position as wrong, evil, and immoral. But violence between intimate partners is harder to address in a genre where everyone is punching or blasting each other all the time anyway. Compounding the difficulty of abusive relationships in the comics is the commonly depicted lascivious sexuality of the caped crusaders and their sexual partners.

Like other mediums, comic books typically misrepresent or skew IPV for the sake of the story. As media forms that are read, watched, or listened to by mas-sive audiences, depictions of abuse often perpetuate false assumptions about IPV. In her analysis of domestic violence in Hollywood movies, for example, Phyliss Frus argues, "Films reinforce the view that woman battering is the victim's prob-lem, express 'commonsense' notions about how to end battering—such as the idea that women can simply leave—equate violence with sex as part of 'normal' love" (2001, 227). Moreover, Frus concludes, movies "are apt to depict violence against women or children in their homes as abnormal, not as the everyday real-ity it is, and the men who beat or torment them as psychotic or in other ways deviant. And they often sensationalize or eroticize the incidents and the victims in order to attract audiences" (227). Superhero stories similarly perpetuate ste-reotypes about IPV that make it more palatable as a form of fictional drama. In their review of the instances of IPV in comic books, Garland et al. (2019) assert that superhero stories reinforce numerous misconceptions, including that IPV only consists of physical violence, that injuries need to be visible, that only men are perpetrators and only women are victims, that only women who are financially dependent on men are victimized, that the men are clearly evil and psychotic, that victims can leave or fight back at any time, and that a failure for women to do so implies that they somehow like or deserve the ill treatment.

The first clear incident of domestic abuse in superhero comics occurred between Hank Pym (Ant-Man) and his wife Janet van Dyne (the Wasp) in *The Avengers* #213 (1981). Despite being one of the few married superhero couples at the time, Hank and Janet had always had a problematic relationship. For example, there was a running gag for years that whenever Hank was too focused on his scientific research, Janet would openly flirt with other male heroes in order to make her husband jealous. Or Hank would threaten to withhold his superpowered inventions from Janet unless she acquiesced to his wishes. But when Hank (who was going by the moniker of Yellowjacket at the time) is on the verge of being kicked out of the Avengers for erratic behavior, Janet tries to stop him from building a robot to attack his own team; in his anger, he punches Janet and sends her reeling. This "wife beater" incident, as it came to be known among fans, led to Ant-Man's expulsion from the Avengers, his eventual divorce, and a persistent reputation for the character as an abusive spouse and/or a potential supervillain despite numerous reboots. The theme was revisited in the prestige format *Ultimate Avengers* (2004), with a greater emphasis on the brutality of the assault. Hank, frustrated by his limitations as an Avenger and by Janet's desires to impress Iron Man and Captain America, starts yelling at Janet. When she insults Hank as less of a hero than the other men on the team, and as less of a scientist than Bruce Banner (the Hulk), he slaps Janet. The two exchange numerous blows until Janet shrinks to wasp size to try to escape, but Hank douses her with poisonous bug spray and then commands hundreds of ants to attack her.

IPV also became a significant plot point for Black Cat when she is assaulted by her ex-lover, Spider-Man. In a complicated turn of events that can only happen in the fantastical world of superhero comics, Peter Parker dies, and for a period of time the evil and arrogant Dr. Otto Octavious (a.k.a. Doc Ock) puts his own mind in Peter's body and tries to prove that he can be a better Spider-Man than Peter ever was. The aptly titled series *The Superior Spider-Man* (2013–2014), written by Dan Slott, featured the Doc Ock version of Spider-Man ruthlessly fighting crime. In *The Superior Spider-Man* #20 (2013), the Doc Ock Spidey happens upon Black Cat exiting a rooftop skylight. "Oooh. Along came a Spider," Black Cat purrs seductively. "And here I thought tonight was going to be all work and no fun." When this Spider-Man does not flirt back, Black Cat asks, "Why so formal, lover? Long time no . . ." But before she can finish her sentence, Spider-Man sucker punches Felicia in the mouth and knocks her off the roof. "A tooth! You just cost me a tooth!" the bloody and surprised Black Cat screams. "What the hell are you doing?" The superior Spider-Man simply replies, "Apprehending a criminal. I'm Spider-Man. This is what I always do." As Spider-Man webs her to a wall for the police to pick up later, Black Cat protests, "I can't believe you'd . . . We always had a way of dealing with this. A dance. A back and forth . . . I won't forget this Spider. Ever." This shocking moment of betrayal by someone Black Cat believes is her former boyfriend pushes her to embrace

villainy. As disturbing as this scene may be to readers, it is also alarming that the comic's cover depicted a sexy embrace between Black Cat and Spider-Man. Furthermore, this issue was released with two variant covers: one by J. Scott Campbell featuring Black Cat erotically squatting on a ball of yarn adorned with Spider-Man's face; the other by Adi Granov with Black Cat seductively posed on a slanted roof with Spider-Man's mask in her claws. Even in an issue where the only contact between Spider-Man and Black Cat is a violent and unprovoked assault, the covers exploited Black Cat's sexual currency.

A similar scene occurs in the series *Symbiote Spider-Man* (2019), written by Peter David and illustrated by Greg Land, another artist known for his sexy illustration of female characters. The series is a revisioning of one of Spider-Man's earlier periods when he donned the infamous black costume in the 1980s, unaware that the costume was made of an alien symbiote that was slowly taking over Peter Parker. At this point Spider-Man and Black Cat are lovers, and much of the story is focused on their flirty banter and sexual trysts. In a battle with Mysterio, Spider-Man becomes increasingly frustrated until the symbiote asserts control and attempts to kill Mysterio. When Black Cat tries to talk Spider-Man out of using lethal force, he brutally knocks her away. The narrative feint used to deflect responsibility for Spider-Man's unprovoked violence against his intimate partner in both of these examples is that "someone" or "something" else was in control of his actions. In the kind of stories that can only occur in comics, the assault of Black Cat may come through Peter Parker's body, but the real assailants were Doctor Octopus and the alien symbiote. While this narrative twist allows Marvel comics to feature physical conflicts between Spider-Man and Black Cat without actually tainting its flagship character as abusive, it does literalize the oft-heard excuse offered by abusers and some of their victims alike, that the person was "not themselves" or "not in control." The fact that readers are aware that the real IPV perpetrators were Doc Ock and Venom reinforces the myth that only clearly evil men (i.e., supervillains like the Joker) are victimizers. As Garland et al. argue, "Perpetrators have often been characterized as *evil* to justify abusive behaviors as those who are *of the devil* clearly have no control over their actions (2019, 590; italics in original). Conversely, in an earlier story from *The Spectacular Spider-Man* #226 (1995), Peter accidentally hits Mary Jane, his pregnant wife, while fighting with one of his clones. Without the excuse that "someone else was in control," the moment was regarded as a low point in Spider-Man's history and has since been retconned out of existence.

The most complicated and longest-running comic book relationship based in IPV is the romance of the Joker and Harley Quinn. Since her debut in the first season of *Batman: The Animated Series* (1992–1995), Harley Quinn has become one of DC's most profitable characters. The inclusion of Harley as part of the Joker's gang, and as his on-again, off-again girlfriend, was designed to counterbalance any queer implications of the Joker's flamboyancy and his obsession with Batman. Despite the violence that has defined the Joker and Harley Quinn's

relationship from the very start, ranging from cartoony slapstick to realistically gruesome, they have become one of the most famous fictional couples. In addition to the countless stories about the Joker and Harley's volatile romance, their coupling is celebrated by fans through fan fiction and art, cosplay, and a plethora of merchandise from such retailers as Hot Topic, Spenser's, and Box Lunch emblazoned with "I Love Puddin!" or "He's my Joker." "Their problematic relationship is well-loved, in part, thanks to the Joker's iconic status, but also due to Harley's own compelling characterization," argues Anastasia Salter in her study of how fans received the *Suicide Squad* (2016) movie. "While she began as an accessory, imitating Joker in style and origin, she has grown into a fully-fledged villain and antihero of her own" (2020, 136). From the outset, though, the Joker and Harley dynamic has been based on his frequent physical, psychological, and emotional abuse of her. Originating in a children's cartoon meant that the first instances of the Joker and Harley were in the vein of slapstick humor—more *Punch and Judy*, *Tom and Jerry*, or Bugs Bunny and Elmer Fudd than real-life IPV. "In keeping with their carnivalesque criminal personas, the Joker and Harley imbue instances of abuse with theatricality," argues Tosha Taylor in discussing their gender attributes, "which, on one hand, may serve to lighten their violence by assuring the reader that it's 'only a joke,' while on the other hand adding a layer of grotesquerie absent in violence enacted by any other character" (2015, 83). But as Harley Quinn grew in popularity, the stories began to explore the abusive nature of the relationship unequivocally.

Despite having begun in a children's cartoon, the physical violence that defines the Joker-Harley dynamic has been embraced by some fans as a passion based in a mutual BDSM-style relationship. Certainly, Harley is a violent psychotic in her own right, often portrayed as just as dangerous as the Joker. By the time the pair were first depicted together in the live-action movie *Suicide Squad*, the underlying tones of the relationship were outed as fairly obvious fetishisms. Salter clarifies, "The film recasts Harley and Joker's relationship with heavy allusions to visual iconography and costuming associated with BDSM or dominant-submissive relationships conducted under guidelines of consent" (2020, 142). But the degree of "consent" inherent in most depictions of the Joker and Harley is debatable. She is usually on the receiving end of the violence despite only wanting to make "Mr. J," her "Puddin'," happy. The excessive violence endured by Harley, who always returns for more, has marked her until recently as a deserving victim who refuses to walk away. For example, in *Mad Love* (1994), Joker repeatedly screams at Harley, drags her down a flight of stairs, punches her, throws her into a pile of garbage in a dirty alley, tries to impale her with a swordfish, and throws her out a fifth-floor window. But even as Harley is recovering in the hospital with numerous broken bones and regretting her submissiveness, a simple note from Joker puts her right back into his thrall. As Tosha Taylor observes, Harley's submission to the Joker in *Mad Love* is emblematic of real-world IPV in which "the male perpetrator assumes dominance through

emotional and physical subjugation of the female object, who in turn accepts the abuse as her fault and, out of her own affection for him, forgives her abuser at the slightest sign of repentance" (2015, 87). In the first issue of her own series, *Harley Quinn* (2000–2004), the Joker shoots her in the stomach, but Harley thinks that is just an indication of how much he loves her. In *Gotham City Sirens* (2009–2011), Harley teams up with Poison Ivy and Catwoman and swears she is done with the Joker, though she perks up like an excited puppy anytime his name is mentioned. By the third issue of the series the Joker is trying to kill her for going on a date with another man (she takes it as proof he still loves her), and by the end of the series Harley enthusiastically goes back to being the Joker's girlfriend. This pattern is repeated over and over again, in different series, and different media platforms.

Increasingly, the slapstick nature of the Joker-Harley pattern of violence has given way to more gruesome encounters. In *Suicide Squad* #14 (2012), for example, the Joker returns to Gotham, and even though Harley is excited to see him, he greets her with a brutal sucker punch, threatens to cut off her face, chains her in a pit with decaying corpses, and tries to strangle her. Occasionally Harley has tried to fight back, but Joker has always maintained control over her. "Without question, Harley often engages in violent behavior against the Joker, but this is simply a means of self-protection as the Joker has tortured and attempted to murder her repeatedly," argue Garland et al. "In essence, Harley's behavior may be depicted as retaliatory against her true love, the Joker, but it is simply a mechanism of survival as it is he who consistently maintains the power in the relationship. One minute he tries to kill her, and in the next, he is sending her roses although sometimes they may be armed with dynamite. As a result, he is able to manipulate and control Harley at will regardless of whether the manipulation is emotional or violent" (Garland et al. 2019, 596). The Joker-Harley relationship has, for most of its history, depicted Harley as the imagined "deserving victim" of IPV because she always forgives him, does not leave or defend herself, and even repeatedly assumes the beatings are her own fault for not "getting the joke."

Harley Quinn's status as a "deserving victim" of IPV, or as a willing participant in a romance based on IPV, reinforces the broader stereotype about people in abusive relationships. Harley's role as victim to Joker's abuser is compounded by the basic premise of the superhero genre where characters are capable of using physical violence to solve any problem. When regarded as a deserving victim who does not fight back against her abuser, Harley perpetuates the misguided logic that those trapped in a serially abusive relationship "get what they deserve." The fact that Harley is capable of besting Joker in a physical confrontation (she even has moderate superpowers now, thanks to a chemical treatment from Poison Ivy) but doesn't confirms the notion that she "deserves it" for readers who believe a retributive punch can fix anything in Gotham City. Harley Quinn writers, such as Paul Dini and Amanda Conner, do not imply that she is a deserving victim; they are cognizant of the psychological and emotional manipulation that factors

into Harley's continued abuse. But superhero fans may expect a more proactive solution from Harley for her own problems, a heroic sense of self-agency from a costumed character. K. Scarlett Harrington and Jennifer A. Guthrie argue, "Harley's extraordinary abilities automatically give her some notion of agency whereby she has the capacity to act against her abuser. When Harley does not act in the way expected of agents, she cannot be defined as agents in their IPV situations, regardless of her superpowers. The preexisting notions of agency place Harley in a double bind because her abilities automatically determine that she has the capacity to act and is therefore not a pure victim" (2017, 63). According to this line of thinking, a "pure" victim has no agency, no recourse to violence, and since Harley is capable of violence herself, she must be a "deserving" victim. And, by implication, so must anyone who is trapped in a relationship with IPV.

But Harley Quinn is no longer just the Joker's girlfriend. Harley now headlines both her own monthly comic book series and the current iteration of DC's *Suicide Squad*, makes regular guest appearances across all of the DC comics, and has her own feature film, her own cartoon program, her own book series for young readers, and numerous prestige-format limited comic book series, as well as a thriving merchandising line with hundreds of products. As Harley Quinn has become an increasingly popular character, she has been reformed from a villain's assistant to an independent antiheroine. The revisioning of Harley Quinn has involved untangling her narrative dependency on the Joker, as well as removing her from the role of "deserving" victim of Joker's violence. Though Harley's love for Joker may wax and wane as storylines need it, the character has been granted an increased sense of agency where she has, in true superhero fashion, successfully fought back and triumphed over the Joker.

Harley's assertion of autonomy and her refusal to play the victim have occurred in a number of contexts, from her children's cartoon to her R-rated feature film *Birds of Prey, and the Fantabulous Emancipation of one Harley Quinn* (2020). Perhaps the clearest example came in *Harley Quinn* #25 (2016). As Harley explains to her current boyfriend, as she is breaking him out of jail, "There was a time in my life, way back when, that I'm not especially proud of. I lost my way an' put my heart an' trust into someone so dark and twisted. . . . Well, when I was with him, I had nowhere ta go but up. It's why I left Gotham, an' started a new life in Brooklyn, with a bunch of good, supportive, real friends. People who had my back." The Joker taunts Harley from his neighboring cell: "C'mon, you just can't help but fall for me over and over."—"Open this door now, you red and black bimbo! I made you who you are today! Don't forget it." Harley enters Joker's cell and they begin to punch and kick each other. Joker slams Harley's face into the wall, and she bites off his bottom lip. As Harley gets the upper hand, throwing Joker to the floor and stomping on his face, she tells him, "I hate ya fer what ya bring out in me. All I wanted to do was talk to you an' here we are muckin' around with each other's marbles and poundin' each other to a pulp, as usual. 'Cause every time we get together, that's what we do. It's not my thing. I don' like it.

FIG. 8.7 *Harley Quinn* #25, 2016, Amanda Conner, Jimmy Palmiotti, and Chad Hardin

An' I'm done with it." Then in an enlarged frame with Harley holding Joker's bloody head by his green hair, her fist cocked to punch him again (figure 8.7), she declares, "I'm not yer toy anymore. Unnerstand? You did mean somethin' ta me one time, but that time is over." Without ignoring the history of IPV that exists between Joker and Harley, this scene erases her status as a victim ("deserving" or otherwise), gives fans a cathartic moment of Harley's self-rescue from an abusive relationship, and acknowledges the depression that trapped her in the first place, the hard work involved in removing herself from the Joker, and the importance of a support network.

This revision of Joker and Harley's relationship still falls within the conventional boundaries of superhero action. Just as the Joker embodies the abstract idea of chaos in a single character that Batman can decisively overcome with a powerful punch to the jaw, in stories like the one described above from *Harley Quinn* #25, the Joker personifies an abusive partner that Harley can likewise defeat with a few well-placed punches and kicks. The aspiration that Harley (and by extension anyone else) can simply fight her way out of an abusive relationship conforms to comic book ideas of violence as the solution to almost any problem. Moreover, it is a symbolic refutation of IPV that is all too often normalized in the media. The conciseness of this symbolic moment of Harley's redemption from Joker's abuse is presented in other stories as a longer process of emancipation, a process that is more realistic for most survivors of IPV. In the HBO cartoon *Harley Quinn*, and at various points during her solo comic book series, Harley is shown struggling to free herself of Joker's influence and slowly building up the fortitude to stand on her own. Furthermore, this new Harley who sticks up for herself (and for less powerful people as an unconventional superheroine) models the complex ways that victims may escape from IPV. If Harley Quinn can stay out from under the Joker's abusive thumb, there is hope that the superhero genre can rewrite what is normal and not normal for gendered violence without giving up some of the format's basic thrills.

9

Pleasure, Pain, Climaxes, and Little Deaths

■■■■■■■■■■■■■■■■■■■■■■

An early scene in *New X-Men* #118 (2010), written by Grant Morrison and illustrated by Frank Quitely, became an infamous example of comic books crossing the line into explicitly adult themes. In the story, bigots waving antimutant placards and shouting genetic slurs protest at the gates of the Xavier Institute for Higher Learning. As Scott Summers (Cyclops) and Jean Grey attempt to argue on behalf of mutants to the gathered reporters, the crowd suddenly gets distracted and less angry. The protesters shake and grin nervously, some grimace and collapse. "Emma!" Jean shouts at her colleague Emma Frost, a powerful psychic mutant. "I pushed their *bliss buttons*, Jean," Emma replies as she struts away. "They'll wake up utterly ashamed of themselves. Don't say another word." Emma Frost apparently used her superpowers to create instant orgasms for an entire crowd as a means to disperse them. Some fans praised the scene as a novel and humorous use of her psychic abilities; others regarded it as a disgusting and unnecessarily provocative violation. Though this is just a minor scene with no real bearing on the central story, it does suggest the odd confluences possible regarding issues of sex, violence, and representation in superhero stories. This chapter considers the role of orgasmic release, both literal and metaphorical, as a narrative and visual theme that links together issues of gender, sex, and death within the phallic economy of the superhero formula. The superhero genre is all about fantastic bodies, the amazing things they can do, and what those bodies symbolize. The genre has developed specific conventions to signify the interior emotional state of the hero through his or her body, be it rage, love, or sadness.

The superhero genre has extended those visual conventions to represent extremes of pleasure in ways that overlap, and sometimes overshadow, more conventional themes like violence or anger. Moreover, the nearly indistinguishable difference between pleasure and pain, between an explosive orgasm and explosive powers, reveals ongoing insecurities about women and their bodies. This theme also exposes an obsession with the fragility of masculine strength and the need for heroic climaxes, both physically and narratively.

Despite the current popularity of everything superhero, the genre is still regarded by many critics as one of the lowest forms of entertainment. Comic books remain stigmatized as a children's medium, or the domain of nerdy and immature men. Graphic novels may be marketed as a more prestigious format, but they are often derided as neither literature nor art. And the blockbuster movies are dismissed as formulaic spectacles rather than serious cinema. While all of these points are certainly debatable, and premised in long-standing cultural assumptions about what constitutes artistic merit, quality, and social significance, the fact remains that the superhero genre is classified as a lower form of commercial media. One of the reasons the superhero remains mired as a lowbrow form of entertainment is the genre's central obsession with bodies. Perfectly muscled and perfectly curvy bodies, bodies that defy gravity or the laws of physics, bodies that literally erupt with fantastic energies, bodies that can change shape, be swapped, turn into stone, ice, fire, diamonds, or sand. Bodies that are put on display, that are eminently visible even while in disguise. The superhero body functions as a locus for the genre to explore, reinforce, and sometimes challenge cultural ideas of gender, sexuality, love, violence, racism, and power. The centrality of the body in superhero stories situates them as lowbrow entertainment alongside other bodily focused genres like horror, melodrama, and pornography.

Linda Williams's landmark essay "Film Bodies: Gender, Genre, and Excess" (1991) links together the genres of pornography, "the lowest in cultural esteem," and gross-out horror, the "next to lowest" (3), with the emotionally wrought melodrama to emphasize the focal point of the body, especially the female body, as a site/sight of physical expression, even ecstasy. Williams notes that all three of these genres revel in the spectacle of "a body caught in the grip of intense sensation or emotion" (4). Specifically, the "body spectacle is featured most sensationally in pornography's portrayal of orgasm, in horror's portrayal of violence and terror, and in melodrama's portrayal of weeping" (4). Williams argues that in each of these low genres, the "ecstatic excesses could be said to share a quality of uncontrollable convulsion or spasm—of the body 'beside itself' with sexual pleasure, fear and terror, or overpowering sadness" (4). The superhero body functions in a similar manner to visually express emotions and feelings that exceed description and, in fact, exceed the body's ability to contain them. Superheroes are a genre of emotional and physical excesses converged on the body. The typical superhero adventure incorporates the terror of horror and the tragedy of melodrama alongside other excesses like the thrill of action, the wonder of science

FIG. 9.1 *Batman and the Outsiders* #1, 2019, Bryan Hill and Dexter Soy

fiction, and the passion of romance. Though it may seem anathema to the super-hero's stoic bravery, these caped crusaders are often depicted in fear and pain, as in horror, and in tearful grief, as in melodrama. Even orgasm, which at first blush would seem out of place in the superhero genre, is depicted and suggested through symbolism and metaphor, and at times directly.

These emotional extremes that overwhelm the body and are expressed through the body, in horror, pornography, and melodrama, are repeated, combined, and exaggerated in superhero stories. The central themes of the superhero (gender, sexuality, and power) are not just displayed on the body of the superhero, they are presented overwhelmingly *through* the body. The genre employs narrative and visual conventions to signify bodily excesses as devastating and ecstatic, as feared and desired, as uncontainable but purposeful. Though superhero bodies are often bulletproof, impenetrable, or made of rock, steel, or iron, many superhero bodies are also explosive—capable of transforming, expanding, igniting, blasting, and shooting. As Scott Bukatman has argued, superhero bodies are "traumatized, eruptive bodies . . . that continually threaten to overspill their fragile vessels" (1994, 115)—for example, the Human Torch's flames, Iceman's snowy spray, Captain Marvel's energy blasts, and Black Lightning's electric bolts (figure 9.1). Even Superman, the Man of Steel, is capable of discharging physical energy from his body with powers like heat vision and freeze breath. Superheroes rarely need to use anything as mundane as a gun because their bodies are the weapon. Any type of energy can be shot straight from their bodies, be it physical, mystical, or psychic. Guns have obviously doubled in popular culture for phallic appendages, most clearly with action movie icons like Dirty Harry, Rambo, and James Bond. As Barry Keith Grant summarizes in relation to action films, there is a "conventional association of the gun with the phallus, exploring the representation of

the gun as a totem of masculine power" (2004, 377). A similar masculine economy is in place with superheroes, but with costumed avengers the phallic body replaces the phallic gun.

These incredible powers that erupt from the superheroic body are part of what consolidates the hero's hegemonic masculinity and phallic symbolism. Chapter 1 addressed the phallic nature of the superhero's masculinity at the axis points of costumed identity and secret identity, visible and invisible, powerful and powerless. And chapter 2 discussed how female sexuality functions within the genre as a castrating threat that can symbolically rob a man of his powers, his free will, his very self. But the excessively symbolic nature of the superhero further signifies sexual elements in the way that bodies are depicted as unable to contain themselves. Just as the body screams, convulses, and weeps uncontrollably in horror, pornography, and melodrama, the superhero body explodes with passions and powers that cannot be contained. The superhero's initial steps may be about learning to control his powers (hence all the training montages in contemporary superhero movies), but as often as not the hero's powers erupt as an expression of overwhelming emotions: the Hulk smashing everything in sight out of anger, the Scarlet Witch committing magical mutant genocide in anguish over her lost children, Cyclops unleashing his optic blasts in rage every time a girlfriend is injured or dies, Green Lantern exploding as an emerald-hued nova in a desperate attempt to stop Sinestro. The excessive physical reaction of the superhero is clearly in line with Linda Williams's observation about bodies "beside themselves" and "out of control" in other genres "with sexual pleasure, fear and terror, or overpowering sadness" (1991, 4). Audiences do not need to be familiar with Freud to perceive the sexual implications of all these super bodies blasting and thrashing and exploding. In fact, the genre uses very clear visual conventions to present orgasms as synonymous with superpowers, thus uniting the genre's central themes of gender, sex, and violence through the body.

The depictions of superpowers and super sexuality often overlap and intertwine in genre-specific ways. For example, the epic battles that make up the centerpiece of superhero adventures—scenes that Mila Bongco has accurately described as "orgies of violence and brutality" (2000, 195)—routinely include dozens of tightly costumed bodies passionately punching and grabbing each other, blasting one another with various energies. Some stories are blatantly self-conscious about the visual overlap between superhero fights and sex. In *Ultimate Wolverine vs. Hulk* #5 (2009), Nick Fury demands to know what happened to the rogue Hulk and She-Hulk. Wolverine tells him, over a montage of the two huge green characters rolling around in the mountains, "Well, Nick. What if I told you this . . . cause even though they thought they had their privacy, I saw the whole damn thing. And I still ain't sure whether they was fightin' or *screwin'*." Within the mainstream superhero comic books, movies, and television series, the link between powers and orgasms has to remain primarily at the metaphorical level. But the association is often brought to the fore in parodies and other forms

that circulate on the fringes of the dominant superhero types. For instance, when comedian Jack Black hosted the *MTV Movie Awards* program in 2002, he re-created the transformation scene from the film *Spider-Man* (2002), starring Tobey Maguire. Black wakes up as Peter Parker and discovers his body has undergone a transformation after being bitten by a radioactive spider. In the movie, this scene makes a direct connection between puberty and becoming a superhero. The MTV parody takes it a step further as Black's Peter spies on the beautiful girl next door, Mary Jane Watson, as she undresses. Suddenly, to his surprise, the aroused Peter shoots spider webs from his penis. The metaphoric slippage between superpowers and orgasms is easiest to understand in relation to phallic masculinity, in much the way Jack Black makes fun of Spider-Man's powers.

Of course, context can make a huge difference between understanding inherent symbolic meanings and just misrepresenting an image's intent. The context of Spider-Man's pubescent fluids spraying all over his bedroom may imply incredible powers or sexual emissions, or both. Though I am including images and stories that incorporate both explicit and symbolic orgasms in this chapter, I do not want to make an argument based on scenes taken out of context. To help avoid this pitfall, I will return several times to the Marvel miniseries *X-Men: Phoenix Endsong* (2005). Written by Greg Pak and illustrated by Greg Land, *Phoenix Endsong* includes numerous moments that link sexuality, orgasms, gender, and violence into a conventional superhero adventure. The series details the return of the all-powerful, celestial Phoenix force that had previously taken over the body of X-Men psychic Jean Grey on the way to killing five billion people across the universe. In a story that has been replayed several times, the X-Men had to kill Jean in order to save the world from the Phoenix. This time, a weakened Phoenix force reanimates Jean Grey's corpse and seeks out X-Men team leader Cyclops, a.k.a. Scott Summers, Jean's ex-husband, in an attempt to absorb his optic blasts and reenergize the Phoenix. The sexual symbolism in *Phoenix Endsong* drives the story, and I will return to it at times in this chapter to illustrate different dynamics. The first issue, for example, clearly invokes the metaphor of uncontainable powers exploding from the body as orgasmic. Asleep in bed with his girlfriend Emma Frost, Scott senses Jean's reanimation and he suddenly screams her name as his optic blasts burst through his protective lenses (figure 9.2). Though the scene is dramatic rather than humorous like Jack Black's Spider-Man skit, Cyclops's nighttime eruption is just as suggestive of the overlap between powers and orgasms.

The blasting and exploding super body is, to put it bluntly, an ejaculating body. The orgasm-like bodily explosions so common in superhero battles are akin to the ejaculatory "money shot" of pornography. In her landmark study of pornography, *Hard Core* (1989), Linda Williams describes the money shot in Marxist terms as evidence of what viewers are paying for, of an actual sexual act and bodily pleasure: "to prove that not only penetration but *also* satisfaction has taken place"

FIG. 9.2 *X-Men: Phoenix Endsong* #1, 2005, Greg Pak and Greg Land

(72–73). The "money shot" is industry jargon for the moment of external penile ejaculation captured on film. Seeing the money shot proves male sexual pleasure as tangible, but there is no obvious equivalent to substantiate a female orgasm (I will return to superheroine orgasms below). The male orgasm marks the conclusion of the sex act as the male performer ejaculates onto the female's body or face. In addition to offering tangible evidence or authentic sexual pleasure, the money shot completed on the compliant woman also signifies a form of masculine dominance and presumed mastery, a conquering. Sun, Ezzel, and Kendall (2017) argue that the external money shot onto the female body or face "is a sexual act largely constructed and popularized through the pornography industry. Second, the act of EOWF (ejaculating on woman's face) induces no apparent physical pleasure in and of itself (beyond masturbation). Thus, the audience's pleasure derived from watching EOWF, fantasizing about it while masturbating, or acting it out with female partner(s) can be argued to be primarily psychological and ideological" (1711). The external money shot has become a conventional means to spectacularize orgasm and provide proof of male pleasure, literally evidenced on the female body.

There is an easy connection between the ejaculating body in the low genre of pornography and the erupting body of the low genre of superheroes. It is no coincidence that the phrase "money shot" has been adopted by other forms of commercial entertainment. There is even a popular comic book series simply titled *Money Shot* (2019–ongoing), in which interstellar scientists fund their exploration of other planets by posting videos of themselves having orgasmic sex with aliens. The phrase is also used for both superhero movies and comic books to describe the culminating moment of the final epic battle, the explosion of heroic fury that finally defeats the villain. The bodily substances may be different materials (semen for porn; fire, ice, and various energy blasts for superheroes), but they serve similar symbolic and economic functions. Both the pornographic and

the superhero money shot are depicted as spectacles, as an achievement, as a conquest, as the body losing control, as a vicarious thrill for viewers, and as the climax of the action.

The pornographic and the superhero money shots are each coded as masculine by default. There has been much speculation in academic and activist circles about the evidentiary possibility of female discharge (a.k.a. "squirting") as an equivalent to male ejaculation, but the presumption remains that only male secretions are physical proof of orgasm. While both male and female characters in superhero stories can blast glowing energies from their bodies, it is still coded as a phallic, aggressive, penetrative act. Despite the hypersexual and hyperfeminine depiction of superheroines—and, in many ways, *because* of this appearance— the equivalent powers that project from their bodies in moments of emotional angst and impassioned battles as energy blasts infer that these women are dangerously phallic. Female characters in the superhero genre are already thoroughly coded as phallic women through the excessive fetishization they are subjected to. As Laura Mulvey has famously established in relation to classic cinema, "Woman as representation signifies castration, inducing voyeuristic or fetishistic mechanisms to circumvent her threat" (1975, 10). In other words, because the female lack suggests a possibility of castration (literally, but more importantly figuratively in that a woman can steal a man's independence and strength), patriarchal culture projects phallic substitutes or fetishes onto women. The obsessive focus on women's specific body parts (hair, legs, breasts) and adornments (high heels, makeup, tight clothing) is a form of phallicization. And, of course, female superheroes, with their tight and skimpy costumes, thigh-high boots, gravity-defying breasts, and long flowing hair, are among the most fetishized depictions of women.

In his analysis of sexual economies, Jon Stratton describes the "fetishistic phallicisation of the female body" as having multiple effects on men and being represented in seemingly oppositional ways on women. Stratton divides fetishized women into either passively phallicised (the damsel in distress, or centerfold type) or actively phallicised (the powerful, aggressive woman). Superheroines fall primarily into the actively phallicised category, which Stratton describes as "the phallic woman who, from a male perspective, reworks the phallic power attributed to her into a spectacle which men experience as threatening to their own, already lacking, feeling of phallic power" (2001, 144). The projectile powers that erupt from the superheroine's body compound her fetishization, her phallic symbolism, and the threat she poses to masculinity, while also positioning her powers as *actively* phallic. From a different angle, superheroines can be understood to perform masculinity within the traditional binary of gender attributes that still categorize strength, action, and violence as masculine, whereas weakness, dependency, and fear are coded as feminine. In this regard, the superheroine is similar to the action heroine of film and television, who, as Yvonne Tasker points out, "has been read as masculinized—a disturbing and potentially disruptive

evocation of the woman who takes action—and as a reassuring sexual spectacle whose connotations of availability undercut her agency" (2006, 420). The strong, active, and capable superheroine is likewise masculinized through her heroic actions and then hypersexualized as a means to offset these traits that confound traditional gender divisions. The projectile energies that erupt from female as well as male bodies among superheroes suggest phallicization, sexual pleasure, and a body beside itself can function the same regardless of gender. But the masculine focus of the genre, compounded by the eroticization of superheroines and super-villainesses, does not give the explosive female money shot as much import as it does the males'. Moreover, women are framed as orgasmic via an entirely different set of signifiers (I will return to these below) that are in line with the frenzy of the visible but are presented as less ejaculatory.

The presentation of superhero sex as hyperbolic, orgasmic, passionate, uncontainable, and uncontrollable can achieve extremes not even imaginable in other genres. When Superman and Wonder Woman make love in *Batman: The Dark Knight Strikes Again* #2 (2002), for instance, the earth literally moves. The ultimate power couple have sex soaring through the skies, into space, and crashing back down into the ocean. Their passion crushes a mountaintop and causes a tidal wave, an earthquake, and a volcano to erupt. Afterward, Wonder Woman compliments him: "Goodness, Mr. Kent, you could populate a planet. I'm pregnant again." Wonder Woman's flattery about Superman's ability to "populate a planet" implies that his impressive masculinity is confirmed by the quality and quantity of his orgasm. Comments like this one (uttered by female characters but scripted by men) reinforce what Corbett and Kapsalis describe as "the quantitative evaluation of male sexual pleasure by means of the money shot ('payoff' measured in amount of ejaculate, force, and distance of stream)" (1996, 103). This extreme example of Superman's godlike sexual prowess bolsters a ridiculous claim to phallic masculinity as spectacular and violent. The implication that superpowered bodies would have superpowered orgasms was first addressed in science fiction writer Larry Niven's 1969 essay "Man of Steel, Woman of Kleenex." In the humorous (and graphic) piece, Niven thinks through the unspoken ramifications of Superman's constantly deferred romance with Lois Lane. Yes, Niven acknowledges, for commercial and narrative purposes, the writers have kept Superman free from Lois Lane's attempts to get him to the altar in order to continue his fantastic adventures unencumbered by a family. But, more realistically, Niven points out that an all-powerful alien like Superman would present a range of sexual problems that are routinely glossed over in the comics. In particular, Superman's ejaculation would be so powerful that it would tear right through the human Lois Lane. Indeed, this very scenario is explicitly depicted in Garth Ennis and Amanda Conner's miniseries *The Pro* (2008), when a down-trodden sex worker is gifted with superpowers. At one point she performs oral sex on the Saint (a Superman derivative). When the Saint achieves orgasm he yanks her head to the side to save her life, but the super ejaculate soars into the

sky and slices the wing off a plane flying overhead. Similarly, in a scene cut from the theatrical release of the film *Hancock* (2008), which has since been widely circulated, Hancock has vigorous sex with a woman in his trailer. When Hancock is about to orgasm, he throws the woman off of him and his ejaculate shoots out like a machine gun, blasting holes in the ceiling.

Male superhero orgasms are treated humorously, but also as self-evident. In hardcore pornography, the male orgasm is presented as visible and irrefutable evidence of genuine sexual pleasure. The female orgasm, on the other hand, is difficult to represent as proof of satisfaction because there is typically no material product, no ejaculate to confirm the body has lost control because of overwhelming sexual pleasure. As I discussed in the first chapter regarding the phallus as a sign of masculine power, Linda Williams (1989) argues that pornography is premised on a "principle of maximum visibility," where every part of the body, and all the sensations it experiences, is available to see. "Hard core desires assurance that it is witnessing not the voluntary performance of feminine pleasure, but its involuntary confession," argues Williams. "The woman's ability to fake the orgasm that the man can never fake (at least not according to certain standards of evidence) seems to be at the root of all the genre's attempts to solicit what it can never be sure of: the out-of-control confession of pleasure, a hard core 'frenzy of the visible'" (50). With no equivalent to the masculine money shot, women in porn have resorted to providing evidence of pleasure, of the body beside itself, with exaggerated moaning, thrashing, spasming, screaming, and shaking. To varying degrees, this "frenzy of the visible" as proof of female orgasm has become a normalized or expected demonstration of female pleasure in every media form as well as in real life.

The comic book medium, and the superhero genre in particular, has developed several means to represent or signify female orgasms in a manner that mimics other mediums but is also unique to the long-form combination of illustrations and written words. The frenzy of the visible identified by Williams is employed in superhero comic books in a variety of ways despite the static illustrations and the silence of the medium. Cindy Patton argues, "Culturally, female orgasm is understood as mimetic and mystical" (1989, 106). Despite shifts in social standards and morals, Patton notes that in mainstream films and advertisements, as well as pornography, "female sexual pleasure is still depicted through facial expressions: the transcendent glazed-over eyes, lips glistening and slightly parted, head thrown back" (105). Comics make ample use of these facial clichés to signify female ecstasy. Moreover, other female facial expressions that indicate intense moments of pleasure, like clenched teeth, mouths stretched open, and flexed neck muscles, are also employed in comics. Comic book illustration styles typically mean that these intense orgasmic expressions are indistinguishable from faces grimacing in pain or screaming in rage. This confusion between the face extended in ecstasy and the face in anguish is one of the ways that

superheroes blur the line between violence and sex. The overlap between facial expressions and conflicting emotions is not unique to comics, but the style and conventions of the superhero genre make the similarities hard to ignore.

Just as the body out of control is common to horror, porn, and melodrama (representing different emotions through nearly identical physical motions), the facial clichés used in comics illustrate the overlap between extreme pleasure and pain. As the main focus for conveying inner feelings via external signifiers, the face and what it implies about pleasure and pain is subject to confusion in real life as well. As Susan M. Hughes and Shevon E. Nicholson note, "Although very distinct emotions, facial expressions of those who are experiencing pain/agony appear surprisingly similar to those experiencing heightened sexual pleasure" (2008, 289). Even more specifically, Chen et al. argue, "the facial expressions produced during pain and orgasm—two different and intense affective experiences—are virtually indistinguishable" (2018, 10013). The primacy given to facial expression as evidence of female climax, and the overlap between pleasure and pain, is foregrounded by one of the most popular porn sites to emerge in the past decade or so, BeautifulAgony.com. The site shifts the focus of pornography's traditional principle of "maximum visibility," as Linda Williams describes it, by showing only the faces of women as they masturbate to orgasm (men are included but are far fewer in number and far less selected by site visitors). The classification of these relatively brief video clips as pornography is premised on the assumption that observing the female face is proof that an orgasm is occurring. Where most pornography almost clinically shows genitals, penetration, and other sexual acts undertaken by the body, Beautiful Agony offers the orgasm as taking place most visibly on the face rather than somewhere else on the body. As the name of the site makes clear, these are faces that are meant to celebrate and reveal both the beauty and the agony of orgasm. In her analysis of Beautiful Agony.com as an important trend in amateur pornography's pursuit of authenticity, Anna E. Ward argues, "Beautiful Agony claims that the face of orgasm is meaningful—that it can be isolated from a scene of sexual context, that it can be isolated from the rest of the body, and that this confirms pleasure" (2010, 177). Moreover, Ward continues, "the idea that orgasm can be captured in the face stems, in part, from a more generalized belief that the interiority of a person reveals itself through embodied signs" (177). This easy slippage between the face extended in pleasure and pain, especially in the absence of secondary signifiers like motion or sound, can function in superhero stories to further confuse (or fuse) young consumers' ideas about sex and violence.

Faces in ecstasy and agony in comic books are often indistinguishable, especially female faces. Several internet sites catalog images from superhero comics that humorously overlap the two extremes when taken out of context. The merging of pleasure and pain is most apparent in the work of comics artists noted for their hypersexual depiction of women, including creators such as Amanda

Conner, Adam Hughes, Terry Dodson, and J. Scott Campbell, whose work is so clearly idealized that the female forms still seem like centerfolds when engaged in battle. Infamously, best-selling artist Greg Land is widely criticized for swiping images from other artists, repeating his own drawings, and frequently tracing porn stars' faces to use for superheroines. Comic book fans have posted dozens of Land's panels alongside the original photographs he has traced. In addition to the complaints that all of Land's women look like Pamela Anderson, Playboy Playmates, or Victoria's Secret models, his work is disparaged by some for his obvious "swipes" of female porn stars' faces used in dramatic or action-packed scenes. Greg Land's illustrations literally confuse the borders between ecstasy and agony as his images of heroines in pain or rage are based on X-rated models' faces signifying uncontainable pleasure. Land's overuse of porn stars' faces does lead to some visually confusing images where superheroines seem to be enjoying the pleasures of flying a little more than expected, or where fear and physical assaults appear to be causing spontaneous orgasms. For example, in *Phoenix Endsong* Wolverine repeatedly stabs Jean Grey with his claws in an attempt to drive out the Phoenix force. But the close-up panels showing her reactions to being stabbed look more like an extreme "Oh" face than excruciating pain. Still, for the most part, the fact that casual readers (and editors for both Marvel and DC) do not notice (or perhaps do not care about) the difference between female faces in ecstasy and those in pain further infers that the two are interchangeable, or at least intimately linked.

At the movies, the shaking or convulsing body and the heavily coded facial expressions serve as external signifiers for inner feelings—the emotional excesses demonstrated by the sight of a body out of control. In addition to the sight of the body beside itself, films typically use sound to reinforce the image of an authentic experience. "Aurally," Williams argues, "excess is marked by recourse not to the coded articulations of language but to inarticulate cries of pleasure in porn, screams of fear in horror, sobs of anguish in melodrama" (1991, 4). The aural signification of the female orgasm, in particular, is intrinsic to the frenzy of the *visible*. In their analysis of orgasmic sounds in music, John Corbett and Terri Kapsalis note, "Female sexual energy or 'letting go,' in this case, is explicitly linked to the 'release' of sound, the vocal expression of an inner state" (1996, 103). Corbett and Kapsalis conclude that "as evidence of the truth of her orgasm and the truth of his/her ability to bring her to orgasm, the listener is offered the sound of uncontrollable female passion. Sound is used to verify her pleasure and his/her prowess" (104). When Batman asks Catwoman if she is okay as the couple lay exhausted on a rooftop after having passionate sex in *Catwoman* #2 (2011), she replies, "I'm better than okay. You couldn't *hear* how 'okay' I was? I thought you're supposed to be a master detective?" As this scene implies, Catwoman's sounds are supposed to be indisputable evidence of her satisfaction. I will return to the status of Batman as a "master detective" below, but Catwoman claims that her sounds are proof that she experienced a pleasure that could not be contained.

Of course, we do not really *hear* her passions (nor does Batman) because this is a comic book. Still, the story tells readers that a woman's vocal responses are a measurable sign of her pleasure.

Though the medium of comic books is devoid of sound, the excessive aural signs of female passion are still incorporated through conventions that combine the aural and the visual. The superhero cliché of "BAM" and "POW" sound effects splashed across images of heroes punching villains (discussed in chapter 8) provides a convenient and spectacular way to simulate the moans and screams of female orgasm used in other media. For example, in the graphic novel *Black Canary and Zatanna* (2014), a long stream of "EEEEEEEEEEE" floats from Canary and Green Arrow's bedroom, shattering a vase in the living room. "Sorry, Ollie, the vase was lovely," Canary says afterward as they lay in bed. "So was that," he replies, "besides, what's a Waterford vase where passion is concerned?" Despite being a static and silent medium, the comic makes it clear that Canary experienced such genuine sexual pleasure that her orgasmic scream shatters glass. The fact that Canary's superpower is her sonic scream further confirms the overlap between powers and orgasms: that losing control, letting go, or physically erupting is a type of climax—be it ecstasy or violence.

The desperate wish to witness (and hear) authentic female pleasure that Williams identifies as pivotal to hard-core pornography and that extends to the representation of women in other media forms is born from masculine insecurities. The compulsory orgasm as an indication of "good sex" and being a "good lover," combined with the perception of female climax as a mystery, contributes to fears of not living up to standards of hegemonic masculinity, like the superhero. Given the invisibility and the performative nature of the female orgasm, even Batman, the "master detective," has to ask Catwoman if she genuinely enjoyed sex. In her discussion of the emotional work involved with women faking orgasm, Hannah Frith argues that "visual representations of female pleasure rely on the performance or display of orgasm through facial expressions or bodily movements—yet at the same time, the widespread practice of feigning orgasm renders this performance unreliable. Taken together, these two issues—the invisibility of female orgasm and women's propensity to fake—pose a considerable challenge to distinguishing between the real and the fake in the visual representation, and recognition, of orgasm" (2015, 387). Moreover, the need to confirm female pleasure is linked to notions of successful masculinity. In a clinical study of male interpretations of female arousal, Sara Chadwick and Sari van Anders note, "Evidence indicates that men's sexual script is increasingly characterized by proficient sexual skill that is defined by an ability to provide women with sexual pleasure and orgasm" (2017, 1142). This insecurity about the authenticity of female pleasure and the cultural perception that inducing, or "giving" a woman, an orgasm is a measure of masculine success can interfere with the identificatory fantasy for the stereotypical young male comic book reader. *With all his powers, of course, Superman can make the Earth move for Wonder Woman, but how do I*

do that? The genre does offer some magical solutions for the mystery of pleasuring a woman. After all, in a fictional world where characters can fly and shoot laser beams out of their eyes or electricity from their fingertips, even the problem of how to give a woman an orgasm can be displaced in a variety of ways.

Legendary Italian comic auteur Milo Manara is closely identified with erotic illustrations of women, including a few recent controversial covers of Marvel superheroines. But the bulk of Manara's stories are about men witnessing the truth about the unbridled sexuality of women. Manara's most famous (or infamous) creation is the *Click!* series of four graphic novels (1983, 1991, 1994, 2001). The central fantasy of the *Click!* stories revolves around a small box with a simple dial that can magically cause any woman to become insatiably aroused and experience unlimited orgasms. The male protagonist who wields the device just needs to aim the box at a woman and turn the dial, and then "click" she loses all control of her aroused body. The device is like a mythical, magical, invisible vibrator that no woman can resist and that causes her to completely reveal herself and her euphoria to leering male eyes. In effect, Manara's imaginary device for making the female body speak its hidden truths is not unlike the powers of complete sexual control over women used as a type of comic book date-rape drug by men like Starfox and Kilgrave (see chapter 8). The ability to cause others to orgasm through a magical device or superpower is a minor trope in the comics, but it has also found its way into modern live-action adaptations. In an episode of the television series *Doom Patrol* (2019–ongoing), the super muscleman Flex Mentallo accidentally causes the rest of his team, and dozens of bystanders, to orgasm uncontrollably when he flexes the wrong group of muscles. But even though the dream of a simple device or power guaranteed to bring a woman to climax may remain appealing, modern stories do condemn men who use such abilities for sexual advantage as villainous (at least on the surface). When women in superhero stories use their powers to induce orgasms in others, such as Emma Frost and the protesters mentioned above, it is depicted as a sophomoric joke rather than a sexual assault. At one point, the ever-expanding roster of mutants in the X-Men books even included the former brothel worker turned heroine Stacy X (a.k.a. X-Stacy), whose sole power is the ability to give men overwhelming orgasms with just a look or a touch.

Of course, men are not required for women to achieve sexual satisfaction. Lesbian sex can be, and is, shown in superhero stories to be just as satisfying as heterosexual relations, if not more so. Likewise, masturbation is implied as an alternative means for women to achieve satisfaction. As Black Canary teases Green Arrow when he reaches for the television remote rather than cuddling after the vase-shattering sex: "I swear, next time I'm just going to borrow your frequency-matching agitator arrow." Interestingly, there are a few superheroine moments where orgasms are still magically produced in a manner inspired by the fantasy of Milo Manara's *Click!*. When Poison Ivy and Harley Quinn are on the run in South America in *Batman: Harley & Ivy* #2 (2004), Ivy enters the

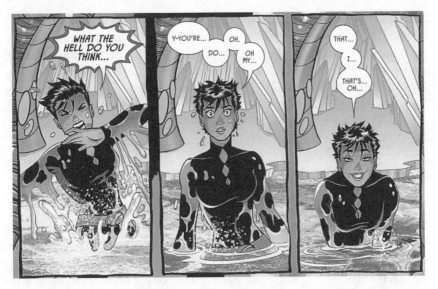

FIG. 9.3 *Batman* #68, 2019, Tom King and Amanda Conner

jungle in a languid haze and the vines appear to caress her to a refreshing orgasm. *Power Girl* #12 (2010) sees the titular heroine visiting her super friend Terra's underground society where they take a near-naked dip in the magical "emofluids." The liquid induces "the highest state of consciousness," which, based on Power Girl's facial expressions, is orgasmic. Similarly, in *Batman* #68 (2019), Lois Lane throws a bachelorette party for Selina Kyle (Catwoman) at Superman's Fortress of Solitude. Lois shows Selina some of Superman's trophies, including the multicolored, glowing "Paradise Pool." Lois explains the pool "gives you *bodily bliss*. Like, a *lot* of bodily bliss, so much, and you like, never want to leave. It was a Brainiac trap he *tried* to use on Clark one time and Clark got out and here it is." Lois then pushes the fully clothed Selina into the pool. "What the Hell do you think . . . ," Selina begins to shout in protest, and then is overcome with pleasure as she relaxes blissfully into the pool, eyes half-closed, plump lips curved into a sinful smile (figure 9.3). Scenes like these hold out some hope for readers that maybe there is a magical key to easily and irrefutably satisfying a woman. Just as there may be a superhero hiding under the reader's mild-mannered disguise.

The ineffable and indescribable nature of orgasms, especially women's orgasms, has been signified in comic books in ways that are impossible for other mediums, and in ways that often overlap orgasms with superpowers, or even orgasms *as* superpowers. Black Canary's accidental vase-shattering sonic scream during climax, mentioned above, is only one of countless situations where powers and pleasures become indistinguishable. When Betsy Ross first changes into She-Hulk in *Ultimate Wolverine vs. Hulk* #4 (2009), the transformation occurs in a collage of images across a two-page spread that clearly implies an orgasm. Extreme

close-ups of her face suggest pain and excitement, sweat beads appear on her lips, her body shakes, and she trembles out of control. After the transformation is complete, she flirtatiously asks the nearby soldiers, "Was that as good for you as it was for me?" When the mutant lovers Kitty Pryde and Colossus first have sex in *Astonishing X-Men* #14 (2006), Kitty loses control of her body to the extent that her powers accidentally kick in and she phases through the floor, reappearing naked in the living room below. And the independent comic book series *Off Girl* (2019) follows the adventures of Julia Davenport, who releases a killer demon from her body whenever she climaxes, so of course she decides to become a costumed superhero with this surprising power.

Writer Brian Michael Bendis and illustrator Michael Avon Oeming's *Powers* (2000–2020) explores the seedy side of the genre as cynical detectives Christian Walker and Deanna Pilgrim work homicide cases related to superheroes (all of whom bear a striking resemblance to famous characters at Marvel and DC Comics). Many of the cases in *Powers* are linked to the (often perverse) sex lives of the caped crusaders. On numerous occasions the comic depicted orgasmic sex with superpowered characters as a flash of bright light. The *Powers* storyline "Little Deaths" (I will come back to the double entendre of this story title later) features the death of a Superman-like character called Olympia who is found naked in bed. In issue #14 (2001), after questioning dozens of female groupies Olympia had slept with, one woman, Angela, recounts how he died of a heart attack while they were engaged in a "super quickie." Accompanying her admission is a two-page flashback sequence of them having sex. In one frame, when Angela orgasms, the panel suddenly glows in white light as her mouth opens in a wordless scream. The same technique is used later in the series when Detective Walker has (re)gained superpowers that have an extreme effect on his girlfriend Heather whenever they have sex. In the second volume, issue #19 (2006), the two lovers reach climax as she screams "AAIIEE!!" and "UGH!!," and a bright white light flares from between her legs (figure 9.4). "Wh—wh—What was *that*?" she asks in shock. "I don't know," Walker replies. "Are you OK?" "No," she gasps, lying on top of him, "no, I'm just . . . That was really *intense* for me." In later issues, the light shoots out of her crotch like electricity when she orgasms; eventually it also shines out of her eyes and shatters the windows. This sign for orgasm as a type of light is also used in the comic books series *Sex Criminals* (2013–ongoing), by Matt Fraction and Chip Zdarsky. In *Sex Criminals*, the leads Suzie and John both discover that when they climax, time stops around them, thus giving them a small period of time when they can rob banks or do anything else they want. These magical orgasms are illustrated via a diffuse, but sparkling, rainbow glow of light.

The visual effect of bright light to signify orgasm in comic books clearly implies the frenzy of the visible as evidence of sexual pleasure, an attempt to give form to the ineffable experience of climax. This orgasm lighting is similar to the filmic special effect used to illuminate, but not necessarily show, something that

FIG. 9.4 *Powers* #19, 2006, Brian Michael Bendis and Michael Avon Oeming

is overwhelmingly beautiful or valuable or dangerous. It is akin to the radioactive glow from the sinister briefcase in *Kiss Me Deadly* (1955), the light that escapes from the ark in *Raiders of the Lost Ark* (1981), the mysterious contents of the briefcase in *Pulp Fiction* (1994), or the glowing patronus spirit animals in *Harry Potter and the Prisoner of Azkaban* (2004). The exact meaning of the light is ambiguous, but powerful. Blinding light suggest the indescribable, the unknowable, the uncanny, even the divine. It is akin to the bright light people claim to see during near-death experiences. And it is routinely used in Hollywood to depict heaven itself. Richard Dyer's (1997) discussion of whiteness as a constructed racial category details how light has been used in everything from medieval paintings to modern films as a way to imply purity and superiority. Dyer argues that an artificially created "inner light" is associated with divinity: "The sign of this was the sense of glow, of something in but not of the body, something heavenly" (127). In superhero stories, however, the effect of bright light is

FIG. 9.5 *Wonder Woman*, 2017, Warner Brothers

also used to symbolize a different form of the uncanny: incredible energy and superpowers. The magical, ineffable quality of lightness imbues Iron Man's pulsar blasts, Starfire's starbolts, Nova's pulsar rays, Firestorm's quantum projections, Green Lantern's emerald light beams, Captain Atom's atomic blasts, Scarlett Witch's magical beams, and countless other projectile powers. As Black Lightning warns in figure 9.1: "This gets *bright*."

The current wave of live-action superhero movies only expands the idea of uncanny powers manifesting from the body as bright, barely containable light. In *Thor: Ragnarok* (2017), when Thor realizes his power as the god of thunder resides within himself rather than in his hammer, his eyes begin to glow with a white light and lightning sparks across his body. In Wonder Woman (2018), when Diana learns that she is imbued with the power to defeat the god of war, she crackles with electricity from within (figure 9.5). Likewise, when Carol Danvers reaches her maximum level of power in *Captain Marvel* (2019) her whole body glows fiercely with the same energy that she uses in her signature blasts. The use of uncanny lighting in the superhero genre for both orgasms and explosive powers implies an important link between sexuality and violence. Tellingly, all the Thor, Wonder Woman, and Captain Marvel "inner-glow" scenes occur during each film's climactic battle, the onset of the movie's money shot.

One of the central preoccupations of pornography is the substantiation of female climax. As Linda Williams details, it is male insecurities about the authenticity of female pleasure that drives techniques to represent a feminine truth through hard-core's frenzy of the visible. Though female pleasure is not as pivotal a concern in superhero stories as it is in pornography, the use of bodies out of control, erupting with energies, even glowing, extends the principles of making the body speak its involuntary truths and mimic the gendered logic of pornography. Of course, it is not just the invisible nature of female orgasms that

presents a threat to assumptions of hegemonic masculinity. Nor is it just the possibility that women may drain a man's strength or compromise his independence through her captivating sexuality (see chapter 2). A further threat lies in the possibility that female desires may not be satisfiable, that she may in fact be sexually insatiable. Women may fake orgasms, but they may also be multiorgasmic. Where the male orgasm has been framed as a spectacular culmination of the sexual act, the woman's orgasm does not necessarily signal the end of her sexual needs, desires, or abilities. She may, in other words, be able to take more than he can give.

One of the most famous examples of a woman's insatiability outstripping male claims to power comes from the cult classic film *Barbarella* (1968), itself based on a comic book heroine. Near the end of the movie, the villain Durand Durand tries to kill the captive Barbarella with too much pleasure by placing her in his ultimate torture device, the Orgasm Machine. But to Durand Durand's frustration, Barbarella is capable of climaxing over and over again until the machine overheats and breaks down. Barbarella's insatiability saves her (and by extension the universe) by being able to take more than a man can inflict on her. The masculine failure and the female endurance concisely played out in *Barbarella* demonstrates the different ways orgasms are gendered as finite or possibly infinite. The woman's orgasm "can be extended indefinitely in time," reasons Cindy Patton. "Male and female sexual narratives are, at present, constituted through different systems of punctuation: the male narrative ends with a come shot and the female narrative . . . well, we aren't sure if women's multiple orgasms ever stop" (1989, 106–107). This fear of an insatiable woman, a woman who can enjoy and endure multiple climaxes seemingly without end, is metaphorically framed in superhero stories, but it is no less a threat to assumptions of male hegemony. A more contemporary instance of female insatiability occurs in *X-Men: Phoenix Endsong* as Cyclops unleashes the full force of his optic blasts on the reanimated Jean Grey. Rather than destroying the Phoenix force inside her, she greedily absorbs all the energy and calls for "Mooorrre!" Additionally, Greg Land's use of female porn stars' faces makes the sexual overtones of the scene obvious. As Cyclops's powerful blast hits Jean in the chest, she throws her head back, eyes closed, a grin on her face. This is clearly framed as a pleasurable experience for her, as she takes everything Cyclops throws at her and still wants more. As impressive as Cyclops's blast may be, it is nothing compared to the Phoenix's appetites.

Discussing the problems of presenting satisfaction in pornography, Susan Bordo describes female insatiability as part of a larger perception of female sexuality as more than men can handle: "On the one hand, there is the male experience of woman's sexuality as voracious, 'too much,' threatening to engulf and obliterate the male, a motif . . . that informs the 'consuming woman' and 'man-eating' imagery that upwells at certain historical junctures. On the other hand, much pornography depicts women precisely as sexually aggressive, voracious,

FIG. 9.6 *X-Men: Phoenix Endsong* #5, 2005, Greg Pak and Greg Land

insatiable, presumably as an antidote to the constraints on male sexuality placed by 'real' women, who are not sexual *enough*" (1993, 708). This same double bind of female sexuality exists in the superhero genre where highly eroticized, excessively fetishized, and aggressive women are everywhere—lusted after by male characters and readers alike, but also capable of rejecting or overwhelming the men. The reconciliation provided by most heterosexual pornography, Bordo argues, "is a world in which women are indeed in a state of continual readiness and desire for sex, but one in which female desire is incapable of 'emasculating' the male by judging or rejecting him, by overwhelming him, or by expecting something from him that he cannot (or fears he cannot) provide" (708). In the hyperbole of the superhero genre, the unlikely reconciliation of female insatiability and male insecurity is navigated through the fantasy of superpowers.

As *X-Men: Phoenix Endsong* reaches its conclusion, the heroes persuade the insatiable cosmic Phoenix force to leave Jean Grey's body and enter Emma Frost's. Just as the transition is complete, Cyclops tackles Emma and hurls her and himself into a specially designed containment capsule. The two lovers are able to let go; Cyclops is nervous, but Emma tells him, "It's all right, Scott. We're *safe* in here! We can let go!" If Greg Land's illustration (figure 9.6) did not make the carnal nature of the "letting go" clear enough, the next panel shows the young X-Man Kitty Pryde asking, "What's going on in there?" When Kitty gets a glimpse of their sexual antics through the monitor, her reaction is simply "*Eeeew!*" Dr. Hank McCoy (a.k.a. Beast), on the other hand, looks at the readings and explains: "Perfect . . . Scott's eyes are pouring forth what seems to be an *unlimited* amount of energy. This energy is now feeding the unlimited hunger the

Phoenix seems to possess." In terms of sexual economy, this scene is a fairly direct analogy of magically satisfying a woman's insatiable hunger with a male's unlimited output of energy. This not very subtle example enacts the genre's dominant fantasy that super masculinity can ultimately save the day *and* satisfy the woman. Cyclops and Emma Frost's situation may be more literal, but it is echoed in every story where Lois Lane is left swooning when Superman catches her, or when Spider-Man swings Mary Jane Watson out of harm's way. Whatever *she* needs *he* can provide. The superhero may have insecurities, but he is always capable of satisfying his romantic partner.

The *Powers* graphic novel collection "Little Deaths" (2001), mentioned earlier, cleverly alludes to both the superhero deaths that Walker and Pilgrim investigate in the story and the sexual nature of those cases. In using the English phrasing of the French slang for orgasm, *la petite mort*, author Brian Michael Bendis explicitly links the realms of sex and death that often collide within the genre. Where orgasmic release in the superhero genre is often presented through a gauze of symbolism, death is a much more common event that is frequently dramatized, spectacularized, and repeated. In fact, in the modern era it has become a cliché that major superheroes die and come back to life all the time. Heroic fatalities have become a basic convention ever since the prolonged "Death of Superman" storyline (1992–1994) that resulted in unprecedented sales and mainstream media attention. In his discussion of how *Superman* #75 (1993) changed the comics industry, Jose Alaniz describes, "Through a series of single-panel splash pages, this landmark issue depicts an exhausted and battered Man of Steel, desperate to save his friends and loved ones, sacrificing himself to finally deliver the knockout punch; hero and villain collapse together among the rubble" (2014, 270). Of course, a character worth billions of dollars is not going to remain dead for long, and Superman returned to life within months. Since the "Death of Superman" event, dozens of A-list superheroes have died in continuity, including the Flash, Green Lantern, Green Arrow, Batman, Spider-Man, Iron Man, Captain America, Wolverine, and Charles Xavier. Their deaths are turned into special collector's issues and inspire sweeping story arcs, but they all eventually return to life. The trope of a temporary superhero death has become so common that even the comics have begun to mock it. In *Batman* #16 (2017), for example, several of the Dark Knight's young protégées are teasing each other about having been temporarily dead before. Death seems to be a rite of passage for all the Robins (Dick Grayson, Jason Todd, Tim Drake, Damien Wayne, and Stephanie Brown have each died and come back). Batman's newest teenage recruit, Duke Thomas, is shocked to hear the Robins mocking each other's deaths. "Wait, *all* of you have been dead?" Duke asks in surprise. "Am *I* going to be dead?"

The impermanence of superhero deaths is a curious device. Because superheroes are highly lucrative commercial properties, the idea of killing off or otherwise permanently retiring a popular character is inconceivable. So long as the likes of Superman, Batman, Spider-Man, and Captain America generate billions

in merchandising and licensing rights, they will forever remain young and alive. But why resort to killing the characters even temporarily? As Umberto Eco notes in his essay "The Myth of Superman" (1972), one of the first scholarly considerations of a superhero, the traditional narrative structure of Superman tales was designed to keep him suspended in his adventuring prime. Major life events like marriage or children are avoided (or relegated to imaginary stories) because they would move the Man of Steel one step closer to mortality. But the modern shift to frequent superhero deaths changes the narrative dynamics of the entire genre. Lee Easton and Richard Harrison describe the initial 1968 revival of Captain America's Golden Age sidekick Bucky Barnes as precipitating a different heroic trajectory: "If Bucky 'really' returns from the grave, as so many comic book characters do, his return makes all losses temporary, mere setbacks in the ever-upward arc of the superheroic tale" (2010, 210). In addition to all the back-from-the-dead storylines, the genre's now-regular practice of rebooting and/or revisioning individual characters and entire universes has created a format where heroes can be both mortal and immortal. Death is nothing but another majestic accomplishment for the modern superhero. Any major character's death may be grand, but, in truth, it is always just a "little death." Fans know he will be back in just a few issues. The hero's never-ending pursuit for "truth, justice, and the American way" is now also a seemingly never-ending cycle of grand adventure, death, and return to life.

Returning to Linda Williams's analysis of horror, porn, and melodrama as comparable lower-status genres (to which I have argued we can add superheroes) where extreme emotions and sensations are communicated via the out-of-control body, repetition is a defining trait. Addressing the denigration of these genres as lowbrow entertainment, Williams notes, "The unusual criticisms that these forms are improbable, that they lack psychological complexity and narrative closure, and that they are repetitious, become moot as evaluation if such features are intrinsic to their engagement with fantasy" (1991, 10). The repetition of the central fantasy and the identificatory feelings invoked by each genre (fear, arousal, sadness, and valor) are at the heart of their appeal. In fact, the superhero genre may be more repetitive than any other form. Over and over again, the same costumed avengers have been fighting the same villains, protecting the same innocents, and saving the same cities for decades. Umberto Eco identified the traditional comic book hero formula as an "oneric cycle," returning to the status quo after each adventure so the series can continue in perpetuity, unaffected by the real-world consequences of time. The superhero cycle has now advanced to repetitiously include death as part of the pattern. As superheroes have become so much more than just children's stories—indeed, they have become multimedia, big spectacle franchises with throngs of fans who follow a hero's tales devotedly—the stories have demanded ever-escalating climaxes.

The grand scale of epic superhero battles requires decisive and dramatic victories. The hegemonic masculinity of the hero must triumph to fulfill its cultural

purpose, even if that means sacrificing his own life. The current wave of blockbuster movies has upped the emotional stakes so much that cinematic superhero death is becoming a conventional climax. Batman is presumed dead at the end of *The Dark Knight* trilogy, though the coda reveals Bruce Wayne is living in Europe. Captain America sacrifices his life to save New York at the conclusion of *Captain America: First Avenger*, but the post-credits scene shows that he is brought back to life seventy years later. Superman defeats the monster Doomsday in the final battle of *Batman v. Superman: Dawn of Justice* at the cost of his own life, though he is brought back from the dead in the sequel. In the heart-wrenching conclusion to *Avengers: Endgame*, Iron Man dies saving the entire universe from Thanos. The superhero is more than willing to dramatically sacrifice his own life for the safety of others. And it is usually a "he." Very few major female characters have died and been reborn relative to male superheroes. This inequity is central to the idea of "fridging," originally identified by Gail Simone (discussed in chapter 8), where women are far more likely than men to be killed, assaulted, or crippled in a sexualized manner. Moreover, female deaths are treated as less heroic, less significant, and less likely to be reversed. For example, Iron Man's death in *Avengers: Endgame* is the culmination of the battle (and decades of Marvel movies) and is framed as the sacrifice that saves the universe. Black Widow's death earlier in the film is just a necessary step in the process to collect the infinity stones that Iron Man will use to fix things. Tony Stark receives a beautiful funeral attended by all the heroes, Natasha Romanoff's passing is mentioned only by Hawkeye and the Hulk, almost as an afterthought to Tony's funeral.

The correlation between "little deaths" as orgasms and the temporary deaths of superheroes can be understood in terms of a phallic economy as more than just a cute semantic happenstance. The final clash of the superhero and villain, the epic knockout punch that saves the day, is the money shot of the story . . . even more so if the hero sacrifices his own life to deliver it. And, like the money shot of pornography, this event marks the end of the battle. In economic terms, after the money shot, the hero is "spent," exhausted, drained of life. In her discussion of the hegemony of masculine orgasms, Cindy Patton argues, "There is no question that men have orgasms: the proof is ejaculation. Male orgasm is accomplished or not, an essential and essentialist punctuation of the sexual narrative. No orgasm, no sexual pleasure. No come shot, no narrative closure" (1989, 104). The sacrificial death of the superhero serves a similar (orgasmic) narrative function. The emotional and physical release that depletes the hero signals the climax of the story and the definitive value of the super man's efforts. Recall Alaniz's description of the death of Superman, where "an exhausted and battered Man of Steel" finally delivers the knockout punch and "hero and villain collapse together" (2014, 270). To paraphrase Patton, for superheroes: no money shot, no sacrificial death, no closure. The male climax as visible, decisive, and finite in pornography is mirrored in the knockout blow of the superhero. The finite logic of

the male body may also, at least in part, suggest why it is the super man rather than the wonder woman whose death is spectacularized. The cultural logic of our phallic economy includes a fear of female bodies as potentially insatiable, as out-of-control possibly without end, as infinite.

The intent of the colloquial *la petite mort* is to suggest a period of pleasurable relaxation and exhaustion born out of the intensity of climax. It is not about death per se, but the time before a body is capable of physical arousal again. In other words, it is a refractory period or a time of recovery. It is an opportunity for the body that has been pleasurably and/or painfully out of control to recompose. Likewise, the temporary death of the male superhero is akin to a refractory period rather than a permanent death. The fact that death is now, as Easton and Harrison describe it, merely a routine setback "in the ever-upward arc of the superheroic tale" (2010, 210) allows the hero's demise to be both definitive and repetitive. To carry the analogy a little further, Cindy Patton points out that the physical limitations of male performance in pornography (and in reality) are a problem of impossible repetition: "Male orgasm is *cine verite*; extending it would require repetition of a narrative sequence of stimulation, erection, ejaculation" (1989, 104). The superhero's knockout blow, his money shot, is epic enough to take everything he has got. His death demonstrates the physical and emotional toll of the grand effort that saves the city, the world, or the universe. It is the ultimate climax, the ultimate narrative closure. But the temporary nature of modern superhero death allows the sequence to be repeated infinitely. Rather than an improbable masculine cycle that would require "stimulation, erection, ejaculation" repeated almost endlessly, the superhero's little death facilitates a repeatable heroic sequence of creation, training, and victory.

Conclusion

■■■■■■■■■■■■■■■■■■■■■

Love, Sex, Gender, and Superheroes in Real Life

> Whatever you are doing, do it with the confidence of a 4-year-old in a Batman t-shirt.
> —Motivational meme

The superhero is a useful figure for understanding cultural beliefs and shifting perceptions of gender and sexuality. I have addressed a wide range of themes related to gender and sexuality modeled within modern iterations of the superhero genre. But, with the exception of chapter 4's brief mention of superhero-themed wedding photography and chapter 7's short discussion of cosplay and crossplay, the focus has been primarily on the stories themselves rather than how superheroic themes are brought into the real lives of audience members. The question of "how" people bring an understanding of gender and sexuality derived from superheroes into their daily existence is a near-impossible one to answer satisfactorily. In this conclusion, I want to provide a brief survey of some of the ways people publicly, and privately, use the image of superheroes to express their understanding of, and identification with, various beliefs about gender and sexuality. Learned perceptions of gender are easier to theorize and document than those of sexuality. Research into early childhood development, in particular, has demonstrated the way young people adopt an understanding of gender based on their love of superheroes (for example, see Dallacqua and Low 2019; White et al. 2017). These quantitative studies have also documented how superheroes can

influence beliefs about everything from morality (White and Carlson 2016) to the benefits of eating vegetables (Wansink, Shimizu, and Camps 2012). Sexuality, on the other hand, is a complicated subject—harder to observe and more awkward to discuss. Still, as the superhero-themed weddings imply, people *do* incorporate the concept of superheroes into their most personal, and perhaps intimate, moments. Even a cursory look at the myriad ways people identify with, and express themselves through, superheroes can illustrate how important these figures are as symbolic focal points for gender and sexuality.

Some of the basic misogynistic presumptions regarding superheroes became media talking points in the mid-2010s, while both Marvel and DC were making a concerted effort to attract more female fans. The most famous of these moments, which was eventually dubbed "Comicsgate," started in 2015 when a group of outspoken white male consumers and online trolls began protesting the diversification of the comics industry. Creators from a range of different genders, ethnicities, and sexualities were achieving a good deal of success writing and drawing major titles. Moreover, this diversification was also reflected in an increase of superheroes who were not the default white, heterosexual man. New, revamped, or spin-off characters seemed to displace traditional icons of the genre. For example, the African American woman Riri Williams assumed the mantle of Iron Man, the Afro-Hispanic Miles Morales became a new Spider-Man, a teenage Pakistani American girl named Kamala Khan took on the title of Ms. Marvel, lesbian Kate Kane emerged as Batwoman, and Jane Foster transformed into a female version of Thor when she picked up his legendary hammer (see Brown 2020). At its worst, Comicsgate exposed an underlying bigotry that a small group of extremist fans clung to as they ridiculed and threatened queer and female comics creators, fans, and even a group of women working for Marvel who posted a picture of themselves getting milkshakes on a break from their editorial duties. Fortunately, some of the biggest names in the industry, and many of the stars from the feature films, joined Marvel and DC Comics in dismissing the vile and exclusionary rhetoric of the trolls.

Concurrent with Comicsgate was a less dramatic controversy that erupted over the sale of misogynistic superhero T-shirts at stores like Walmart, Target, and Hot Topic. Among the back-to-school clothes that crowded the racks in the late summer of 2014 were superhero-themed children's T-shirts. But unlike the usual superhero shirts that proudly declared a child's identification with a character, these new graphic Tees declared things like "Score! Superman Does it Again!" over an image of the Man of Steel passionately kissing Wonder Woman, "Chicks Dig the Car" above the Batmobile on shirts for boys, and "I Only Date Superheroes" and "Training to be Batman's Wife" on tops for girls. Numerous parents and gender watchdog groups took to the internet to criticize the clothing trend's use of superheroes to reinforce outdated gender disparities implying that only men can be superheroes and women are merely romantic prizes. The

backlash was met with a quick press release from DC Comics. "We understand that the messages on certain t-shirts are offensive. We agree. Our company is committed to empowering boys and girls, men and women, through our characters and stories" (McMillan 2014). The bold corporate admission included a promise to review merchandise licensing partnerships more closely in the future. Still, despite the recognition of the retrograde gender assumptions of these shirts in 2014, this type of merchandise remains popular for both adults and children years later. In fact, the "Mrs. Superman" and "I only date superheroes" type of merchandise is now also widely available on mugs, journals, water bottles, nighties, jewelry, and other products targeted primarily at women.

I still grimace a bit when I see female students in my classes (many of them advanced women's studies courses) wearing things like the "I only date Superheroes" shirts. Or worse yet, the "I'm His Puddin'" T-shirts featuring Harley Quinn swooning over the Joker, thus romanticizing their abusive relationship. But I do not want to dismiss out of hand the significance of these conventional messages about gender expressed via superheroes. For many of the individuals wearing these shirts, the intention of displaying their fandom on their chests is linked to an ironic perspective, nostalgia (the images tend to have a retro look), an affinity with specific characters, a romantic or sexual interest in those characters, and/or an open acceptance of traditional gender inequalities. For many others there seems to be nothing more than an identification *with* the characters' hypermasculinity (for men) or a romantic desire *for* the male superheroes. Moreover, some of the women simply identify *with* the hypersexual depiction of female costumed characters as flirty bad girls. As flexible, multivalent symbols, superheroes can and are used to indicate a wide range of gender and sexual perspectives from the most traditional to the most unconventional.

The public declaration of one's gendered beliefs via something as innocuous as superhero T-shirts, whether those beliefs align with or challenge traditional heteronormative ideals, is a fairly minor, but still significant, indication of caped characters used as symbols of gender and sexuality. More extreme forms of fashion can expose both the conservative and progressive aspects of superhero gender and sexuality that can be embraced by people in the real world. Halloween costumes, for example, illuminate an obsessive enactment of the most traditional gender binaries found in superhero adventures. In their analysis of Halloween outfits, Sherman, Allemand, and Prickett note, "Costumes are products that affect people in a real-life context because they provide opportunities to identify with the character and/or personal characteristics represented by the costume" (2019, 254). Anyone who has seen the joy in the face of a child dressed up as a superhero can attest to the pleasure children take in imaginatively becoming a superhero. Children can feel confident, strong, independent, and special when costumed as their favorite characters. Superheroes like Batman, Superman, Spider-Man, and Iron Man have maintained their positions at the top of annual

favorite Halloween costume lists for the past twenty years. In fact, the importance of superhero identification for children across racial and gendered lines has been documented in the press as more kids choose to dress up as heroes like Black Panther, Black Widow, and Captain Marvel following their blockbuster films. For all the positive aspects associated with superhero play, most of the commercially available costumes continue to reinforce an assumed gender binary of strong men and beautiful women.

Children's mass-market superhero costumes recycle the genre's traditional distinctions between male and female characters. Modern boys' uniforms come in dark colors, with built-in muscles and a range of weapon accessories. Girls' costumes, on the other hand, often come in shades of pink with fluffy skirts and accent jewelry. In their study of hundreds of advertisements for popular kids' Halloween costumes in 2015, Murnen et al. found that "male characters were far more likely to be portrayed with traditional masculine characteristics like functional clothing and the body-in-motion, and they were often depicted with hyper-masculine accessories such as having a weapon" (78). Conversely, Murnen et al. note that for girls, "characters were far more likely than male characters to be depicted with traditional feminine stereotyped cues (e.g. decorative clothing) and sexually submissive, hyper-feminine cues (e.g. revealing clothing)" (78). Even when the boys' and girls' costumes are based on the same character, explicit gender distinctions are still inscribed on the clothes and are potentially adopted as "natural" by the young wearers. For example, the Batman costumes for boys look like the outfit depicted in comics and worn in feature films; it is an empowerment fantasy made material. But the "Bat" costumes designed for girls look nothing like the uniforms worn by any of the Batwomen or Batgirls in the comics or live-action versions. The girl's costume is merely a pink dress adorned with a few bat-symbol motifs. Boys as Batman are ready for action. Girls as Batman are ready to look cute.

Superhero costumes aligned with traditional gender dichotomies are not restricted just to children, as anyone who has been in a Halloween store in recent years can attest. Adult Halloween costumes typically present exaggerated gender extremes that are intentionally sexual and fetishistic in nature. Comparing male and female adult costumes, Lennon, Zhiying, and Fatnassi found, not surprisingly, that "women's costumes were significantly more revealing than men's in tightness and body coverage" (2016, 2) and that gender stereotypes were a defining feature for almost all male and female adult costumes. Confirming the strict binary gender codes put in place by children's costumes, adult Halloween outfits extend and reinforce the continued pervasiveness of unequal norms. Grown men, it seems, are as insecure about their masculinity as young boys and favor superhero costumes with built-in muscles. Mass-market superhero Halloween costumes for women are designed, modeled, and advertised as extremely sexy versions of popular characters. The differences between the best-selling male

and female versions of costumes based on Batman's sidekick, Robin, exemplify the continued rigidity of the gender divide. Male Robin costumes look like the official version worn by the character in the comics, with foam muscles sculpted into the uniform to reinforce the illusion of hypermasculinity. The female Robin costumes, however, are tighter and skimpier, showing off more of the women's actual flesh and accentuating legs and breasts, the whole look completed by knee-high stiletto boots. If a large part of Halloween fun for grown-ups is still rooted in a desire to dress up as a wish-fulfilling version of one's ideal self, then the superhero costumes most often chosen reveal a firm commitment to traditional assumptions about masculine and feminine gender expectations and heteronormative sexual fantasies.

The traditional gender expectations often associated with superhero costume play can lead to dangerously misogynistic assumptions. The intrusion of real-world sexual inequalities has become apparent through the unequal treatment of male and female cosplayers at conventions. The 2012 New York City Comic Con became a turning point for recognizing the sexual harassment that many female cosplayers experience while wearing superhero (and other) outfits. One of the feature cosplayers at the New York convention was Mandy Caruso, a twenty-three-year-old fashion designer and blogger, who dressed as Spider-Man's villain and occasional lover Black Cat. Caruso bore a strong resemblance to Marvel Comics' Black Cat in her signature low-cut and skintight leather outfit, dark eye mask, and long white hair. Though it is common to see numerous female fans or professional models dressed in tight and/or skimpy costumes patterned after the outfits worn by heroines and villainesses in superhero comics, they are often subjected to verbal and physical harassment by male convention attendees. As Caruso later blogged, it is also unfortunately just as common for these female cosplayers to be sexually badgered and demeaned. In a story that was widely circulated online and picked up by several mainstream news outlets, Caruso described how multiple male fans and a film crew harassed her while she was wearing the Black Cat costume. She recounted how men at the convention openly ogled her breasts, made inappropriate comments, and tried to touch her—and when a documentary filmmaker repeatedly asked about her cup size, Caruso finally had to tell him off and walk away. "It's because many people at these cons expect women cosplaying as vixens (or even just wearing particularly flattering costumes) to be open/welcoming to crude male comments," Caruso wrote in a 2012 post, "like our presence comes with subtitles that say: 'I represent your fantasy thus you may treat me like a fantasy and not a human in a costume.' But it does not mean we owe them a fantasy" (beautilation.tumblr.com /post/33538802648). Caruso's experience is indicative of the sexism that has long been an intricate part of comics' culture. Incidents like Caruso's have resulted in the cosplay community and the organizers of conventions promoting an antiharassment campaign declaring "Cosplay is not consent!" Regrettably,

the sexualized treatment of female characters within the stories can facilitate a misogynistic treatment of costumed women in the real world.

However, at another level, the heteronormative sexual fantasy played out through superhero Halloween and cosplay outfits may be anything but conventional. Yes, a significant number of sexualized superhero Halloween costumes for women are based on female characters like Wonder Woman, Black Widow, Catwoman, Harley Quinn, and Poison Ivy. However, as indicated by the women's version of the Robin costume mentioned above, a large number of the hypersexual women's costumes are derivatives of male characters for whom there are no female variants to be based on. Women's sexy Iron Man, sexy Captain America, sexy Dr. Strange, sexy Flash, and so on are a suggestively queer take on what can make women an irresistible sexual fantasy for heterosexual men. Feminized and fetishized versions of male characters serving as a heterosexual object of lust implies an odd logic of displacement, hero worship, and same-sex, or even self-sex, desires. Is a male hero like Robin an object of heteronormative desire for men? Does the feminine fetishization of Robin just facilitate some underlying homoerotic longing? In fact, the excessively sexualized Halloween costumes for women are only a small step removed from the superhero-themed lingerie, readily available at stores like Hot Topic and Spencer's and through numerous online retailers, that explicitly serves as (presumably) heterosexual stimulation. For example, Batman miniskirts, corsets, stockings, garter belts, and bustiers adorned with trademark Bat symbols are popular lingerie items for women. Interestingly, these items are marketed as Bat*man* corsets, and so forth, which suggests a curious gender and sexual malleability mapped onto the traditionally feminine sexual garments. Even when superhero iconography is employed to stimulate heteronormative sexual relations, there is a great deal of fluidity involved.

At its most reductive, the fetishization of women wearing superhero garb—be it T-shirts, Halloween costumes, or lingerie—may be as simple as incorporating an element of geek fantasy into the heteronormative dynamic. After all, "geek chic" has become an acceptable trend in recent years, especially with the box-office dominance of superhero movies and an increasing claim by women to the realms of fandom. Perhaps, as many fans protest, there is nothing homoerotic about women wearing superhero clothing; it simply proves their "geek cred." In other words, the eroticization may be less about subliminal same-sex desires than it is about perceiving women who may be into superheroes as particularly enticing. Multiple internet sites are devoted to collections of women in superhero clothing. Often these sites are divided into distinct categories for different fetishistic interests, such as professional models, celebrities, amateurs, full costumes, underwear, or by specific characters. But the misogyny of these sites is impossible to ignore: they are unabashedly designed to catalog and display images of women for the voyeuristic delight of men. This type of unequal fetishization via superhero clothing mirrors the gender inequalities and the

rampant objectification that occurs in dominant culture, but with the additional assumption that the women are wearing superhero garb in order to attract men or, better yet, a belief that these women are also genuinely geeks and thus more ideal in fannish terms. In any case, the muddled levels of fetishizing women in (male) superhero clothing is fraught with conflicting impulses. These may just be real-life equivalents of the cartoon scene from *Batman: Brave and the Bold* described in chapter 3 where Robin is confused and overcome by arousal when his crush, Starfire, tries on Batman's costume. The image of sexy Starfire in Batman's uniform leaves Robin shaking on the floor in a puddle of his own drool.

The use of superhero imagery to signify beliefs about gender and sexuality in real life can also be seen in the subculture of cosplay. Once practiced by only a small group of fans, cosplay has become a widely enjoyed and celebrated part of fandom at various conventions around the world. The act of making a costume and publicly dressing up, or "playing," as a character from popular culture now encompasses a seemingly endless list of fandoms, from anime to Harry Potter, and Metal Gear Solid to Bronies. But according to Mountfort, Peirson-Smith, and Geczy, superheroes are regarded as the foundation of the entire activity and still its most common form. "Cosplay is often associated in the popular imagination with comic book superheroes," Mountfort, Peirson-Smith, and Geczy note, "who certainly populate cons globally in large numbers today" (2019, 26). Moreover, they point out that the premise of superheroes makes sense as a prototype for cosplay: "Superhero comics provide a kind of implicit model for cosplay, in that like Clark Kent or Diana Prince cosplayers don costumes and transform into their (albeit imagined) caped crusaders avatars" (26). In its most direct form, cosplay can be aligned with a heteronormative assumption of gender idealism akin to the Halloween costumes worn by children and adults alike. In other words, despite the DIY nature of the elaborate costumes, the male cosplayer who dresses up as Superman and the female cosplayer who dresses up as Wonder Woman are reproducing (and perhaps declaring their affinity for) the conventional gender dichotomy represented by superheroes. But as cosplay has expanded, transformed, and splintered in recent years, the gender and sexual implications have broadened as well. Charting recent changes in fan activities, Elizabeth Gackstetter Nichols stresses that the interesting thing "about cosplay is the way in which the 'law' of who may perform male and female roles is opened up and made accessible to a wider variety of both identities and representations" (2019, 274). Likewise, Claire Langsford describes a philosophy of acceptance and diversity at the root of the fan activity. Langsford draws on interviews with numerous fans who "argue that cosplay and cosplayers should broadly support social justice concepts of racial, gender, and sexual equality" (2020, 183). The original premise of cosplay as simply dressing up as your favorite hero has given way to forms of crossplay, cosqueer, race-bending, and gender-flipping.

These newer variations of cosplay present a more complicated view of identity politics expressed through costumes. Though much crossplay, and its variants, serves to express a queer sexuality, it is not inherent to this form of transvestism. The fluidity and openness of cosplay facilitate a questioning of heteronormative qualities across a range of perspectives, using superheroes' ready association with gender extremes as an anchoring point. Mountfort, Peirson-Smith, and Geczy argue, "The coinage of the term 'crossplay' is used to refer to the practice of female players dressing as male characters, and vice versa, but while this may be a form of drag there is no automatic presumption of queer sexuality attached to such gender-bending costume play" (2019, 235). In fact, the authors continue, the very concept of cosplay can be characterized as queer because *queer*, "like all such terms relating to class, race and identity are porous, hotly debated and contested—is not limited to signifying being gay or lesbian, but embraces all the variants of identity types that do not comply with, or are indifferent to, what queer studies calls 'heteronormativity.'" Furthermore, "like all queer communities, cosplayers celebrate their difference, in the desire to escape what is regularly deemed natural and normal" (235). Regardless of their sexual identities, crossplayers of various types often dress up in superhero iconography in a manner that playfully questions or critiques the traditional rules of gender. If the stereotypical male comic book geek dressed up as Superman signals his aspiration to conform to ideals of hegemonic masculinity, the bearded man in a Wonder Woman costume is signifying something very different. Comic conventions are now rife with cross-dressed cosplayers and gender-flipped cosplayers who reimagine an iconic masculine figure like Captain America as a woman, or female figures like Catwoman as masculine, all of whom undermine the presumed rigidity of superhero genders and sexuality.

Most poignantly, and perhaps most subversively, cosplay has been effectively used by LGBTQ movements to mock heteronormativity and to reposition unconventional identities as heroic. Long before queer superheroes became a part of mainstream comics, masked vigilantes and caped crusaders were regular features at Gay Pride festivals and parades. In fact, the long-standing queerness associated with heroes like Batman and Robin lends itself to their easy use as symbols for the LGBTQ movement. As Henry Jenkins points out in his discussion of superhero imagery evoked in various forms of social activism, "LGBTQ activists have found that secret identity politics offer an ideal metaphor for the process of coming out of the closet. In a number of representative images, the superhero rips open his shirt to reveal a rainbow flag or the marriage equality symbol" (2020, 35). Powerful scenes like Pride parade photos of everyday people dressed up as the Dynamic Duo to share a same-sex kiss, or two women clad in the iconic costumes running down a street holding hands, use potent symbols of hegemonic masculinity to question what exactly the assumed masculine norm is and who has access to it. Here the superhero is used as a tool to broaden concepts of gender and sexuality, literally performed on a stage for all to see. Just as

superheroes have been a useful device for modeling traditional gender dichoto-
mies of men as tough, strong, and stoic and women as beautiful, weak, and depen-
dent, these same characters can be employed to model traits that run counter to
these norms.

Real-life sexual fetishism is invoked in relation to heterosexuality through
things like superhero Halloween costumes, pornography, and officially licensed
superhero corsets and lingerie. Similarly, queer sexualities have also embraced
superhero fetishism through similar means, and most obviously via the expand-
ing gay subculture known simply as Superhero Fetish. As Eric Starker reported
in *Queerspace Magazine* in 2015, "Ripped from the pages of comics, and more
recently a huge surge in popularity in movies, TV and video games, there's a
growing number of people identifying with superheroes, dressing up, and role-
playing. You can find a number of sites dedicated to this fetish, as well as bar
nights and parties across the country" (para. 2). Interviewee Pablo Greene, one
of the first promoters of queer Superhero Fetish events and author of the erotic
gay fiction book series *How to Kill a Superhero*, describes early superhero fetish-
ism primarily among gay men as made up of people who "have lived on the fringe
of BDSM communities" (2015, para. 11). Today, queer-focused events run in con-
junction with every major, and many minor, comic book convention. The
fetish-based role playing acts out some of the BDSM-related implications of the
superhero genre united with many of the queer themes inherent to the form. In
many ways the activity of Superhero Fetish in the queer subcultures can be under-
stood as a live-action and overtly sexual version of fandom "poaching" (to use
Henry Jenkins's [1992] apt term), wherein a special interest group reworks and
reinterprets corporately owned properties in order to explore their own interests.
In particular, these queer costumed role-playing scenarios may be akin to slash
fiction, which has long explored the underlying homoerotic subtext some audi-
ences relate to in popular texts. But though there is a distinctly queer political
aspect of this type of Superhero Fetish, it is really not that different from straight
culture's sexual fetishism of superheroes. The complicated levels of meaning inter-
twined with the concept of superheroes allows them to facilitate and express
any number of gendered and sexual perspectives.

What is clear is that superheroes have become an incredibly influential part
of our collective imagination. They entertain and inspire us; they also teach and
reinforce cultural beliefs about masculinity and femininity by glorifying extremes
of gender through both actions and physical forms. The central preoccupation
with gender in the superhero genre extends to themes of romance and sexuality.
Whether personal relationships are presented through conventional heterosex-
uality or nonheteronormative dynamics, the genre shapes our perceptions about
love as an almost super-powerful emotion. Moreover, the stories stress the impor-
tance of specific relationship rituals from first kisses to wedding ceremonies.
Superheroes also represent an intersection of sexuality and violence as the basic
formula explores the ideological and physical threat that female sexuality is

assumed to pose to men, as well as the potential for intimate partner violence when the boundaries between sex and physical conflict become indistinguishable. The superhero is a potent focal point for abstract ideas about gender and sexuality in large part because the clichés of dual and secret identities, the spectacular powers rooted in bodies, and the overwrought melodramatic nature of the adventures all facilitate a way to explore the ideas of gender and sexuality that are rarely spoken of directly. The colorful masks and cowls provide an exciting disguise for the lessons that superheroes convey about love, sex, and gender.

References

Alaniz, Jose. 2014. *Death, Disability and the Superhero: The Silver Age and Beyond.* Jackson, MI: University Press of Mississippi.

———. 2016. "Standing Orders: Oracle, Disability, and Retconning." In *Disability in Comic Books and Graphic Narratives,* edited by Chris Foss, Jonathan W. Gray, and Zach Whalen, 81–108. London: Palgrave.

Alexander, Dorian L. 2018. "Faces of Abjectivity: The Uncanny Mystique and Transsexuality." In *Gender and the Superhero Narrative,* edited by Michael Goodrum, Tara Prescott, and Phillip Smith, 180–204. Jacksonville: University Press of Mississsippi.

Arend, Patricia. 2014. "Consumption as Common Sense: Heteronormative Hegemony and White Wedding Desire," *Journal of Consumer Culture* 16 (1): 144–163.

Associated Press. 2013. "Can Superhero Parodies Rescue the Porn Business?" *USA Today,* July 27, 2013. https://www.usatoday.com/story/news/nation/2013/07/27/can -superhero-parodies-rescue-the-porn-business/2592913/.

Bacon-Smith, Camille. 1992. *Enterprising Women: Television Fandom and the Creation of Popular Myth.* Philadelphia: University of Pennsylvania Press.

Barry, Erin. 2017. "Eight-Page Eroticism: Sexual Violence and the Construction of Normative Masculinity in Tijuana Bibles." *Journal of Graphic Novels and Comics* 8 (3): 227–237.

Bettcher, Talia Mae. 2014. "Trapped in the Wrong Theory: Rethinking Trans Oppression and Resistance." *Signs* 39 (2): 383–406.

Billard, Thomas J. and Brian MacAuley. 2017. "It's a Bird! It's a Plane! It's a Transgender Superhero!" In *Heroes, Heroines and Everything in Between,* edited by Carrie Lyn Reinhard, 233–252. New York: Lexington Books.

Bodker, Henrik. 2017. "Gadgets and Gurus: *Wired* Magazine and Innovation as a Masculine Lifestyle." *Media History* 23 (1): 67–79.

Bongco, Mila. 2000. *Reading Comics: Language, Culture, and the Concept of the Superhero in Comic Book.* New York: Routledge Press.

Booth, Paul. 2014. "Slash and Porn: Media Subversion, Hyper-articulation, and Parody." *Continuum: Journal of Media & Cultural Studies* 28 (3): 396–409.

Bordo, Susan. 1993. *Unbearable Weight: Feminism, Western Culture and the Body.* Los Angeles: University of California Press.

———. 2000. *The Male Body: A New Look at Men in Public and Private.* New York: Farrar, Straus and Giroux.

Brady, Miranda J. 2009. "The Well-Tempered Spy: Family, Nation and the Female Secret Agent in *Alias*." In *Secret Agents: Popular Icons beyond James Bond*, edited by Jeremy Packer, 111–132. New York: Peter Lang Publishing.

Brody, Michael. 1995. "Batman: Psychic Trauma and Its Solution." *Journal of Popular Culture* 28 (4): 171–178.

Brown, Jeffrey A. 2001. *Black Superheroes: Milestone Comics and Their Fans.* Jackson: University of Mississippi Press.

———. 2011. *Dangerous Curves: Action Heroines, Gender, Fetishism, and Popular Culture.* Jackson: University of Mississippi Press.

———. 2015. *Beyond Bombshells: The New Action Heroines in Popular Culture.* Jackson: University of Mississippi Press.

———. 2016a. "Superhero Film Parody and Hegemonic Masculinity." *Quarterly Review of Film and Video* 33 (2): 131–150.

———. 2019. *Batman and the Multiplicity of Identity: The Contemporary Comic Book Superhero as Cultural Nexus.* New York: Routledge.

———. 2020. *Panthers, Hulks and Ironhearts: Marvel, Ethnicity and the 21st Century Superhero in Comics, Film and Television.* New Brunswick, NJ: Rutgers University Press.

Buchanan, Kyle. 2017. "We Have Now Seen the Hulk's Butt, If You're into That." *Vulture*, November 3, 2017. http://www.vulture.com/2017/11/thor-ragnarok-has-a-hulk-nude-scene-a-first-for-marvel.html.

Bukatman, Scott. 1994. "X-Bodies (The Torment of the Mutant Superhero)." In *Uncontrollable Bodies: Testimonies of Identity and Culture,* edited by Rodney Sappington and Tyler Stallings, 92–129. Seattle, WA: Bay Press.

Caruso, Mandy. 2012. *The Grind Haus.* beautilation.tumblr.com/post/33538802648.

Chadwick, Sara, and Sari van Anders. 2017. "Do Women's Orgasms Function as a Masculinity Achievement for Men?" *Journal of Sex Research* 54 (9): 1141–1152.

Chen, Chaona, Carlos Crivelli, Oliver G. B. Garrod, Philippe G. Schyns, Jose-Miguel Fernandez-Dols, and Rachael E. Jack. 2018. "Distinct Facial Expressions Represent Pain and Pleasure across Cultures." *PNAS* 115 (43): 10013–10021.

Cocca, Carolyn. 2016. *Superwomen: Gender, Power, and Representation.* New York: Bloomsbury Academic.

Cochran, Shannon. 2007. "The Cold Shoulder: Saving Superheroines from Comic Book Violence." *Bitch Media,* February 28. https://www.bitchmedia.org/article/comics-cold-shoulder.

Connell, R. W. 1987. *Gender and Power: Society, the Person, and Sexual Politics.* Sydney: Allen and Unwin.

Connell, R. W., and James W. Messerschmidt. 2005. "Hegemonic Masculinity: Rethinking the Concept." *Gender & Society* 19 (6): 829–859.

Corbett, John, and Terri Kapsalis. 1996. "Aural Sex: The Female Orgasm in Popular Sound." *Drama Review* 40 (3): 102–111.

Coughlan, David. 2009. "The Naked Hero and Model Man: Costumed Identity in Comic Book Narratives." In *Heroes of Film, Comics and American Culture: Essay on Real and Fictional Defenders of Home*, edited by Lisa M. Detora, 234–252. Jefferson, NC: McFarland.

Crawshaw, Tricia L. 2019. "Truth, Justice, Boobs: Gender in Comic Book Culture." *Gender and the Media* 26, 89–103.

Curtis, Neal, and Valentina Cardo. 2018. "Superheroes and Third-Wave Feminism." *Feminist Media Studies* 18 (3): 381–396.

Dallacqua, Ashley, and David Low. 2019. "Cupcakes and Beefcakes: Students' Readings of Gender in Superhero Texts." *Gender and Education* 33 (1): 1–18.

Darwoski, Joseph J. 2008. "It's a Bird, It's a Plane, It's . . . Synthesis: Superman, Clark Kent, and Hegel's Dialectic." *International Journal of Comic Art* 10 (1): 461–470.

Davies, Chris. 2019. "Who Do You Want Me to Be? Scarlett Johansson, Black Widow and Shifting Identity in the Marvel Cinematic Universe." In *Screening Scarlett Johansson*, edited by Janice Loreck, Whitney Monaghan, and Kirsten Stevens, 81–98. New York: Palgrave MacMillan.

De Dauw, Esther. 2020. *Hot Pants and Spandex Suits: Gender Representation in American Superhero Comic Books.* New Brunswick, NJ: Rutgers University Press.

Dickos, Andrew. 2002. *A Street With No Name: A History of the Classic American Film Noir.* Lexington: University Press of Kentucky.

Doane, Mary Ann. 1991. *Femme Fatales: Feminism, Film Theory, Psychoanalysis.* New York: Routledge.

Doty, Alexander. 1993. *Making Things Perfectly Queer: Interpreting Mass Culture.* St. Paul: University of Minnesota Press.

Dyer, James. 2017. "*Thor: Ragnarok* Review." *Empire,* October 23, 2017. https://www.empireonline.com/movies/thor-ragnarok/review/.

Dyer, Richard. 1993. *Only Entertainment.* New York: Routledge Press.

———. 1997. "The White Man's Muscles." In *Race and the Subject of Masculinities,* edited by Harry Stecopoulos and Michael Uebel, 286–314. Durham, NC: Duke University Press.

Easton, Lee, and Richard Harrison. 2010. *Secret Identity Reader: Essays on Sex, Death and the Superhero.* Hamilton, ON: Wolsak and Wynn.

Eco, Umberto. 1972. "The Myth of Superman." *Diacritics* 2 (1): 14–22.

Fawaz, Ramzi. 2016. *The New Mutants: Superheroes and the Radical Imagination of American Comics.* New York: New York University Press.

Foucault, Michel. 1975. *Discipline and Punish: The Birth of the Prison.* London: Vintage Books.

Frankel, Valerie Estelle. 2019. "Reclaiming Power from the Toxic Male: Support and Recovery in Marvel's Jessica Jones." In *Fourth Wave Feminism in Science Fiction and Fantasy,* vol. 2., edited by Valerie Estelle Frankel, 75–89. Jefferson, NC: McFarland.

Fraterrigo, Elizabeth. 2008. "The Answer to Suburbia: *Playboy*'s Urban Lifestyle." *Journal of Urban History* 34 (5): 747–774.

Frith, Hannah. 2015. "Visualising the 'Real' and the 'Fake': Emotion Work and the Representation of Orgasm in Pornography and Everyday Sexual Interactions." *Journal of Gender Studies* 24 (4): 386–398.

Frus, Phyliss. 2001. "Documenting Domestic Violence in American Films." In *Violence and American Cinema,* edited by J. David Slocum, 226–244. New York: Routledge.

Gardner, Jeanne Emerson. 2013. "She Got Her Man, but Could She Keep Him? Love and Marriage in American Romance Comics, 1947–1954." *Journal of American Culture* 36 (1): 16–24.

Garland, Tammy S., Christina Policastro, Kathryn A. Branch, and Brandy B. Henderson. 2019. "Bruised and Battered: Reinforcing Intimate Partner Violence in Comic Books." *Feminist Criminology* 14 (5): 584–611.

Gelber, S. M. 1997. "Do-it-yourself: Constructing, Repairing, and Maintaining Domestic Masculinity." *American Quarterly* 49 (1): 66–112.

Gianola, Gabriel, and Janine Coleman. 2018. "The Gwenaissance: Gwen Stacy and the Progression of Women in Comics." In *Gender and the Superhero Narrative*, edited by Michael Goodrum, Tara Prescott, and Philip Smith, 251–284. Jackson, MI: University Press of Mississippi.

Giroux, Henry A. 2001. *Stealing Innocence: Youth Corporate Power, and the Politics of Culture*. New York: Palgrave MacMillan.

Goodrum, Michael. 2018. "'Superman Believes a Wife's Place Is in the Home': *Superman's Girlfriend, Lois Lane* and the Representation of Women." *Gender & History* 30 (2): 442–464.

Gorman-Murray, Andrew. 2008. "Masculinity and the Home: A Critical Review and Conceptual Framework." *Australian Geographer* 39 (3): 367–379.

Grant, Barry Keith. 2004. "Man's Favorite Sport? The Action Films of Kathryn Bigelow." In *Action and Adventure Cinema*, edited by Yvonne Tasker, 371–383. New York: Routledge.

Greenwood, Carl. 2017. "Green with Envy? Thor: Ragnarok Features Marvel's First Nude Scene." *Sun*, October 19, 2017. https://www.thesun.co.uk/tvandshowbiz/4724141/thor-ragnarok-features-marvels-first-nude-scene-as-a-beloved-character-strips-naked-in-front-of-a-window/.

Griffin, Sean. 2009. *Hetero: Queering Representations of Straightness*. New York: SUNY Press.

Harrington, K. Scarlett, and Jennifer A. Guthrie. 2017. "That Just Proves He Wants Me Back: Pure Victimhood, Agency and Intimate Partner Violence in Comic Book Narratives." In *The Ascendance of Harley Quinn: Essays on DC's Enigmatic Villain*, edited by Shelley E. Barba and Joy M. Perrin, 55–69. Jefferson, NC: McFarland.

Hills, Matt. 2002. *Fan Cultures*. New York: Routledge.

Hirdman, Anja. 2007. "(In)Visibility and the Display of Gendered Desire: Masculinity in Mainstream Soft- and Hardcore Pornography." *NORA—Nordic Journal of Women's Studies* 15 (2–3): 158–171.

Hughes, Susan M. and Shevon E. Nicholson. 2008. "Sex Differences in the Asssessment of Pain Versus Sexual Pleasure Facial Expressions." *Journal of Social, Evolutionary, and Cultural Psychology* 2 (4): 289–298.

Jeffords, Susan. 1993. "Can Masculinity be Terminated?" In *Screening the Male: Exploring Masculinities in Hollywood Cinema*, edited by Steven Cohan and Ina Rae Hark, 245–262. New York: Routledge.

Jeffries, Dru. 2016. "This Looks Like a Blowjob for Superman: Servicing Fanboys with Superhero Porn Parodies." *Porn Studies* 3 (3): 276–294.

Jenkins, Henry. 1992. *Textual Poachers: Television Fans and Participatory Culture*. New York: Routledge.

———. 2006. *Fans, Bloggers, and Gamers: Exploring Participatory Culture*. New York: New York University Press.

———. 2020. "'What Else Can You Do With Them?' Superheroes and the Civic Imagination." In *The Superhero Symbol: Media, Culture & Politics*, edited by Liam Burke, Ian Gordon, and Angel Ndalianis, 25–46. New Brunswick, NJ: Rutgers University Press.

Kakoudaki, Despina. 2014. *Anatomy of a Robot: Literature, Cinema, and the Cultural Work of Artificial People*. New Brunswick, NJ: Rutgers University Press.

Karaminas, Vicki. 2006. "'No Capes!' Uber Fashion and How 'Luck Favors the Prepared': Constructing Contemporary Superhero Identities in American Popular Culture." *International Journal of Comic Arts* 8 (1): 498–508.

Kent, Miriam. 2019. "Destroying the Rainbow Bridge: Representations of Heterosexuality in Marvel Superhero Narratives." In *Comics and Pop Culture: Adaptation from*

Panel to Frame, edited by Barry Keith Grant and Scott Henderson, 110–125. Austin: University of Texas Press.

Kimport, Katrina. 2012. "Remaking the White Wedding? Same-Sex Wedding Photographs' Challenge to Symbolic Heteronormativity." *Gender and Society* 26 (6): 874–899.

Kirkpatrick, Ellen. 2015. "Transformers: 'Identity' Compromised." *Cinema Journal* 55 (1): 124–133.

Kramer Michael R. 2014. "Empowerment as Transgression: The Rise and Fall of the Black Cat in Kevin Smith's *The Evil Men Do*." In *Heroines of Comic Books and Literature*, edited by Maja Bajac-Carter, Norma Jones, and Bob Batchelor, 233–244. New York: Rowan & Littlefield.

Lacan, Jacques. 1958. "The Meaning of the Phallus." Translated in *Feminine Sexuality* (1982). Edited by J. Rose and J. Mitchell. New York: Norton.

Langsford, Claire. 2020. "Being Super, Becoming Heroes: Dialogic Superhero Narratives in Cosplay Collectives," In *The Superhero Symbol: Media, Culture & Politics,* edited by Liam Burke, Ian Gordon, and Angel Ndalianis, 171–188. New Brunswick, NJ: Rutgers University Press.

Lebel, Sabine. 2009. "Tone Down the Boobs, Please! Reading the Special Effect Body in Superhero Movies." *Cineaction* 7756–7768.

Lehman, Peter. 1998. "Will the Real Dirk Diggler Please Stand Up? *Boogie Nights*," *Jump Cut*, No. 42: 120–136.

Lennon, Shannon, Zheng Zhiying, and Aziz Fatnassi. 2019. "Women's Revealing Halloween Costumes: Other-Objectification and Sexualization." *Fashion and Textiles* 3 (21): 2–19.

Liddell, Alex. 2017. "Duality and Double Entendres: Bi-coding the Queen Clown of Crime from Subtext to Canon." In *The Ascendance of Harley Quinn: Essays on DC's Enigmatic Villain,* edited by Shelley E. Barba and Joy M. Perrin, 93–106. Jefferson, NC: McFarland.

Lohan, Maria, and Wendy Faulkner. 2014. "Masculinities and Technologies: Some Introductory Remarks." *Men and Masculinities* 6 (4): 319–329.

Lovelock, Michael. 2017. "Call Me Caitlyn: Making and Making Over the 'Authentic' Transgender Body in Anglo-American Popular Culture." *Journal of Gender Studies* 26 (6): 675–687.

MacDonald, Shanna. 2019. "Refusing to Smile for the Patriarchy: Jessica Jones as Feminist Killjoy." *Journal of the Fantastic in the Arts* 30 (1): 68–84.

McGunnigle, Christopher. 2018. "The Difference Between Heroes and Monsters: Marvel Monsters and Their Transition into the Superhero Genre." *University of Toronto Quarterly* 87 (1): 110–135.

McKay, Hollie. 2013. "Super-Hero Parodies Do for the Porn Industry What Super-Hero Blockbusters Do for Hollywood." *Fox News*, July 30, 2013. http://www.foxnews.com /entertainment/2013/07/30/super-hero-parodies-do-for-porn-industry-what-super -hero-blockbusters-do-for.html.

McMillan, Graeme. 2014. "DC Entertainment on Sexist Merchandising Outcry: 'Certain T-Shirts are Offensive.'" *Hollywood Reporter,* September 30, 2014. https:// www.hollywoodreporter.com/movies/movie-features/dc-entertainment-sexist -merchandise-outcry-737023/.

Medhurst, Andy. 1991. "Batman, Deviance and Camp." In *The Many Lives of the Batman: Critical Approaches to a Superhero and His Media*, edited by Roberta E. Pearson and William Uricchio, 149–163. New York: Routledge.

Messner, Michael A. 2007. "The Masculinity of the Governator: Muscle and Compassion in American Politics." *Gender & Society* 21 (4), 461–480.

Miller, P. Andrew. 2003. "Mutants, Metaphor and Marginalism: What X-actly do the X-Men Stand For?" *Journal of the Fantastic in the Arts* 13 (3): 282–290.

Miller-Young, Mireille. 2014. *A Taste for Brown Sugar: Black Women in Pornography.* Durham, NC: Duke University Press.

Moiso, Risto, and Mariam Beruchashvili. 2016.) "Mancaves and Masculinity." *Journal of Consumer Culture* 16 (3): 656–676.

Mountfort, Paul, Anne Peirson-Smith, and Adam Geczy. 2019. *Planet Cosplay: Costume Play, Identity and Global Fandom.* Chicago: University of Chicago Press.

Mulvey, Laura. 1975. "Visual Pleasure and Narrative Cinema." *Screen* 16 (3): 6–18.

Murnen, Sarah K., Claire Greenfield, Abigail Younger, and Hope Boyd. 2015. "Boys Act and Girls Appear: A Content Analysis of Gender Stereotypes Associated with Characters in Children's Popular Culture." *Sex Roles* 74: 78–91.

Nash, Jennifer C. 2014. *The Black Body in Ecstasy: Reading Race, Reading Pornography.* Durham, NC: Duke University Press.

Nead, Lynda. 2011. "Stilling the Punch: Boxing, Violence and the Photographic Image." *Journal of Visual Culture* 10 (3): 305–323.

Neale, Steve. 1983. "Masculinity as Spectacle: Reflections on Men and Mainstream Cinema." *Screen* 24 (6): 2–16.

Nelson, Tim. 2004. "Even an Android Can Cry." *Journal of Gender Studies* 13 (3): 251–257.

Nettleton, Pamela Hill. 2016. "No Girls Allowed: Television Boys' Clubs as Resistance to Feminism." *Television & New Media* 17 (7): 563–578.

Nichols, Elizabeth Gackstetter. 2019. "Playing With Identity: Gender, Performance and Feminine Agency in Cosplay." *Continuum: Journal of Media & Cultural Studies* 33 (2): 270–282.

Niven, Larry. 1969. "Man of Steel, Woman of Kleenex." *Knight: The Magazine for the Adult Male* 7 (8): np.

Osgerby, Bill. 2005. "The Bachelor Pad as Cultural Icon: Masculinity, Consumption and Interior Design in American Men's Magazines, 1930–1965." *Journal of Design History* 18 (1): 99–113.

Patton, Cindy. 1989. "Hegemony and Orgasm: Or the Instability of Heterosexual Pornography." *Screen* 30 (1–2): 100–112.

Patton, Elizabeth A. 2015. Transforming Work into Play and Play into Work within the Domestic Sphere." *Media History* 21 (1): 101–116.

Pearson, Roberta E., and William Uricchio. 1991. "I'm Not Fooled by That Cheap Disguise." In *The Many Lives of the Batman: Critical Approaches to a Superhero and His Media*, edited by Roberta E. Pearson and William Uricchio, 182–213. New York: Routledge.

Peppard, Anna. 2017. "This Female Fights Back!: A Feminist History of Marvel Comics." In *Make Ours Marvel: Media Convergence and a Comics Universe*, edited by Matt Yocket, 105–137. Austin: University of Texas Press

———. 2018. "'I Just Want to Feel Something Different': Rewriting Abuse and Drawing Strength in Brian Michael Bendis and Michael Gaydos's *Alias*." *Feminist Media Histories* 4 (3): 158–178.

Place, Janey. 1998. "Women in Film Noir." In *Women in Film Noir*, edited by E. Ann Kaplan, 47–68. London: British Film Institute Books.

Rezeanu, Catalina-Ionela. 2015. "The Relationship between Domestic Space and Gender Identity: Some Signs of Emergence of Alternative Domestic Femininity and Masculinity." *Journal of Comparative Research in Anthropology and Sociology* 6 (2): 9–28.

Rodino-Colocino, Michelle, Lauren DeCarvalho, and Aaron Heresco. 2018. "Neo-Orthodox Masculinities on *Man Caves*." *Television & New Media* 19 (7): 626–645.

Salter, Anastasia. 2020. "#RelationshipGoals? Suicide Squad and Fandom's Love of 'Problematic' Men." *Television & New Media* 21 (2): 135–150.

Salter, Anastasia, and Bridgette Blodgett. 2017. *Toxic Geek Masculinity in Media: Sexism, Trolling, and Identity Policing.* New York: Springer Publishing.

Scott, Darieck and Fawaz, Rami. 2018. "Introduction: Queer About Comics." *American Literature* 90 (2): 197–219.

Scott, Suzanne. 2015. "The Hawkeye Initiative: Pinning Down Transformative Feminisms in Comic Book Culture through Superhero Cosplay Fan Art." *Cinema Journal* 55 (1): 150–160.

Serrano, Elliot. 2014. "'Geek Porn' Director Axel Braun on Avengers' Quicksilver, Comic Book Costuming." *Chicago Tribune*, April 8, 2014. http://www.chicago tribune.com/redeye/redeye-axel-braun-quicksilver-interview-20140408-story.html.

Sharrett, Christopher. 1991. "Batman and the Twilight of the Idols: An Interview with Frank Miller." In *The Many Lives of the Batman: Critical Approaches to a Superhero and His Media*, edited by Roberta E. Pearson and William Uricchio, 83–46. New York: Routledge.

Sherman, Aurora M., Haley Allemand, and Shayla Prickett. 2019. "Hypersexualization and Sexualization in Advertisements for Halloween Costumes." *Sex Roles* 83: 254–266.

Shimizu, Celine Parrenas. 2007. *The Hypersexuality of Race: Performing Asian/American Women on Screen and Scene.* Durham, NC: Duke University Press.

Shyminsky, Neil. 2011. "'Gay' Sidekicks: Queer Anxiety and the Narrative Straightening of the Superhero." *Men and Masculinities* 14 (3): 288–308.

Smith, Iain Robert. 2015. "Batsploitation: Parodies, Fan Films and Remakes." In *Many More Lives of the Batman*, edited by Roberta Pearson, William Uricchio and Will Brooker, 107–119. London: MacMillan International.

Stables, Kate. 1998. "The Postmodern Always Rings Twice: Constructing the Femme Fatale in 90s Cinema." In *Women in Film Noir*, edited by E. Ann Kaplan, 164–182. London: British Film Institute Books.

Starker, Eric. 2015. "Superhero Fetish: A Scene Growing Faster than a Speeding Bullet," *Queerspace Magazine,* October 5, 2015. https://queerspacemagazine.com/superhero -fetish-a-scene-growing-faster-than-a-speeding-bullet/.

Steele, Valerie. 1996. *Fetish: Fashion, Sex & Power.* Oxford: Oxford University Press.

Stephens, Elizabeth. 2007. "The Spectacularized Penis: Contemporary Representations of the Phallic Male Body." *Men and Masculinities* 10 (1): 85–98.

Straayer, Chris. 1998. 'Femme Fatale or Lesbian Femme: Bound in Sexual Difference', *Women in Film Noir,* 151–163. London: British Film Institute Books.

Stratton, Jon. 2001. *The Desirable Body: Cultural Fetishism and the Erotics of Consumption.* Urbana: University of Illinois Press.

Stryker, Susan, Paisley Currah, and Lisa Moore. 2008. "Introduction: Trans-, Trans, or Transgender?" *Women's Studies Quarterly* 36 (3/4): 11–22.

Studlar, Gaylyn. 2013. "The Corpse on Reprieve: Film Noir's Cautionary Tales of 'Tough Guy' Masculinity." In *A Companion to Film Noir,* edited by Andre Spicer and Helen Hanson, 369–386. New York: Wiley Blackwell.

Sun, Chyng, Matthew B. Ezzell, and Olivia Kendall. 2017. "Naked Aggression: The Meaning and Practice of Ejaculation on a Woman's Face." *Violence Against Women* 23 (14): 1710–1729.

Tasker, Yvonne. 2006. "Fantasizing Gender and Race: Women in Contemporary US Action Cinema." In *Contemporary American Cinema*, edited by Linda Williams and Michael Hammond, 410–428. Maidenhead, UK: Open University Press.

———. 2013. "Women in Film Noir." In *A Companion to Film Noir*, edited by Andrew Spicer and Helen Hanson, 353–368. London: Blackwell Press.

Taylor, Aaron. 2007. "He's Gotta Be Strong, and He's Gotta Be Fast, and He's Gotta Be Larger Than Life: Investigating the Engendered Superhero Body." *Journal of Popular Culture* 40 (2): 344–360.

Taylor, Tosha. 2015. "Kiss with a Fist: The Gendered Power Struggle of the Joker and Harley Quinn." In *The Joker: A Serious Study of the Clown Prince of Crime*, edited by Robert Moses Peaslee and Robert G. Weiner, 82–93. Jackson, MI: University Press of Mississippi.

Tedeschi, Victoria. 2019. "Poison Ivy, Red in Tooth and Claw: Ecocentrism and Ecofeminism in the DC Universe." In *Superhero Bodies: Identity, Materiality, Transformation*, edited by Wendy Haslam, Elizabeth McFarlane, and Sarah Richardson, 37–47. New York: Routledge.

Torres, Sasha. 1996. "The Caped Crusader of Camp: Pop, Camp, and the Batman Television Series." In *Pop Out: Queer Warhol*, edited by Jennifer Doyle, Jonathan Flatley, and Jose Esteban Munoz, 238–256. Durham, NC: Duke University Press.

Tosh, John. 2005. *Manliness and Masculinities in Nineteenth-Century Britain: Essay on Gender, Family and Empire*. Harlow, UK: Pearson Longman.

Trott, Verity. 2019. "Let's Start with a Smile: Rape Culture in Marvel's Jessica Jones." In *Superhero Bodies: Identity, Materiality, Transformation*, edited by Wendy Haslam, Elizabeth McFarlane, and Sarah Richardson, 47–58. New York: Routledge.

Vale, Catherine M. 2015. "The Loyal Heart: Homosocial Bonding and Homoerotic Subtext between Batman and Robin, 1939–1943." In *Dick Grayson, Boy Wonder: Scholars and Creators on 75 Years of Robin, Nightwing and Batman*, edited by Kristen L. Geaman, 94–109. Jefferson, NC: McFarland.

Valentine, Genevieve. 2018. "Empire of a Wicked Woman: Catwoman, Royalty, and the Making of a Comics Icon." *Journal of Graphic Novels and Comics* 9 (6): 593–611.

Vaz, Mark Cotta. 1989. *Tales of the Dark Knight: Batman's First Fifty Years, 1939–1989*. New York: Ballantine.

Vena, Dan. 2017. "Rereading Superman as a Trans F/Man." *Transformative Works and Cultures* 25: np.

Voelker-Morris, Robert, and Julie Voelker-Morris. 2014. "Stuck in Tights: Mainstream Superhero Comics' Habitual Limitations on Social Constructions of Male Superheroes." *Journal of Graphic Novels and Comics* 5 (1): 101–117.

Walker-Morrison, Deborah. 2015. "Sex Ratio, Socio-Sexuality, and the Emergence of the Femme Fatale in Classic French and American Film Noir." *Film & History* 45 (1): 25–37.

Wanner, Kevin J. 2016. "In a World of Super-Violence, Can Pacifism Pack a Punch? Nonviolent Superheroes and Their Implications." *Journal of American Culture* 39 (2): 177–192.

Wansink, B., M. Shimizu, and G. Camps. 2012. "What Would Batman Eat? Priming Children to Make Healthier Fast Food Choices." *Pediatric Obesity* 7 (2): 121–123.

Ward, Anna E. 2010. "Pantomimes of Ecstasy: BeautifulAgony.com and the Representation of Pleasure." *Camera Obscura* 25 (1): 161–196.

Wennerscheid, Sophie. 2018. "Posthuman Desire in Robotics and Science Fiction." In *Love and Sex with Robots*, edited by A. D. Cheok and D. Levy, 37–50. New York: Springer.

Wertham, Fredric. 1954. *Seduction of the Innocent*. Reinhardt Press: New York.

White, Rachel, Emily O. Prage, Catherine Schaefer, Ethan Kross, and Angela L. Duckworth. 2017. "The 'Batman Effect': Improving Perseverance in Young Children." *Child Development* 88 (5): 1–9.

White, Rachel, and Stephanie Carlson. 2016. "What Would Batman Do? Self-Distancing Improves Executive Function in Young Children." *Developmental Science* 19 (3): 419–426.

Wilde, Jenée. 2011. "Queer Matters in *The Dark Knight Returns*: Why We Insist on a Sexual Identity for Batman." In *Riddle Me This, Batman! Essays on the Universe of the Dark Knight*, edited by Kevin K. Durand and Mary K. Leigh, 104–123. Jefferson, NC: McFarland.

Williams, Linda. 1989. *Hard Core: Power, Pleasure and the Frenzy of the Visible.* Berkeley: University of California Press.

———. 1991. "Film Bodies: Gender, Genre, and Excess." *Film Quarterly* 44 (4): 2–13.

———. 2006. "Of Kisses and Ellipses: The Long Adolescence of American Movies." *Critical Inquiry* 32 (2): 288–340.

Williamson, Catherine. 1997. "Draped Crusaders: Disrobing Gender in the Mark of Zorro." *Cinema Journal* 36 (2): 1–15.

Worland, Rick. 2018. "Original Swingers: Hollywood's Postwar Bachelor Pad-Pad Cycle." *Journal of Popular Film Television* 46 (3): 156–168

Yockey, Matt. 2014. *Batman (TV Milestone Series).* Detroit, MI: Wayne State University Press.

Index

About the Author

JEFFREY A. BROWN is a professor in the Department of Popular Culture in the School of Critical and Cultural Studies at Bowling Green State University. He is the author of several books, including *Black Superheroes: Milestone Comics and Their Fans*, *Dangerous Curves: Gender, Fetishism, and the Modern Action Heroine*, *Beyond Bombshells: The New Action Heroine in Popular Culture*, and *Panthers, Hulks, and Ironhearts*.